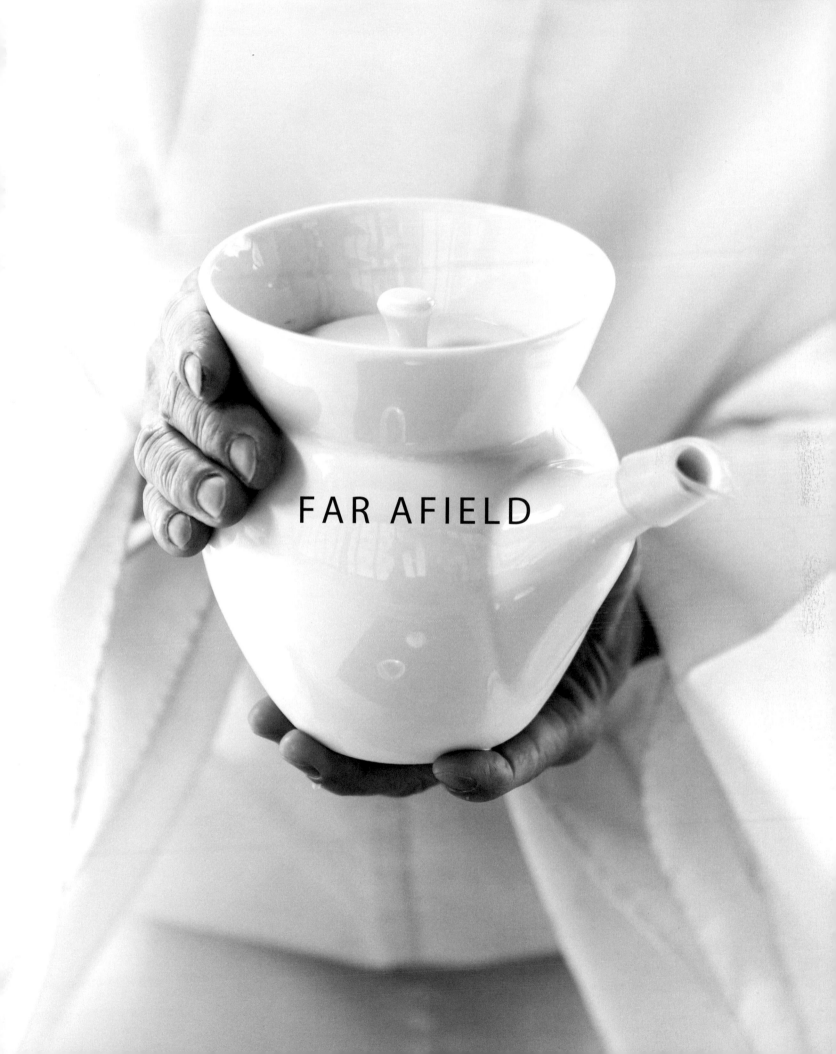

FAR AFIELD

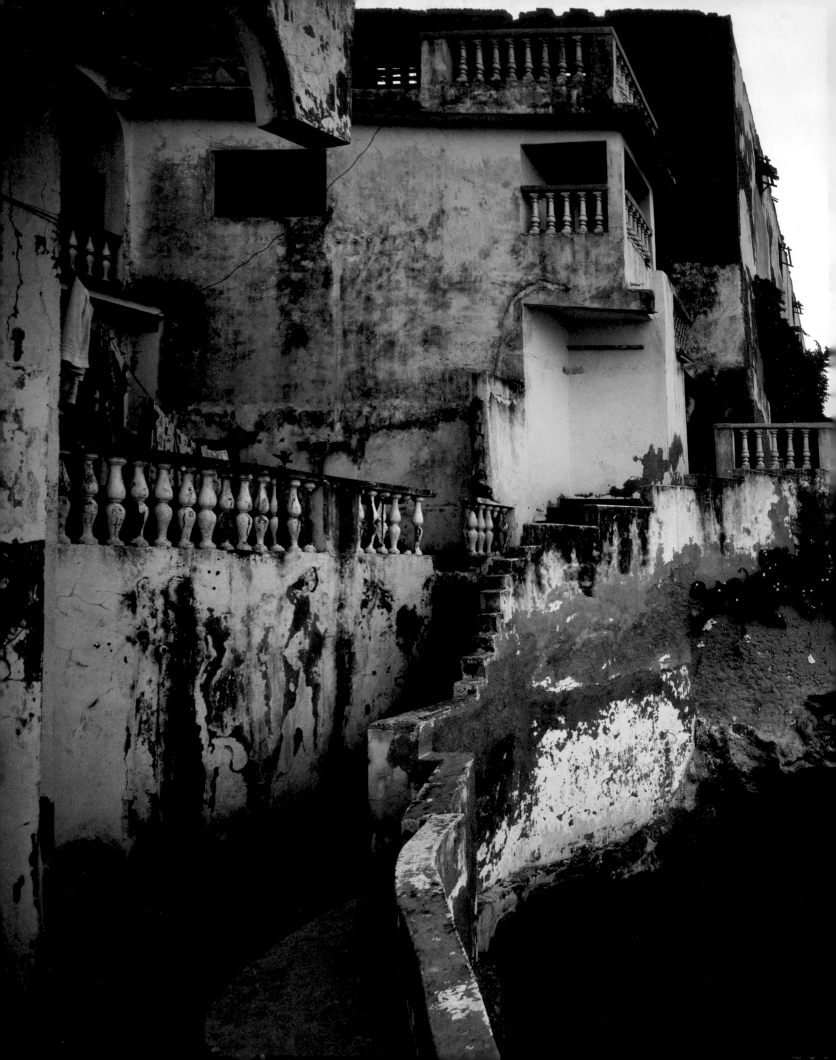

FAR AFIELD

Rare food encounters from around the world

SHANE MITCHELL

Photographs by James Fisher

TEN SPEED PRESS
Berkeley

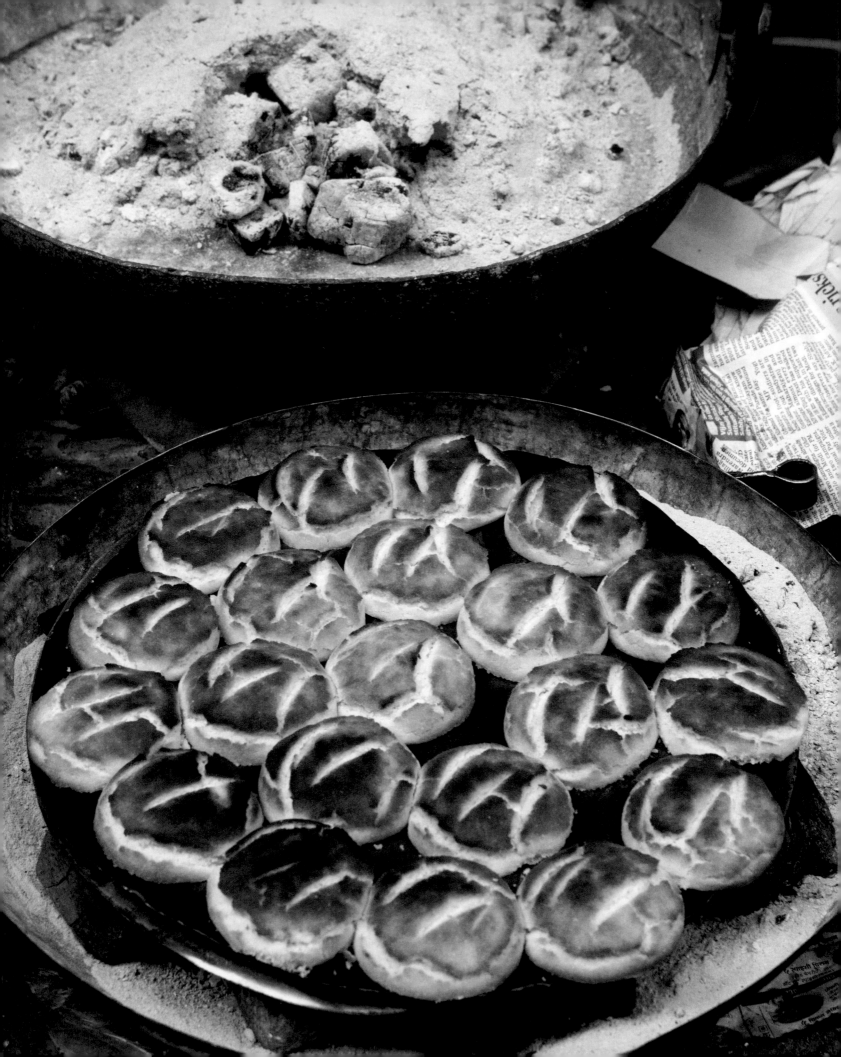

CONTENTS

INTRODUCTION

Umami Road

It was not a soft landing. Lying on a grassy patch, the Arctic wind roared around me as the runaway horse, trailing a broken harness, skidded down the rocky incline and disappeared from sight. It took a while to catch my breath. When I sat up, searing pain shot along my left arm, and it was shock enough to knock me flat again.

The Vikings found me that way, cradling my arm, cheeks cold and wet from the autumn squall. Sindri, Siggi, and Agnar clustered around. One of them held my taciturn mount.

"Come on," Siggi said gruffly. "Best thing is to get back on the horse."

"Something is wrong with my wrist," I replied. "It may be hard to stay on."

We were in the glacial highlands, miles from the nearest road. Agnar tossed me into the saddle and led the horse along the steep track while cheerfully recounting how many bones he had broken wrangling Icelandic stallions. Two front teeth, ribs, a shoulder—the same one twice—and a leg. I think he was trying to distract me.

No one had told me how hard it was to herd sheep.

<p style="text-align:center">✳</p>

The same applies for pulling taro corms out of a pond in a Hawaiian valley or fishing with a hand line on a *dhow* drifting along the coast of East Africa. But, throughout our travels together on several continents, photographer James Fisher and I were lucky enough to see what life is like

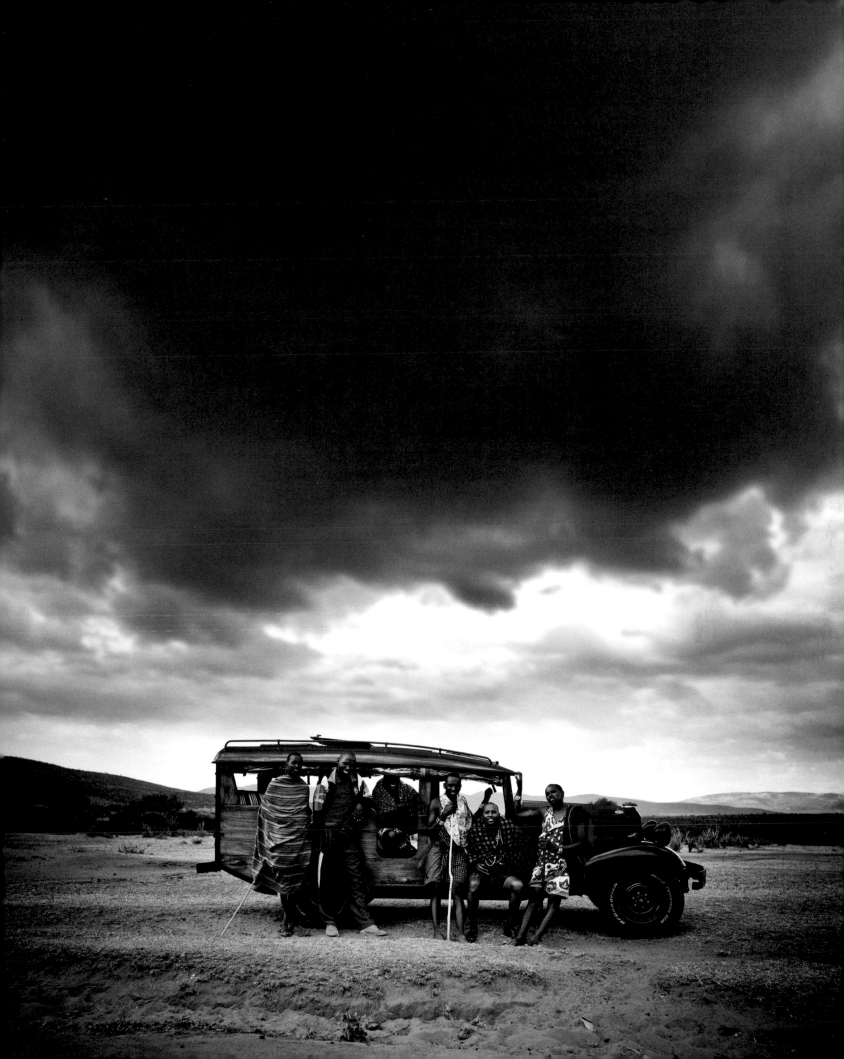

for people who are firmly rooted in their culture and landscape, in some of our most isolated or marginal communities, where keeping the food chain vital remains a daily chore. Each profile in this book—as well as James's remarkable images—represents a distinct tradition or practice not often witnessed by outsiders, some of which are millennia old, reaching far back into the collective culinary memory. It took us almost ten years to locate them all; the search involved a lot of knocking on doors, lurking around farmers' markets, begging invitations, and detouring from more mainstream assignments into what the poet Robert Service called "the map's void spaces." Why go? Researchers claim certain people have a variant DNA sequence, specifically identified as DRD4-7r, which has been tied to the traits of curiosity and restlessness. It is sometimes cited as the underlying predisposition for exploration that drove the first humans to migrate out of Africa. Popularly called the wanderlust gene, it's as likely a rationale as any for why some of us wind up in fringe places, happily poking into kitchens not our own.

Many of the following stories also focus on rituals where hospitality plays a key role. A wedding feast. A luau. Afternoon tea with refugees. A boy's ascension to warrior. Food for the dead. Food for the gods. Being asked to witness, and occasionally participate in, these celebrations was worth the time and effort it took to get there. Some days, it even involved risking our lives. (James fended off a leopard attack in the Maasai Mara—his camera still has the scratches to prove it.) In creating this book, we didn't fret over an omission of Southeast Asia, or the Middle East, or more easily accessed communities closer to home. Instead of rushing around in an attempt to be geographically inclusive, we got to sit longer in one green valley and watch a quiet man with such a heightened sense of place that he knew exactly where to position a child's pinwheel to catch an odd little breeze for his own amusement, while everyone else around him was yammering away, oblivious of this exchange with nature.

The recipes in *Far Afield* are souvenirs of this long journey. They are a highly personal reflection of meals shared in the moment. Most are dishes intended for the family table, eaten with the hand where customary, skewered with a worn but favored utility knife, or scooped with a banana leaf from a cooking pot. The occasional meal at a street stall, a dive bar, or

a modest restaurant, often the only one around for miles, easily adapted. Comforting food after a hard day's labor. They are as simple as a scorched chapati smeared with chile paste shared by goatherders on the verge of the Thar Desert in India; as lavish as a birthday *asado* (barbecue) on the pampas of Uruguay, with a whole *lamb* roasting on hot coals and wine flowing like a river. You will note the lack of cookies in this book—but there is amazing pie. And doughnuts. Lime pickle that takes over a month to macerate will become a favorite; the okra dish that will convince you to finally appreciate this slimy member of the mallow family; tangy preserves made from wild rhubarb; and some kickass cocktails. A recipe for Peruvian *cuy* (guinea pig) didn't make the cut. Neither did a kaiseki dinner at one of Japan's most venerable ryokans. Umami, that most elusive flavor, so difficult to translate or transport, is occasionally lost somewhere back on the road.

<div align="center">✳</div>

"This isn't how sheep are mustered in Australia."

During the roundup in Iceland, James offered another perspective on what we were experiencing. (He grew up on a sheep station in the Outback, where penned grazing is the norm.) All day we'd sighted one or two animals at a time, skittering away from the shepherds who hunted them through mossy bogs and rain-slick ravines. We only had smoked lamb on *flatkökur* bread, the local equivalent of peanut-butter-and-jelly, smashed in our pockets. Hunger made me cranky.

"Keep hunting," I said. "There must be a reason for doing it this way."

Eventually, the two of us learned why Icelandic sheep wander the island at will, but not before my arm wound up in a plaster cast and James played drinking games with singing Vikings. Travel should be about expanding your universe, even if that means venturing beyond other people's comfort zone. (Not everyone has that variant DNA sequence.) If you've chosen this book, however, your appetite for the map's void spaces is just as insatiable. We're glad to have you along for the ride.

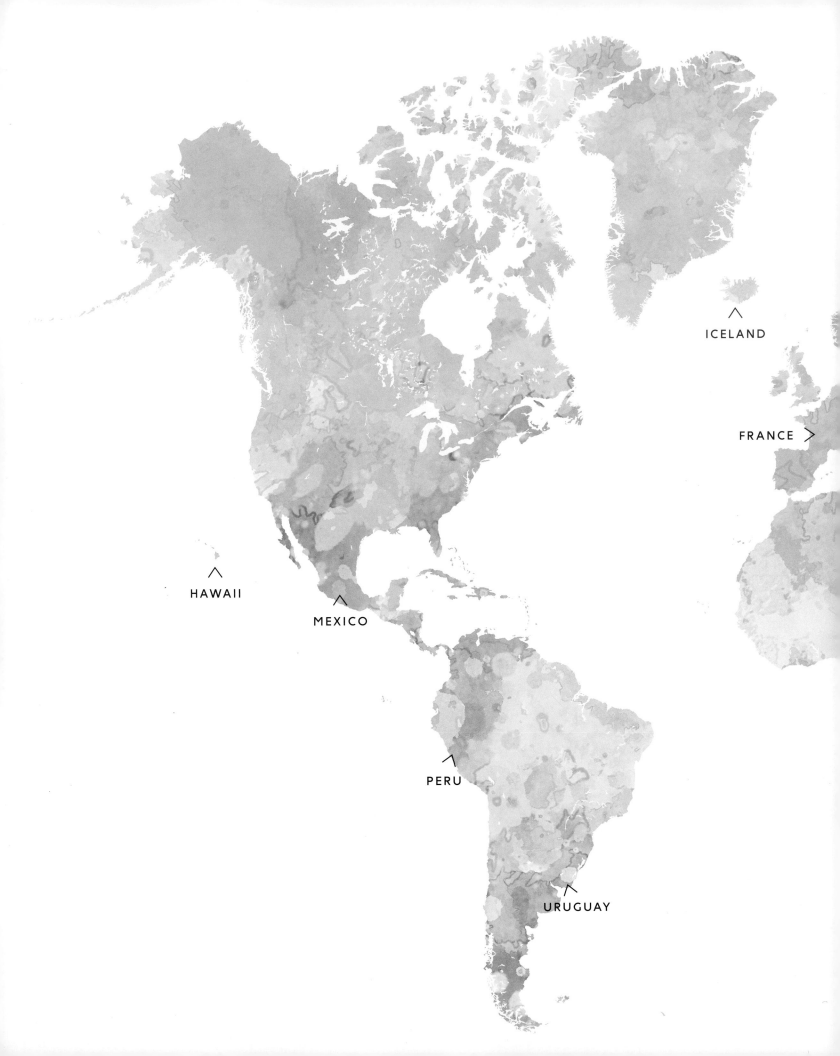

ICELAND

HAWAII

MEXICO

PERU

URUGUAY

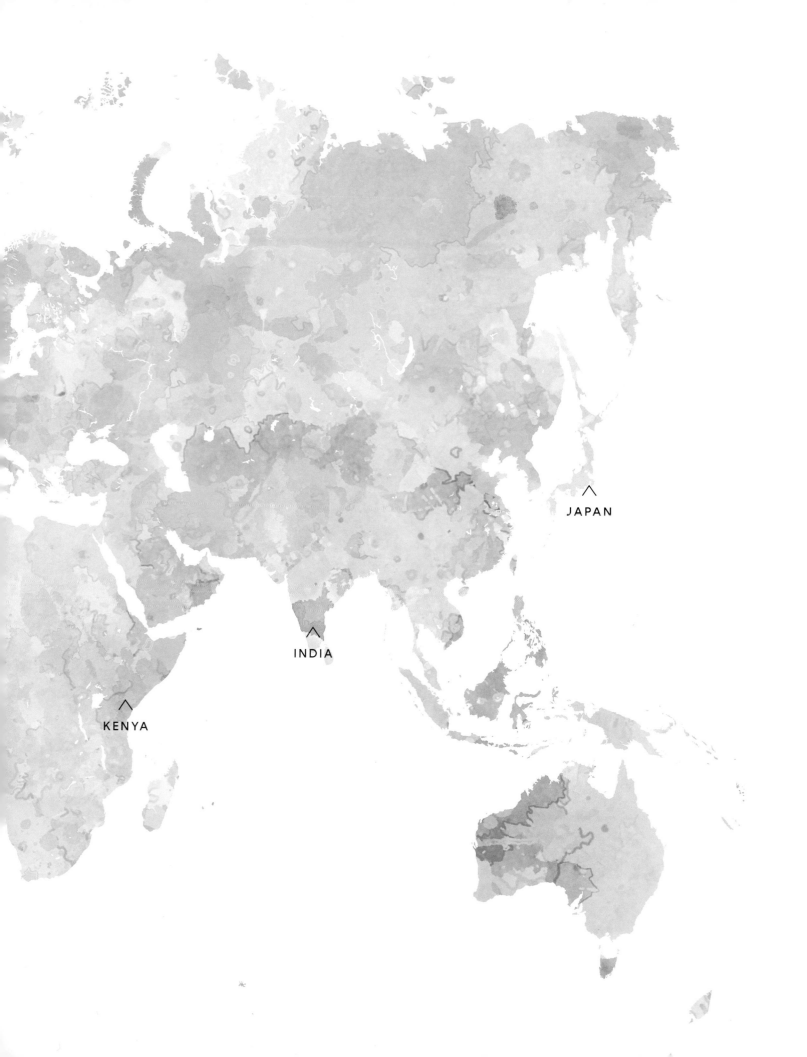

JAPAN

INDIA

KENYA

GODWAR PROVINCE
RAJASTHAN
INDIA

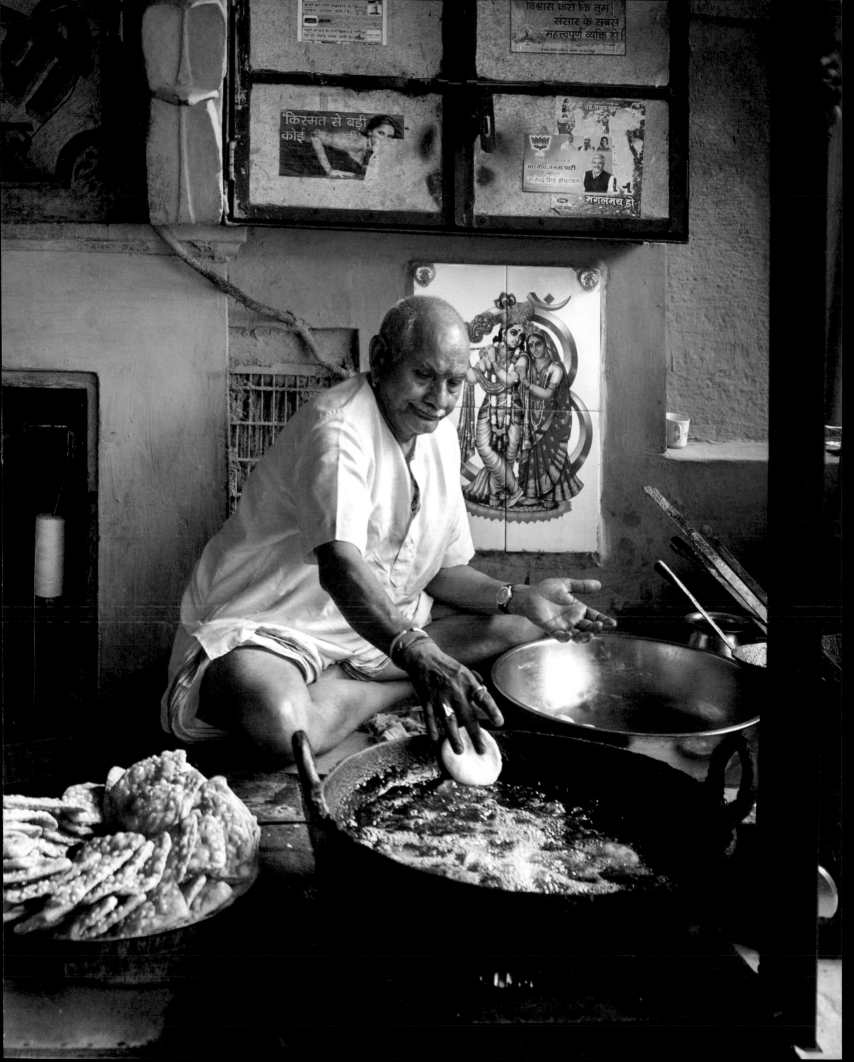

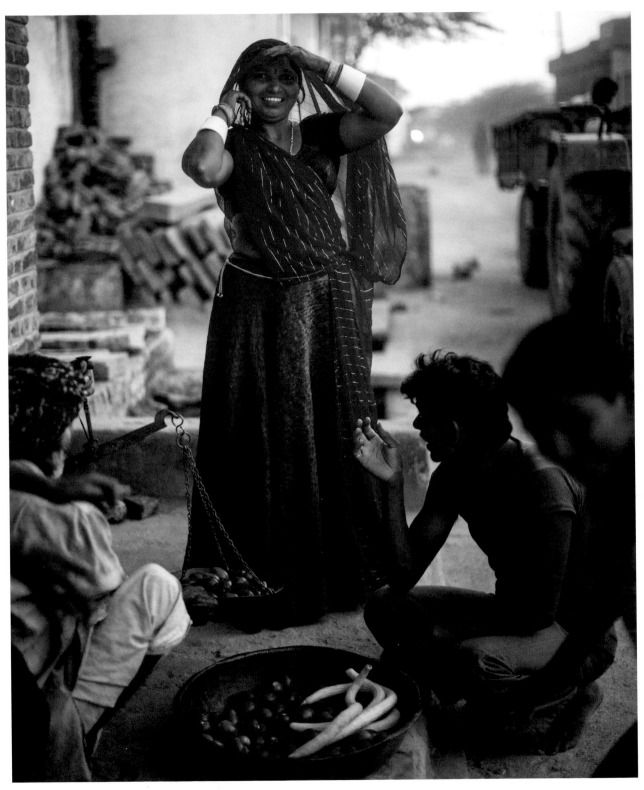

During harvest season, Rabari women toil along with their husbands and sons in the fields, but they also tend to the market chores, gather water from communal wells, and prepare meals for their extended families.

MANTRA RAM / RABARI TRIBESWOMAN

Godwar Province, Rajasthan, India

"Ma'am?" said Kapil Singh. "Hold on, we are going around a bend now."

In Rajasthan, many professional drivers decorate their vehicles with "Horn Please" warnings; statues of Ganesh, the godly remover of obstacles; and colorful tassels intended to repel raging demons. They have good reason. Years before, another driver revealed the secret to successfully navigating the back roads of India: "You must have three things on your side," he claimed. "Good horn, good brakes, good luck." It became my mantra.

Wheat was ripening on the flood plains when I arrived in Godwar, a marginal province of Rajasthan between ancient city rivals Jodhpur and Udaipur. Women tossed sheaves into bullock carts that lumbered off to threshing grounds. It is grueling labor, made almost unbearable in the months before monsoon with the arrival of a hot wind known as the Loo. Some call it the devil's wind. It rises unbidden from deep in the Thar Desert, bringing destruction and madness. So the harvest is hurried. This grain came to India by way of the Levant, around 6000 BCE. Flatbreads integral to the northern Indian diet—naan, papad, paratha, roti, puri, chapati—developed as a result.

Riding in the back of an open Jeep steered by the angular young Kapil dressed in starched paramilitary khaki, we circled mounds of tan chickpea plants drying in the sun. Black-faced monkeys hung together near the entrance to a cavernous shrine. Young girls pumped water into clay pots at a village well. A boy pushed along a rubber tire with a stick, a load of firewood balanced atop his head. A Hindu priest wearing a white tunic slowly descended a long flight of stairs cut into the hill where, moments before, a leopard perched. The people of this region seem to have a concord with large cats—no one has been attacked for ages, although dogs go missing now and then. Godwar isn't far from the original setting Rudyard Kipling intended for *The Jungle Book.*

My tailbone ached and my face felt as hot as a ghost pepper. Turmeric stained my fingers from the fritters bought for breakfast at a street stall. My left foot itched from a possible infection. Just when I couldn't take anymore, an overcrowded bus roared toward us from the

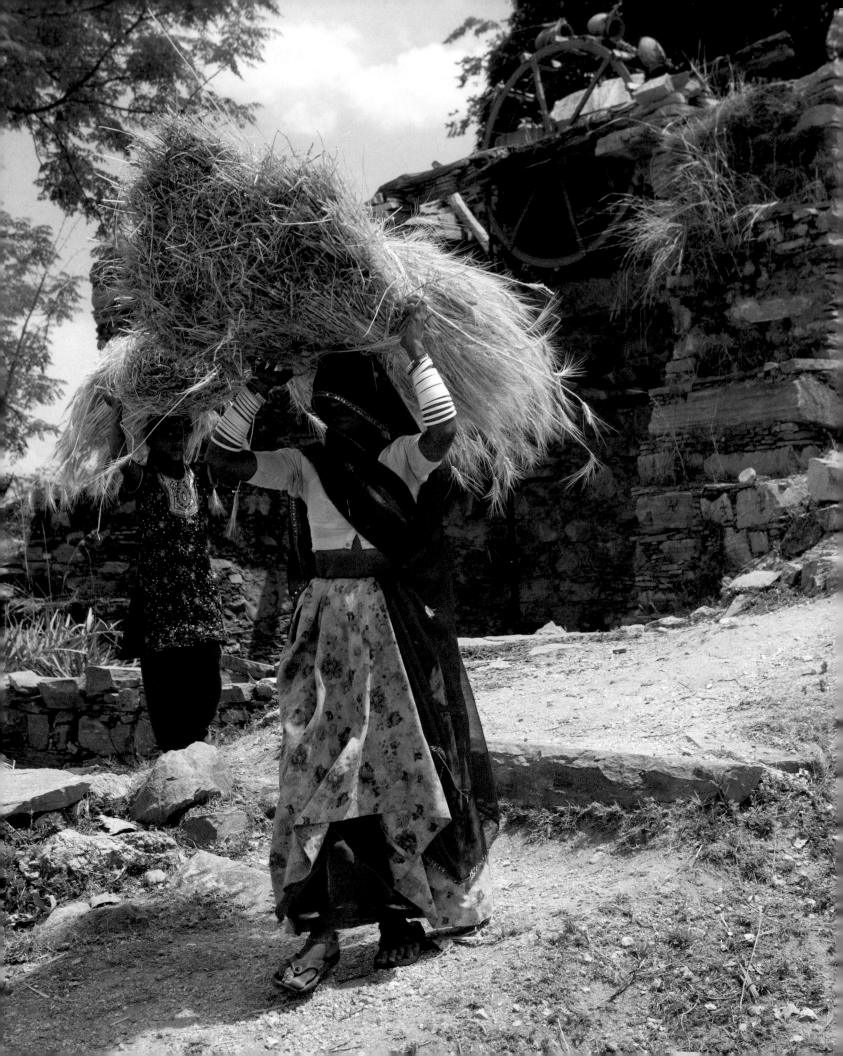

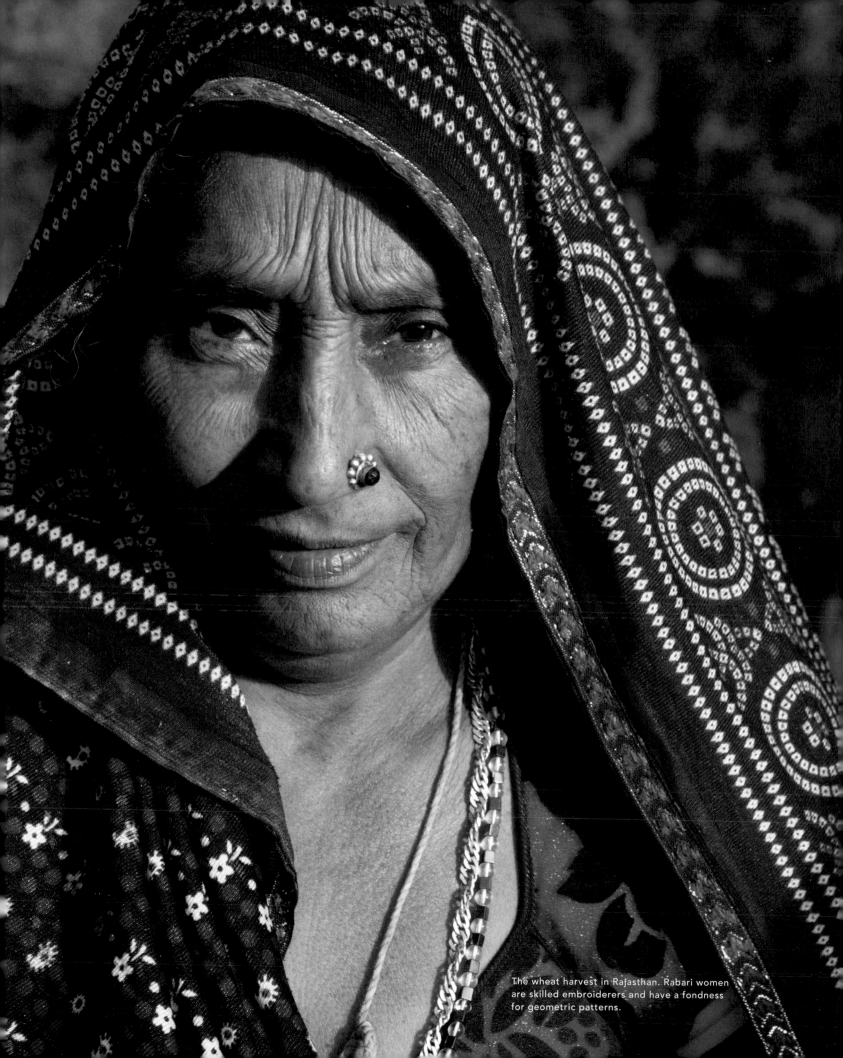

The wheat harvest in Rajasthan. Rabari women are skilled embroiderers and have a fondness for geometric patterns.

opposite direction. Men clung perilously to baggage on the roof and, as we swerved, tossed something down at us. Accustomed to being the target of nasty projectiles in more hostile situations, I flinched.

Flower petals rained down on my head.

A cheer went up from the passengers, all waving and laughing at the successful prank as the bus moved on. They left us where we had pulled over, by the side of the road, bemused.

<div align="center">✳</div>

At the end of this long day we passed through Sena, Kapil's home village, at the base of a granite hill streaked by millennia of harsh weathering. In the soft evening air, the smell of cooking oil drifted out of courtyards where, visible through an open doorway, women sat on a cool concrete floor, winnowing grain.

"What are you doing here?" asked Dheera Ram, curious. His floppy-eared Sirohi goats pressed around the parked Jeep, kicking up dust. He nudged the flock along with a cane. He had an extravagant beard. His vest and loincloth were bleached white. Ram's red turban identified him as a Rabari tribesman. Its thirty feet of fabric—artistically rolled atop his head—is handy for concealing packs of cigarettes, coins, and a cell phone among the folds.

The word *rabari* loosely translates as "outsider." The tribe's exact origin is unknown. They worship Mata Devi, the great mother goddess; their own family structure is consequently matriarchal. Women tend to business; men tend to livestock. For most of their history, Rabari have wandered the Indian subcontinent on annual migrations. Only recently have they settled in villages, unintended victims of the Criminal Tribes Act and increasingly restricted grazing. In 1871, India's British colonial rulers imposed a law that classified many nomadic castes as habitual criminals, curbing their movements and forcing them to register with police. It was intended to combat bandits who attacked unprotected travelers on the northwest frontier, but it also discriminated against traders, entertainers, and pastoralists who didn't conform to a settled existence. The law was repealed in 1949, post-Independence, but the stigma remains.

I followed bleating goats through the streets, walking side by side with the amicable Ram, who lived in a joint family compound on the far edge of Sena. Kapil patiently brought up the rear. Soon the goatherd lounged under a shady acacia, sharing a pipe with two brothers and a nephew, who happened to be Kapil's best friend. Excited children gathered. In this swirl of activity, one woman emerged to scatter the crowd cluttering her front yard. Hands on hips, she looked me up and down. She had crooked teeth in a stern, lined face.

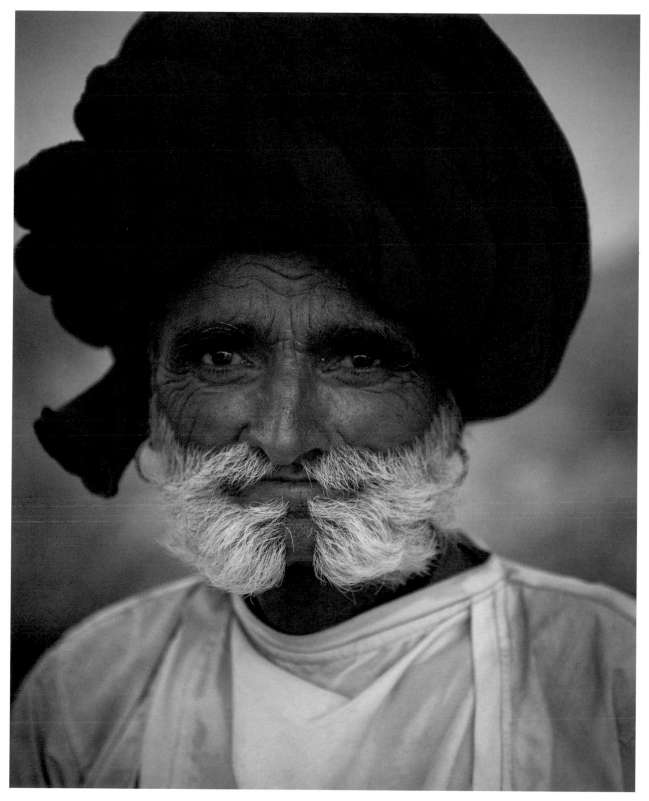

Rabari men like herder Dheera Ram favor extravagant
turbans and embroidered *juti* slippers.

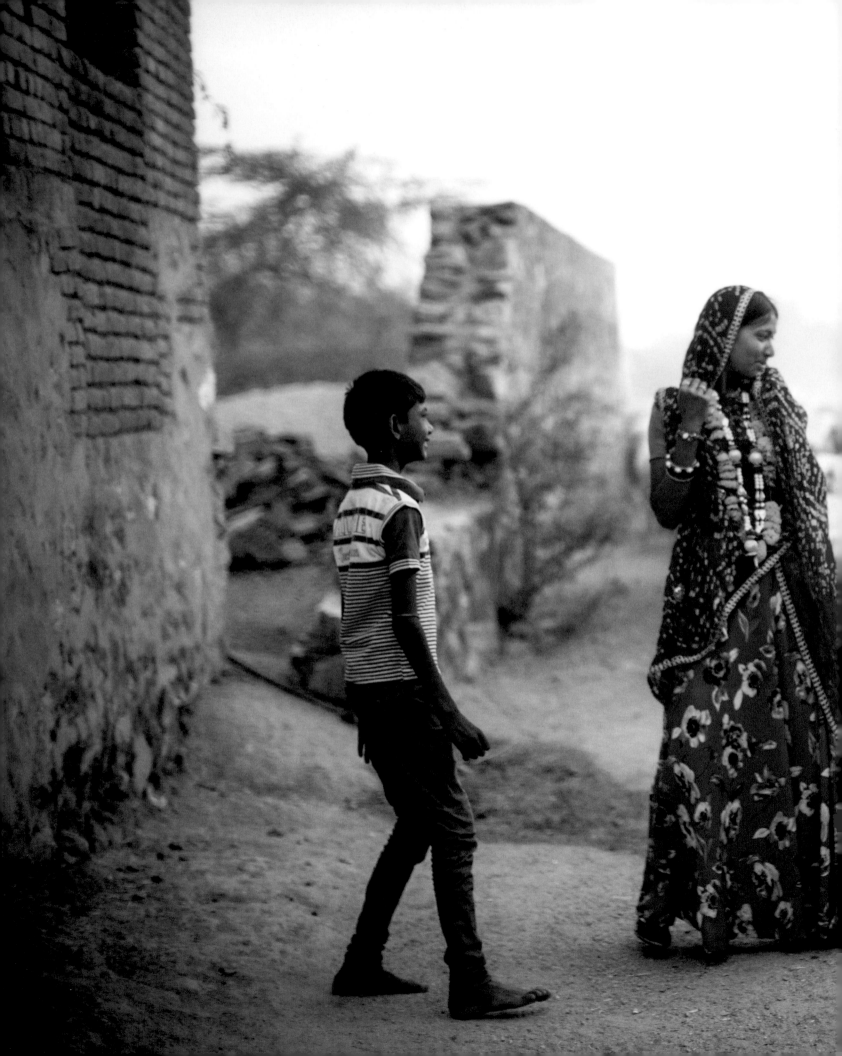

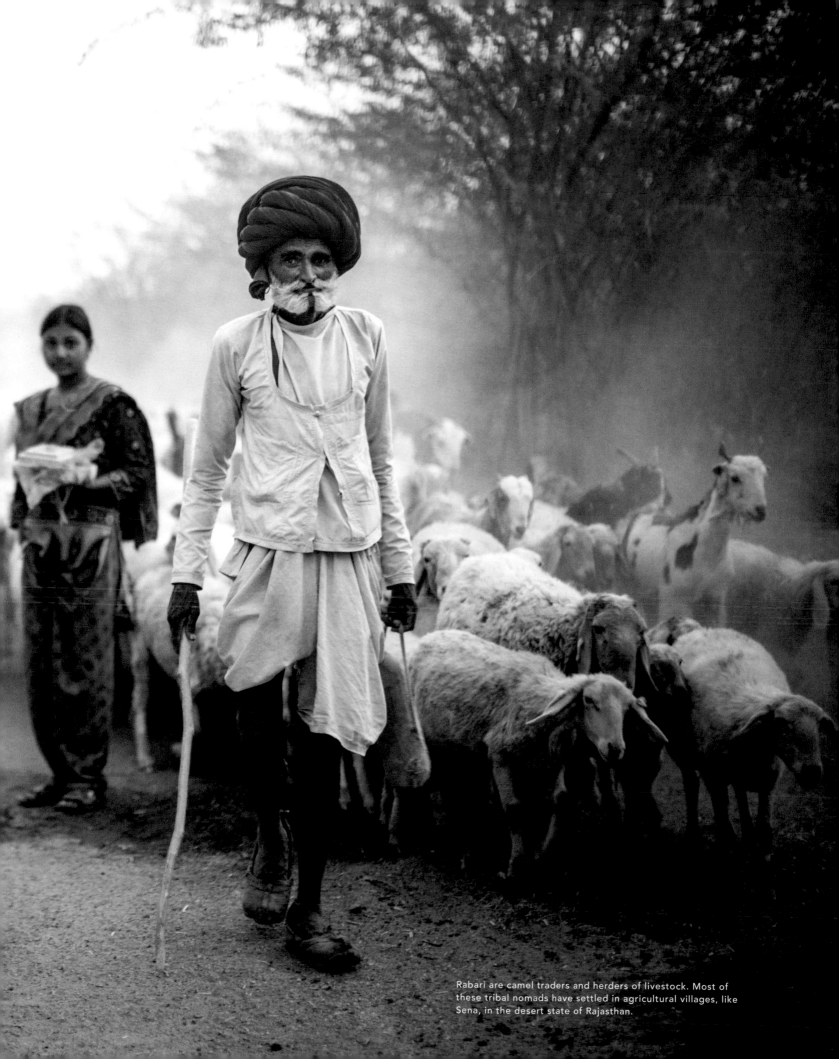

Rabari are camel traders and herders of livestock. Most of these tribal nomads have settled in agricultural villages, like Sena, in the desert state of Rajasthan.

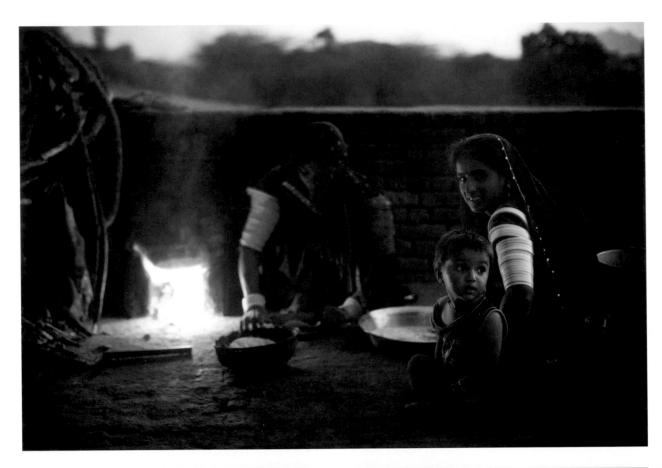

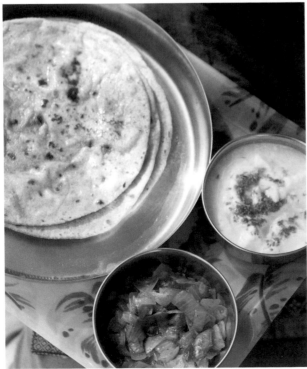

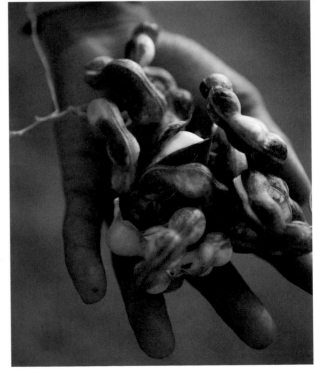

"What is you name?" she demanded.

I told her. "And yours?"

"Mantra."

"That's a strong name!"

"So is yours. Come into my kitchen."

She grabbed my arm and pulled me away from the men, up a flight of steps to a courtyard with a sweeping view of the hills. Her sister, whose face was covered with a purple veil, fanned a wood fire under a makeshift brick griddle. The two women indicated that I should squat on the ground next to a rolling pin and *chakla* pastry board. They watched closely as I picked up a dough ball and rolled it out. It wasn't too badly misshapen. Mantra nodded approval. Her sister took over, swiftly patting the flatbread on a hot surface, flipping it with bare hands, until it puffed with the heat.

At one time, married Rabari women adorned themselves with dowry silver and distinctive ivory bracelets. Now they wear cheap PVC piping, cut in decreasing size to fit over their forearms. Mantra's bangles clattered as she waved me toward her kitchen, where porridge simmered on a propane burner. We sought refuge in the cool alcove while she stirred and chatted, mostly with hand gestures, shrugs, and smiles. The wall above us held metal plates and bowls. Newspaper, painstakingly snipped like doilies, draped tidy shelves.

In India, there is a saying, often quoted from the *Mahabharata: "Atithi devo bhava."* It means "the guest is god" and applies equally in slum or palace. Mantra poured milky chai in a crude clay cup. Her sister crossed the yard to offer a fire-singed chapati lavished with ghee.

One of Mantra's granddaughters appeared around the corner, munching on her own bread smeared with crushed chiles. The little girl wore store-bought pants and a tank top, her hair cut in bangs. Between mouthfuls, she reached out and touched one finger to my breast, immodestly visible through a sweat-soaked T-shirt. The innocent gesture caught us off guard. Mantra looked shocked for a moment.

The men, still waiting outside, heard our laughter echo off the rocks.

OPPOSITE TOP: Mantra Ram and her sister roll out dough to bake chapati on a wood-fired *chulha*, or clay stove, for the evening meal.

LEFT: Chapati and onion chutney at the Singh family residence.

RIGHT: Ripe chickpeas in their husks.

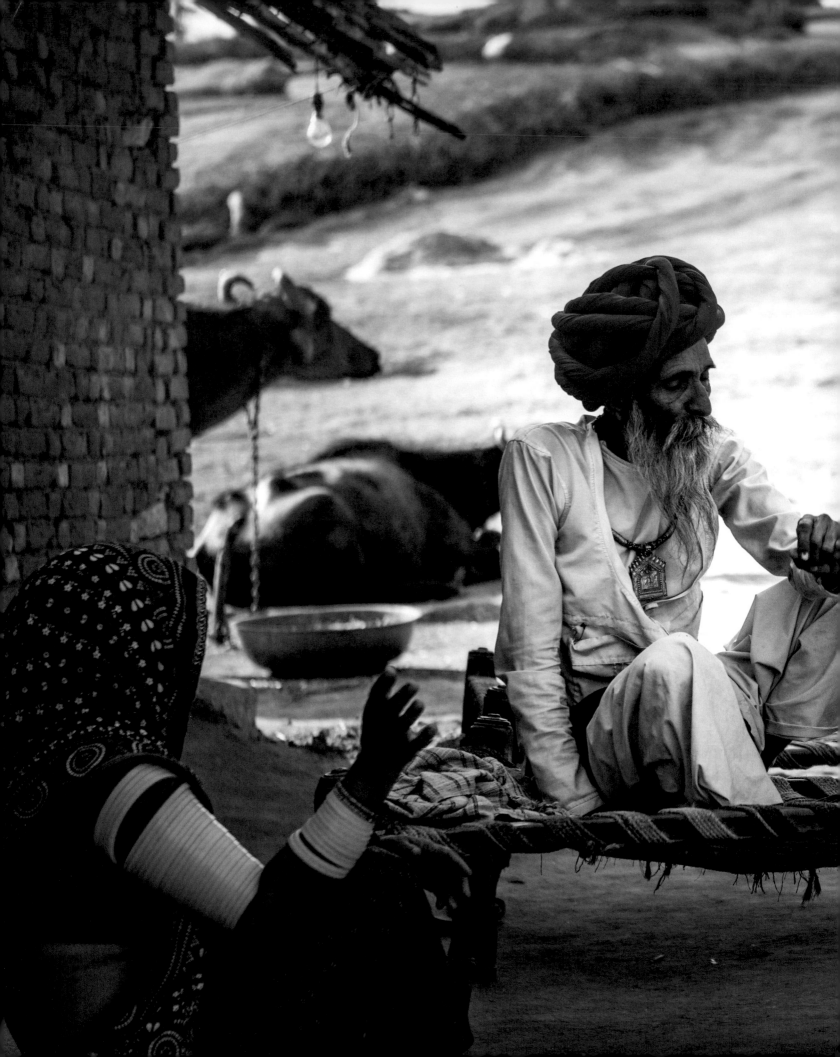

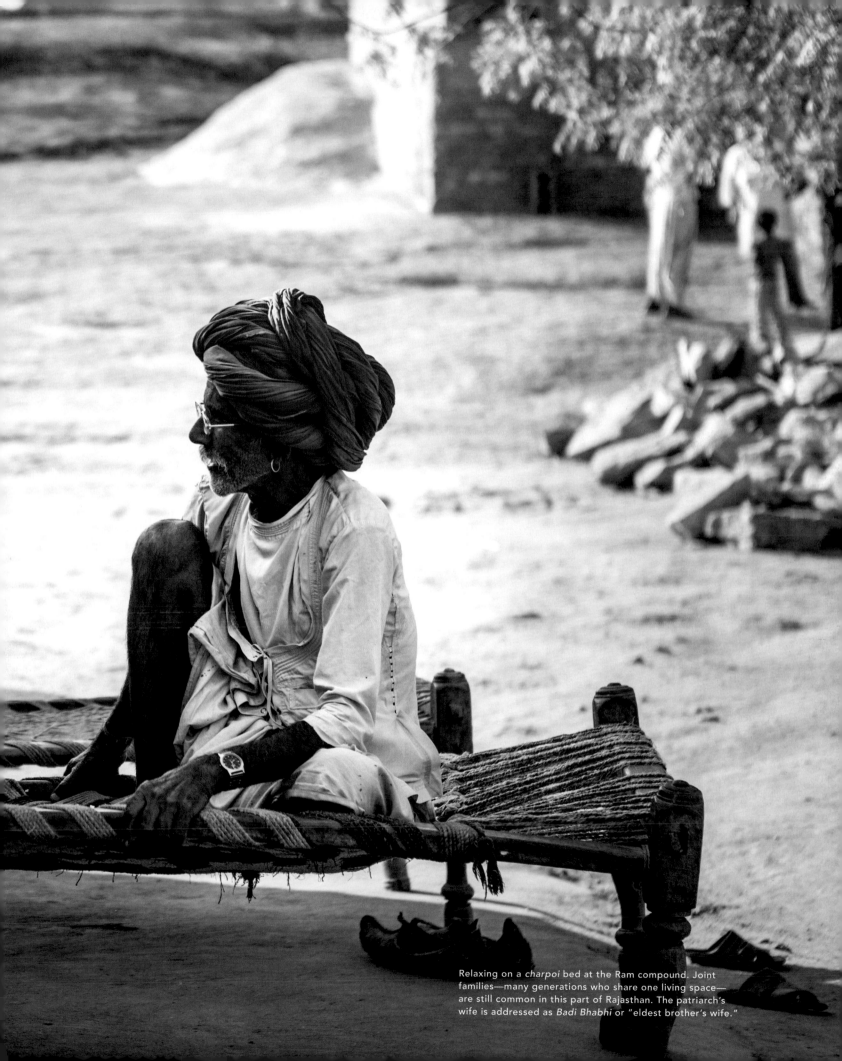

Relaxing on a *charpoi* bed at the Ram compound. Joint families—many generations who share one living space— are still common in this part of Rajasthan. The patriarch's wife is addressed as *Badi Bhabhi* or "eldest brother's wife."

LAL MAAS / GOAT STEW

SERVES 2 TO 4

Rajasthani cooking has a long history dating to Silk Road trade caravans. On one hand, it is austere and make-do, with dried fruits, seeds, and spices most common in recipes. On the other, the princely life of high-caste Rajputs lends panache to certain delicacies, including this fiery goat stew, simmered for hours with smoky black cardamom and vibrant Kashmiri chiles, which gives the dish its signature red color. Mantra Ram showed me how to crush dried chiles to a paste on a round marble *chakla* (beveled pastry board) with a rolling pin. The resulting flavor and heat matches the arid climate. This was the best lesson I've ever had about following arduous techniques, rather than shortcutting to make a recipe easier. You can find Kashmiri chiles and black cardamom online (see Sources, page 294) or at Indian grocers. Goat may not be available from your local market but specialty butchers and organic farmers now supply it.

10 to 12 whole dried Kashmiri chiles

3 tablespoons mustard or safflower oil

1 teaspoon plus 1 cup water, more as needed

4 cloves

3 black cardamom pods

1 teaspoon cumin seeds

1 bay leaf

1 large onion, peeled, halved, and sliced into rounds

2 cloves garlic, minced

1-inch piece fresh ginger, peeled and minced

2 pounds goat stew meat, cubed

½ teaspoon chile powder

½ teaspoon salt, plus more to taste

¼ teaspoon turmeric

1 cup plain yogurt

1½ tablespoons ghee (clarified butter)

½ cup chopped fresh cilantro

Blend the chiles with 1 tablespoon of the oil and 1 teaspoon of the water. Allow them to soften and rehydrate. Using a rolling pin, crush the mixture until a coarse paste forms. A food processor does not achieve the same consistency but a mortar and pestle and elbow grease also work fine.

In a Dutch oven or cast-iron pot, heat the remaining 2 tablespoons oil until it starts to smoke. Add the cloves, cardamom, cumin, and bay leaf and fry until brown. Add the sliced onion, garlic, and ginger, and then reduce the heat to medium, stirring until they caramelize. Then add the goat meat, chile paste, chile powder, salt, and turmeric. Stir to combine. Cook until the meat is browned on all sides, about 20 minutes. Reduce the heat to low. Slowly stir in the yogurt so it doesn't curdle. Then slowly add the remaining 1 cup water. Stir in the ghee. Increase the heat to medium again and allow to simmer, covered, for 2 to 3 hours. Stir occasionally to prevent sticking. Add another cup of water, if necessary, and continue to simmer until the meat is fully broken down. Add salt to taste and garnish with the cilantro before serving.

RAW MANGO CHUTNEY

MAKES ABOUT 2 CUPS

Sugan Bedla, a brilliant home cook, invited me to a *thali* lunch with her husband Vijay and son Karan in Udaipur. (*Thali* meals incorporate six key flavors—sweet, salty, bitter, sour, astringent, and spicy—on a single plate.) She loves making pickles and chutneys; this favorite accompaniment is made with unripe mangoes. When passing through Old Delhi, I bought Kashmiri saffron for this recipe from venerable spice dealer Shri Niwas & Sons on Lal Kuan Bazar Road, but the best saffron available will work fine. You can find Kashmiri saffron online (see Sources, page 294) or at Indian grocers.

1¼ pounds raw green mango, peeled and seeded (about 3)

1 teaspoon fenugreek seeds

1 teaspoon black mustard seeds

1½ teaspoons fennel seeds

2 tablespoons safflower or mustard oil

1 teaspoon turmeric

1 teaspoon salt

1½ teaspoons chile powder, or 1 fresh red bird's eye chile, minced

3 cups sugar

Pinch of freshly ground cardamom

Pinch of whole saffron threads

Wash the raw mangoes, then remove their elongated seeds by standing them on the stem end and cutting away the flesh on either side. Remove the peel, slice the fruit into long strips, and then weigh.

Using a mortar and pestle or rolling pin, slightly crush the fenugreek, mustard, and fennel seeds to release their oils. In a saucepan, fry the spices in the oil. When the seeds turn golden, add the mango slices, turmeric, and salt. Mix well. Cover and cook over low heat for 5 to 7 minutes, or until semicooked. (Don't fully cook and don't add water.) The mangoes will darken slightly.

Add the chile powder and sugar. Blend thoroughly and cook over low heat, uncovered, for 15 minutes. When the syrup in the pan thickens, stir in the cardamom and saffron.

With a slotted spoon, remove the mango slices and divide between two 8-ounce canning jars.

If the syrup appears watery, reheat and reduce by one-third until thickened. Pour over the mango slices. Stir the fruit to distribute evenly.

Seal the jars when cooled slightly, then submerge in boiling water and process for 10 minutes. The jars can be stored at room temperature but should be kept in the refrigerator once opened.

MIRCHI VADA / STUFFED PEPPERS

SERVES 2

One morning I stopped at Shahi Samosa Shop, near the entrance to Jodhpur's main vegetable market, to watch this classic Rajasthani snack being prepared. Whole, stuffed peppers are dipped in chickpea batter before being fried in a vat of roiling oil. Asafoetida, a highly pungent condiment made with resin from *Ferula assa-foetida*, a perennial herb native to Iran and Afghanistan, enhances the flavor of these peppers. I burned my fingers and my tongue and fell in fiery love. You can find asafoetida online (see Sources, page 294) or at Indian grocers.

4 Hungarian wax, banana, or serrano peppers

1 green bird's eye chile, minced

FILLING

1 cup mashed potatoes

¼ teaspoon fennel seeds, toasted and crushed

1 tablespoon fresh cilantro, chopped

¼ teaspoon ground cumin

¼ teaspoon chile powder

½ teaspoon coarse sea salt

Pinch of asafoetida

BATTER

½ cup chickpea flour

¼ teaspoon salt

¼ teaspoon baking powder

⅓ cup cold water

½ cup peanut oil

Cut a lengthwise slit in each pepper and carefully remove the seeds and ribs. Leave the stems on.

To make the filling, in a bowl, blend together the filling ingredients. Then stuff each pepper with a generous amount.

To make the batter, mix the chickpea flour, salt, and baking powder in a bowl. Slowly add the cold water and blend until a smooth batter forms.

Heat the oil in a wok or skillet over high heat.

Holding each pepper by its stem, dip it in the batter until thoroughly coated, and then carefully slide into the hot oil and fry, turning once if needed, until golden brown, about 5 minutes. Drain on paper towels or a cake rack. Serve immediately.

BHINDI MASALA / SPICED OKRA

SERVES 2

I have never been a fan of okra. But this version, served at the height of the harvest season in Rajasthan by a talented Brahmin cook named GSN Bhargava, changed that. Fresh okra makes all the difference, especially when sautéed quickly, rather than stewed until glutinous, which is the way I grew up eating it. You can find mustard oil and spice blends like chaat masala online (see Sources, page 294) or at Indian grocers.

2 cups fresh okra, stems removed
¾ teaspoon olive or mustard oil
¼ teaspoon cumin seeds
1 clove garlic, chopped
¼ cup chopped onion
¼ teaspoon turmeric
¼ teaspoon chile powder
¼ teaspoon garam masala
¼ cup seeded and chopped tomato
2 tablespoons chopped fresh cilantro leaves
2 tablespoons fresh lemon juice
½ teaspoon chaat masala
Coarse sea salt

Chop the okra into ½-inch pieces.

In a frying pan, heat the oil over medium heat. Add the cumin seeds and toast until they begin to pop. Add the garlic and onion, stir to combine, and cook until they soften, about 3 minutes. Add the okra, turmeric, chile powder, and garam masala and sauté until tender, about 10 minutes. Add the chopped tomato, cilantro, lemon juice, and chaat masala. Stir until blended. Season with salt to taste before serving.

BAINGAN / STUFFED EGGPLANT

SERVES 2

Sometimes, cooking instructions come with a "figure it out" shrug. My friend Sugan Bedla served stuffed baby eggplants for lunch in Udaipur, and all I have scribbled in my notebook about this fragrant dish is a list of the spices she used in the stuffing, which are wildly different from more typical recipes. But that's what makes it such a treasure.

FILLING

2 tablespoons mustard oil

1 small onion, chopped

2 black cardamom pods

1 teaspoon black pepper

1-inch piece cinnamon

⅛ teaspoon ground cloves

1-inch piece ginger, minced

2 small cloves garlic, smashed

4 to 6 baby eggplants

2 tablespoons mustard oil

To make the filling, heat the oil in a frying pan over medium heat. Add the onion and sauté until soft, about 2 minutes. Stir in the cardamom, pepper, cinnamon, cloves, ginger, and garlic, reduce the heat to low, and cook, stirring frequently, until the mixture is almost dry, about 5 minutes. Remove cardamom pods and cinnamon. Transfer to a bowl and let the mixture cool a little.

Quarter the eggplants lengthwise, leaving each attached at the stem. Stuff with equal portions of filling.

Wipe out the frying pan and heat the remaining oil. Add the eggplants and cook over low heat, turning carefully every few minutes, until cooked through, about 20 minutes.

ANAR TAMATAR KI CHURI / POMEGRANATE AND TOMATO SALAD

SERVES 2

While I was passing through Jaipur, my friend Kaushika Kumari invited me to lunch in a *haveli*, or townhouse, on the grounds of her family's sprawling palace complex. She married into the house of Diggi, a noble clan historically allied with the rulers of Jaipur, who are known for their hospitality. This wonderfully cooling side salad was a highlight. It has become a favorite of mine whenever ripe tomatoes and pomegranates are available. I prefer juicy heirloom varieties—Brandywine, Early Girl—when in season, but have found that Kumatos, the trade name for Olmecas, are a good year-round option if you live in an area where the fresh tomato season is short.

2 cups chopped ripe tomatoes
½ cup finely minced red onion
½ cup pomegranate seeds
1 tablespoon fresh lime juice
Pinch of coarse sea salt

Mix the tomatoes, onion, and pomegranate seeds in a serving bowl. Add the lime juice and salt. Toss well. Best served slightly chilled.

WATERMELON COOLER

SERVES 1

This simple cooler makes use of the watermelon sold by vendors on street corners in Rajasthan's capital cities.

2 cups chopped seedless watermelon
1 tablespoon rose water
2 ice cubes

Puree the watermelon, rose water, and ice in a blender. Pour into a tall glass and serve.

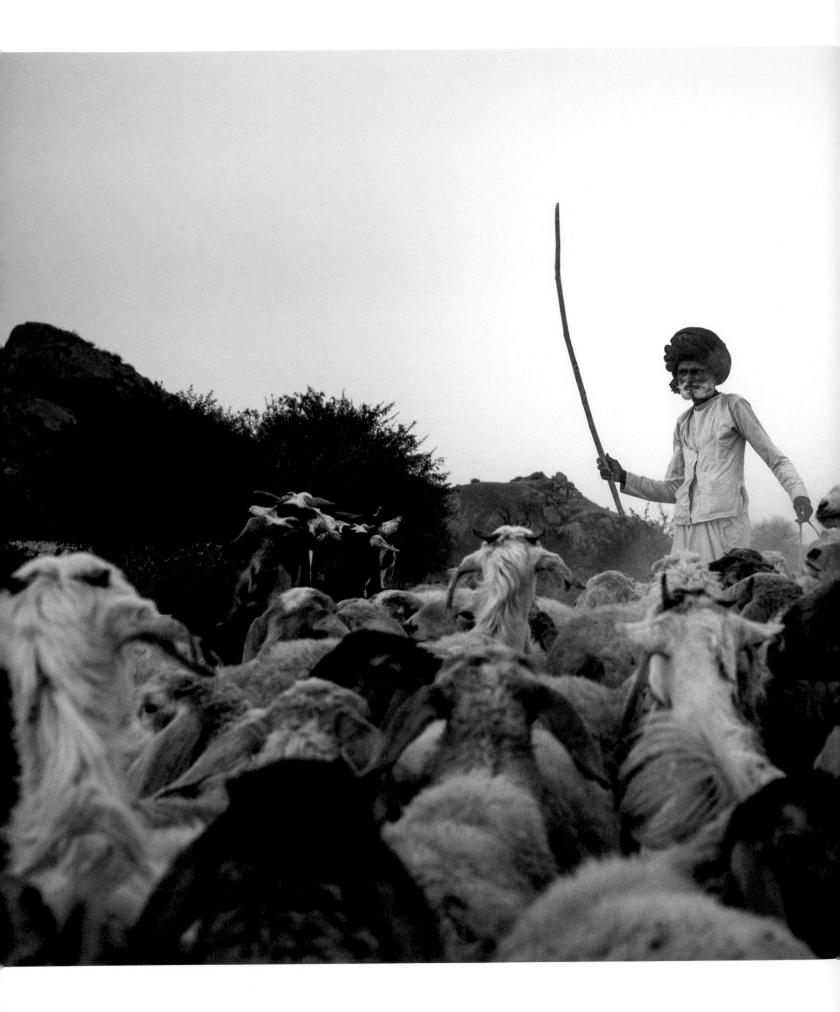

Rabari herders prize the Sirohi goat breed, indigenous to the Aravalli Hills region, for its meat and milk.

Okra, also charmingly called "lady fingers," is a warm-season crop in Rajasthan, harvested in the months leading up to monsoon.

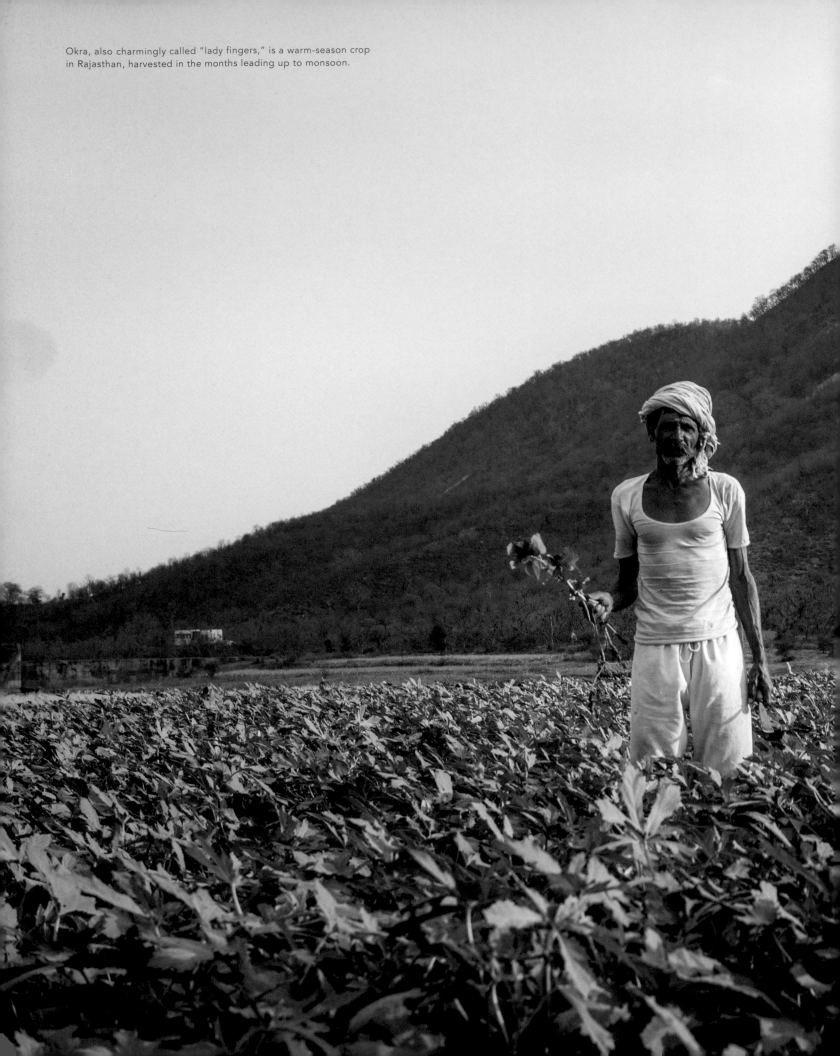

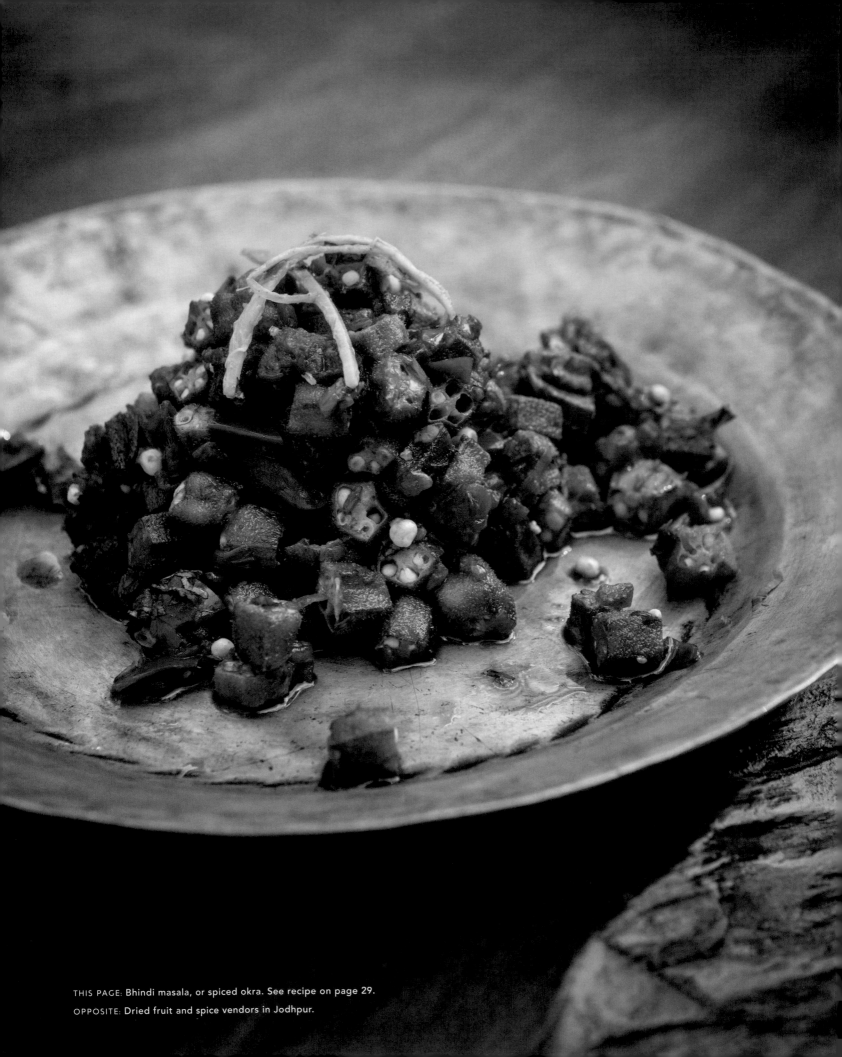

THIS PAGE: Bhindi masala, or spiced okra. See recipe on page 29.

OPPOSITE: Dried fruit and spice vendors in Jodhpur.

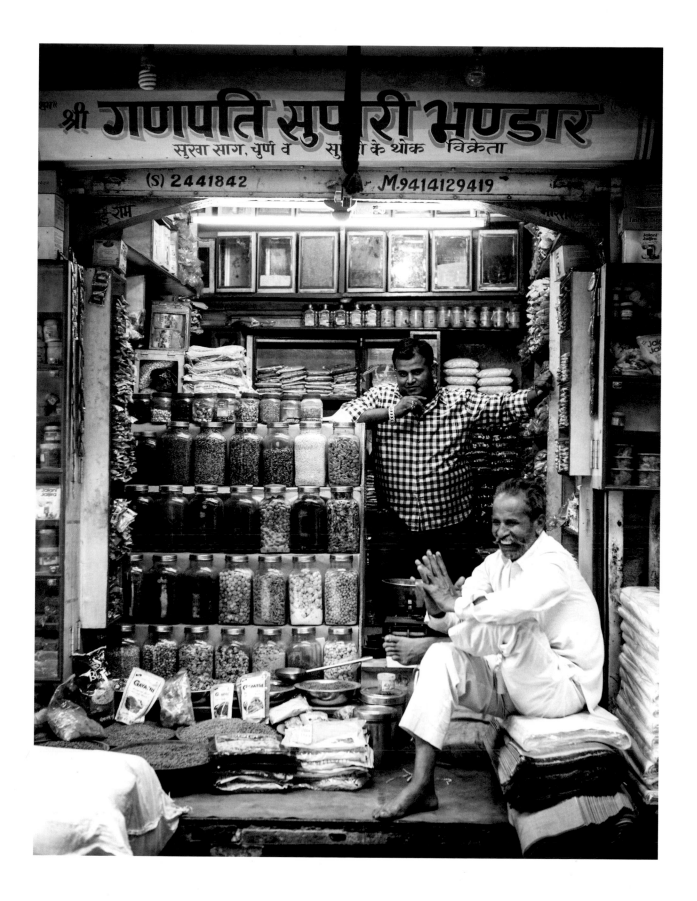

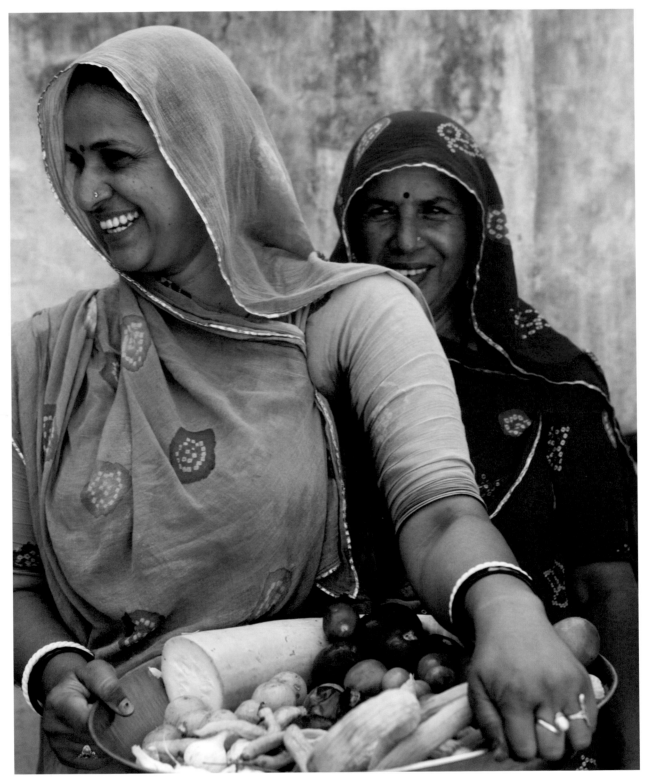

THIS PAGE: Kapil Singh's sisters at their home in the village of Sena.

OPPOSITE: Vibrant Kashmiri chiles are a key ingredient in *lal maas*, the goat stew beloved of herders and Rajput royals.

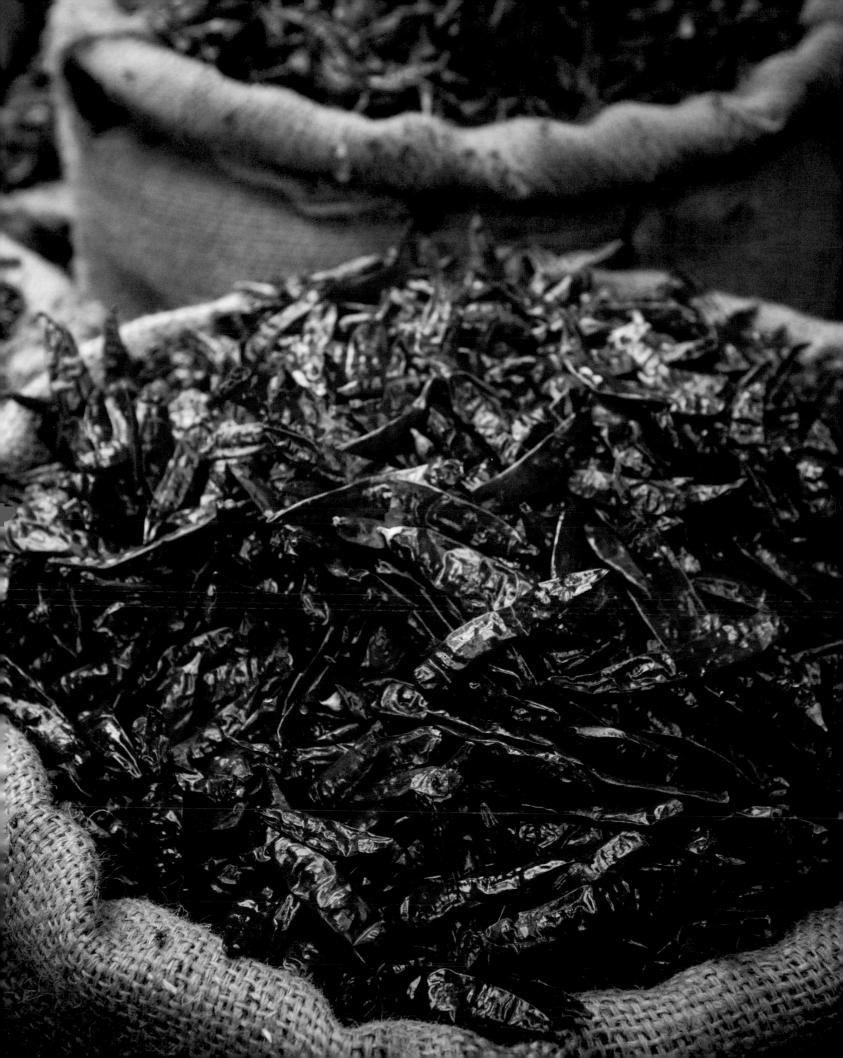

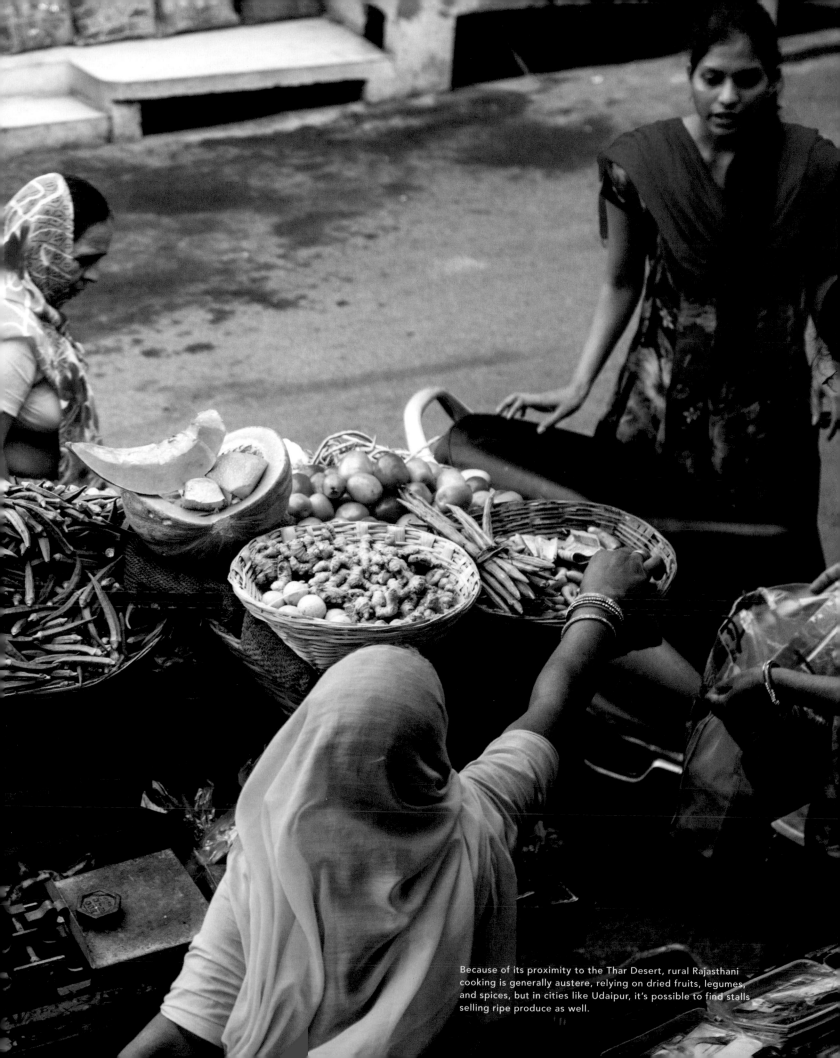

Because of its proximity to the Thar Desert, rural Rajasthani cooking is generally austere, relying on dried fruits, legumes, and spices, but in cities like Udaipur, it's possible to find stalls selling ripe produce as well.

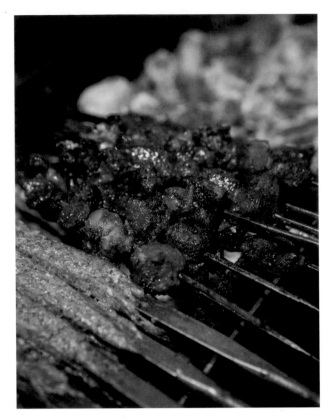

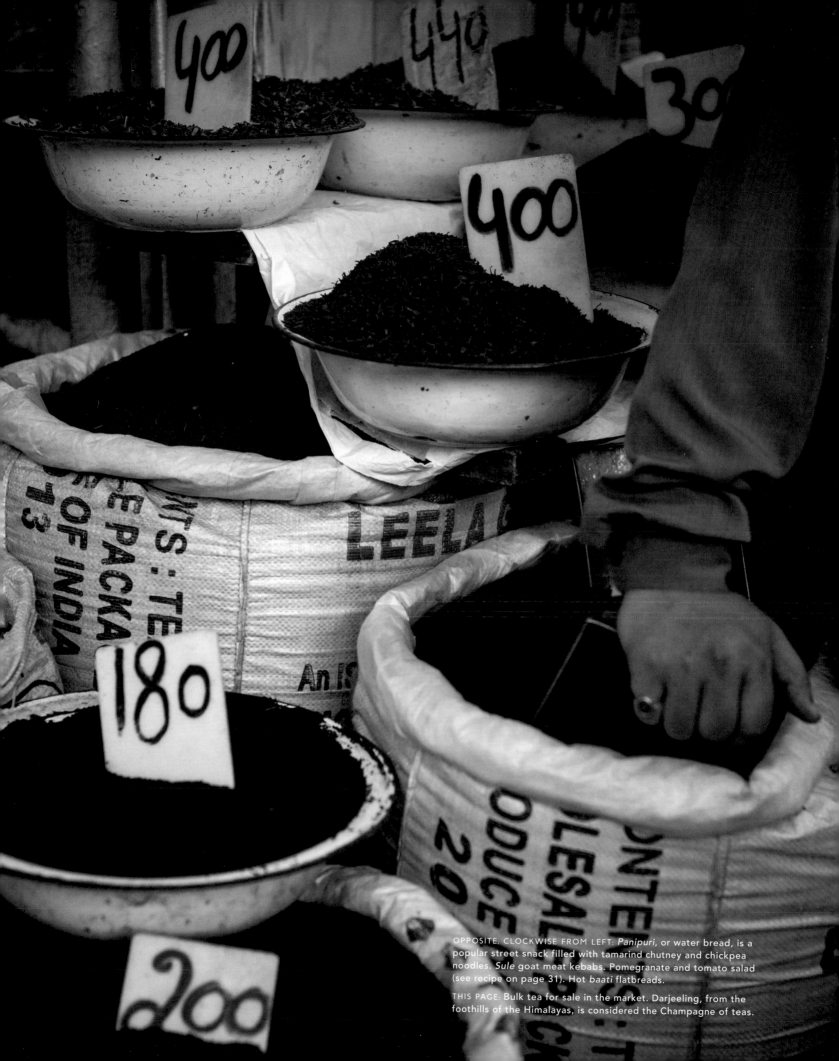

OPPOSITE. CLOCKWISE FROM LEFT: *Panipuri*, or water bread, is a popular street snack filled with tamarind chutney and chickpea noodles. *Sule* goat meat kebabs. Pomegranate and tomato salad (see recipe on page 31). Hot *baati* flatbreads.

THIS PAGE: Bulk tea for sale in the market. Darjeeling, from the foothills of the Himalayas, is considered the Champagne of teas.

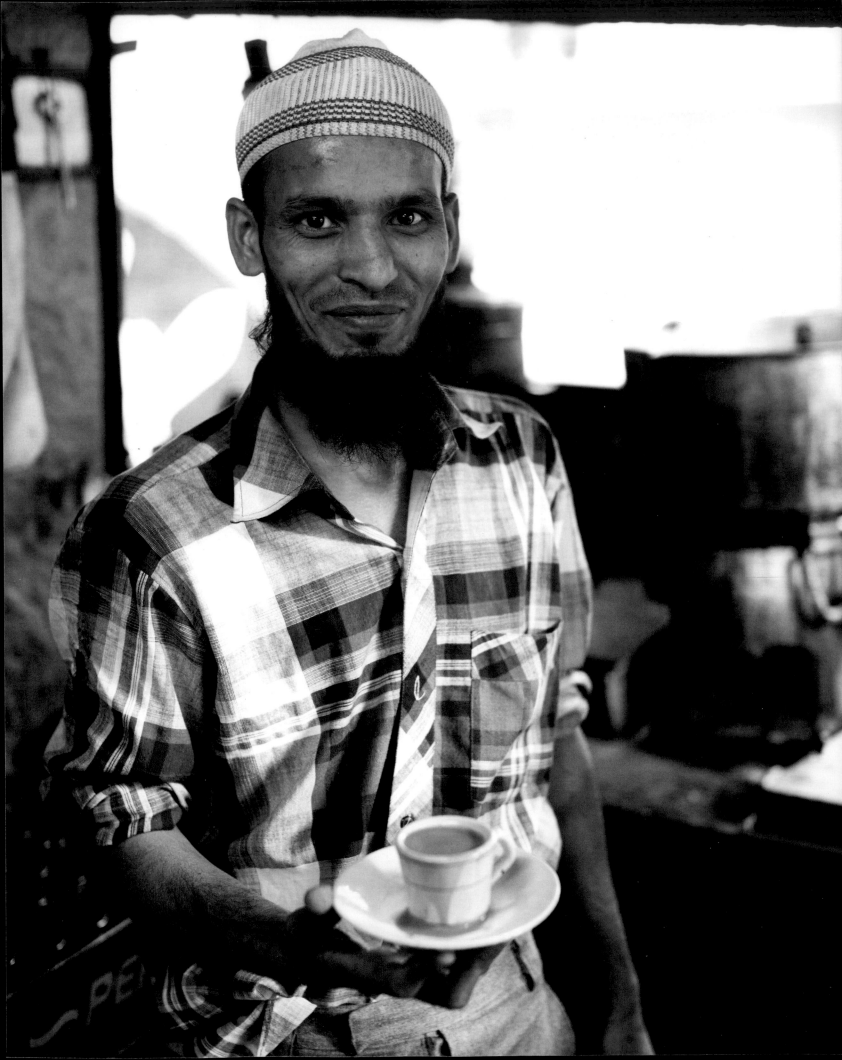

A chai wallah (tea vendor) serves cups at his stall in Jodhpur. British colonists introduced the habit of adding milk and sugar to strong Assam tea; however, masala chai is brewed with spices like cardamom, ginger, cloves, and black pepper. Every wallah has his own recipe.

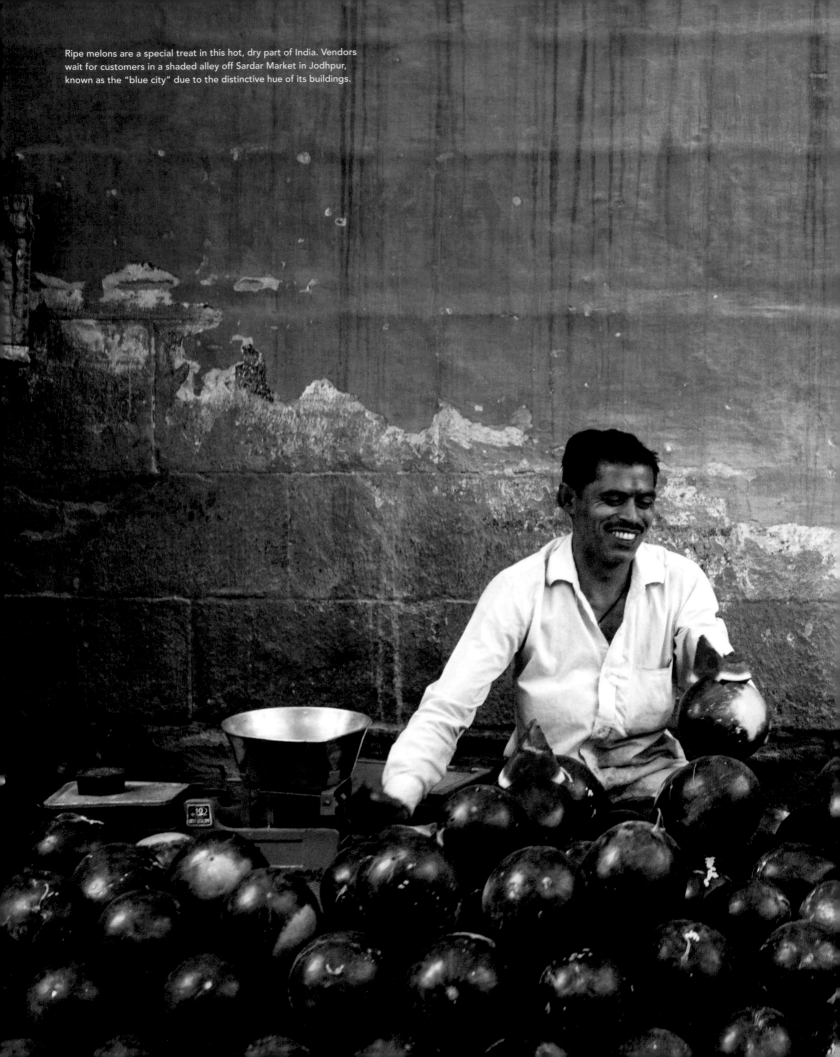

Ripe melons are a special treat in this hot, dry part of India. Vendors wait for customers in a shaded alley off Sardar Market in Jodhpur, known as the "blue city" due to the distinctive hue of its buildings.

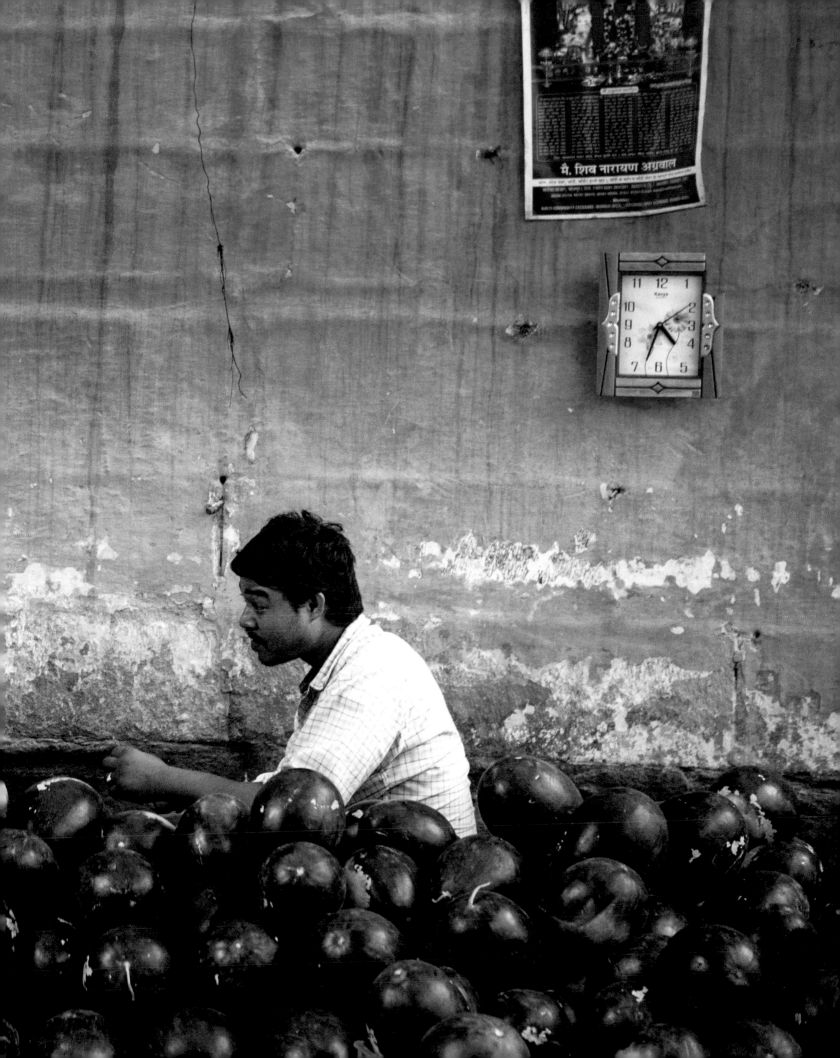

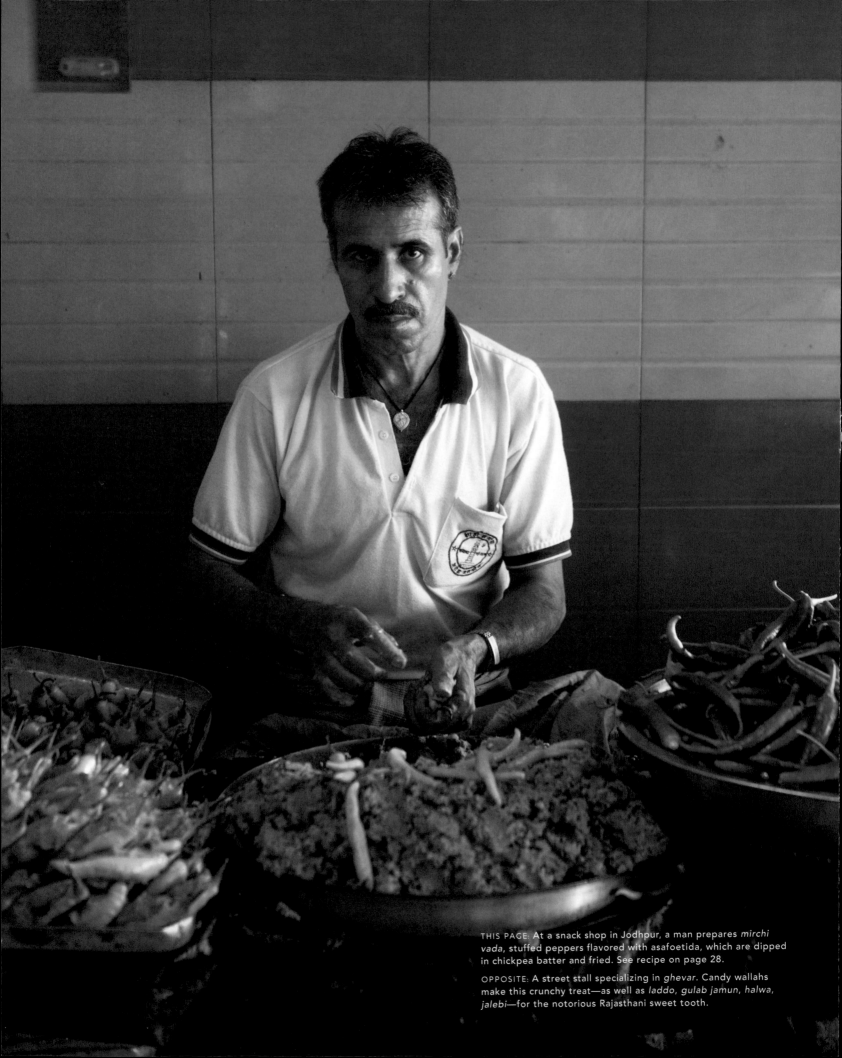

THIS PAGE: At a snack shop in Jodhpur, a man prepares *mirchi vada*, stuffed peppers flavored with asafoetida, which are dipped in chickpea batter and fried. See recipe on page 28.

OPPOSITE: A street stall specializing in *ghevar*. Candy wallahs make this crunchy treat—as well as *laddo*, *gulab jamun*, *halwa*, *jalebi*—for the notorious Rajasthani sweet tooth.

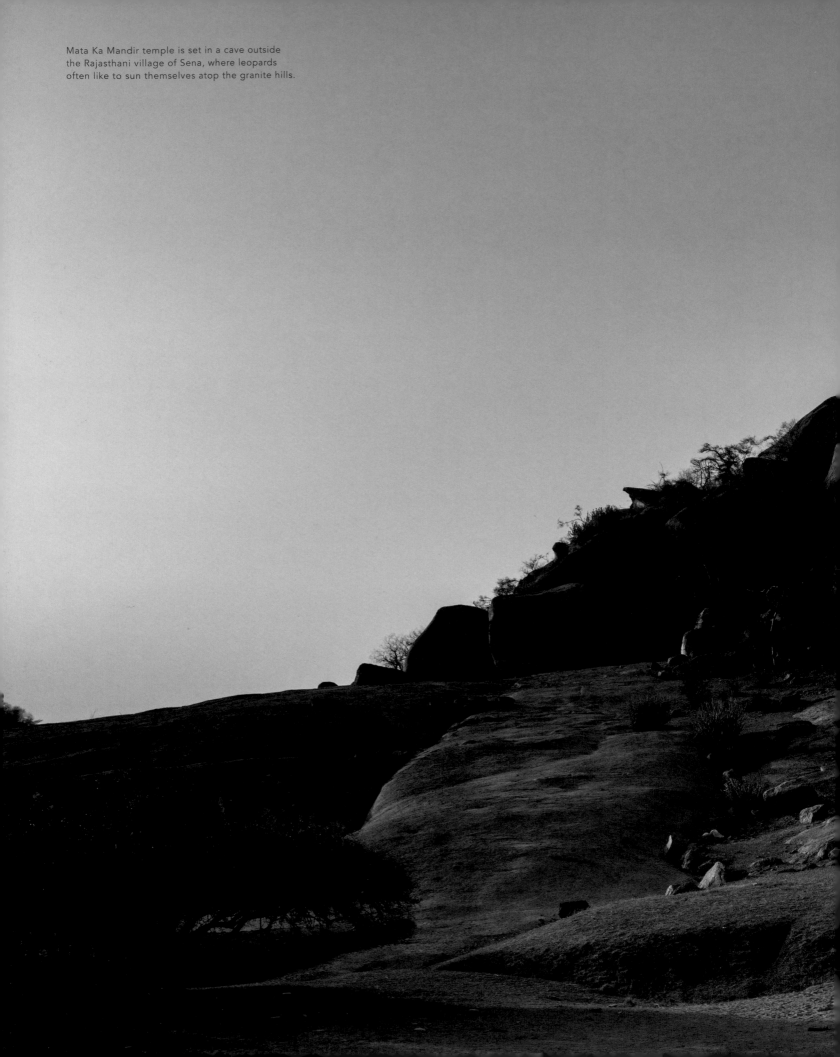

Mata Ka Mandir temple is set in a cave outside
the Rajasthani village of Sena, where leopards
often like to sun themselves atop the granite hills.

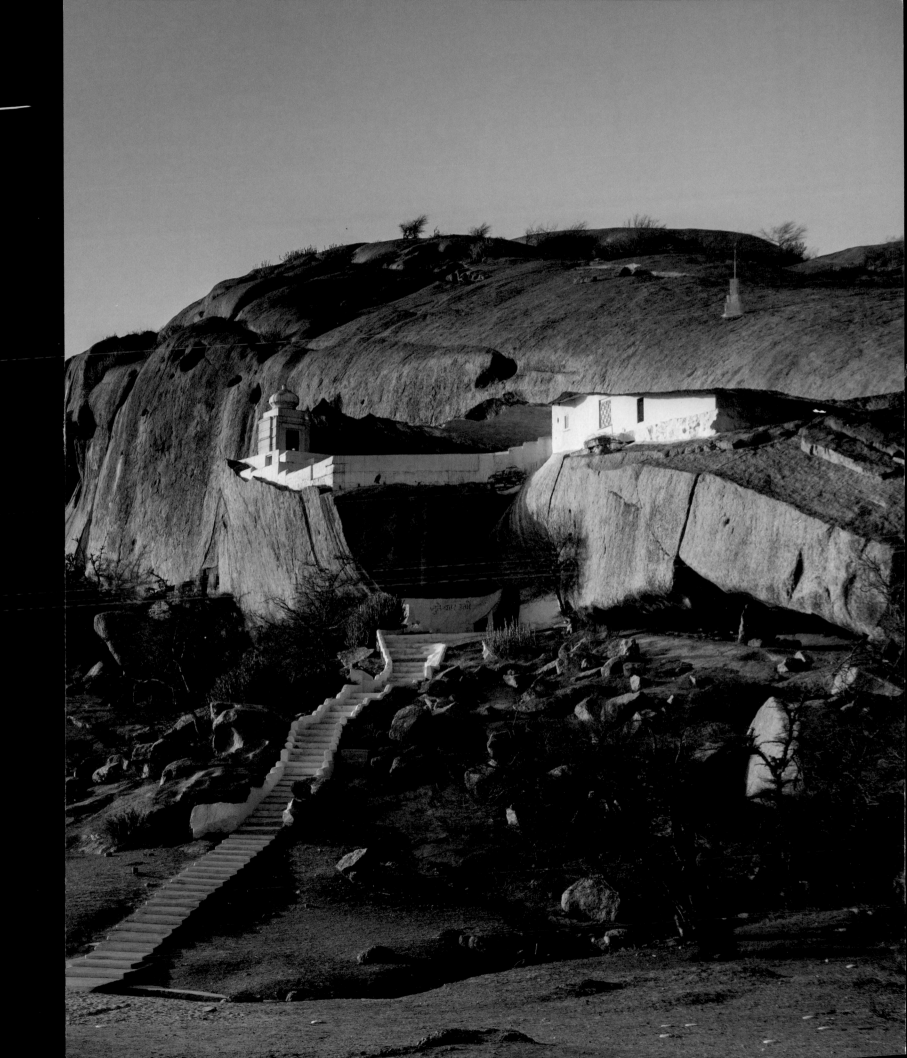

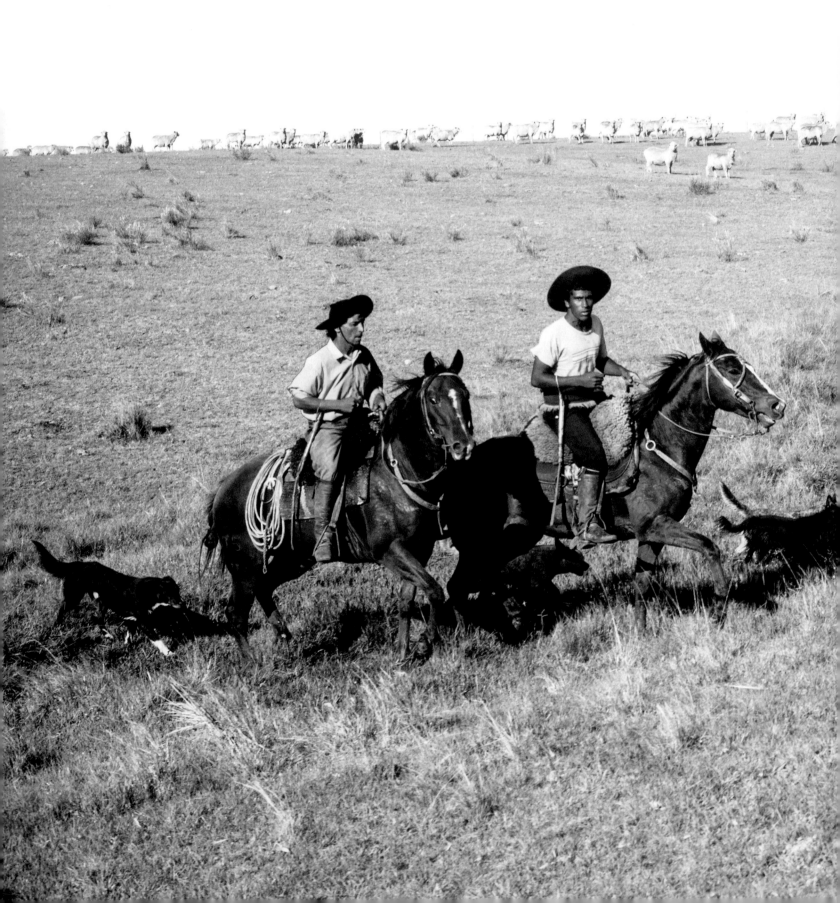

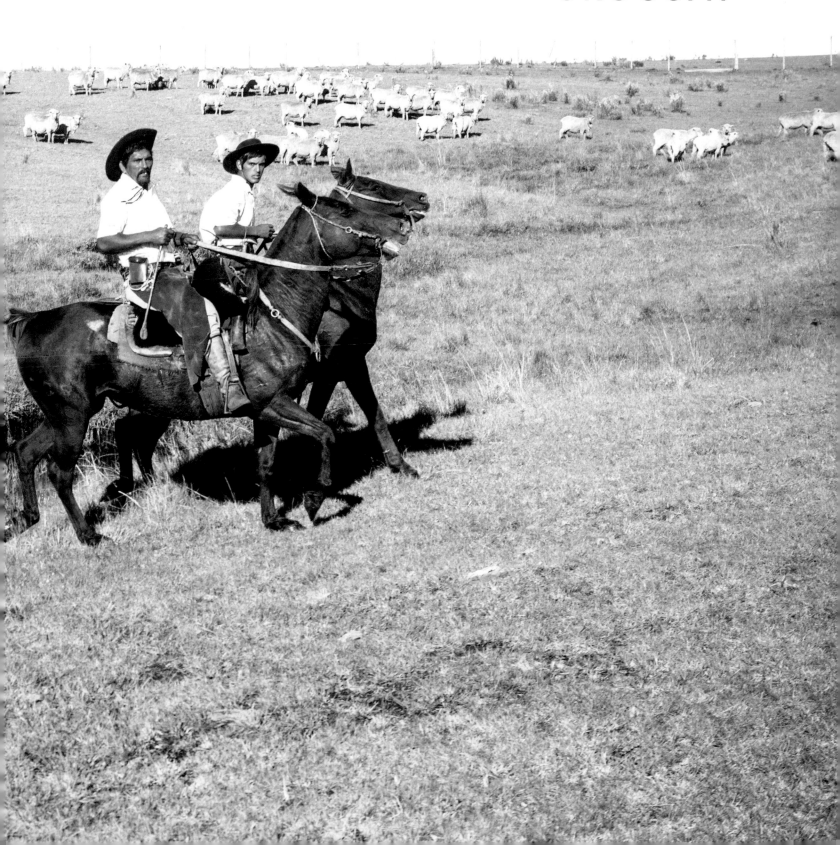

SALTO
URUGUAY

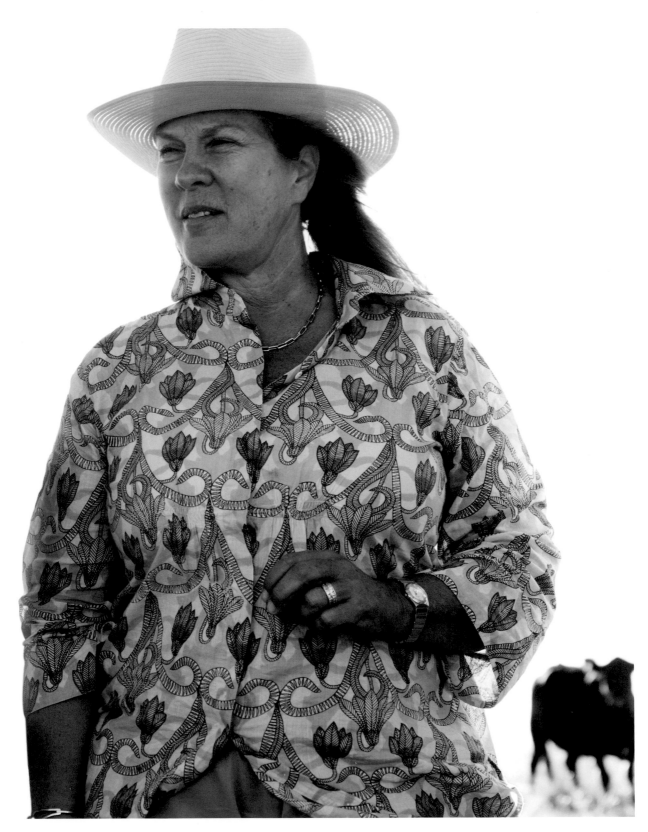

Christine von Bonstetten on her *estancia* outside Salto, Uruguay.

CHRISTINE & JEAN-JACQUES / GAUCHOS

Salto, Uruguay

"Give them guns?" Jean-Jacques von Bonstetten asked incredulously. "My God, do you want a revolution?" We bounced along a dirt track in his pickup. "No *patrón* would be that stupid. It's hard enough for me to get a gun permit in this country." He muttered something about Che Guevara before climbing out of the cab to open a steel cattle gate.

My inquiry was fueled by a steady diet of pulp Westerns and naiveté about the right to bear arms in a distant part of the Americas that had an unstable history of democracy. Bonstetten, a middle-aged banker turned rancher, was born in Switzerland. His family emigrated to Uruguay at the start of the Cold War, just when insurgents were about to make life uncomfortable for an oppressive regime secretly backed by the CIA and not averse to torture or disappearances. Growing up on the frontline of Operation Condor, a clandestine campaign of state-sponsored terror in South America during the 1970s, could make anyone nervous— regardless of political leanings and social class—about a hot-blooded breed who relished fighting with knives normally reserved for castrating bulls.

"The *facón* is used for three things," he continued, referring to the gaucho utility knife. "Work, decoration, and defense. There are a lot poisonous snakes in the *campo*." Bonstetten's 25,000-acre property was once part of a much larger *estancia* bordering the Uruguay River outside the port of Fray Bentos. The town began as a meat-processing depot for the cattle raised in western and northern Uruguay; in 1899, a local canning company first produced corned beef for export.

"Did you know there is a tin of Fray Bentos beef in *The English Patient*?" he asked.

Jean-Jacques turned into a field as thousands of doves streaked across a green sea of soy. "Now the ground is covered with this shit," he grimaced, waving disdainfully at the crop engulfing his grasslands. "The soy is for the Chinese. Corned beef was for the Americans. Before that, we had a half-century alone and were starving. We are close to the end of the world here."

The first gauchos were *mestizo* (mixed blood) descendants of early Andalusian settlers who landed in the New World to search for gold during the sixteenth century. While they didn't fit in—the Quechua word *huacho*, meaning orphan, is the root of "gaucho"—these bastard

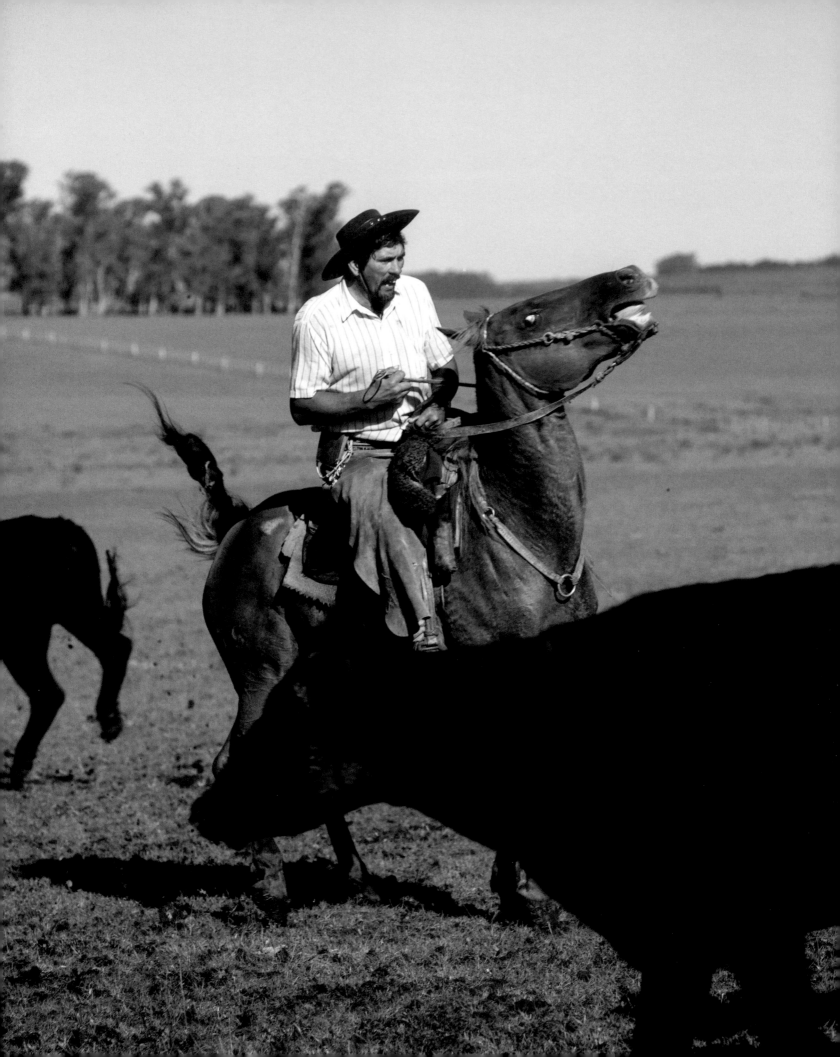

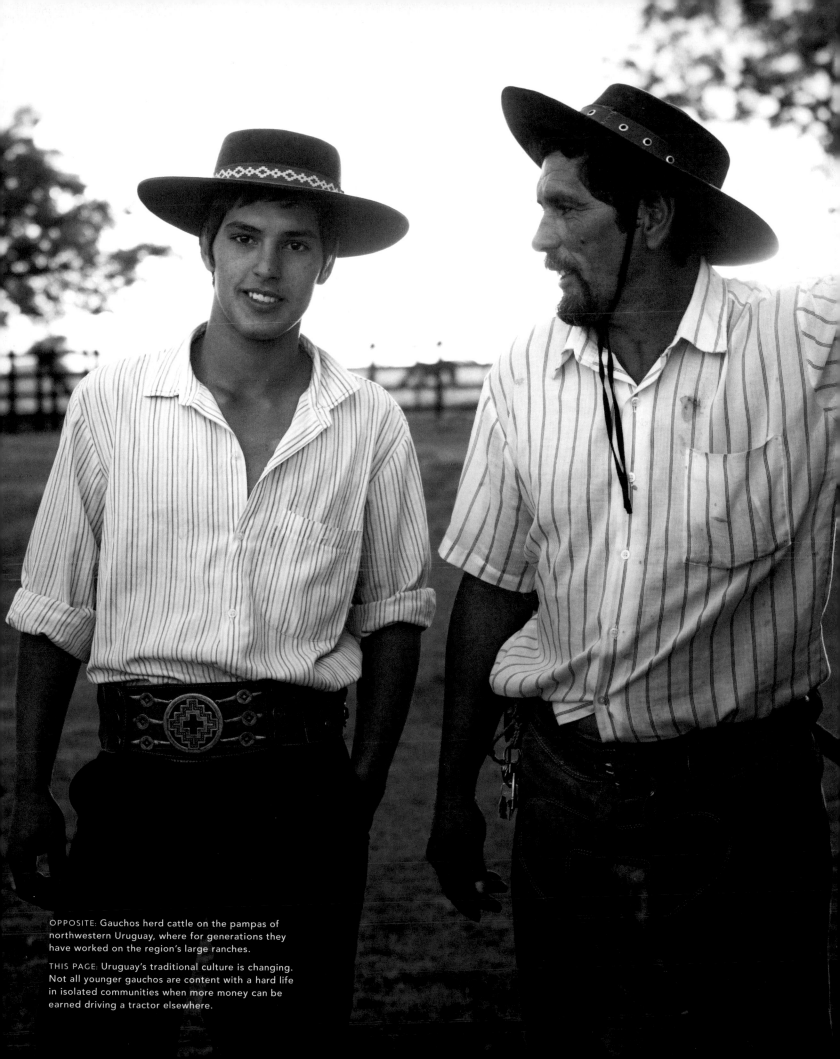

OPPOSITE: Gauchos herd cattle on the pampas of northwestern Uruguay, where for generations they have worked on the region's large ranches.

THIS PAGE: Uruguay's traditional culture is changing. Not all younger gauchos are content with a hard life in isolated communities when more money can be earned driving a tractor elsewhere.

sons swiftly found a purpose herding the feral cattle and horses that spread across the plains east of the Rio de la Plata. From the beginning, gauchos were shaded closer in temperament to cattle rustlers than more law-abiding cowboys. And the moody republic of Uruguay, a tiny buffer state between Argentina and Brazil, seems uniquely suited to their independent spirit.

More cattle clustered around the next gate. When Jean-Jacques drove up, they spooked. The animals shoved over the post-and-wire enclosure and stampeded. Jean-Jacques shut off his engine and, on foot, paralleled the cattle, now placid in the honey-scented grass. He spoke quietly, and advanced slowly with his arms held wide, until they turned together to move back across to their proper pasture.

Back at the hacienda, a pack of dogs greeted us, leaping up from their siesta on the courtyard patio. Jean-Jacques's sister Christine, a stocky blonde with a wide smile, called us into the dining room. The ranch cooks had prepared *puchero criollo*, the gaucho version of chuckwagon chile, which simmers on stoves at *estancias* throughout the Southern Cone. It is a characteristic meal for orphans, thrown together from meat scraps and vegetable ends, its ancestry rooted in Italy's *bollito misto*. Christine offered me a bowl. The broth was rich with yellow beef fat.

"Do you think gauchos are disappearing as agriculture changes?" I asked.

Jean-Jacques snorted. "The younger generation are just gauchos in blue jeans," he replied. "Now, they want to be *tractoristas*. No one wants to be on a horse looking for a cow."

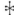

At a weekend *criolla* on the edge of the pampas, one of the gauchos preparing to ride knelt in the grass and cinched his spurs. Gauchos are working horsemen, but they also test their skills at informal county fairs, where riders throughout *el Uruguay profundo*—or the great interior—gather and compete. Up on the bandstand, a *payador* (gaucho poet) strummed his guitar, reciting improvised verses in rapid tempo, underscoring the mounting tension when a blindfolded bronco slipped sideways in its bindings at a hitching pole in the rodeo ring. It took several men, all slapping, shoving, punching, and kicking, to force the straining beast erect again. The gaucho climbed into the saddle and dug in his spurs so the horse bucked wildly when handlers released its trusses. Eight seconds later, he was flat on the ground again; the frantic steed crashing through the gathered crowd.

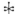

Leaving Jean-Jacques' *estancia* the next day, his sister, Christine, her daughter, Sofia, and I traveled farther northwest to Salto, the second-largest city in Uruguay. Faded architectural

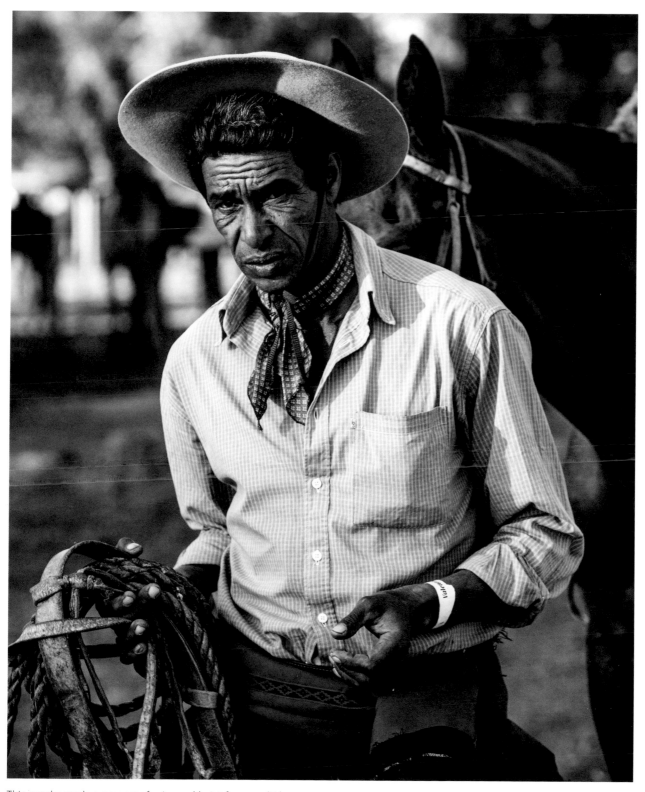

This gaucho made a new set of reins and lariat from cowhide
for one of the regional *criollas*, or rodeo gatherings that draw
competitors from every part of Uruguay on weekends.

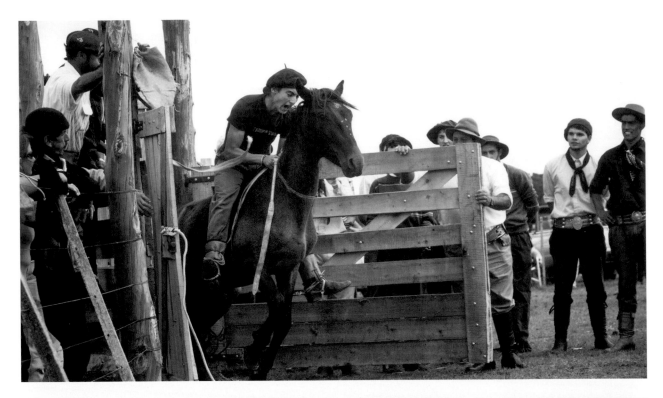

TOP: A competitor explodes from the gate as the crowd cheers him.

BELOW: Rural Uruguayans learn to ride and compete in *criollas* at an early age.

flourishes were still evident under tangled power lines and neon shop signs on the main avenues. At a corner restaurant, families were glued to the televised broadcast of a soccer match as waiters brought large platters of veal *Milanesa* to their tables. Sofia ordered a *chivito* sandwich, homage to protein by a country that isn't fond of vegetables. A single lettuce leaf was buried under an avalanche of sliced skirt steak, fried ham, molten cheese, and a hard-boiled egg, all poised to slide out between a beleaguered sesame seed bun. She shared half with me.

We stayed in town long enough for Christine to load the flatbed with chicken feed at the ag store and visit the vet to check on one of her golden labs, which had been bitten multiple times by a *yarará* snake. When Christine's son, Rodrigo, died in a car crash several years before, she left her condominium in Punta del Este and moved into an unheated bungalow on a thousand scrubby acres that he had purchased with an inheritance. His vision had been to turn the ranch into a model of sustainability.

"That phone call. That *awful* phone call," she said, still angry, pounding the steering wheel. "I was in Italy when it happened. He was only twenty-three."

She turned off the main road and passed between stands of eucalyptus. We pulled into a yard next to an open barn stacked with lumber and tractor parts. A wind turbine whirred beside a hut where a retired *péon* sat in the doorway and sucked *yerba maté* through a metal straw. A young man on horseback appeared over the rise, a flat sombrero tilted back on his long brown hair. He waved to us. When Jorge Godoy was a teenager, Christine explained, he rode his bicycle all the way from Salto to seek a job from Rodrigo. After his friend's death, Jorge stayed on to help run the place for her.

As supplies were unloaded from the pickup, I sat on a garden bench in the summer sun. A prevailing easterly wind puffed the grassland into patterns. Almost three-quarters of Uruguay is rolling plateau marked by rocky hills; the highest elevation is eight hundred feet above sea level. When the wind blows, little impedes its influence until the Andes. It could be either soothing or maddening, depending on one's tolerance for such things.

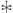

The *asador* raised his axe and killed the cow with a blow to its forehead. The animal slumped, no longer straining desperately against the rope that bound it. Then out came knives as long as swords. Surrounding the rodeo arena was a tarpaulin encampment: makeshift bars, traveling salesmen hawking spurs and saddles, crated pigs, portable toilets, and this blood-soaked pen where gauchos were butchering for an *asado*. Raw sausages were heaped on a table waiting for the grill; cooks raked hot coals from a wood pyre and shoveled them under butterflied

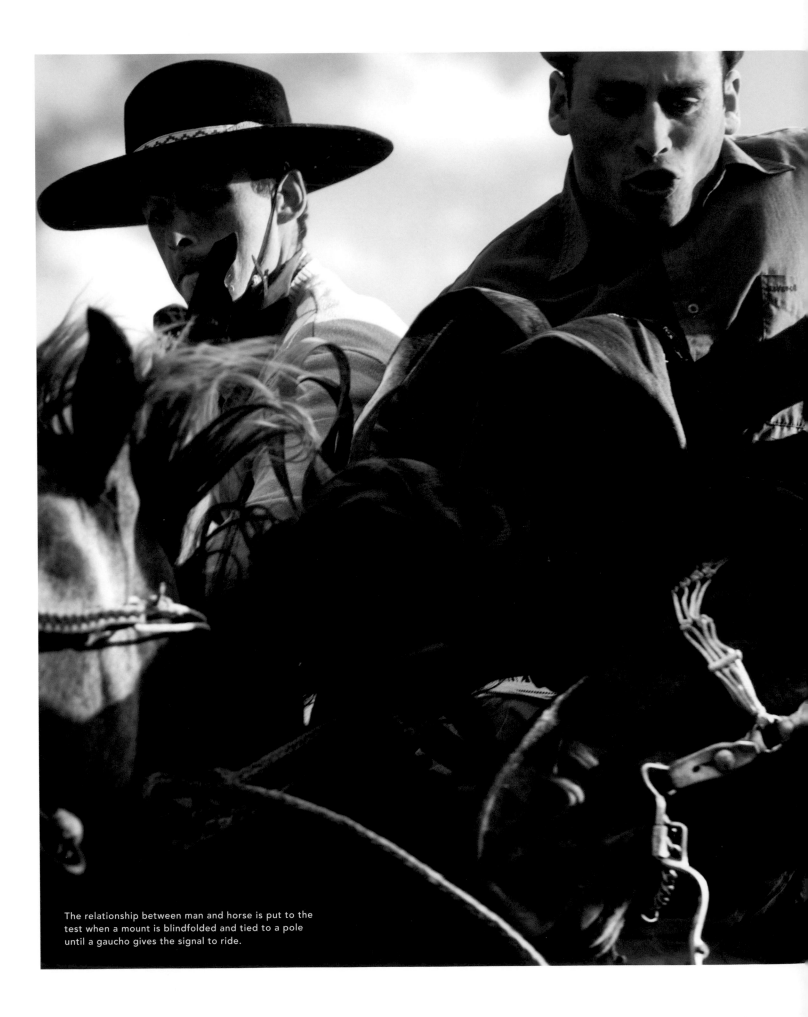

The relationship between man and horse is put to the test when a mount is blindfolded and tied to a pole until a gaucho gives the signal to ride.

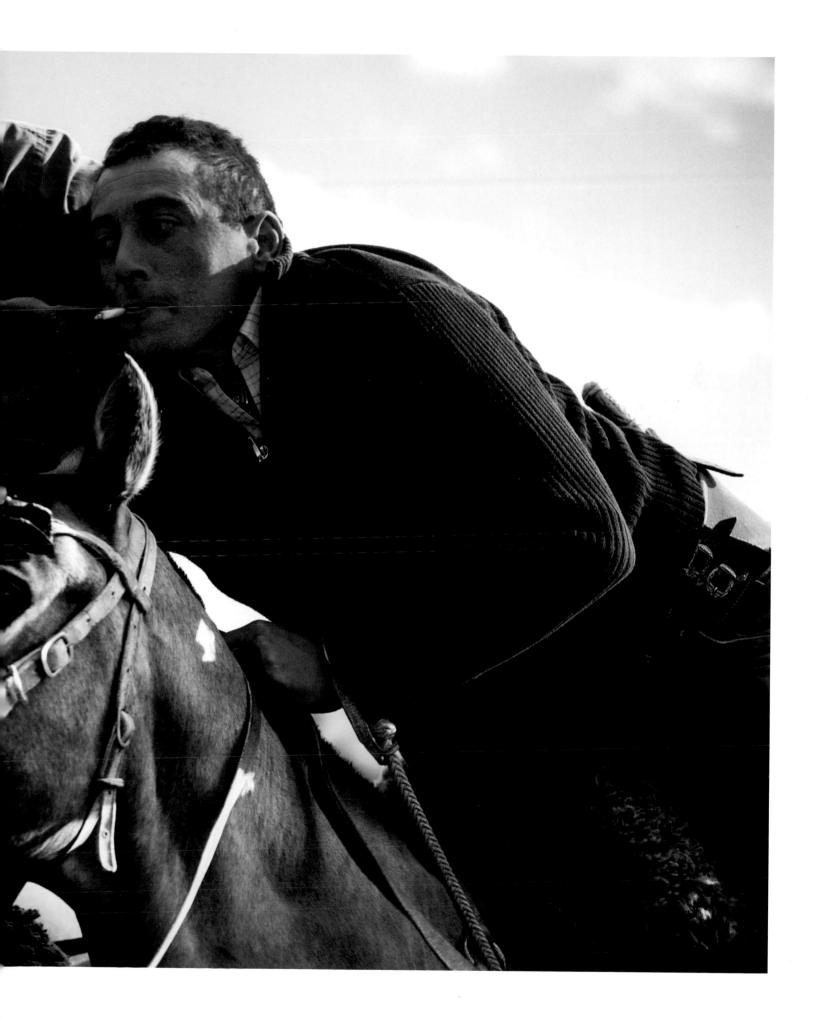

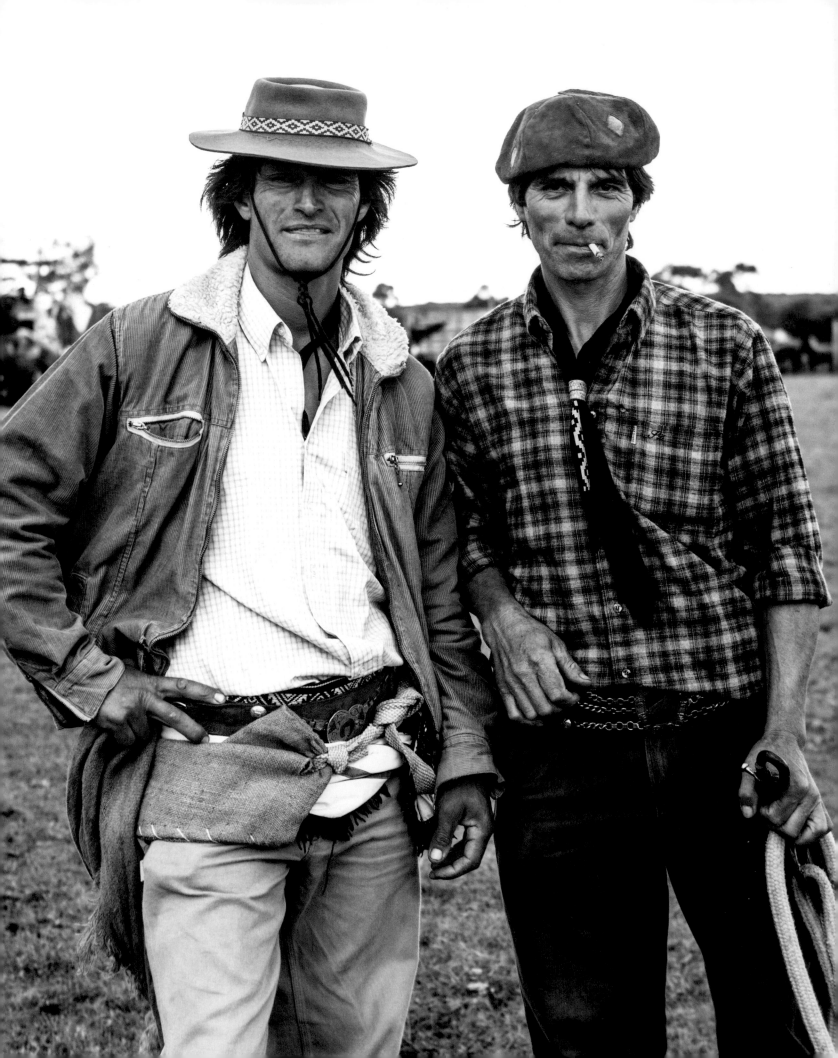

While some wear boleros, the floppy *boina* hat is
an integral aspect of gaucho style. It was introduced
when Spanish settlers colonized the pampas.

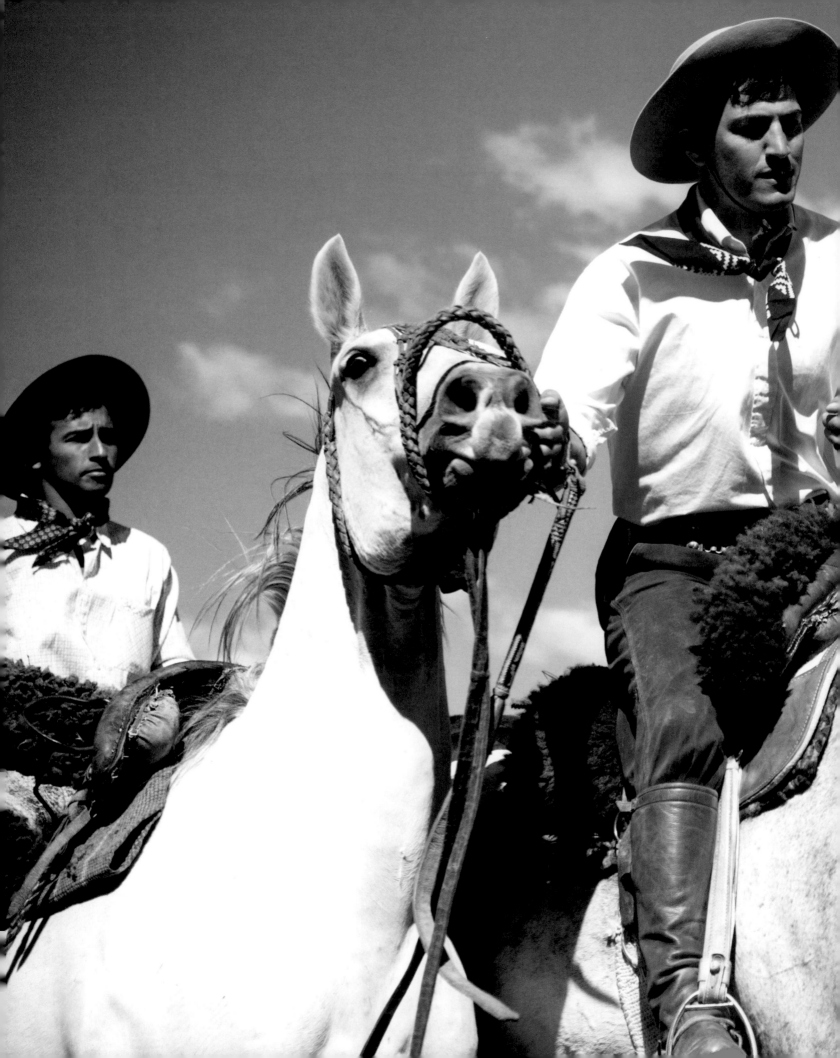

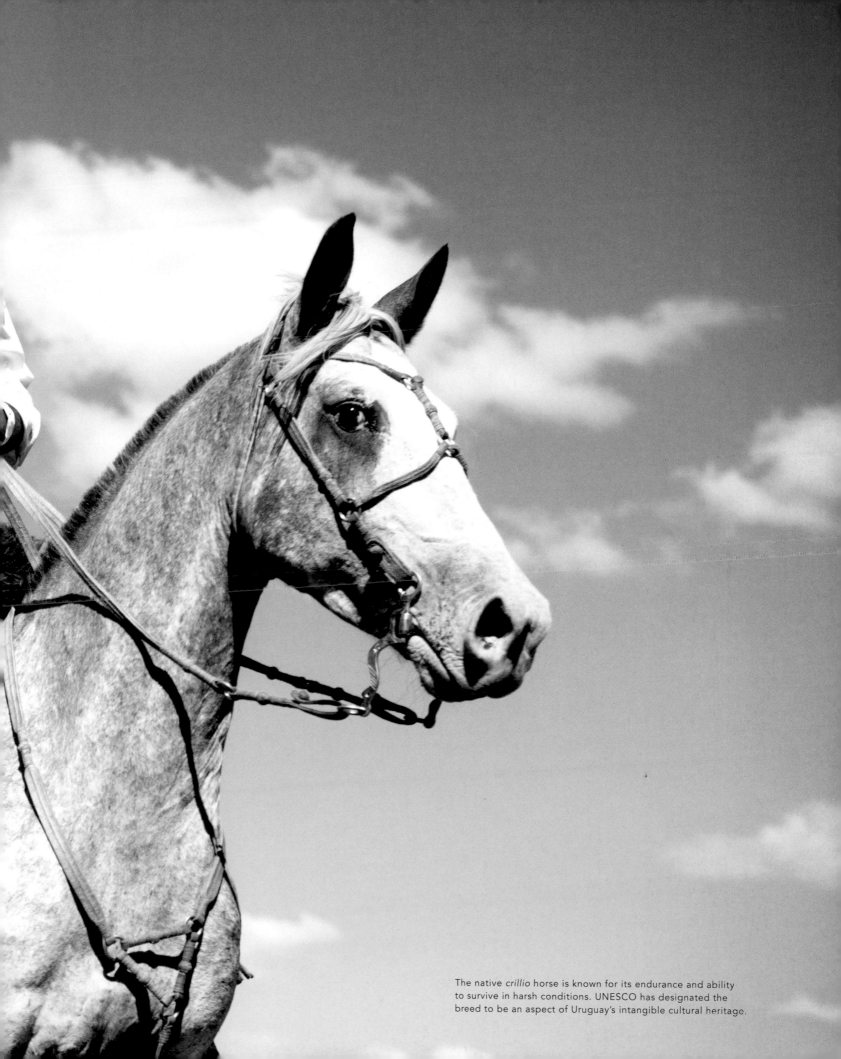

The native *crillio* horse is known for its endurance and ability to survive in harsh conditions. UNESCO has designated the breed to be an aspect of Uruguay's intangible cultural heritage.

The *facón* is a utility knife used by gauchos to castrate livestock, carve hunks of meat for roasting over roaring fires, and occasionally to settle brawls.

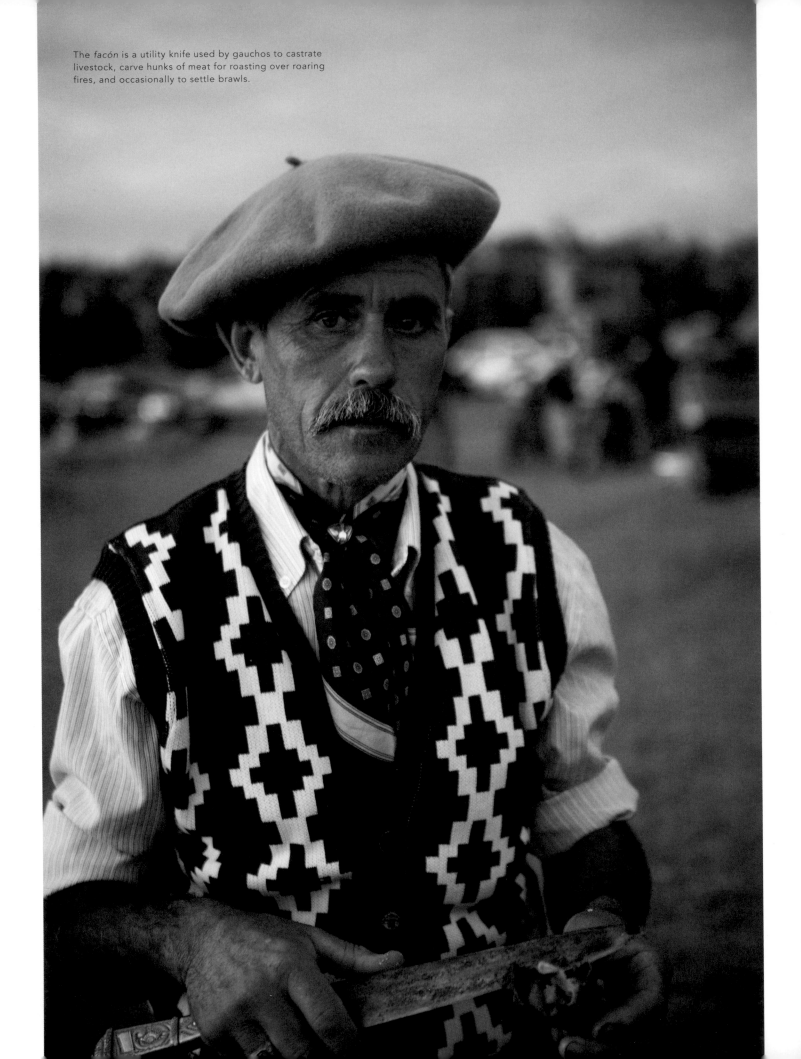

haunches of beef spitted on iron crosses. Complete with the matted hides still attached, *asado con cuero* is barbecue with major macho attitude. The history of *asado* parallels that of the gaucho. It has evolved from a primitive grilling technique to feed hungry cattlemen on the pampas into a protein-centric social event involving huge cuts of beef, lamb, or pork. No *criolla* in Uruguay would be complete without at least one pit surrounded by men tending the fires.

Later, a drunken gaucho leaned against the bar and quietly advised, "The meat is better at other stalls." It would have been wise to heed a correlation between the violent, frightened end of an animal and the sour turn of its meat, but who paid attention to glassy-eyed men stinking of horse sweat and sloshed beer?

<div align="center">✳</div>

At first light, Jorge Godoy climbed into his saddle and rode out of the yard. Green parrots shrieked from twig nests high in the branches of a eucalyptus. One of the *estancia*'s dogs threw itself down on the lawn, rolling back and forth, ecstatic as a dervish. Christine emerged from her bungalow wearing a pair of leather chaps and slouched riding boots. Sofia preferred jeans. We headed into the fields leading to a mud-brown tributary of the Uruguay River.

Along most of the highways in this part of the world, seminomadic cattlemen trot on mounts with dogs at their heel. Ponchos flapping, they wear *bolinas* and jaunty boleros, whips clutched in fists, medallion-studded belts holding up balloon pants that would look foolish on anyone else. The von Bonstetten women belonged to another class, but their posture was as erect as any rodeo queen. Sofia dropped back on the trail to talk about her mother. The night before, Christine and Jorge met with farm contractors on the patio of his bungalow to negotiate the next crop cycle.

"Ten years ago that would have been impossible," she said. "Well, maybe not so much, but they would make fun. Now, the most successful breeders and farmers are women."

For the past forty years Christine has refined a specific equine bloodline, the *criollo*, descended from purebred Andalusian horses shipped to the New World in 1535. Coffee and mocha in color, they are sensitive creatures with short necks and brawny lines, prized by gauchos for their endurance. UNESCO has even designated the *criollo* an aspect of Uruguay's intangible cultural heritage. We caught up to Christine, halted in a field where Jorge had rounded up a dozen horses and lined them against the fence, neck to neck for her inspection.

When Christine was a young woman engaged to her first husband, she and her mother sailed home to Uruguay from Europe after shopping for her trousseau. One night they over-heard a man in the ship's mess bragging that his gang was planning to raid a society wedding,

and the two women realized he was referring to Christine's nuptials. Once they arrived in port, the wedding date was secretly changed and the plot foiled. That marriage didn't last and Christine was left to raise Sofia on her own, selling fine horses to friends with larger *estancias*.

Jorge kept me company on the trail back to the bungalows. His father had also moved out from Salto to work for the von Bonstettens when his young *patrón* died.

"Will you go to the rodeo tomorrow?"

Jorge shrugged. "I sit on a horse all week long. Why would I want to dress up on my day off and ride in a parade?"

Christine's kitchen had a wood-burning stove and a concrete sink. A lantern suspended from a hook doubled as a shrine containing a dripping wax candle, potpourri, and a photograph of her son. In the cramped space, the two women worked side by side, the way only mother and daughter know how, prepping for her birthday *asado* later that evening, when guests would arrive to sing, dance, and gnaw on charred lamb ribs.

"It is peaceful here," said Christine, looking out the tiny window at luminous fields. "I like to stay alone here. This gave me something to think about after Rodrigo."

She chopped parsley and herbs from the garden for chimichurri sauce. After Jorge unsaddled the horses and set them to graze in a field of sorghum, he and his father laid a whole lamb on a pit fire. Sofia poured glasses of Tannat wine and we stood under the Milky Way, waiting.

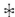

The *payador* urged the spectators on again, as outriders stormed down the field with the last horse in tow. "My joy is to live as free as the bird in the sky," he recited. "I make no nest on this earth." The nineteenth-century epic poem "Martin Fierro" recounts the tale of a wayward gaucho turned freedom fighter. It's practically a national anthem in Uruguay. Memorizing ballads is one of those skills—like sweet-talking a cow back into its pasture or entrusting a toddler to the back of a *criollo*—essential to the gaucho way. Just outside the ring, a little boy climbed on his sister's back. He wrapped his arms around her neck and puckered his lips, making the kissing sound that signals giddy-up in this part of the world. Both looked at me, grinning. As the girl pranced away into a field, a bell rang in the grandstand, signaling the last ride. Moments later, there was a triumphant shout over the loudspeaker, followed by wild applause.

OPPOSITE: *Al aire libre* is a favored gaucho
expression for life in the great outdoors.

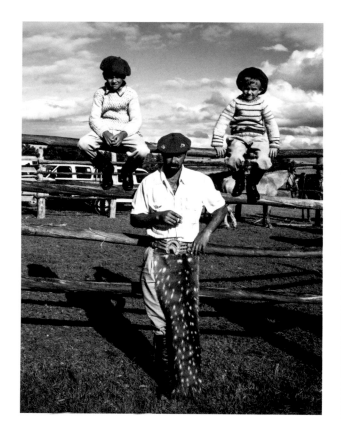

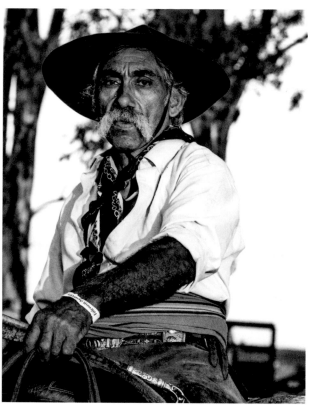

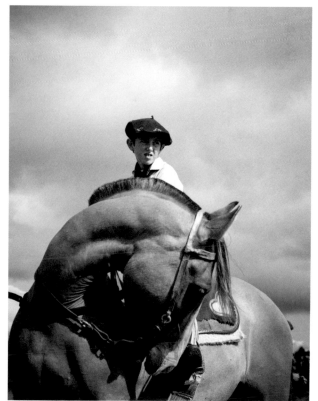

CHIVITO

SERVES 4

This sandwich is Uruguay's answer to the hamburger. *Chivito* means "little goat" in Spanish. It was created in 1946 at a beachside restaurant in Punta del Este when an Argentinian customer requested her favorite goat recipe and owner Antonio Carbonaro, who only had filet mignon in the kitchen, had to think fast. The rest is South American sandwich history. My preferred variation is the *chivito canadienese*, because it includes bacon or Canadian ham and a fried egg.

4 to 6 slices thick-cut, hickory-smoked bacon

4 large Kaiser or sesame rolls, split

Mayonnaise

1 pound skirt or sandwich steak, thinly sliced

4 large leaves Boston or Bibb lettuce

2 ripe tomatoes, sliced

¼ pound honey ham, medium sliced

4 ounces fire-roasted red peppers, sliced

8 ounces queso fresco or mozzarella, thinly sliced

4 small eggs

Coarse sea salt

Black pepper

In a large skillet, fry the bacon until crisp. Drain the grease from the pan and reserve. Add the split rolls to the pan, cut-sides down, and toast. Remove from the pan and spread generously with mayonnaise.

Without crowding the pan, fry the slices of skirt steak quickly over high heat, turning once as the pieces brown, about 20 seconds on each side. Repeat, if necessary, with more steak. Reserve.

Assemble the sandwiches in the following order, starting with the lettuce and tomato, steak, bacon, ham, peppers, and then cheese.

Add 1 tablespoon of the reserved bacon grease to the skillet. Fry the eggs over low heat, sunny side down. The yolks should remain runny. Do not overcook. Top each sandwich with an egg, so the cheese melts. Season with salt and pepper to taste. Cover with the top half of the roll and serve.

CHIMICHURRI

MAKES 8 TO 10 OUNCES

In Uruguay, a jar of this garlicky herb sauce is a standard marinade at *asados* in the countryside or at the *parrilla* restaurants in Montevideo's Mercado del Puerto. "Chimichurri is a moving target," said one Uruguayan friend. "Everyone's recipe is different." This version uses lemon peel rather than vinegar to brighten the sauce. When Christine von Bonstetten's daughter, Sofia, handed me a plate of long, thin lamb ribs charred with chimichurri over hot coals, I have favored them more than beef or pork ever since.

1 cup water

1 tablespoon sea salt

1 head garlic, at least 4 large cloves, separated and peeled

1 cup fresh flat-leaf parsley leaves

1 cup fresh oregano leaves

2 teaspoons dried red pepper flakes

½ cup olive oil

1 tablespoon minced lemon peel

Bring the water to a boil in a small saucepan over medium-high heat. Add the salt and stir until it dissolves. Remove from the heat.

In a food processor or blender, coarsely chop the garlic, parsley, oregano, and red pepper flakes. Add the oil and then the salted water, continuing to blend. Stir in the lemon peel, transfer to a jar, and refrigerate. Chimichurri is best when prepared in advance so the flavors have time to blend. Can be refrigerated for up to 1 month.

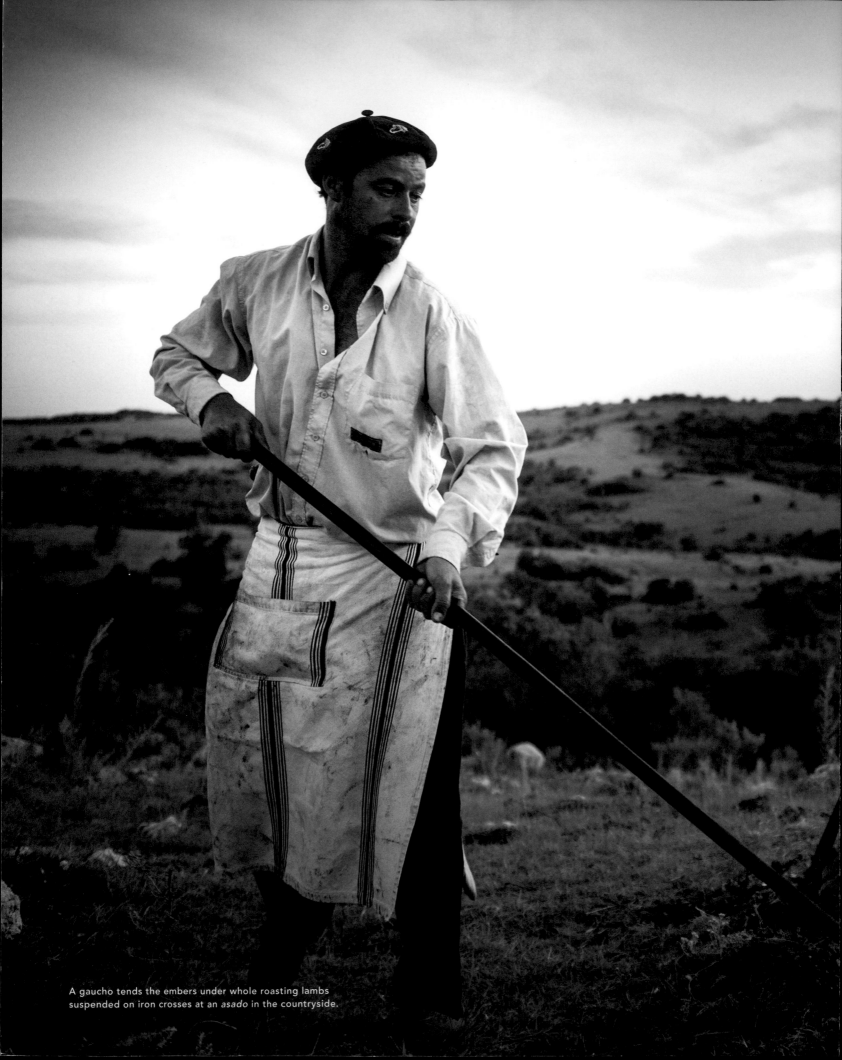

A gaucho tends the embers under whole roasting lambs
suspended on iron crosses at an *asado* in the countryside.

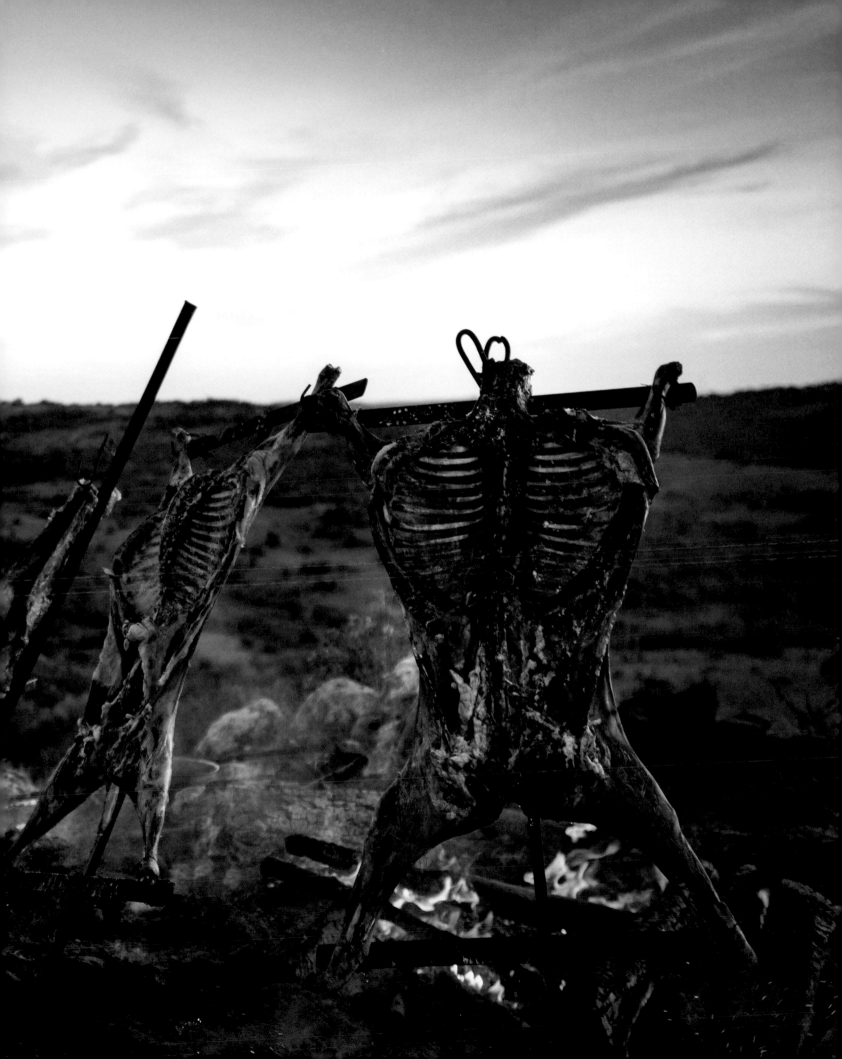

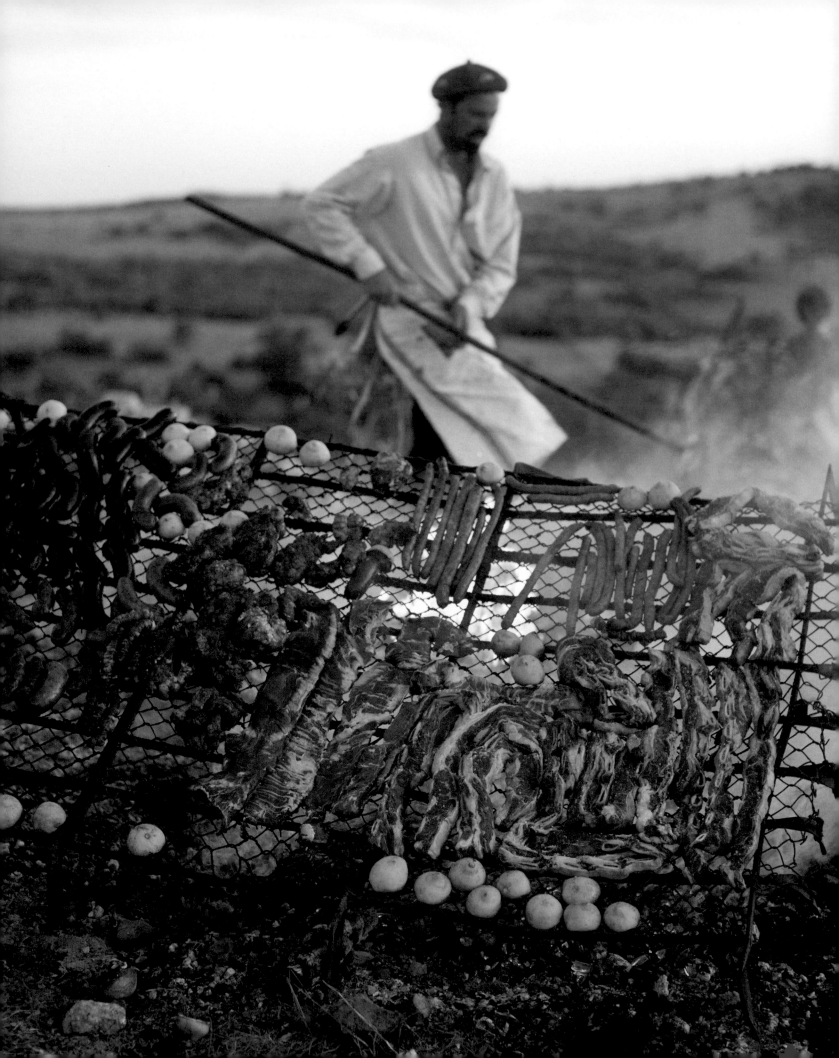

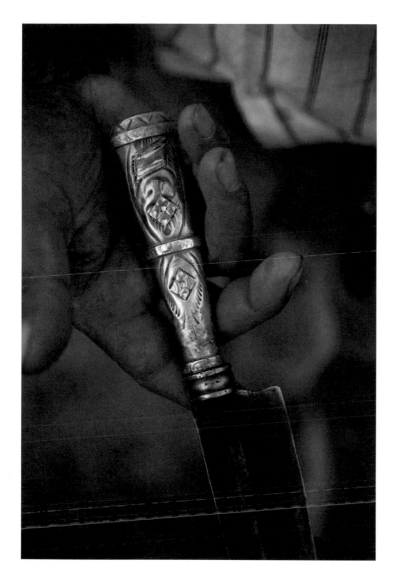

OPPOSITE: The typical gaucho diet consists of yerba
maté and numerous cuts of meat, including blood
sausage, chorizo, chitterlings, and *asado de tira* ribs.

ABOVE, LEFT: *Facón* knives are prized possessions,
often decorated with silver and gold.

ABOVE, RIGHT: Garlicky chimichurri sauce is the
standard marinade at *asados*.

LAMU ARCHIPELAGO
KENYA

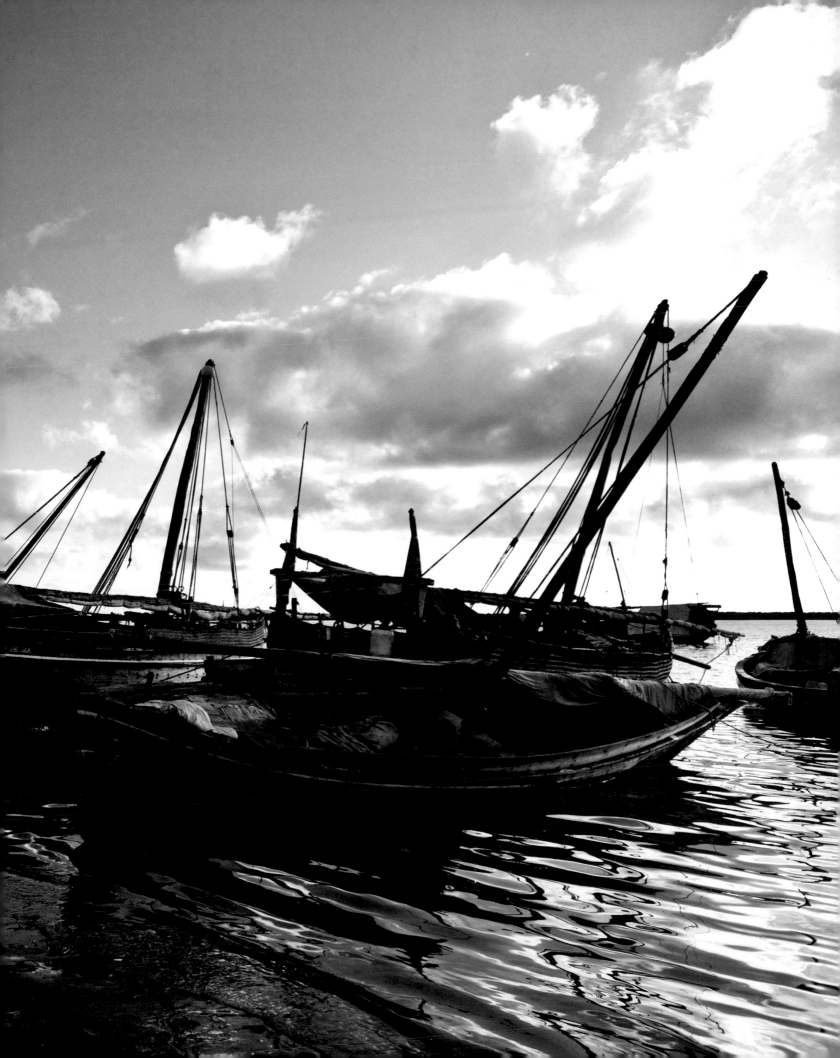

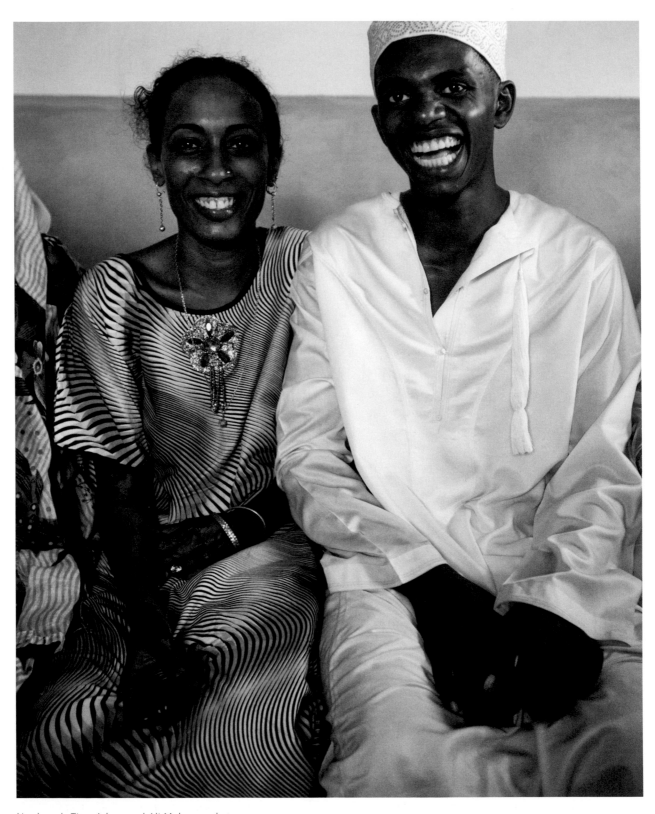

Newlyweds Tima Adnan and Ali Mohammed at
her mother's house on their wedding day in Lamu.

TIMA & ALI / FISHERMEN

Lamu Archipelago, Kenya

A rat skittered up my spine. Kahindi, the night watchman on the street corner, heard my shriek. He shifted slightly in the gloom as I ripped away the tight barrier of mosquito netting tucked under the mattress and tumbled onto the floor. Fearful of being bitten, I scrambled away from the rodent that had found its way into the bed. Why couldn't I hear it? I found the light switch and looked for something to throw. Were neighbors now peering at the half-naked *mzungu* ("foreigner") from the shadows of their window embrasures? I pulled down my T-shirt. Where was it? My heartbeat slowed as I grew fully conscious.

The breeze off Lamu Channel had dropped away to nothing in the night, and even on the fourth floor, the ceiling fan paddled through air humid enough to offer resistance. My thrashing had twisted the sodden sheets and I wasn't about to fall asleep again after being hagridden. Grabbing a pillow, I threw back the brass bar on the door lock and felt blindly for the stairs to the roof.

The call to prayer came just before dawn. When the loudspeaker crackled to life and the muezzin chanted his request to the faithful, thin Swahilis in long white robes hurried, their slippers slapping on bare earth, to attend their first obligation of the day. In Arabic, the high voice quavered.

"O, Muslims, come for prayer. O, Muslims, come for good deeds. Prayer is better than sleeping."

My own vigil at an end, I uncurled from a hard chaise and watched from the balustrade as the equatorial sun rose red as a torch. I was getting feverish as well. Not an auspicious start to a wedding day on the East African coast.

<div align="center">✳</div>

On the ground floor, I shut the front door quietly and walked through empty alleys perfumed with jasmine tumbling from shuttered townhouses in Shela. A wooden water taxi christened *Beyoncé* was waiting at the landing.

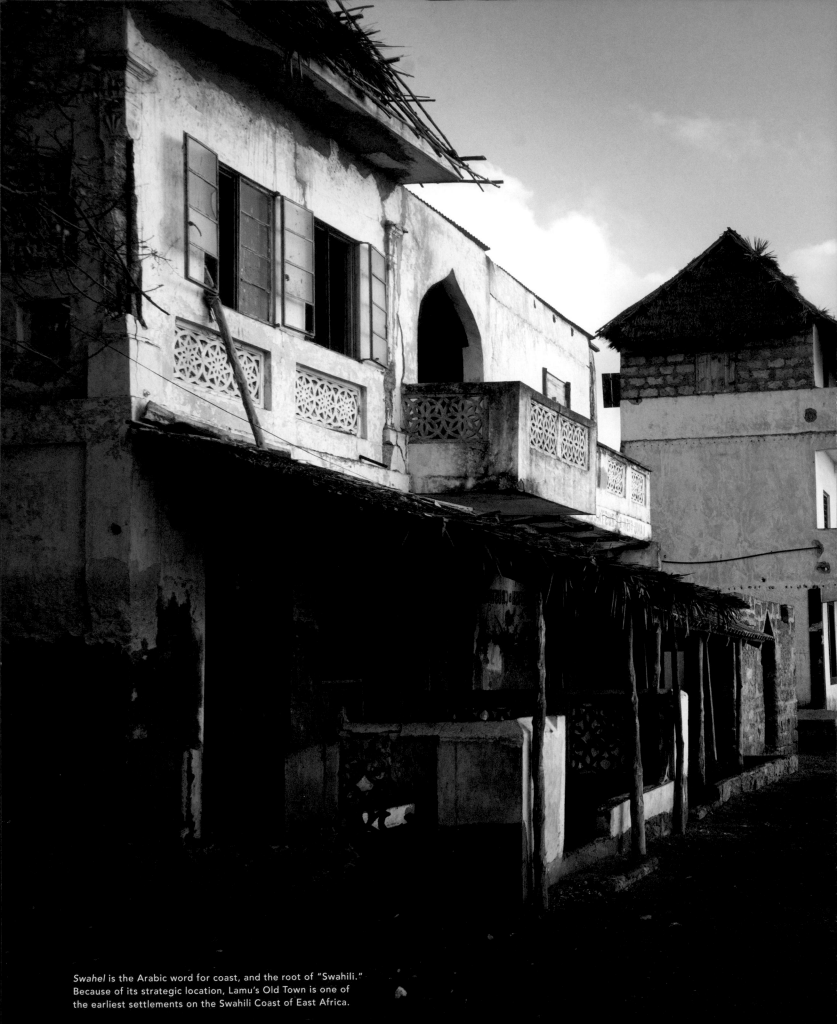

Swahel is the Arabic word for coast, and the root of "Swahili." Because of its strategic location, Lamu's Old Town is one of the earliest settlements on the Swahili Coast of East Africa.

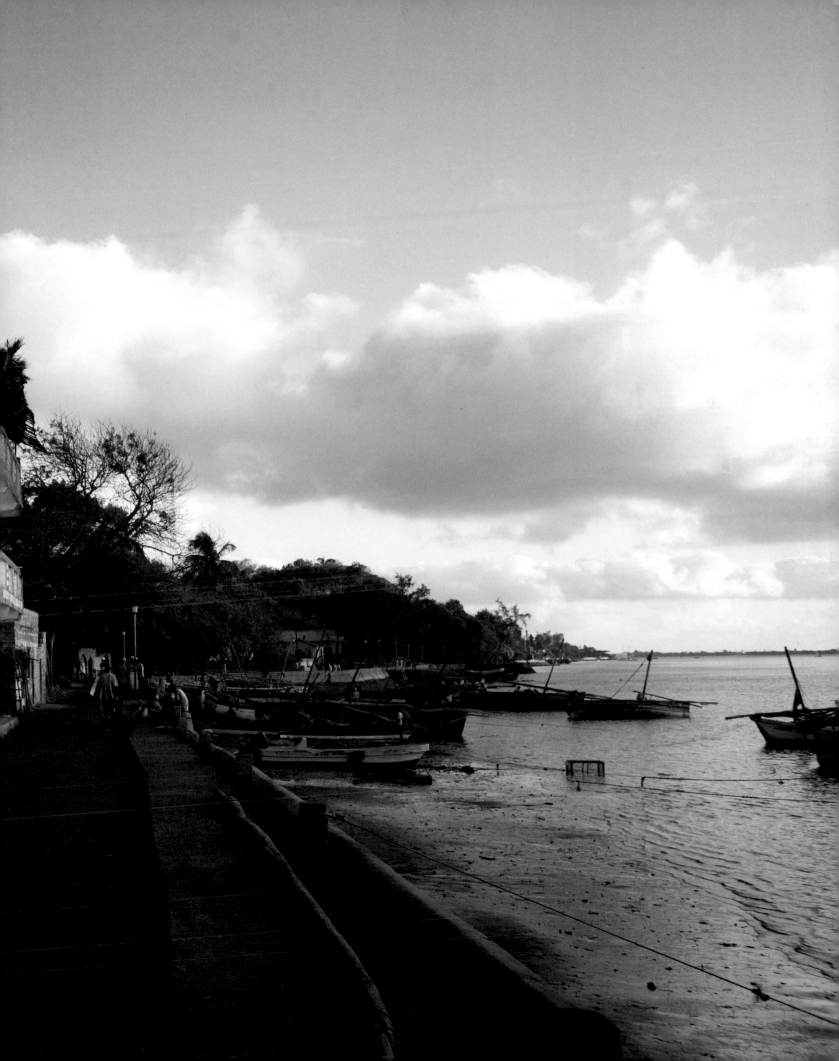

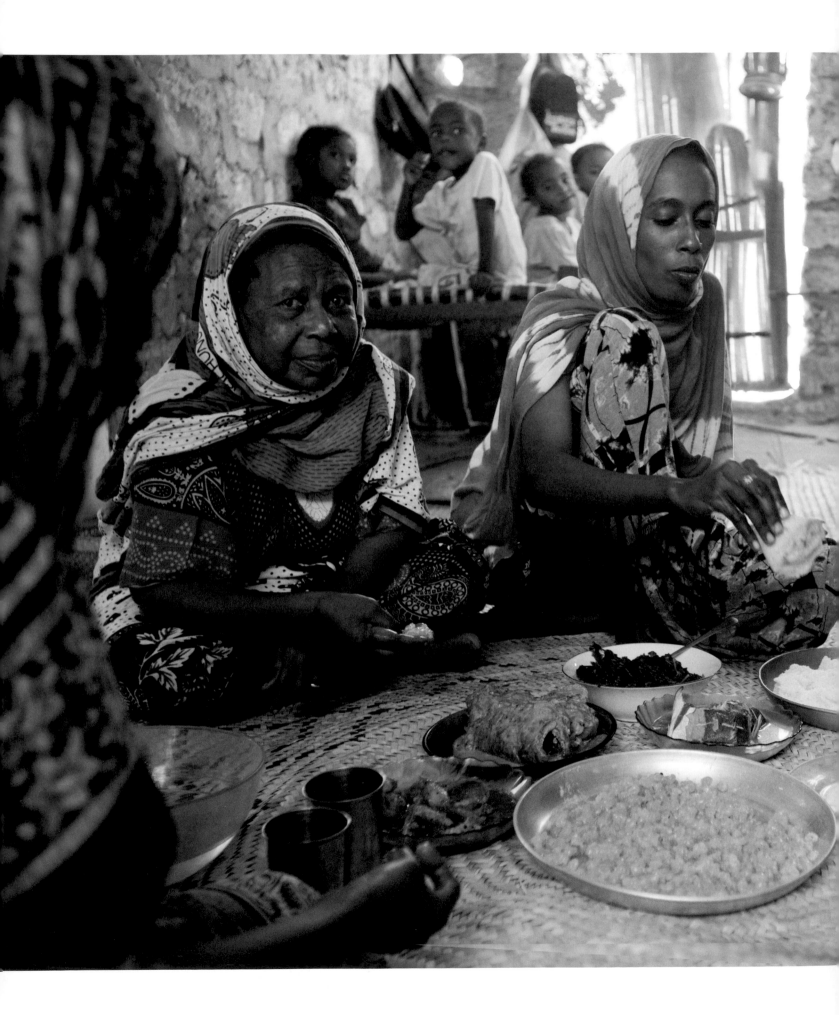

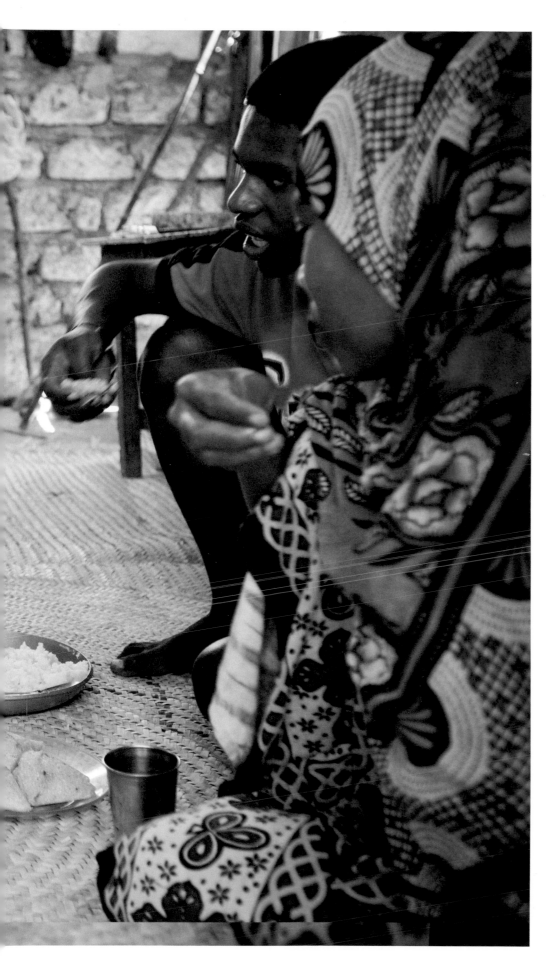

The Mohammed family serves lunch at their coral stone house in the fishing village of Kipangani.

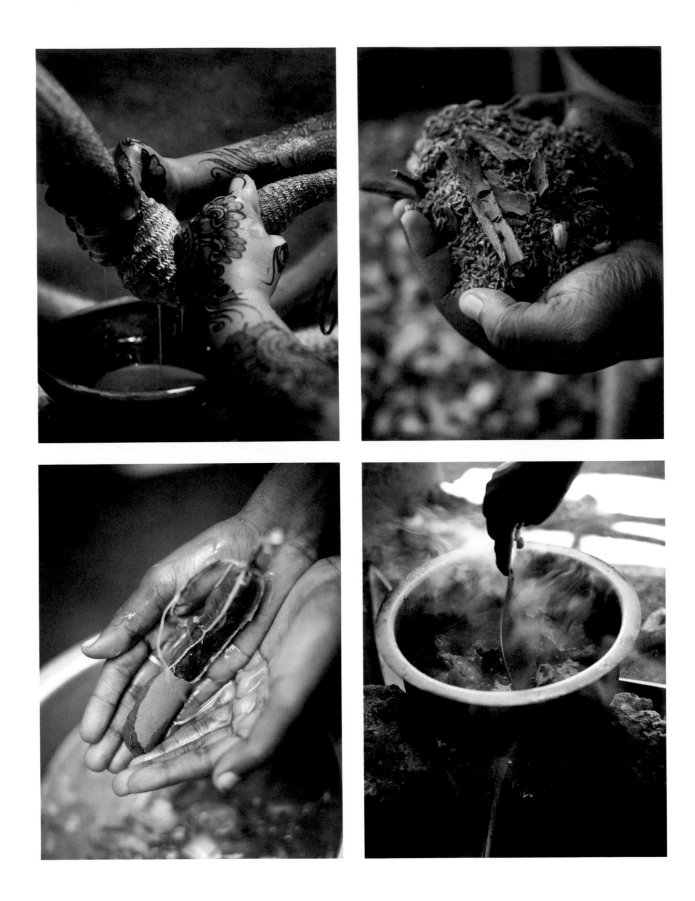

"*Habare yako*, Nasser," I greeted the young boatman.

"*Mzuri sana*, Mama," he replied.

Two men wearing conical *kofia* caps approached. One of them asked, "Please, may we ride with you? We are also going to the wedding." I glanced at Nasser. He was conveniently gauging the running tide.

It was the time of the Kusi monsoon. For more than a thousand years, this cooling wind has carried traders from Arabia and the Subcontinent to the Swahili Coast, where the island of Lamu, in an archipelago of the same name, became a strategic stop on Indian Ocean shipping routes for those who bartered slaves and spices in this severe latitude. (The main settlement, Old Town, is Kenya's oldest, founded in 1370.) Their descendants, now knit together by a complex skein of linguistic and religious kinship, waited patiently for the shift in weather, from soft Kaskazi to blustery Kusi, that would relieve the parched archipelago just as village wells were running dry. Some claimed they could smell rain advancing from distant Mombasa. But the swollen clouds that piled up on the horizon at the end of each day were like a troubled promise.

"*Poli poli*," Nasser cautioned. He pushed the tiller wide as speedier boats whipped past and rocked *Beyoncé*. He repeated this phrase over and over as we motored along the channel between towns. A plume of black smoke rose from the diesel generator at the power plant on the waterfront. Gaily painted fishing *dhows* tilted in the exposed mud. We reached a jetty opposite the archway leading into Old Town. I clambered over sacks of rice in the open holds of ferries docked alongside the crumbling, mollusk-crusted steps. Pennants were hung for Maulid, the springtime celebration of Mohammed's birth. I ducked around the corner of a mold-blackened fort. It had been built in haste some centuries ago by a financially distressed sultan before Lamu was left to fend for itself against pirates and the Portuguese. Up a hill, on the town's largest square, pairs of sandals tidily faced inward on circular entrance steps at Riyadha Mosque. Within earshot of the men kneeling inside, Tima's mother beckoned me to join her. Other women draped in black *bui bui* ("robes") stood by her side. Asked what she was giving as a gift to the groom's family, she burst into tears.

"My only daughter," she cried. "Is that not enough?"

TOP LEFT: Swahilis use a woven palm *kifumbu* utensil to extract milk from shaved coconut.

TOP RIGHT: A typical spice blend for coconut rice. See recipe on page 108.

BOTTOM LEFT: Extracting pulp from tamarind pods for chicken stew.

BOTTOM RIGHT: *Kuku wa rojo*. See recipe on page 107.

✳

I met Tima Adnan and Ali Mohammed the week before their wedding in a fishing village on the back side of Lamu. Ali's mother, Rahamah, beckoned me inside their coral stone house to avoid heatstroke. Faded cloth was draped modestly over her head and shoulders. She didn't speak English, but a younger woman offered to translate.

"We are about to eat," Tima announced.

Kerosene lamps hung on mangrove beams. Chickens hopped on beds in alcoves on either side of the common room. A sleeping baby swayed in a hammock under the slats of a woven palm settee where I was urged to sit. Tima had learned English at school in Old Town. She had a narrow face and a nose piercing. I was reminded of bony cats lurking in Lamu's alleys, their immediate pedigree uncertain, but bearing a strong resemblance to the sacred felines beloved of pharaohs. When her future sisters sat on a floor mat to roll out ropes of rice flour dough, she introduced me to her fiancé. Ali was plastering a new addition that would be their bedroom. Whitewash spattered on his red T-shirt and thin arms. They had courted modern style, she confessed, flirting and trading playful texts. Ali put down his brush and left to practice for the Maulid bareback races. The year before, his gray donkey had placed second.

Rahamah showed me how to fashion a Swahili turban. She deftly flipped a swatch of patterned cloth around her sweetly freckled face. It was difficult to guess her age, somewhere beyond childbearing but not yet careworn. Then we entered the kitchen—a walled courtyard with a gap in the roof to draw smoke from the smoldering cook fire. A niece threw a handful of coconut husks on the ashes and fanned the flame higher. The other girls cut up spinach and soaked tamarind pods.

"When you cook slowly, *poli poli*, then the food is good," instructed Tima.

We sat in a circle on a floor mat and everyone rinsed his or her hands, pouring a small amount of water from one bowl to another. Then Tima served chicken smothered in dense gravy that could easily have been prepared in the kitchen of a mughal emperor, an ocean and an age away. But I guessed that chickens did not have their necks wrung every day in this modest household of fishermen.

Before I left, Tima issued another invitation: "My wedding is on Friday," she announced. "You should come."

✳

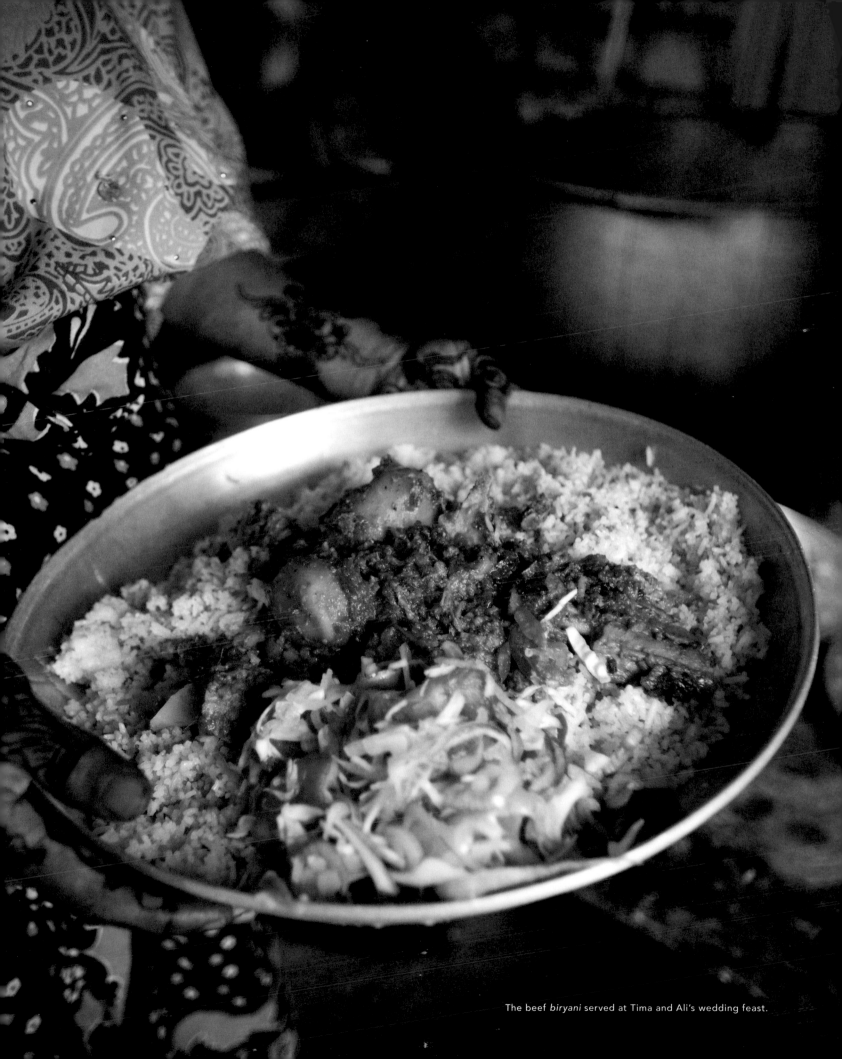

The beef *biryani* served at Tima and Ali's wedding feast.

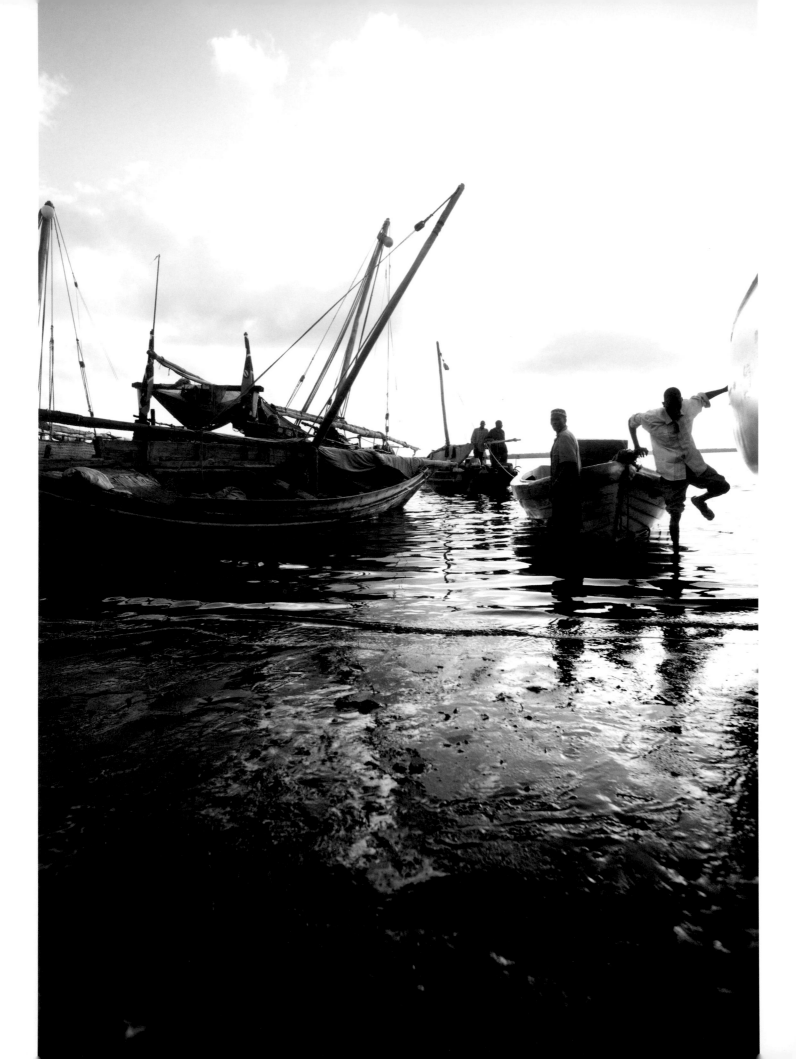

The cicadas sang like mad beggars. They swarmed bougainvillea climbing the villa's shaded balcony. Jumah, the clean-shaven houseboy, placed warm *mandazi* doughnuts and milky tea down on a table next to the cushions where I rested, achy and sluggish.

"Miss, will you be needing the boat today? Nasser has been asking."

"Tell him yes. I'll call when ready."

"I wish I had a phone of my own," he admitted, reluctantly pulling mine out of his trouser pocket and handing it back. "They are very expensive here."

"Jumah."

"Yes, miss?" He turned again at the stairs to the kitchen.

"Can you show me where to buy *kanga*?"

Jumah nodded. "I know the best places."

When I forced myself to get up, a thin hairless tail skirted the base of the settee.

<p style="text-align:center">✳</p>

Sunni pilgrims packed the waterfront promenade. Touts were everywhere. "Mama, do you want a ride in my *dhow*? I serve the best Swahili dishes in my café. Do you want to buy tobacco? Postcards? Cold beer!"

Jumah fended off the most persistent. Shrouded housewives crowded a spice stall. The merchant barely kept up with muffled demands. He leaned over open sacks of lentils to dispense paper parcels of saffron and Zanzibar peppercorns. Jumah and I stepped next door, where a fabric shop had bolts stacked against the walls. The owner unrolled printed cottons. *Kanga* are like wearable greeting cards. Each rectangular swath of fabric has a riddle or proverb in bold black letters along the border that reflects the mood of the wearer toward romance and other fine sentiments. Colors and patterns in the central panel also shade the meaning. A pretty pink handkerchief paisley caught my eye, but somehow *Wacha utani wewe umwangu mawazoni* ("Please stop teasing me") didn't send the right message. I settled for *Mkipendana mambo huwa sawa* ("Everything is all right if you love each other") in red and black. Jumah's smirk indicated this might be interpreted differently. Tiring of a constant male escort, I handed over the bundle and sent him to deliver it to the happy couple.

OPPOSITE: During low tide, fishing *dhows* keel over in the mud of the Lamu estuary.

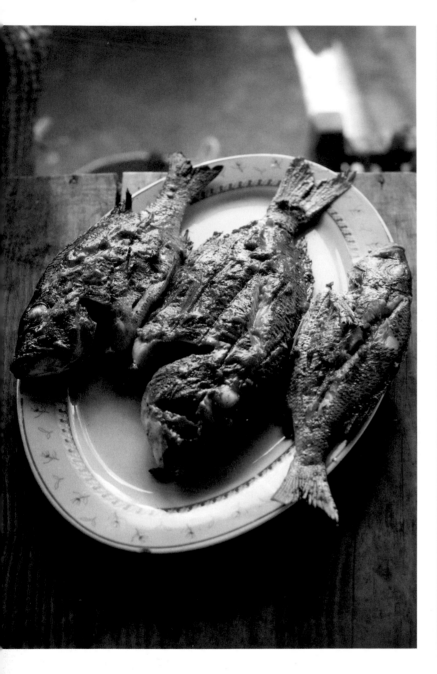

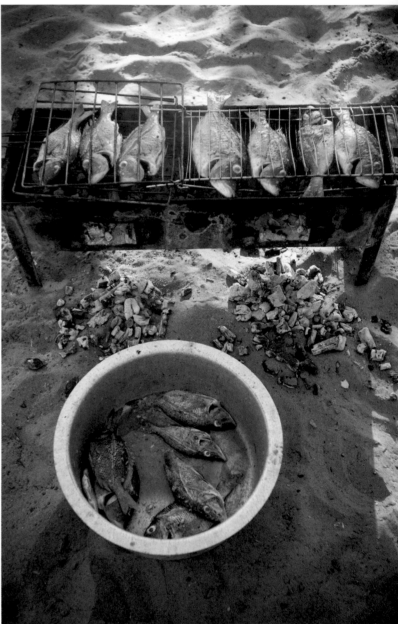

TOP LEFT: *Samaki wa kupaka*. See recipe on page 106.

TOP RIGHT: White snapper marinating in curry on a
beach outside Lamu.

OPPOSITE: Amir, whose nickname is Lemon Squeezy, on his *dhow*
after a day of fishing for white snapper in the Indian Ocean.

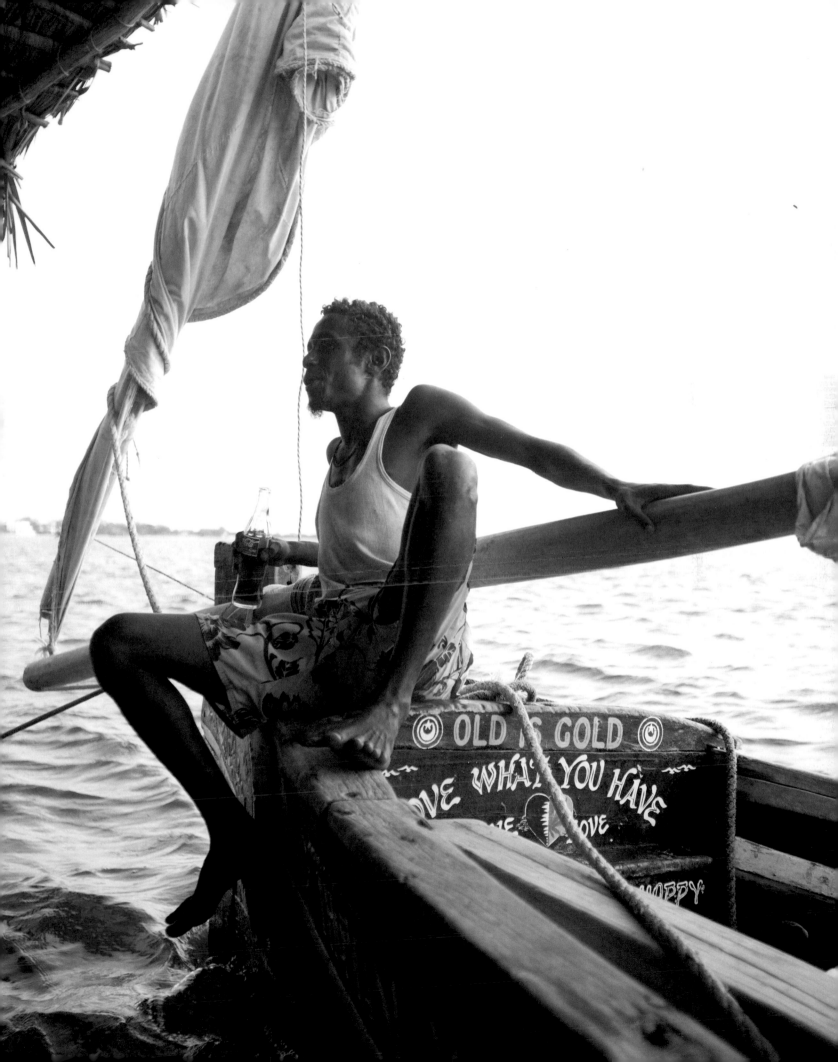

In the narrow lanes, upper windows had shutters thrown back to catch any stray puff. I drifted beyond Old Town, where pavement turned to soft brown sand and a tangle of mangroves. Four fishermen waded into the channel with a seining net. They let it arc in the current and then pulled it back toward shore, drawing it together again to bunch the heavy netting. Silver shrimp seethed in the webbing.

<p style="text-align:center">✳</p>

Amir arrived on the waterfront in Shela with the outgoing tide. His *dhow* was small and shabby but still resembled the ancient vessels belonging to Red Sea slavers. His two crewmen jumped out to steady the boat in the current until I could be hoisted aboard. Free of the shallows, they raised a ragged canvas sail on the mast. It caught in the breeze beyond a reef that separated the back channel from the brinier blue. Other sails were visible up and down the tan coastline as fishermen spied telltale gulls feeding on schools of snapper and mackerel. Often they would be out at sea for days.

"I like to tie a hand of bananas to the mast," Amir said. "So we can eat one whenever we wish." He was lean and wiry. A single sun-bleached tuft in his curly bronze hair earned him a nickname based on a British dish soap jingle.

"Too many Amirs in Lamu," he laughed. "Easy peasy, Captain Lemon Squeezy!"

He belonged to a clan of fishermen from Pate, an island farther north in the archipelago, but his parents had moved to Old Town to try their luck. "They wanted electricity and a dependable well," he explained.

Amir missed his childhood sweetheart, who had left for Mombasa to work as a bank teller. He confessed that they used to play at being married. I didn't want to add to his anxiety by saying that once young girls move to the big city, they are rarely content to find happiness in backwaters.

When the boat reached the swell point where shoals dropped away to fathoms, the sails were furled and we bobbed freely in water the color of an evil-eye charm. Amir pulled out a fishing line baited with bits of shrimp. He cast and jigged with one hand bent at the wrist. The bottom of the boat filled with slippery fish.

A sky blue flag was painted on the stern. Amir's *dhow* had been a gift from a Swedish expat, so he could earn an honest living, but he was having difficulty selling enough fish to make repairs to the sail and hull. Tourists were harder to catch than fish. It was only fifty nautical miles north to Somalia's border. Piracy had become the most tempting livelihood for

anyone with saltwater in their veins between the Gulf of Aden and Tanzania. But it was hard to imagine a gap-toothed, squeaky-clean corsair. The salt wind slipped across my cheekbones until Amir hoisted the sail.

<div align="center">⁜</div>

I needed a drink, but not in the solitude of my villa with Jumah hovering. As I walked onto the colonnaded veranda of a clubby bar favored by scorched colonials and their plump mistresses, an Englishman with a pink face and pinker pants complained loudly about his bill. Two women invited me to share a plate of samosas. They wore *kikoi* (cotton sarongs) and bikini tops. One had inherited a fortress built among the sand dunes by her dead lover. She slept in a tower bedroom as Maasai guards stalked the parapets.

"How did you enjoy your *dhow* ride?"

I stared at her.

"We saw you sailing with the saltwater boys."

And then she winked. Apparently, one did not rent the best house in Shela, also known as "Little Europe," and then associate with junior pirates—even charming ones who made their rickety hull hum on a close tack. I excused myself quickly, and then trudged on a path connecting the two towns, to hell with warnings about the snatch-and-run artists lurking behind every coconut palm. High tide flooded Old Town's promenade, trash and donkey turds awash. The light was shading to silver and rose where *dhows* bobbed at anchor. In the ladies' washroom at the Palace Hotel, I rinsed my feet with bottled water and toweled my armpits. Drumming from the street signaled waves of *madrasa* students in tan robes and embroidered shawls marching past. Every few yards they paused, held hands while bowing low and chanting, or clattered on tambourines and cowhide kettledrums. Children clutched small paper flags printed with *Mil Ad Un Nabbi* ("Happy birthday, Mohammed"). When the Maulid revelers receded, they pulled everyone behind them to the square at the top of town, where the celebration continued late into the night. A group of women in *bui bui* sat together on one corner. My pocket camera accidentally flashed. A man came up and wagged his finger in my face.

"No taking pictures."

I pretended not to understand. He looked annoyed, and then took a deeper breath.

"NO. TAKING. PICTURES!"

When he announced to the square that a *mzungu* was intruding, I retreated down a street that bottomed near the market. Sparks flew from charcoal braziers where cooks were

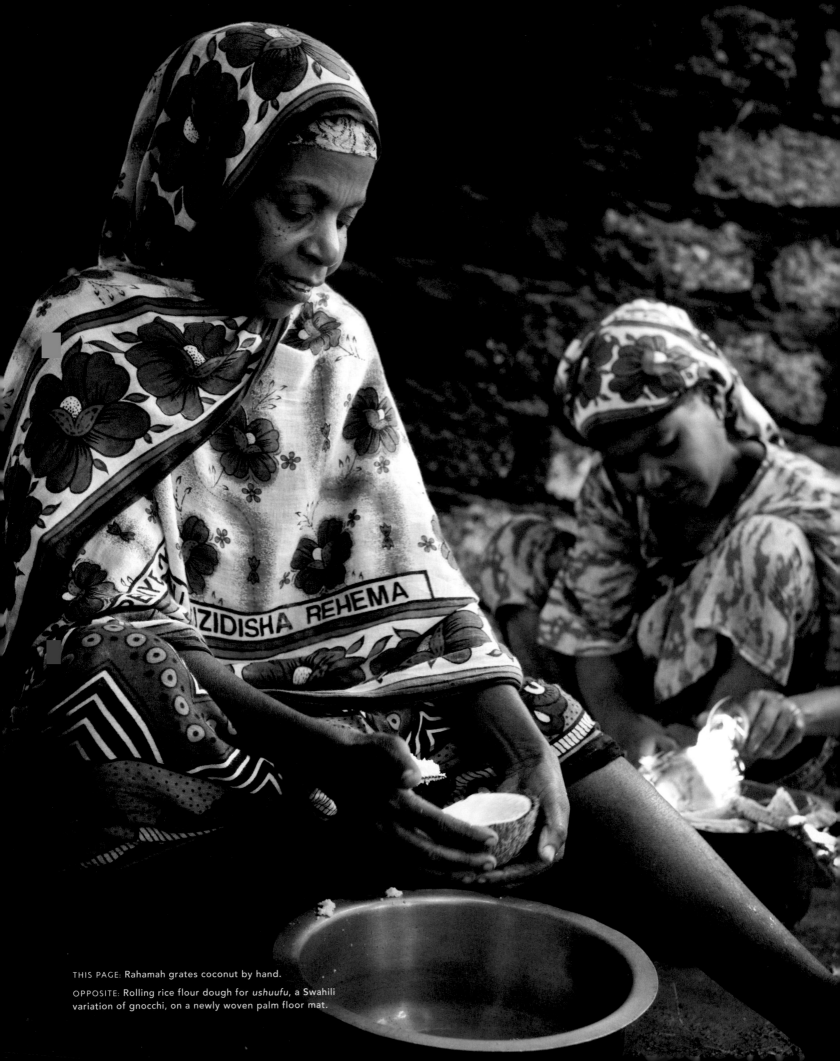

THIS PAGE: Rahamah grates coconut by hand.

OPPOSITE: Rolling rice flour dough for *ushuufu*, a Swahili variation of gnocchi, on a newly woven palm floor mat.

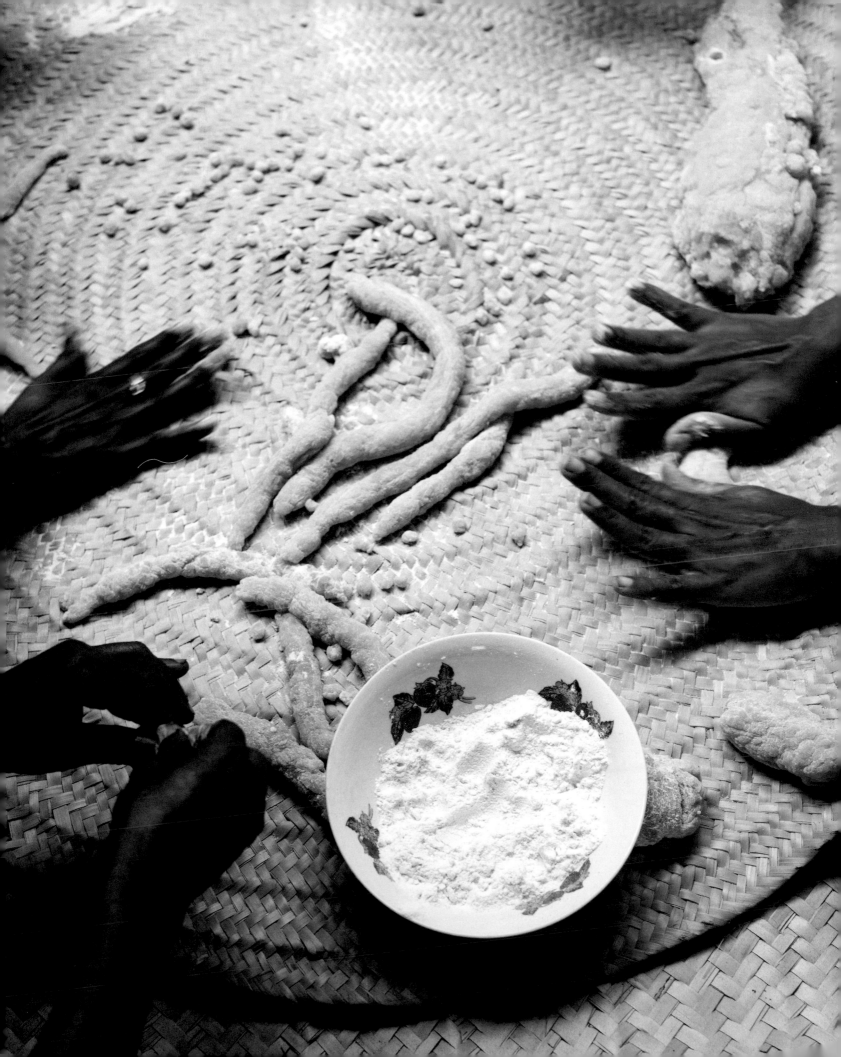

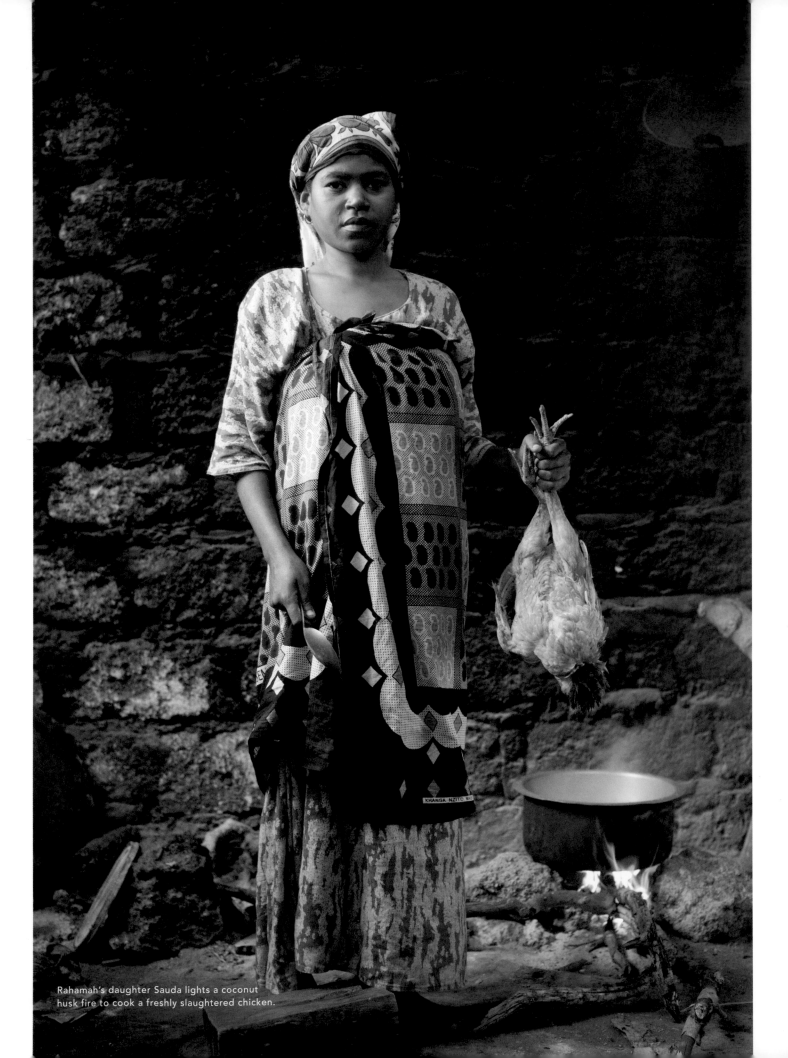

Rahamah's daughter Sauda lights a coconut husk fire to cook a freshly slaughtered chicken.

roasting cashews and preparing *chipsi mayai*, or fried potato omelets. A feral cat sat near a grill of sizzling barracuda. The vendor dropped a tidbit on the ground.

"The cats of Lamu are always satisfied," he laughed.

Gauging the pounce, I whispered, "Do you have a taste for rats, kitty?"

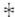

It was still early when I pulled up a stool at the varnished bar in Petley's rooftop pub.

"What do you want to drink tonight?" asked Satan.

I never learned his real name, but this bartender certainly looked the fallen angel. Hooded eyes, sardonic mouth, Che Guevara beret. Nursing a glass of cheap South African chardonnay while trading niceties with a former Nairobi street tough finally cooled my blood. Satan cranked up Lucky Dube's "House of Exile" on the sound system. The more respectable beach boys—those with neatly combed hair and clean polo shirts—lounged in profitably dark corners. They came to drink sodas and troll for customers who might make their foreign visa dreams come true.

"Boys who do massage," Satan said bluntly. "Naughty massage. Boys for men, boys for women. Boys for couples."

"Do you get a kickback?" I asked.

"Doesn't everyone pay the devil?" he leered.

We continued our discourse about coffee stalls and chutney sellers. When a woozy safari guide sitting near me chimed in about street life, Satan turned ugly. "What the hell do you know about Lamu?"

The man ducked his head and went back to contemplating his warm Tusker ale. When drink orders distracted Satan, I made my way back downstairs. A tall beach boy ambushed me under the dim tungsten streetlight outside.

"Mama, I want to go to Shela," he whined.

Who wouldn't want to go to lovely Little Europe, with its guarded villas and jaded *mzungu* who bought presents in exchange for pretty smiles. He persisted, keeping pace as I walked faster toward the pier where Nasser was waiting.

"Not tonight," I mumbled.

Nasser brushed the boy aside with a curt remark.

*

On the morning of the wedding, Tima's mother wiped her tears as Ali, inside the mosque, recited the marriage vows in Arabic. Women are not permitted in mosques, but can stand outside to hear the vows. Meanwhile, the bride stays cloistered. His voice trembled. While the men remained at prayer, Tima's mother and I walked down the street to a beauty parlor where Tima was waiting. Her long brown hair was pomaded and twisted into an elaborate chignon of curlicues pinned with satin rosettes; her bare arms were painted with henna arabesques, and gold dangled from her earlobes. A slinky lime-hued gown overlaid with gold beads and emerald sequins swirled on fishnet. Lucky green, fertile green. Painted brows, coral lipstick.

Over this marvelous costume, she donned full veiling, not even a slit for kohl-lined eyes, and we set off for her mother's house, walking through back streets and a field of scorched trash toward the slum known as Kashmir, a separate settlement of half-built houses, hanging laundry, and burlap-and-twig market stalls, far from the conspiracies on the waterfront. Children pumping water from a bore well into yellow jerry cans paused to run after the bridal party, shouting "*Jambo*!" Every few doors, I was politely introduced to cousins, aunts, neighbors. Tima stepped into an open courtyard. The walls were freshly whitewashed. Ali had been busy all week.

Tima passed through a small foyer and into a room containing two beds. The *bui bui* was carefully removed as she sat on a brown satin bedspread to wait for her groom to arrive. Green curtains covered the windows, keeping flies out and heat in. Tima chatted confidently with two girlfriends, who teased each other about their own marriage prospects with boys from the island. She picked up a small fan from the bed and waved it to keep her makeup from melting.

"Where did you find your dress?" I asked.

"I had the fabric sent from Mombasa," she boasted. "It was made here in Lamu with a pattern from a magazine." Gradually, she grew silent with the long wait, and for a brief moment, hung her head timidly. "Today, I start a new life," she murmured.

Tima cheered up when her brothers burst into the room. They slammed the door and locked it. One of the girlfriends covered the bride's face with chiffon. A crowd turned into the street. The boys stood guard as someone knocked insistently from outside. They playfully demanded money in exchange for opening the door. When the latch was drawn back, Ali appeared dressed like a sultan in a striped turban and black linen robe embroidered with gold thread. A hired sword tied to his waist got in the way as he stepped close to Tima, who was breathing fast and tightly clutching a small beaded purse in her lap. Ali lifted off the veil and reached for her right hand. They shook and the marriage was sealed. He sat down and she

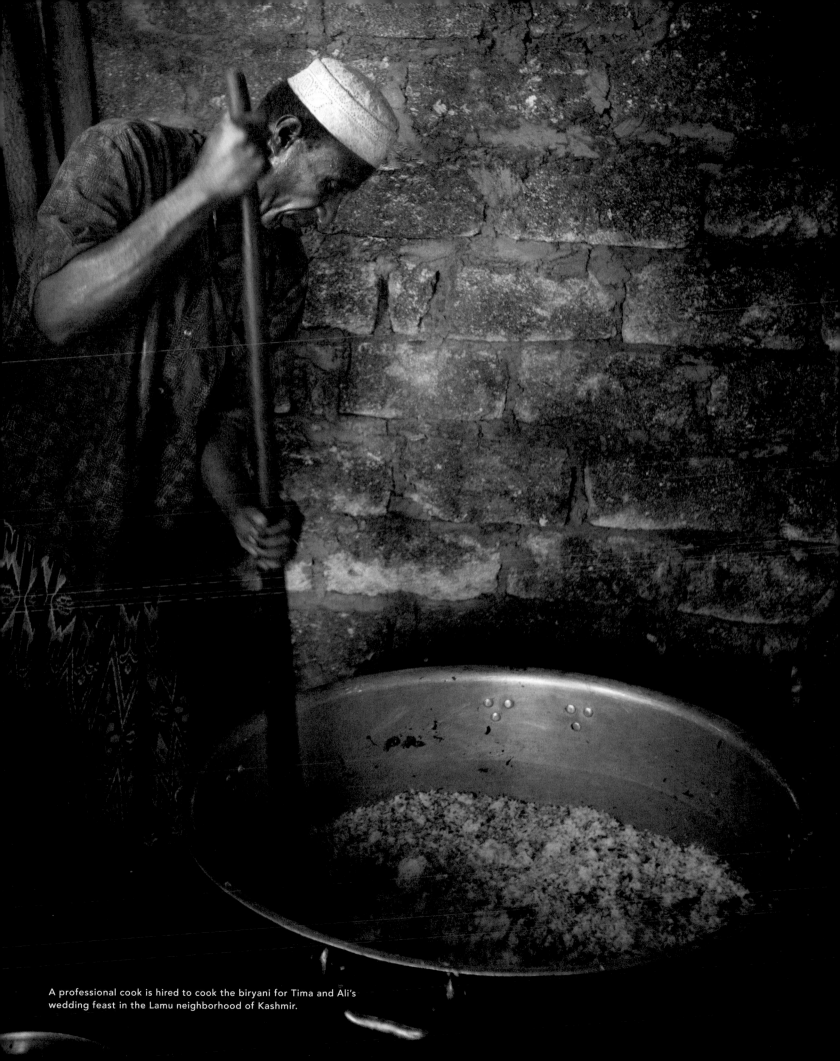

A professional cook is hired to cook the biryani for Tima and Ali's wedding feast in the Lamu neighborhood of Kashmir.

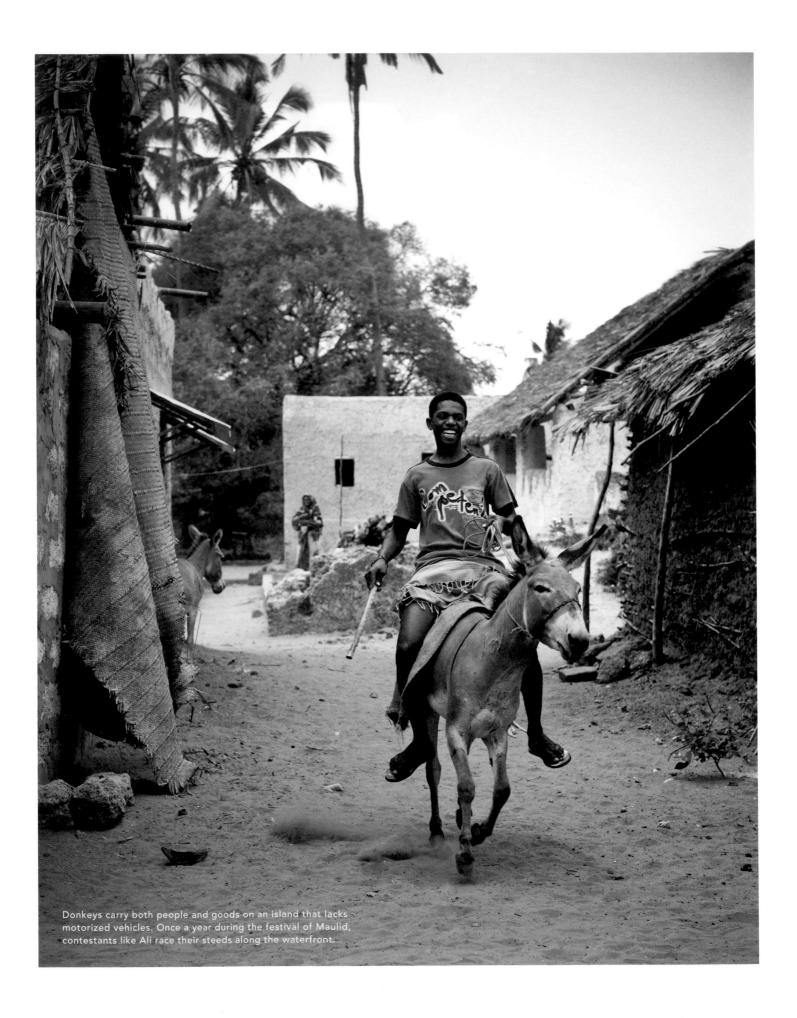

Donkeys carry both people and goods on an island that lacks motorized vehicles. Once a year during the festival of Maulid, contestants like Ali race their steeds along the waterfront.

threw her hennaed arms around his neck, hiding her teary face against his shoulder as guests sang outside. Family members poured in to chant congratulations.

The lack of fresh air made me dizzy. I stepped over the pile of sandals at the door and stood in the courtyard. Newspapers were laid on the foyer floor, and in the kitchen alcove, a hired cook boiled water for rice in a cauldron. A cow had been butchered. It must have cost the two families a small fortune. Rahamah, wearing a new cotton *kanga* dress and matching headscarf, was busy washing, tidying up, and pushing curious children away from the fire. She paused to hand me a cup of mango juice and a cardamom-scented fritter. The men squatted on the newspapers and poured thermoses of hot arabica coffee into their mugs.

Half of Kashmir filled the courtyard when the cook finally ladled *biryani* and lime pickle onto large metal platters. I carried two back into the bridal bower, where Tima had changed into a loose blue caftan. Her hair was unbound and elaborate makeup removed. Ali had peeled off his black robe and replaced the turban with a *kofia*. We sat on the beds with the meal in our laps. The stew was intensely spiced with clove and cinnamon. I would still reek days later. It oozed from my pores and unsettled my bowels but broke the fever at last.

I wanted to know when Tima would return to her secretarial job. She waved proudly at her new husband.

"You must ask Ali that."

Lunch at an end, the men departed. Someone turned on a boom box and East African *taarab* music blasted into the bedroom. Tima's girlfriends appeared in the doorway and pulled her away from Ali. Outside, the women were dancing. An older woman gave me a calculated look and undulated her hips. Everyone turned to watch. I shimmied back. Swiftly, they gathered in a circle around us, roaring with laughter as I tried to keep up with the old lady.

"That's my grandmother!" Tima exclaimed.

Tima's nosy brothers peeked around the corner from the alley but were shooed off. These women who spent their days sweeping bare earth floors and wiping snotty noses and washing clothes by hand were having a moment. Even Tima's mother smiled. My feet were filthy again and sweat ran down my spine. Out of breath, Rahamah placed her hand over her heart, repeating the word *rifiki* several times.

"She says you are her friend now," translated Tima.

Rahamah and I left together. Donning her black *bui bui*, she hummed happily. As the last piece of chiffon buttoned over her wide smile, only golden eyes remained visible. Following outside, my uncovered face flushed as we made our way into Old Town. Reaching the waterfront, we walked side by side a while longer, jostled by the crowd of early evening shoppers. Momentarily distracted, I turned my head. Just as quickly, I looked back again, to find that I had lost her in a sea of veils.

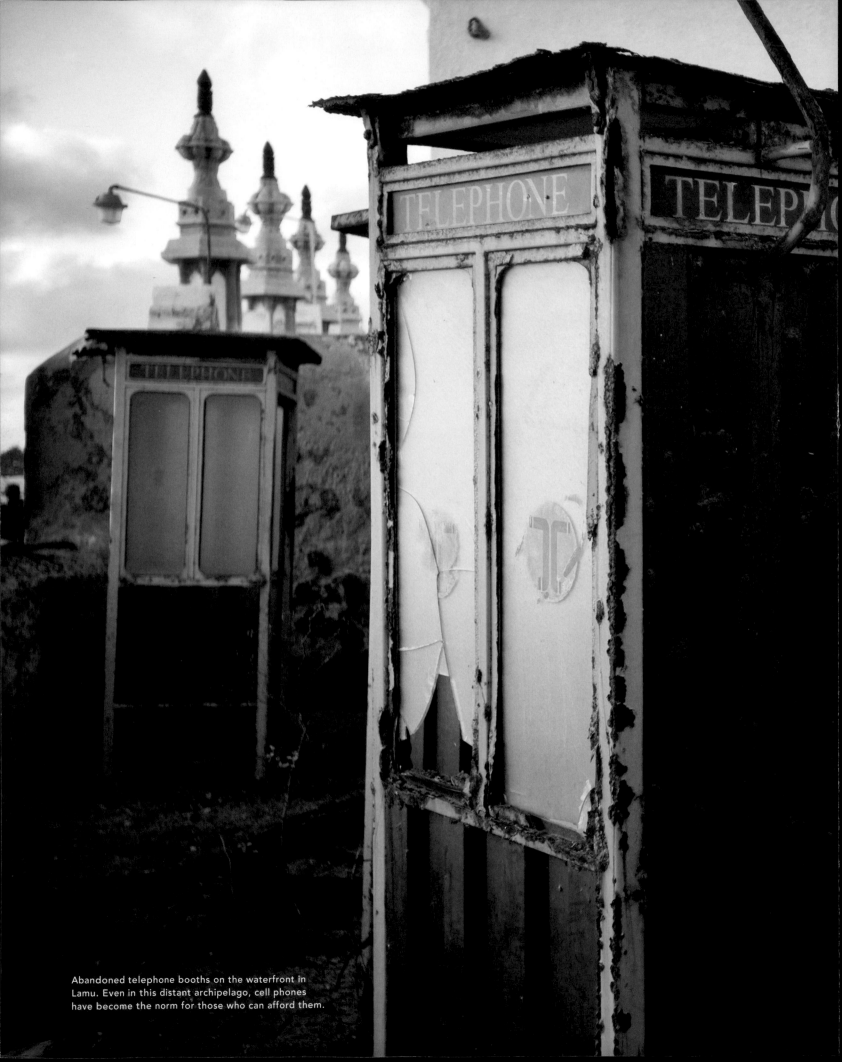

Abandoned telephone booths on the waterfront in Lamu. Even in this distant archipelago, cell phones have become the norm for those who can afford them.

SAMAKI WA KUPAKA / RED SNAPPER CURRY

SERVES 2 TO 4

Swahilis use a *jiko*, or charcoal-burning portable stove, to prepare daily meals at pop-up snack stands and in home kitchens. A Mombasa housewife, Lela Abdulaziz, whose family owns a spice stall in the Old Town's main market, taught me to make this version of red snapper curry. African bird's eye chile, called *piri piri* in Swahili, gives this dish extra heat. You can find both bottled *piri piri* sauce and crushed chiles at specialty grocers (see Sources, page 294) or order seeds and grow your own.

1½ to 2 pounds whole red snapper, gutted, or boned fillets, if preferred

MARINADE

4 cloves garlic

1 to 2 ripe red piri piri, bird's eye, or similar chile, seeded and chopped

1 green bird's eye chile, seeded and chopped

3 tablespoons minced fresh ginger

½ teaspoon freshly ground black pepper

⅓ cup fresh lime juice

SAUCE

1 cup unsweetened, first pressing, canned coconut milk

1 tablespoon turmeric

1 teaspoon coarse sea salt

1 tablespoon tomato paste

1 teaspoon fresh minced cilantro

2 tablespoons tamarind concentrate

Place the fish in a shallow dish. Cut ⅛-inch-deep slits crosswise into the skin.

To make the marinade, combine the garlic, chiles, ginger, pepper, and lime juice in a food processor or blender and process until smooth, 1 to 2 minutes. Generously coat the fish with the marinade, cover, and refrigerate for at least 1 hour.

To make the sauce, combine all the sauce ingredients in a pan and simmer for 5 to 10 minutes. This can be prepared while the fish is marinating and reserved.

Build a medium-hot fire in a charcoal grill or heat a gas grill to medium-high. Wipe excess marinade from fish with paper towels and brush generously with the sauce. Transfer to the grill. (A grilling basket will help prevent fish from sticking to the grates.) Sear on one side, and then flip carefully, basting again with the sauce, until cooked through, 15 to 20 minutes. Transfer the fish to a platter and serve with coconut rice (page 108).

KUKU WA ROJO / CHICKEN IN SAUCE

SERVES 2 TO 4

In the fishing village of Kipangani, on the island of Lamu, the chicken (*kuku*) is a productive member of society. Serving it for dinner means an important guest has arrived. Rahamah Mohammed and her daughters grind the sauce for this rich stew, including potent black peppercorns from Zanzibar, by hand with a mortar and pestle.

2 cloves garlic

1 to 2 tablespoons freshly ground black pepper

1 red bell pepper, stemmed, seeded, and sliced

½ red onion, chopped

2 ripe tomatoes, chopped

1 whole chicken, cut into pieces, or 6 drumsticks and thighs

1 red onion, halved and sliced into rounds

3 tablespoons safflower oil

¼ cup tomato paste

2 tablespoons curry powder

2 cups cold water

Coarse sea salt

In a food processor or blender, combine the garlic, black pepper, red bell pepper, chopped red onion, and 1 of the tomatoes and process until it forms a paste.

In a Dutch oven or deep saucepan over medium heat, brown the pieces of chicken on all sides and continue cooking until the juices are released, about 20 minutes.

In a frying pan, sauté the sliced red onion in the oil over low heat. Add the garlic-pepper mixture and continue to cook. Stir in the tomato paste and remaining tomato. Add the curry powder. Allow to thicken slightly.

Transfer the paste to the Dutch oven. Pour in the cold water. Cover with a lid and simmer for 30 minutes, then cook uncovered until the sauce is reduced by half, about 10 minutes more. Season with salt to taste. Serve with coconut rice (page 108).

COCONUT RICE

SERVES 2

Most Swahili kitchens would be lacking without a cylindrical *kifumbu*, made of loosely woven palm frond, which is used to strain milk from freshly grated coconut, a staple of life on Africa's East Coast. Before I left Lamu, the fisherman Amir gave me one as a parting gift. Of all the ways rice can be prepared, this version, simmered in coconut milk with crushed spices, is one of the most memorable.

2 cloves
2-inch piece of cinnamon bark
Pinch of cumin seeds
Pinch of coriander seeds
3 or 4 cardamom pods
2 or 3 star anise
1 cup basmati rice
1½ to 2 cups unsweetened, first pressing canned coconut milk

In a mortar or spice blender, crush the spices slightly to release their oils.

Rinse the rice in 2 or 3 changes of cold water to remove starch. Drain thoroughly. In a saucepan, combine 1 cup of the coconut milk with the rice. Stir once to even out the rice. Top with the spice mixture; do not blend it into the rice. Cover partly and cook over low heat until the liquid is absorbed, about 10 minutes. Turn off the heat, add ½ cup more coconut milk without stirring, and continue to steam with the lid firmly on until the rice grains separate, 10 to 15 minutes more. The rice grains should be dry, not sticky, to the touch. With a spoon, scrape off the spices and discard. Use a fork to fluff the rice and add the remaining ½ cup coconut milk if a creamier consistency is desired. Serve immediately.

ACHARI YA NDIMU / LIME PICKLE

MAKES ABOUT 2 CUPS

The ladies of Matondoni, a village on the island of Lamu, are famous for their pickles. They must be ordered up to a month in advance for special occasions like a Swahili wedding. Tangy *achari ya ndimu*, or lime pickle, is similar to versions found in Mombasa and other outposts where Indian immigrants have settled. (*Achaar* is the Hindi word for "pickle." Swahilis similarly call these highly spiced condiments, made with fruits or vegetables, *achari*.) To macerate properly, the mixture is left out in the hot African sun. After eating this Swahili pickle at Tima and Ali Mohammed's wedding, I bought a jar in a Lamu restaurant to bring home.

1½ pounds Key limes (about 28)
6 fresh *piri piri* or bird's eye chiles (3 red, 3 green)
3 tablespoons turmeric
3 tablespoons chile powder
¼ cup coarse sea salt
½ cup lime juice

In a large saucepan, boil sufficient water to cover the limes, then turn off the heat.

Wash the limes and add to the hot water to soften for about 5 minutes. Drain the limes and dry with a kitchen towel. Cut into quarters and place in a nonreactive container or plastic tub.

In a food processor, combine the chiles, turmeric, chile powder, and salt. Slowly add the lime juice while pulsing until the chiles are completely chopped and the mixture forms a loose paste. Add the paste to the container with the limes and mix well. Seal the container. Keep it out in the sun to ripen.

Stir or shake the pickles every 2 days. Depending on the climate or season, it takes up to 20 to 30 days for the pickles to set. Can be stored in the refrigerator up to 6 months.

KAHAWA / COFFEE

SERVES 1

The social interaction around the first and last cups of the day at pop-up coffee stands in Mombasa or Lamu is a delight. Vendors typically brew highly spiced, aromatic arabica or Kenya beans in old-fashioned urns, pouring coffee into ceramic cups for their regulars, who take tiny sips and watch the world rush by. It's always served black, no milk or sugar necessary.

SPICE BLEND
1 teaspoon ground ginger
1 teaspoon ground cinnamon
1 teaspoon ground cloves
1 teaspoon ground cardamom

Blend all the spices in a container, reserving extra for later use. Add 1 teaspoon spice blend for each 2 tablespoons of ground coffee during the brewing process. This is best made in a filter drip or French press coffeemaker.

MANDAZI / CARDAMOM DOUGHNUTS

MAKES ABOUT 12

These pillowy, cardamom-infused doughnuts are a breakfast staple in Mombasa's Old Town. Many small bakeries offer them hot out of the fryer, along with tiny cups of intensely spiced arabica coffee (page 110) or chai. When I was handling the dough, Isaac, the cook who taught me how to make *mandazi*, said, "Roll faster, roll faster! They won't puff up!"

¼ cup water

5 tablespoons demerara sugar

¼ ounce (1 packet) active dry yeast

2 cups flour, sifted, plus more for rolling

2 teaspoons ground cardamom

Pinch of salt

¾ cup coconut milk

2 cups safflower oil

Confectioner's sugar, for dusting (optional)

In a small bowl, stir together the water, 1 teaspoon of the sugar, and the dry yeast. Allow to rest until the mixture bubbles and activates.

In a separate bowl, combine the flour, cardamom, the remaining sugar, and salt. Add the coconut milk and the yeast mixture, blending swiftly. Cover with a cloth and set aside at room temperature for up to 6 hours, or overnight. The dough will double and rise.

Dust a clean cutting board with more flour. Quickly knead the dough, adding a small amount of flour if necessary, so the ball won't stick. Roll out to ½-inch thick. With a pastry cutter or knife, slice into triangles or rectangles. Allow to rest for 15 minutes, until the dough rises again.

Heat the oil in a heavy-bottomed skillet or wok. Without crowding, fry the *mandazi* until golden brown on each side, about 1 minute. Drain. Dust with confectioner's sugar, if desired. Serve hot.

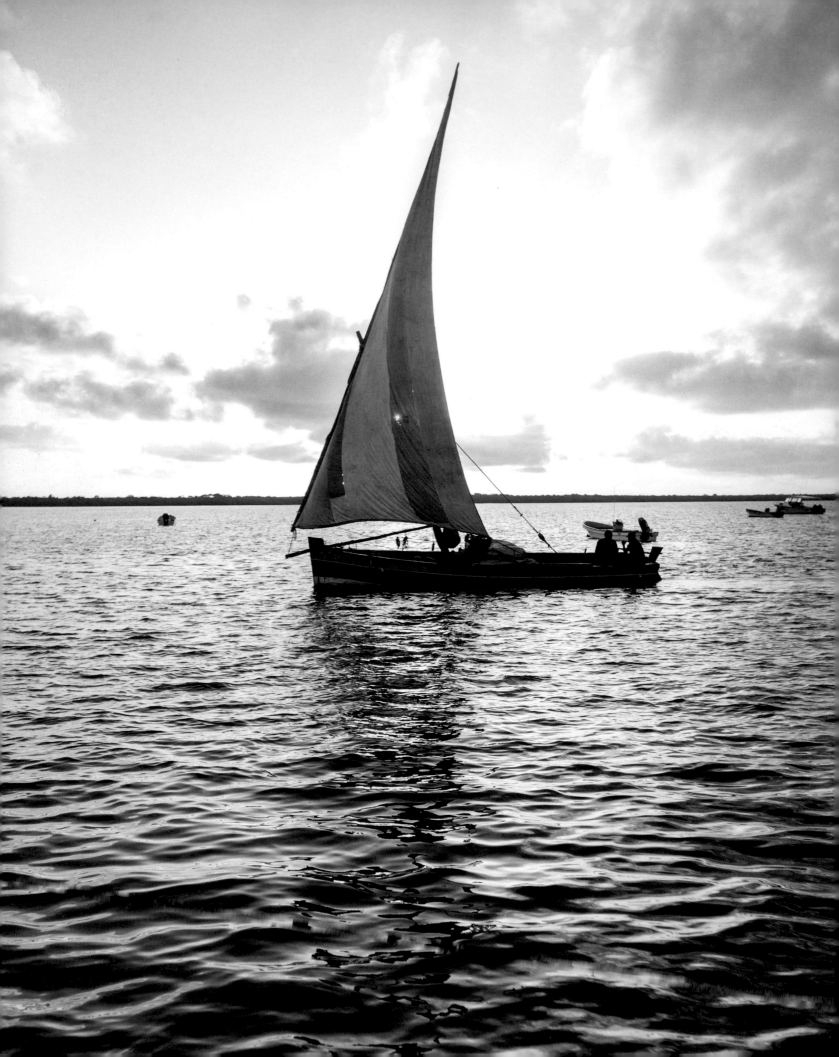

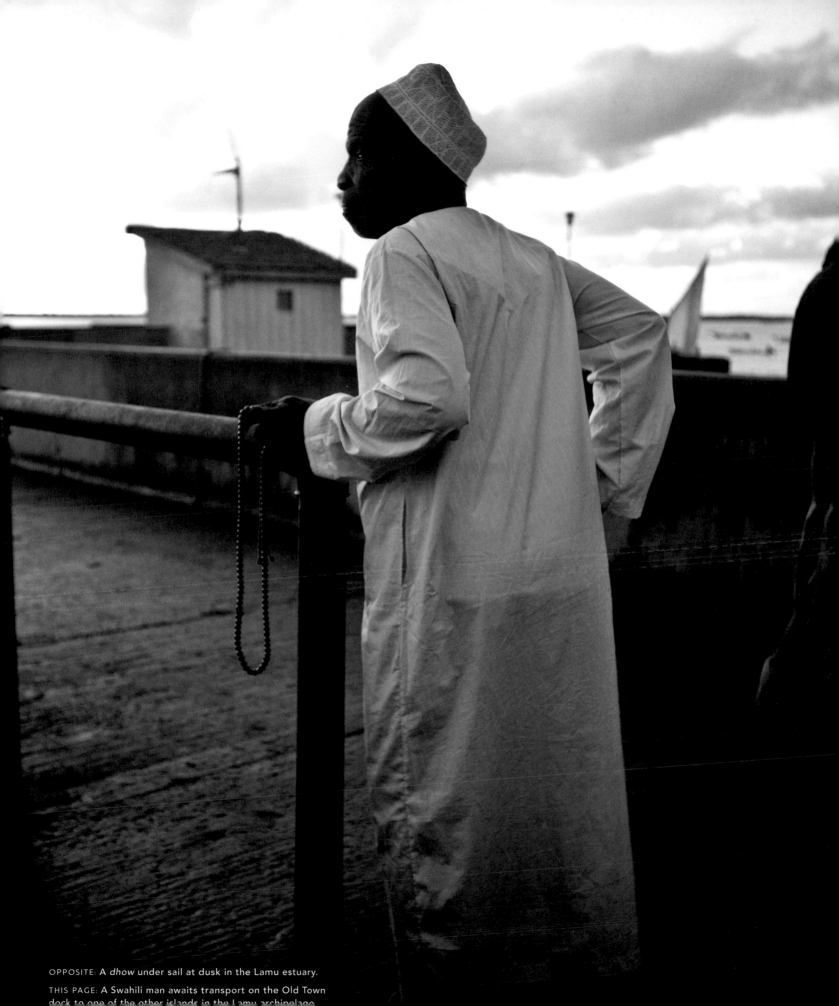

OPPOSITE: A *dhow* under sail at dusk in the Lamu estuary.

THIS PAGE: A Swahili man awaits transport on the Old Town
dock to one of the other islands in the Lamu archipelago.

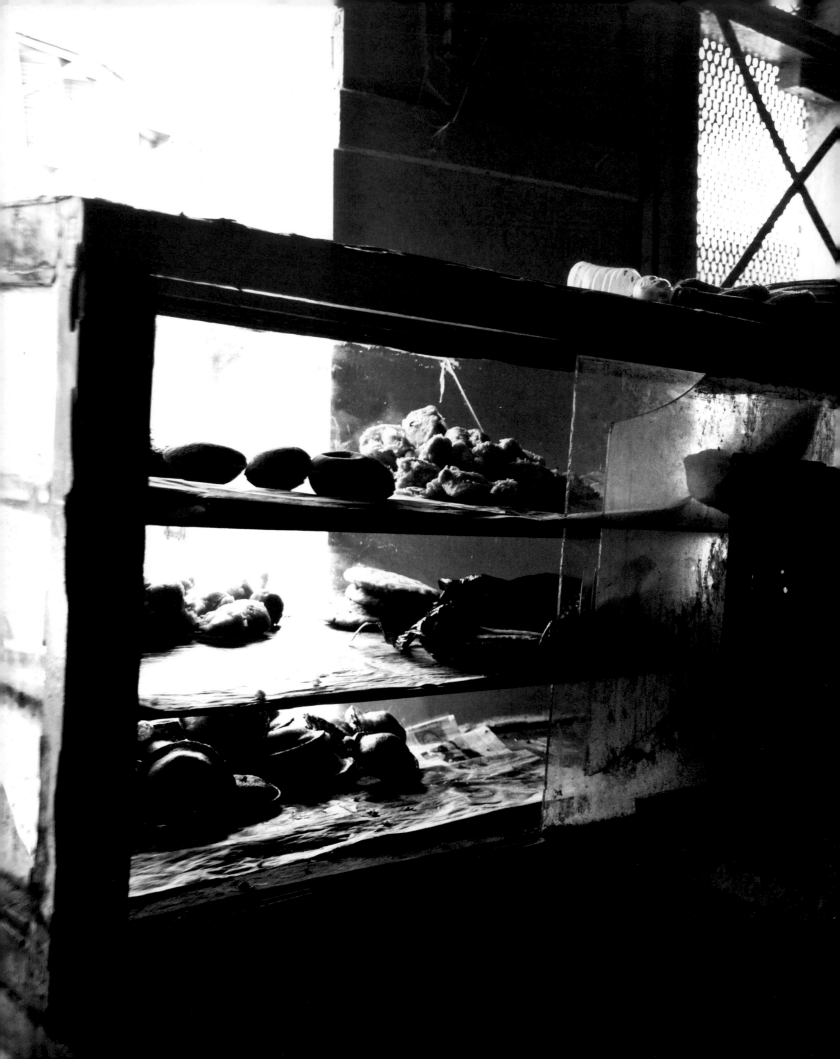

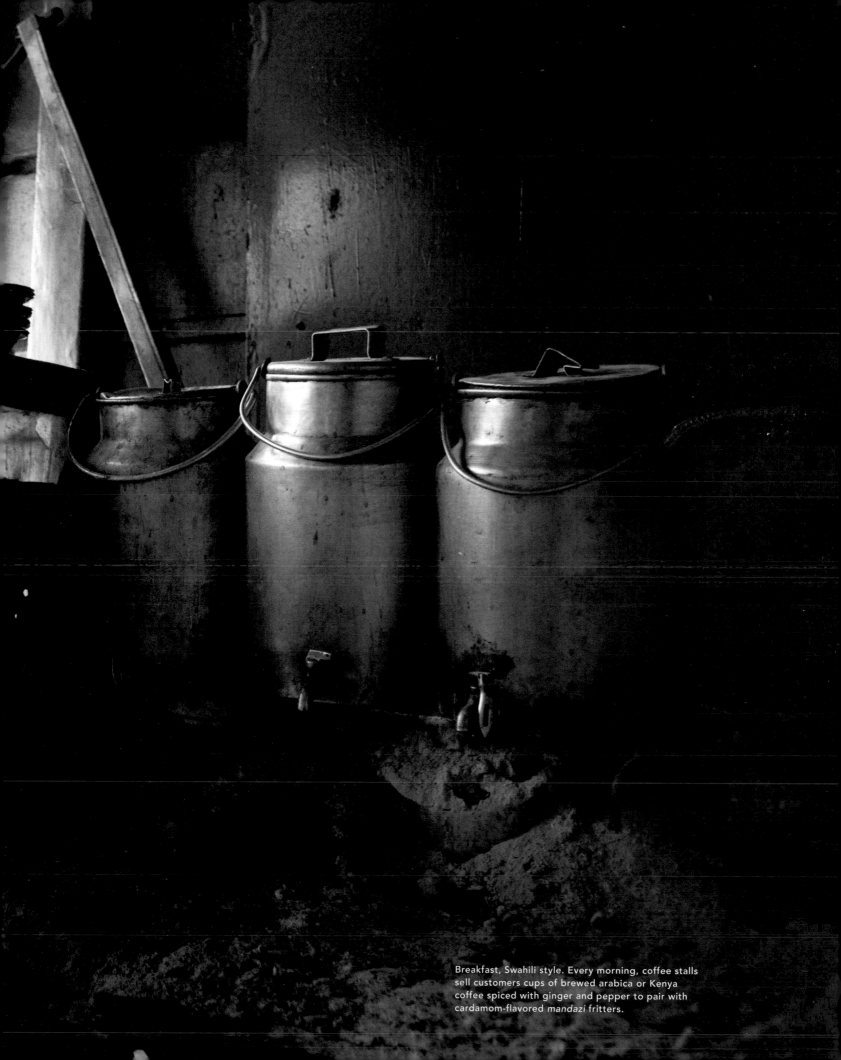

Breakfast, Swahili style. Every morning, coffee stalls sell customers cups of brewed arabica or Kenya coffee spiced with ginger and pepper to pair with cardamom-flavored *mandazi* fritters.

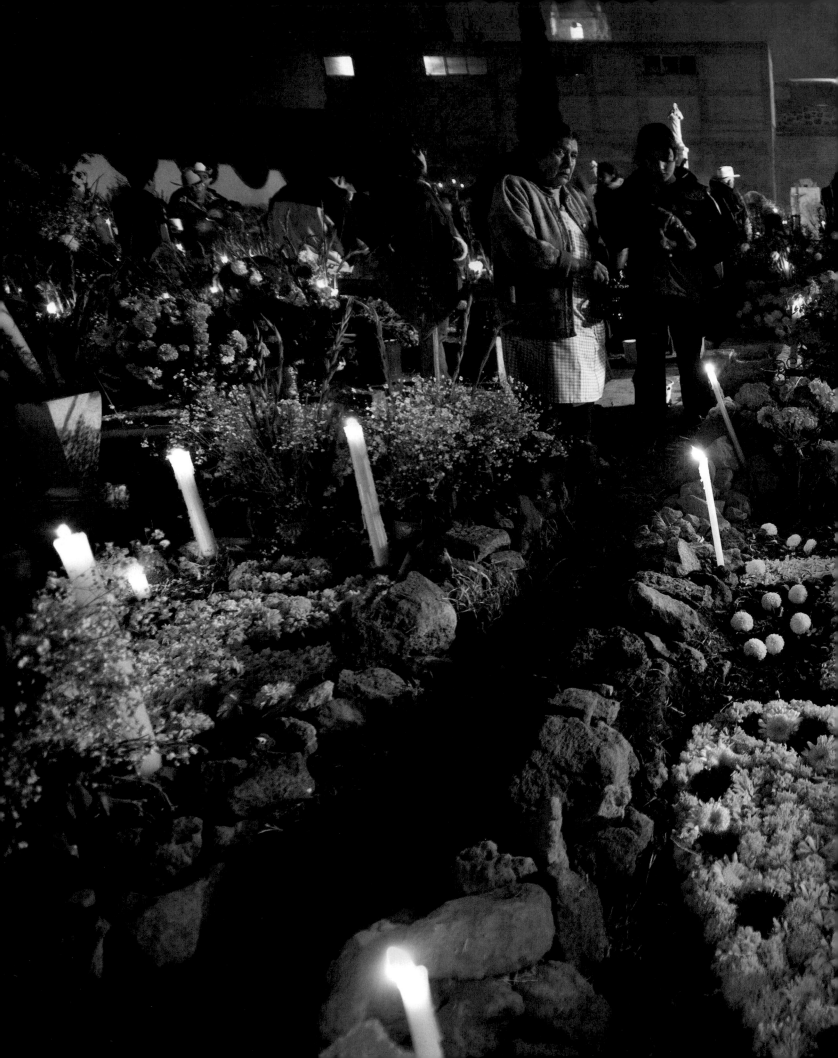

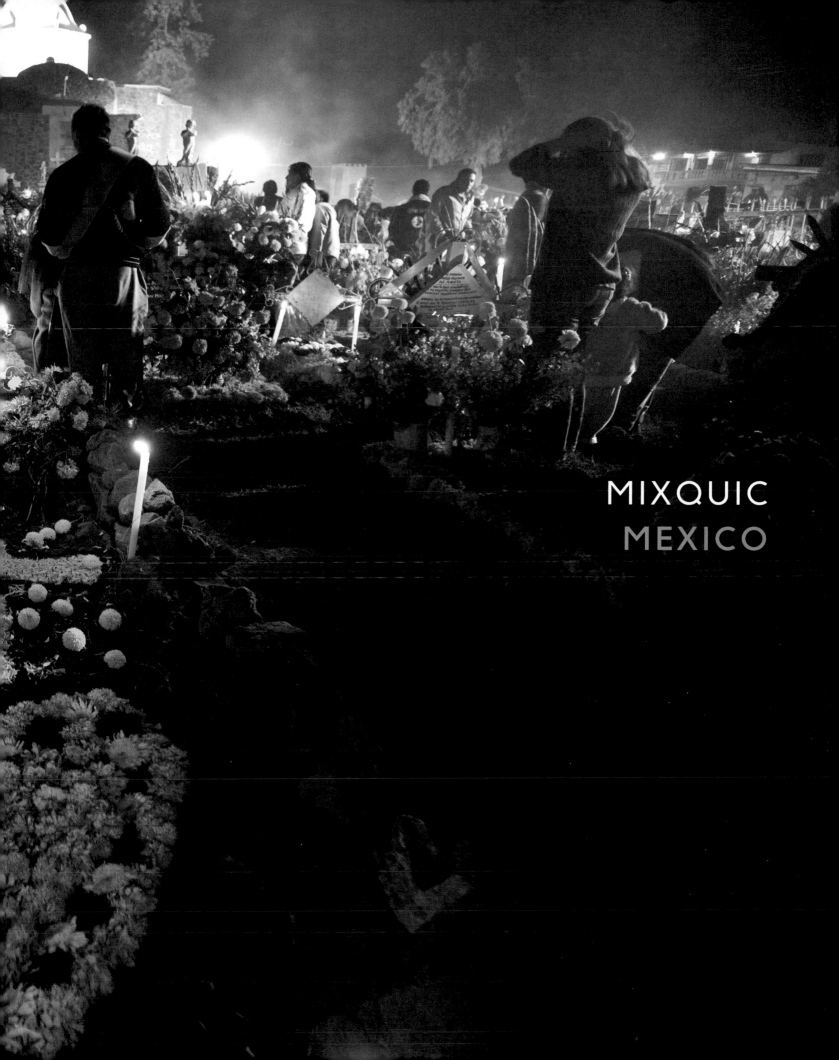

MIXQUIC
MEXICO

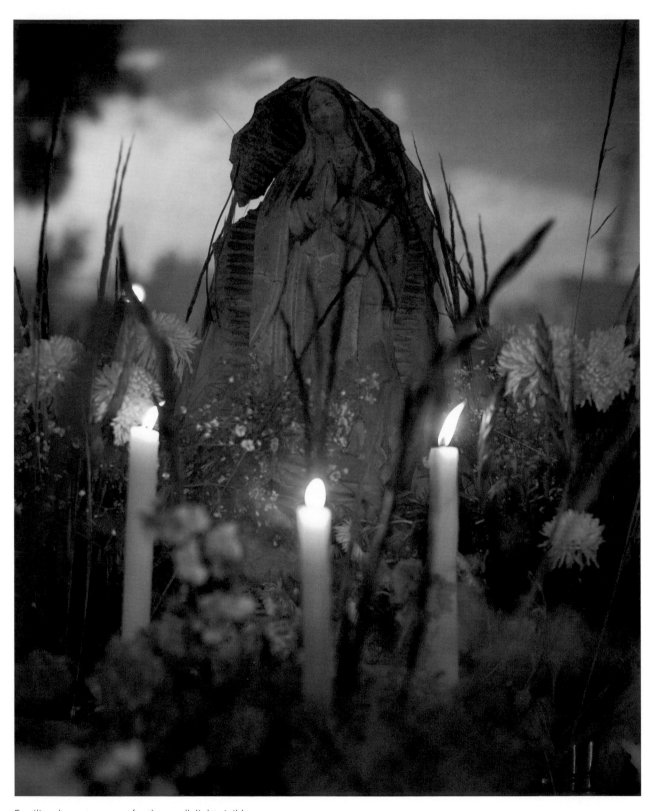

Families decorate graves for the candlelight vigil known
as *La Alumbrada* during Day of the Dead in Mixquic.

KAKI / DEPARTED SPIRIT

Mixquic, Mexico

In the streets leading toward the Church of San Andrés Apóstol in the village of Mixquic, an hour southeast of Mexico City, vendors tempted the festive crowd with the hominy rich stew *pozole*, radishes, fried grasshoppers, and pillowy *pan de muertos*, Spanish for "bread of the dead," a sweet holiday treat. Children laughed around me, begging for cotton candy and sugar skulls. Mariachis strummed guitars. The sun was setting as everyone proceeded through the gates of the churchyard's walled cemetery.

On the Day of the Dead, the veil between the worlds of the deceased and the living becomes more transparent; only then may spirits press against that elastic fabric to savor the essence of tequila poured into a glass or a cigarette burned to ash. To mark the way from Mictlan, the Aztec underworld, families across Mexico create *ofrendas* (altars) piled with spices, black beans, tamales, and other favorite foods that serve as earthly signposts for the departed and help everyone else evoke endearing details that might otherwise be lost.

"You know I can talk to them?" Kaki once said, grinning wickedly. "Mostly Nana. But never Mom; I shut her down." I believed her—spooky runs deep in my family. She took it to a professional level, by way of energetic healings and house clearings. Now and then, she would wave a hand in the air, as if to shoo away some invisible but persistent presence. On darker days, she drew demons. She had a complex about being the younger sister. Her brown hair was kinky and uncontrolled, and she loved even wilder wigs, especially on Halloween. She was afraid of thunder but not much else. Kaki wore a red leather biker jumpsuit and rode a Kawasaki crotch rocket to Daytona Bike Week. She sailed frostbiters and earned her scuba certification. And then her husband bought the twin engine plane.

Inside the cemetery, families sat bundled next to headstones covered with marigolds during the candlelight vigil known as *La Alumbrada* (The Illumination), awaiting the return of their lost loved ones. Weaving around the graves late into the chilly November night, adrift and hoping for God knows what, I was invited to slug mescal from a communal bottle by cheerfully drunk brothers. Another family shared *pan de muertos*. It was coarse and chewy, with a dusting of sugar on the brown crust. One of the daughters was near to tears. Her sister had died almost four years before.

"It takes that long for them to reach Mictlan," she said.

I hugged her.

The path to the underworld is fraught; departed souls must pass many challenges: the crossing of obsidian-sharp mountains, freezing gorges, a river of blood. Fearsome jaguars and lizards lurk along the way. With these obstacles surmounted, however, they are permitted to visit with mortals again.

Mexicans have always poked macabre fun at death in their art, literature, and music. Few other countries have this intimate relationship with the most mysterious aspect of the cycle of life. The Aztec goddess Mictecacihuatl was keeper of the bones in the underworld and presided over festivals of the dead. With the arrival of Catholic missionaries, these celebrations received a Christian overlay, and became syncretically aligned in the Gregorian calendar with All Souls Day. Mictecacihuatl didn't perish; she transformed. In the early twentieth century, cartoonist José Guadalupe Posada created a series of satiric engravings depicting dandified *calavera* (skeletons), including one wearing an extravagant bonnet. La Calavera Catrina, or the Lady of Death, was further celebrated by Diego Rivera in a mocking mural titled "Dream of a Sunday Afternoon in Alameda Park." Now, this animated skeleton is depicted humorously in all art forms—from papier-mâché to sugar—related to Day of the Dead. And when grief overwhelmed me, I came to Mixquic, whose stone church and graveyard were built atop a sacred Aztec precinct, seeking ways to communicate with *la chiquita muerta*.

<p style="text-align:center">✳</p>

Kaki loved junk food: processed cheese-stuffed pretzels, Spam pizza, a hypercaffeinated cult soda called Jolt Cola. (Her email address was "Jolt Beyond.") I used to give her grief for all the empty wrappers tossed in the backseat of her car. When our father was battling cancer, she would turn up on his doorstep unannounced, to sneak him out for chili dogs and pulled pork barbecue, instead of the healthy crap his second wife subsisted on. When Kaki gave the rest of us a prized family recipe at our last Christmas dinner together, complete with

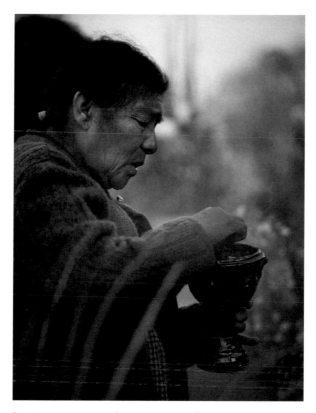

Burning aromatic copal incense on an *ofrenda* (altar) is believed
to guide spirits back to their loved ones.

instructions received from our departed mother in the hereafter, I laughed so hard reading it aloud that my mascara ran. She sat there beaming back.

The first *ofrenda* I ever made held Kaki's battered teddy bear, a medicine bag she beaded herself, and candy corn in a papier-mâché devil I found when cleaning out her house after the plane crashed.

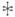

A stinging fog of copal incense rose from clay burners to swirl eerily around our heads. Most celebrants settled down for the night, huddled in blankets, the sounds from the street slowly dying away as the *taquerías* closed. And before dawn, when the church bells chimed, throughout Mixquic, the aromas and flavors of proffered food faded as phantom travelers, sated, fled once again into the mystic.

"Come back," I whispered. "Come back."

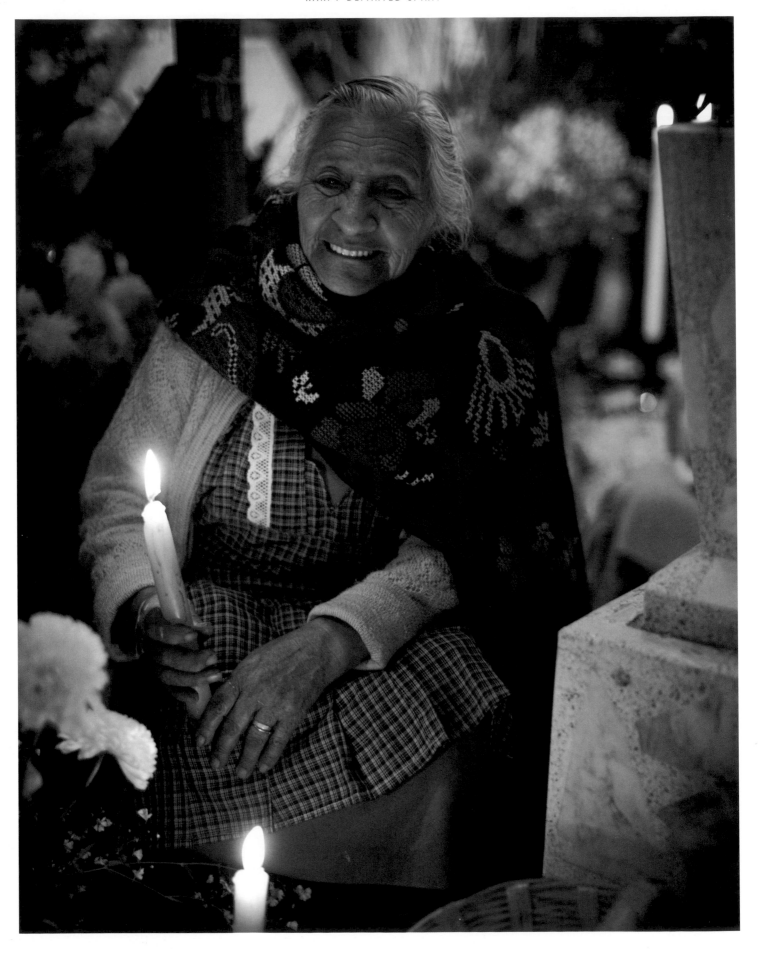

Waiting for spirits to return, families lay out their favored foods; the most basic altars include water to quench thirst, salt for seasoning, and bread for nourishment.

BARBACOA DE CONEJO / GRILLED RABBIT

SERVES 2

Modest *barbacoa* restaurants line a stretch of highway leading to Valle de Chalco, an outlying district southeast of Mexico City. Just before Day of the Dead, artist David Mecalco took me there for lunch after visiting his studio, where he paints *retablo*, or devotional portraits, inspired by the prostitutes and *lucha libre* wrestlers who hang out in his neighborhood's bars. The special that day was rabbit. (Coincidentally, *Centzon Totochtin*, or 400 Rabbits, are the Aztec deities associated with drunkenness.) This far out of the city, the greater urban sprawl gives way to dirt roads and wheat fields along the lower slopes of the twin volcanoes Popocatépetl and Ixtacihuatl. The wild-caught rabbit, basted with a smoky chile marinade, was seared on a grill above a pit of hot coals. I still have the lucky rabbit's foot that our waiter presented with the bill. You can find dried Mexican oregano and ancho and guajillo chiles online (see Sources, page 294) or from Latin American grocers. Rabbit is available from specialty butchers.

1 to 2 cups mesquite wood chips

MARINADE
5 dried guajillo chiles, stemmed and seeded
3 dried ancho chiles, stemmed and seeded
2½ cups water
2 tablespoons plus 2 teaspoons apple cider vinegar
1 medium tomato, cut into quarters
½ medium onion, coarsely chopped
1 large clove garlic, chopped
½ tablespoon dried Mexican oregano
¼ teaspoon ground cinnamon
¼ teaspoon whole cumin seeds
¼ teaspoon freshly ground black pepper
3 whole cloves, stems removed
1¼ teaspoons coarse sea salt
1 teaspoon brown sugar

1½ teaspoons safflower oil
2½- to 3-pound rabbit, dressed

In a bowl, soak the mesquite wood chips in enough water to cover for up to 4 hours.

To make the marinade, heat a large, dry skillet over low heat. Add the guajillo and ancho chile peppers and toast for 20 to 30 seconds per side, taking care not to burn them. Add the water and cook for 12 to 15 minutes more over medium heat, until the peppers have softened and rehydrated.

Transfer the peppers to a food processor or blender. Add 2 cups of their cooking liquid and the vinegar, tomato, onion, garlic, oregano, cinnamon, cumin, black pepper, cloves, salt, and sugar. Puree until smooth.

In a medium saucepan, heat the oil over low heat for 1 to 2 minutes. Stir in the pureed marinade. Partially cover, and cook for 10 to 12 minutes, stirring occasionally, until the color darkens and the mixture thickens to a paste.

Rinse the rabbit and pat dry with paper towels. Place in a large sealable bag or shallow baking dish. Use sufficient marinade to cover completely, rubbing the mixture into the meat. Cover and refrigerate for at least 2 to and up to 24 hours. Reserve any remaining marinade for later use.

In a kettle grill, build a charcoal fire to one side, and then toss a handful of the soaked mesquite onto the hot coals. If using a gas grill, place the wood chips in foil on the grating. (This method, which is yet further removed from traditional *barbacoa* pit barbecuing, will yield less smoky meat.) Lay the rabbit on the grill, away from the immediate heat, and cover, adjusting the air vent to draw smoke across the meat. Grill on one side for 15 to 20 minutes, then turn and grill the other side for another 15 to 20 minutes. Add more wood chips for additional smoky flavor. Baste with more marinade if desired. The meat will develop a nice char. Remove and allow to rest before quartering. Serve with warm corn tortillas, black beans (page 126), and salsa verde (page 128).

FRIJOLES NEGROS / BLACK BEANS

SERVES 4

Setting a pot of *frijoles negros* to simmer for hours on end, as the dried beans absorb the flavors of chiles, herbs, stock, and a generous chunk of salted pork, is its own act of remembrance during Day of the Dead. Epazote, a perennial herb native to Latin America, is the secret ingredient to this dish. The name derives from the Nahuatl word *epazotl*, meaning "skunk sweat." Be warned: fresh leaves can be pungent. I often substitute equally robust Mexican oregano. You can find fresh epazote at some farmers' markets. The dried variety is more readily available both online (see Sources, page 294) and from Latin American grocers.

1 cup dried black beans, rinsed

8 cups water

3 to 4 cups chicken stock (page 127)

1 dried ancho chile pepper

2 to 4 ounces salted pork belly

1 tablespoon dried epazote, or
2 tablespoons dried Mexican oregano

Coarse sea salt

Black pepper

Soak the beans overnight in the water. The next day, strain the beans and reserve the soaking liquid. In a saucepan, heat the chicken stock. Before reaching the boiling point, add the beans, chile, pork, and epazote. Reduce the heat and simmer for 3 hours, or until soft, adding the reserved soaking water, 1 cup at a time, if necessary, to keep the beans soupy. Season with salt and pepper to taste before serving.

CHICKEN STOCK

MAKES ABOUT 2 QUARTS

Whenever a chicken winds up on the table, save the bones—making stock is the best use of a picked-over carcass. Other ingredients are dependent on the desired flavor profile. A hard rind of Parmesan makes the stock creamier, lemongrass and ginger instill woodsy notes, herbs add brightness, mushrooms create depth, dried chiles imbue heat, and innards like kidneys and hearts add, well, guts. No matter what is tossed into the pot, this is the foundation for a stock that nourishes beans, soups, gravies, and stews.

1 chicken carcass, plus kidneys and heart, if available
Handful of parsley with stems attached
1 onion, quartered, with skin attached
3 or 4 cloves garlic, slightly crushed
Small bunch of thyme
Small bunch of rosemary
Small bunch of sage
Shiitake or other mushroom stems
1 carrot, unpeeled
1 stalk celery
1 or 2 dried bird's eye chiles
1 teaspoon red or black peppercorns
1 teaspoon coarse sea salt

In a large stockpot, add all the ingredients and cover with cold water. Set over low heat and simmer until the liquid is reduced by half, about 2 to 4 hours. Do not cover the pot or the stock will turn cloudy. Strain into one or more containers and discard the solids. This stock keeps in the freezer for about 3 months.

SALSA VERDE

MAKES ABOUT 2 CUPS

This is a mild salsa that complements *barbacoa*. For salsa that is a little less green, and with a fiercer flavor, add a dried ancho chile that has been softened in boiling water to the final process instead of the broiled jalapeño.

4 or 5 large tomatillos, husked
1 large jalapeño, seeded, cored, and halved
3 or 4 large cloves garlic
½ cup chopped fresh cilantro
¼ cup olive oil
½ onion, chopped
Coarse sea salt

Preheat the broiler. Spread the tomatillos, jalapeño, and garlic in a pan and place under the broiler. Allow them to scorch slightly on all sides, turning occasionally, until the tomatillos turn from bright green to olive in hue, about 10 minutes. Cool, and then transfer to a food processor or blender. Add the cilantro, oil, and onion and pulse the mixture until coarsely chopped. Season with salt to taste and refrigerate until ready to serve.

XOCOLATL / HOT CHOCOLATE

SERVES 2

The Nahuatl word for chocolate is *xocolatl*, referring to the beverage made from roasted cacao beans tempered by hand with a *metate* stone and then mixed with hot water. Some Mesoamericans still prefer their chocolate on the bitter side. Every visit to Mexico is the chance to buy dark bricks or disks of chocolate. Mayordomo is a basic commercial brand from Oaxaca, but recently my palate has also shifted away from sweetened varieties, as regional chocolatiers like Ki' Xocolatl in Merida have started to produce bars with more intense flavors. You can find Mexican chocolate online (see Sources, page 294). Originally a ceremonial drink, a frothy mug of chocolate now starts the day.

4 ounces bittersweet or unsweetened chocolate, chopped
¼ teaspoon chile powder
¼ teaspoon ground cinnamon
2 to 3 teaspoons safflower oil
2 cups whole milk
Sugar (optional)

Melt the chocolate in a double boiler over low heat. Add the chile powder and cinnamon and stir to combine. Stir in the oil to temper. In a saucepan, heat the milk until nearly boiling. Pour a small amount of milk into a mug and add chocolate to create a paste. Then add to the remaining milk, stirring until combined, about 1 minute. Add sugar, if preferred, to taste.

PAN DE MUERTOS / BREAD OF THE DEAD

MAKES 1 MEDIUM LOAF

No wonder it raises the dead. This crusty, sweet bread has tempting hints of anise and orange blossom. In Mexico, bakeries produce this sugary loaf for picnics during the graveside vigil on Day of the Dead. Sometimes the bread resembles animals or humans in shape, but it can also be decorated with strips of dough to represent the bones of the departed and topped with another knob of dough that signifies a teardrop. Still warm from the oven, smeared with butter, it is best paired with Mexican hot chocolate.

DOUGH

½ cup whole milk

1 tablespoon orange flower water

5 tablespoons raw or demerara sugar

1¼ teaspoons (1 packet) active dry yeast

2 cups all-purpose flour, plus more for rolling

½ teaspoon salt

1 teaspoon anise seeds

2 eggs, at room temperature, lightly beaten

1 egg yolk

½ cup (1 stick) unsalted butter, softened

GLAZE

1 egg white

1 tablespoon water

¼ cup raw or demerara sugar

To make the dough, warm the milk in a small saucepan to around 120°F, then add the orange flower water and sugar. Stir until dissolved. Pour the milk into a large bowl, then add the yeast and ½ cup of the flour. Mix until combined and set aside in a warm place until the mixture begins to bubble, about 20 minutes.

In a standing mixer fitted with a bread hook, combine the yeast mixture, the remaining 1½ cups flour, salt, and anise seeds. Knead at medium speed until a dough forms. Gradually add the beaten eggs and additional egg yolk and continue to knead for 5 minutes more, until smooth. Add the softened butter a few pieces at a time and knead until fully incorporated. Place the dough in a clean bowl, cover with a kitchen towel or plastic wrap, and set aside overnight until doubled in size.

On a cutting board lightly dusted with flour, knock back the dough and knead by hand for 30 seconds (it may be sticky). Form the dough into a round loaf and place on a parchment paper–lined pizza stone or baking sheet. Cover with a kitchen towel and set aside in a warm place to proof for another hour.

Preheat the oven to 350°F.

To make the glaze, whisk together the egg white and water. Brush dough with the glaze and sprinkle generously with the sugar. Transfer the loaf on the pizza stone or baking sheet to the oven and bake for 50 to 60 minutes, until golden and the bread sounds hollow when tapped on the bottom.

Remove from the oven and cool on a wire rack before serving.

SANGRITA

SERVES 6

The classic Mexican aperitif is tequila blanco, paired with a tart, peppery chaser known as *sangrita*, or "little blood." I learned to drink it this way after a visit to the Siete Leguas distillery in Jalisco. (Siete Leguas, or Seven Leagues, was the name of Pancho Villa's horse.) Authentic sangrita never contains grenadine or tomato juice, although they're not bad variations at all. And never put ice in tequila. Sip it straight, following each with this citrusy accompaniment.

2 cups freshly squeezed blood orange or Seville orange juice

¾ cup freshly squeezed lime juice

¼ cup unsweetened pomegranate juice

2 teaspoons ancho chile powder

6 to 8 dashes Cholula or other hot sauce

½ teaspoon sea salt

Combine all the ingredients in a pitcher and refrigerate until chilled. Serve in small glasses, to pair with tequila.

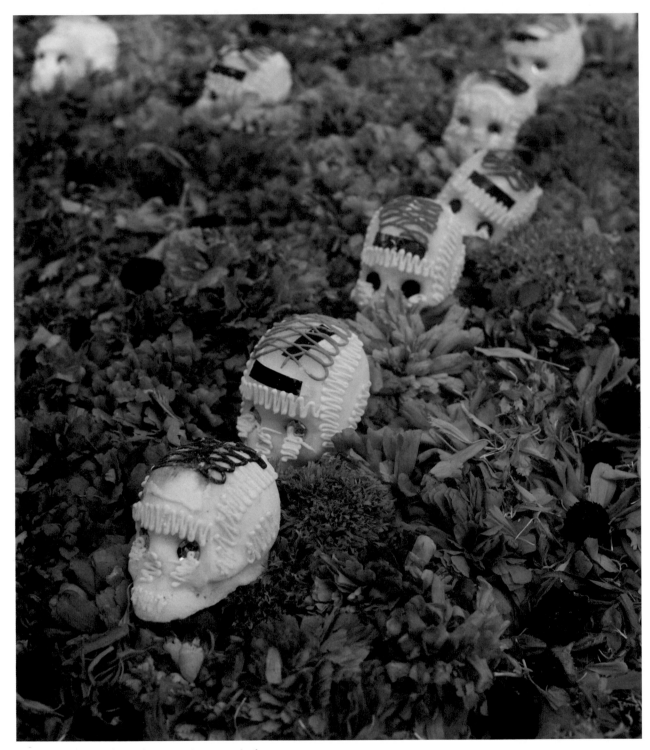

OPPOSITE: Decorated *pan de muertos* is a sweet loaf
prepared specially for Day of the Dead.

THIS PAGE: Sugar skulls rest on a bed of marigolds, called
zempoalxochitl in Nahuatl; Aztecs used them in funerary
rites and now the strongly scented petals are essential on
modern *ofrendas* as well.

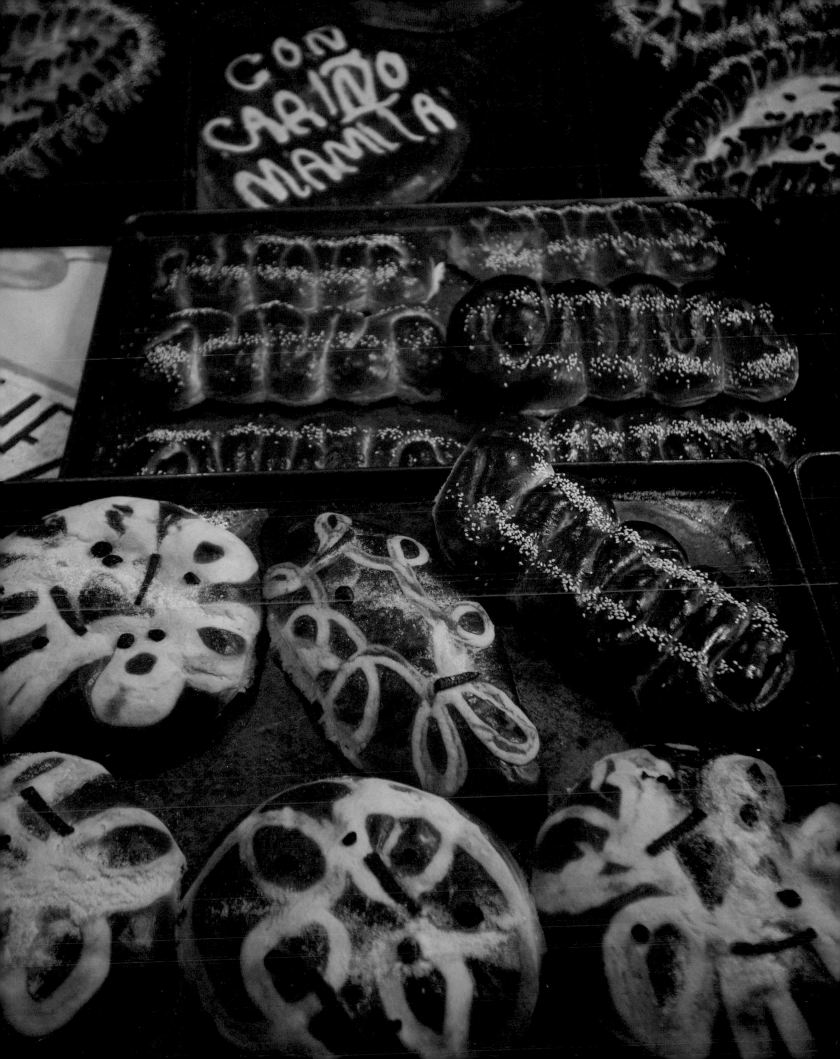

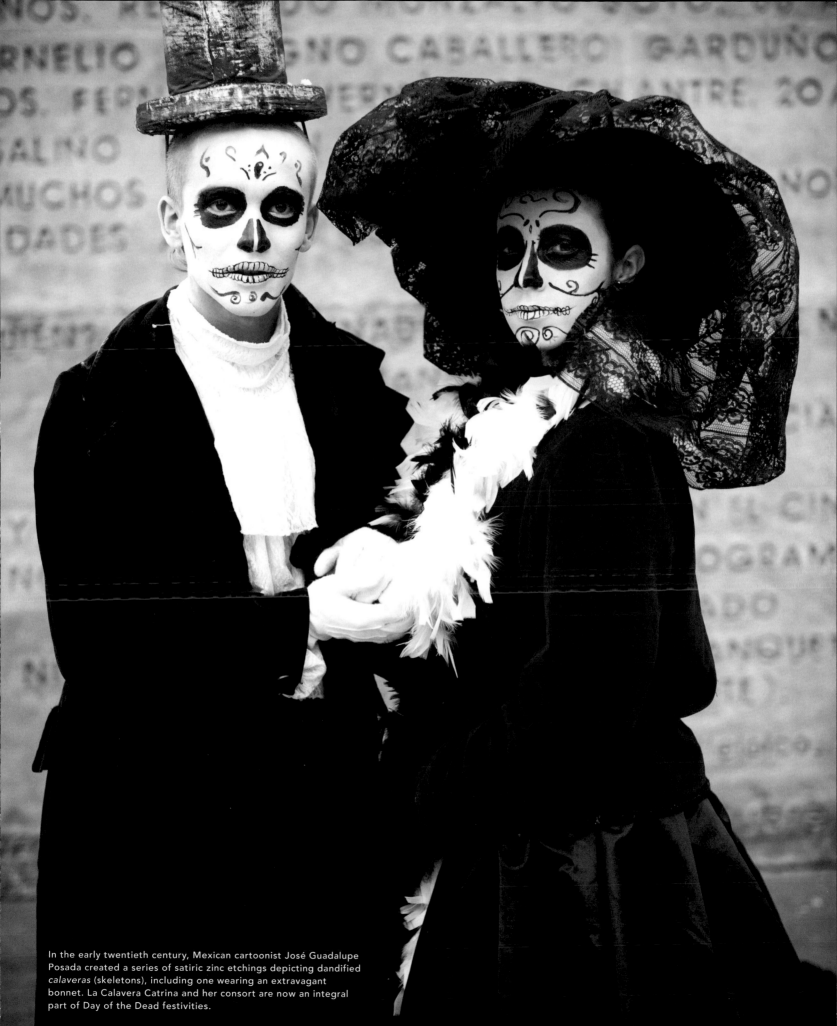

In the early twentieth century, Mexican cartoonist José Guadalupe Posada created a series of satiric zinc etchings depicting dandified *calaveras* (skeletons), including one wearing an extravagant bonnet. La Calavera Catrina and her consort are now an integral part of Day of the Dead festivities.

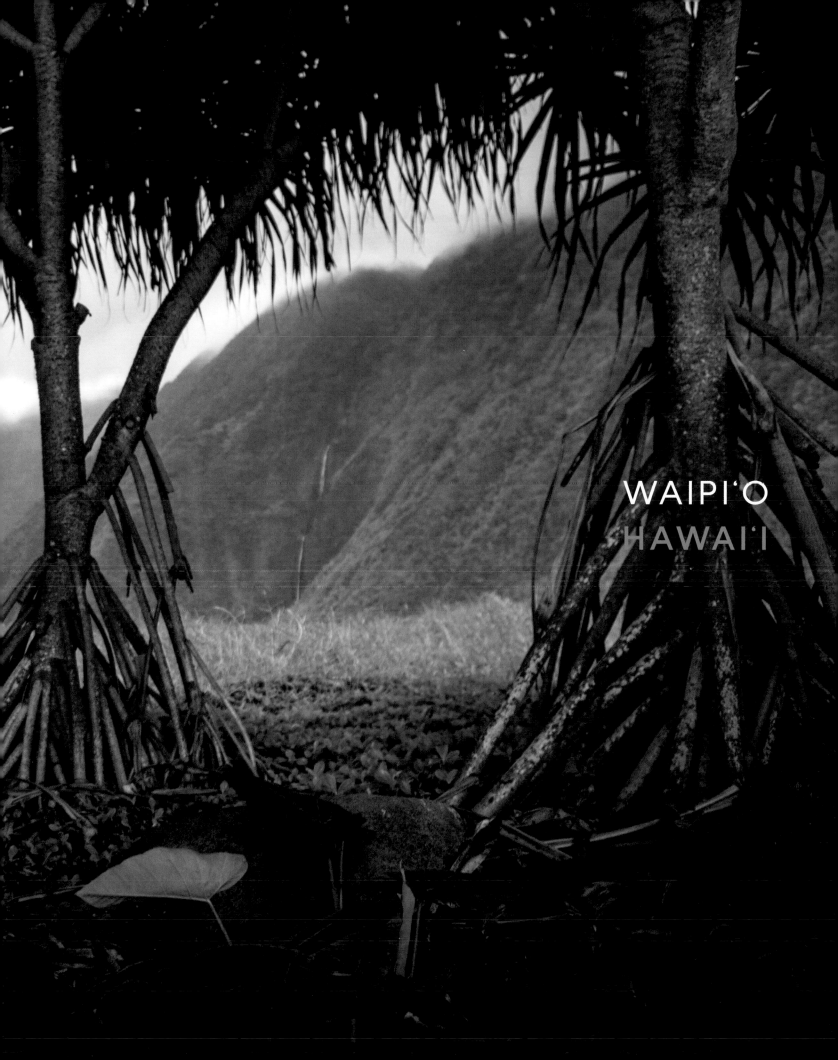

WAIPIʻO

HAWAIʻI

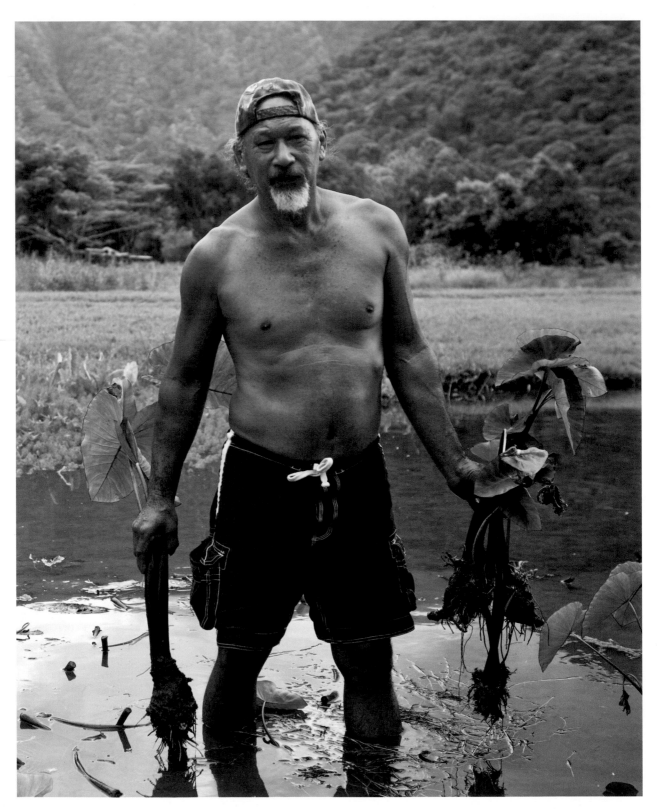

Jayson Mock Chew in the *l'oi*, or taro
pond, on his farm in the Waipi'o Valley.

CHAPTER 5

JAYSON & ALBERTA / TARO FARMERS

Waipi'o, Hawai'i

Only four-wheel-drive vehicles were permitted past the forest ranger station at the top of the palisade and, after the first hairpin turn, the reason was apparent, as ripe mangoes pockmarked the patched single-lane asphalt. The road descending into Waipi'o valley is treacherous at the best of times; one side plummeted two thousand feet to a black beach below. Guardrails? Who said anything about guardrails? The only other egress was the ancient King's Trail from the opposite side of the Kohala Mountains. On foot, this takes seven days to traverse.

"Slow down, flying rocks *da hui*."

Passing this hand-painted sign nailed to a tree near a cluster of bungalows on the valley floor, I always thought it had to do with boulders dislodging from the cliff. That was before I came to understand the retaliatory action implied in surf gang slang: speed here and rocks will be tossed at your uninvited windshield. The "Parking for Hawaiians Only" notice was more blunt, as were the barbed wire fences and "No Trespassing" signs along two rushing streams I had to ford before finding the Mock Chew's cattle gate.

"Oh, I'm gonna smack that man," said Alberta Mock Chew, exasperated. She was standing next to the bungalow where her cell phone caught a signal when I called. She meant Jayson's cousin, Kaniela "Danny" Akaka. My friend Danny knows everyone on the island. He's the sort of person who will give away the aloha shirt off his back or the private number of a distant relative in one of the island's most isolated communities.

"What does he think we are? We're not open to the public, yah?" There was silence on the other end of the line. "Well, if it's just you, come on in," she offered gruffly. "Jayson is harvesting."

Beyond the gate, monkeypod trees and dwarf palmettos gave way to an open field. A track in the sawgrass led to a cluster of green-and-white bungalows. The front yard was littered with a brush hog, a frontload tractor, and three battered Dodge pickups. On the porch of the main house, chickens sat atop a pie safe and an African gray parrot screeched in its cage. The outside wall was covered with old plowshares and mule harnesses. Wet laundry

139

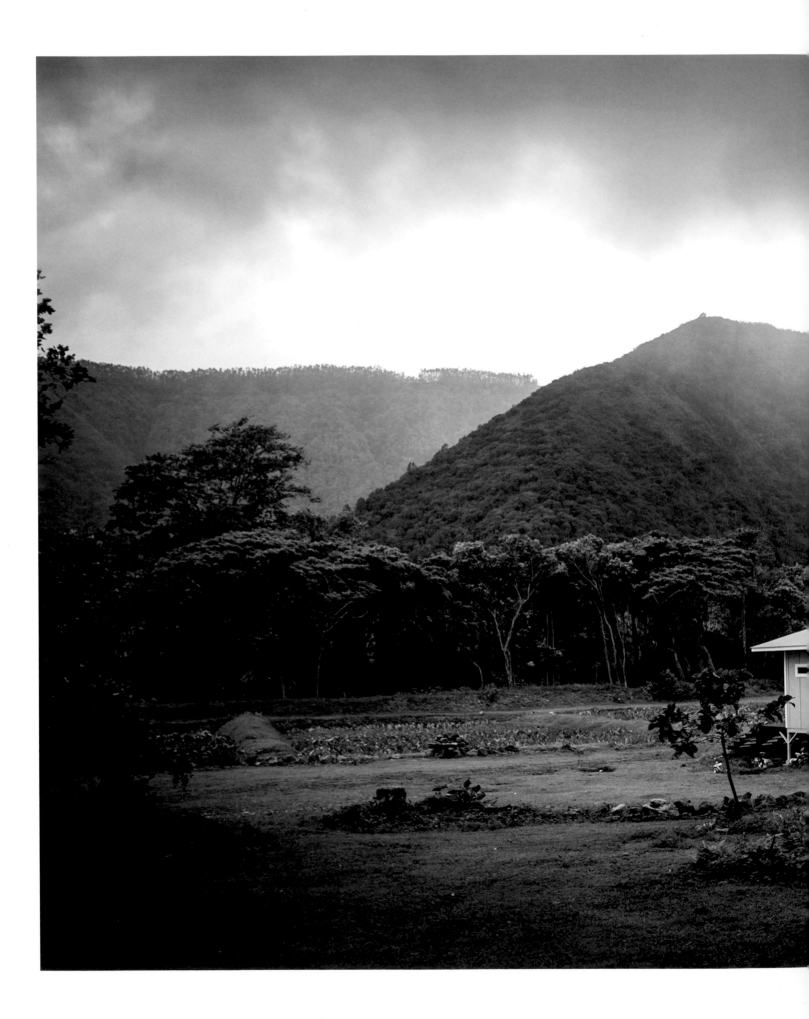

Thousands once lived in Waipi'o before the arrival of Captain Cook; in 1946, a tsunami swept through the valley, and only a few taro farming families remain today.

hung on a clothesline. A sign above the front step read: "The most important things in life aren't things."

Alberta appeared at the other end of the field on her red ATV. A solidly built woman in her late fifties, she wore track shorts and a tank top. A sports bra crossed her chest awkwardly where surgery had removed one of her breasts. She braked next to me, cut the engine, and took a swig from a water bottle. Her dog Natumi trotted out of the orange grove. A collie-heeler mutt, he flopped on the ground, wet from an excursion into the stream at the far end of the farm.

"I'm not holding you up or anything?"

Alberta snorted. "Jayson has the longest day," she said. "He's in the *lo'i* until dark. Follow me."

She fired the ignition and turned her quad around. I trailed behind on foot. The Mokuwai Pio taro ponds on the western side of the valley contained leafy plants poking through the slow-moving water. Fat white ducks chuckled after snails along the mown edges. A solitary man waded barefoot among the crop. His camouflage baseball cap, bill flipped backward, covered a graying ponytail. He nodded briefly, and then bent over his taro patch again.

Alberta and I sat under an ironwood tree and watched Jayson methodically yank taro out of the mud to pile them in a floating wooden box. He grew up in the valley while Alberta, whose family came from Portugal, was born in the sugar mill town at the top of the palisade. They met in high school. Back then, her hair was long and dark.

"We are basically still harvesting the same *huli* Jayson's grandpa did, yah?"

She held up fingers and ticked them off.

"Because it's generation, generation, generation. We plant one in hopes that it will multiply and we take all the babies, and we plant them, too." Alberta unconsciously tugged at her tank top. "It's known to be our older brother, yah? It bleeds, has hair, has children hanging onto them," she grinned. "Believe me, they are alive."

When island kids refuse to eat their poi, the lilac-hued taro mash with a consistency like wallpaper paste, their parents recite the legend of Taro. The Hawaiian sky god's daughter bore him a premature infant shaped like the gnarled root of a plant, so he buried the lifeless body next to his house. Taro sprang from the grave. A healthy second human child

OPPOSITE: Only in Hawai'i is taro harvested, cleaned, boiled, and then made into the gooey purple mash called *poi*. A lava stone pestle was originally used to pound the corms, but now they are ground to a smoother consistency in small commercial kitchens like the one owned by the Mock Chew's daughter.

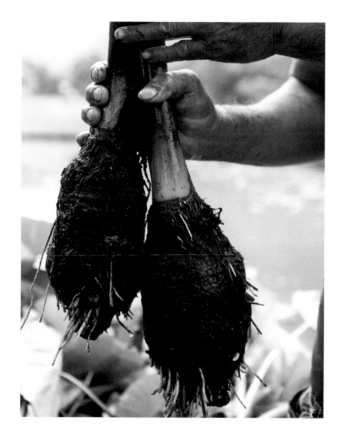

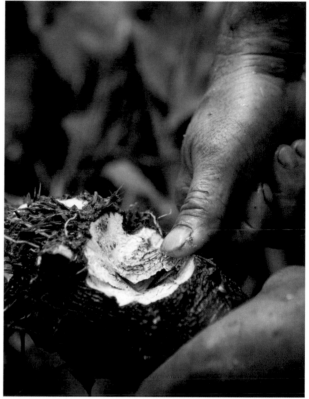

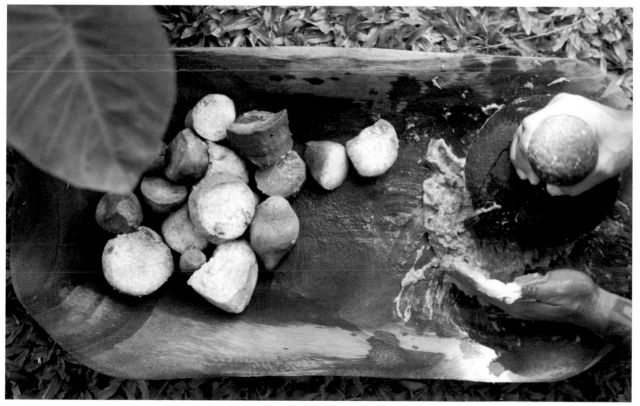

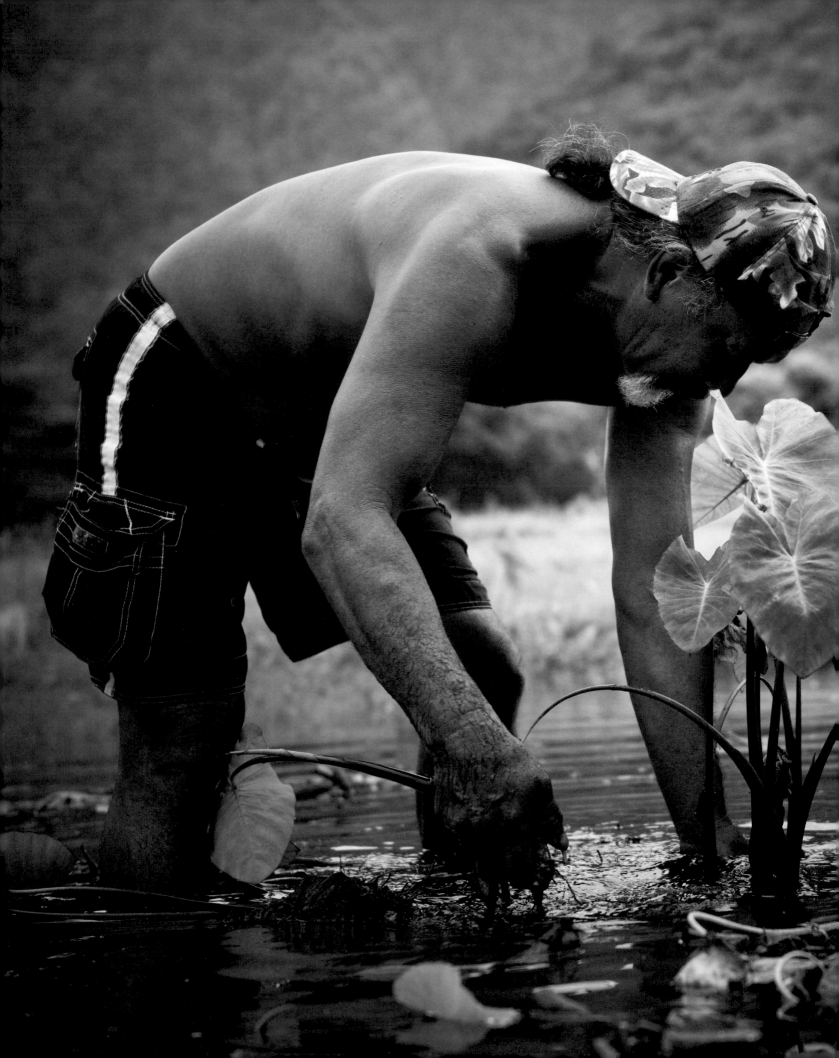

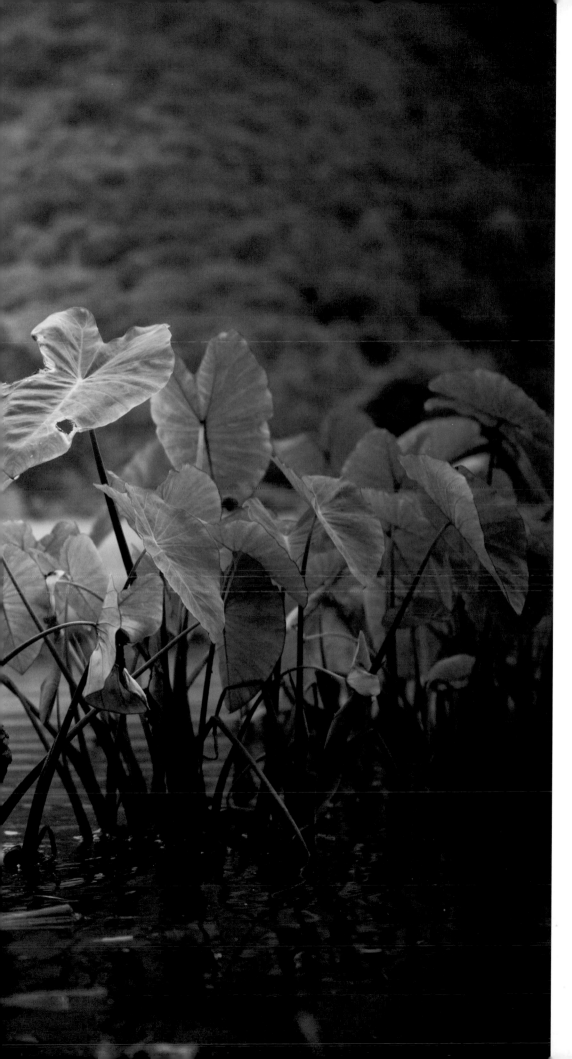

Taro is a staple of the Hawaiian diet. Even parts of the plant are lovingly named to indicate its essential role: the place where the stem meets the leaf is called *piko*, or navel. The stem itself is *ha*, breath, and the cluster of shoots, known as *keiki* (children) that sprout from the mother plant are called an *ohana*, or family.

was taught to respect his older brother Taro and, in return, the root of life nourished his sibling's descendants, who became the first Hawaiians. While other Polynesian cultures eat taro, only Hawaiians pound it into poi. No one would think of holding a luau, the impromptu backyard kind or the more commercial variety, without this staple and, while taro is raised on neighboring islands, farms in Waipi'o are considered by many to produce the tastiest. (The flavor can range from sweet right after grinding, to intensely tangy, almost like yogurt, as it ages.) The Mock Chew's daughter, Kahealani, sells their poi to weekly subscription customers, including the Costco branch in Kailua-Kona, and donates it to cancer patients undergoing chemotherapy as well.

"You better stay for dinner," Alberta said. "Come back to the house when you're done here."

The dog loped alongside as she sped away again. Jayson, who still hadn't said a word, towed the taro box to the pond's far edge. Leaving him to bag the crop in large plastic sacks, I wandered into one of the meadows where wild horses grazed. It was too far away to hear Hi'ilawe waterfall, but I could see a silver ribbon falling slowly from its crest. A cloudbank obscured the back of the valley where two slopes folded together in a cleavage of rainforest. Cardinals swarmed a guava tree to peck at bruised fruit littering the ground. A mule trotted up to the wire fencing surrounding its pen. Alert ears twitching suspiciously, it allowed me to lightly touch its muzzle with a single finger. I could feel its breath on my hand before it backed away.

Alberta was stirring eggs and linguica sausage in a frying pan on the stove top in her house. Taro boiled on another burner. The main room also had a rack holding five worn saddles, some bentwood chairs, and a tiled counter. I sat on a bar stool and ran my hand over the mosaic.

"We built that together one night. Can you tell which side I did? Mine is all rough and uneven. Jayson did the smooth part."

It was close to dark when he arrived to start up a gas generator for the lights and satellite dish. He opened an Orange Crush and tuned the television to a documentary on Norman Finkelstein. During a commercial break, he turned to me.

"Did the mule let you touch him?"

"A little."

"He never lets me get near him."

Rain chattered on the roof. It grew loud enough to drown out the television. Alberta put

OPPOSITE: The streams that crisscross the valley floor are full of tasty freshwater shrimp called 'opae.

boiled breadfruit with crushed Hawaiian chiles on the counter.

"Thank you for this day," she intoned.

The taro was cut into chunks. It had the floury consistency of an Idaho russet. The eggs and sausage were fragrant with garlic. Jayson rubbed his goatee.

"Do you ever see ghosts?"

"Not exactly," I replied, warily.

"We've heard night marchers drumming out there."

The downpour finally stopped, but swollen streams were treacherous to cross in the dark. Jayson went outside to light a fire under a cauldron for a hot bath. Alberta turned to me.

"That was *awesome*. Sometimes he just disappears until people leave."

I lay awake in another bungalow next to the main house and listened to the night come to an end. Tree frogs chirped slower and then stopped altogether. Natumi rustled on a plastic tarp outside the screen door. It was still pitch dark when a rooster crowed loudly in the orange tree next to the window. At first light, I heard a flutter of wings and the boom of surf in the distance.

Picking a couple of oranges, I went for a walk along the fence line as Natumi ranged back and forth. A mongoose scooted across one of the canals and dove into a pond. The scent of green rose from the ground as the sun peeked over the eastern ridge top. On the other side of the fence, the low brush rustled and a wild boar emerged. It had tobacco bristles and razor tusks. I threw one of my oranges. The fruit bonked its nose. It stood snuffling, unfazed.

"That pig?" Alberta was toasting cheese sandwiches for breakfast. "It's penned up for a luau next spring. Danny wants to cook it in an *imu* pit, but I think that's getting tired. We should barbecue it Chinese-style for a change."

"Will you have poi for that party?"

"Oh, sure."

In future years, I come back again and again for this luau, where family and friends set up propane-fired woks and crack open ice chests full of beer on the back of pickup trucks. Men haul the ti leaf–smoked pig out of a pit, and it slumps lusciously on a prep table where they pull back the crisp skin and use the beast's own hip bones to shred the meat. Boys spear ʻopae shrimp in the river and girls collect wild oʻhia ferns while their parents drink pineapple

moonshine and strum guitars. No plastic leis, no fire dancers, no grass skirts. And when I eat that poi, generously spooned by Alberta onto my paper plate, it tastes like *welcome home*.

✝

After breakfast, Jayson pulled out a family album of black-and-white photographs taken in Waipi'o during the 1920s. His beautiful Hawaiian grandmother in a straw hat on the beach. One of his Chinese uncles who made the saddles that now hung in the bungalow. Another of a barefoot fisherman standing on lava rocks, dripping wet from the sea, holding a casting net in his hands and a live fish clenched between his teeth, mugging for the camera.

"Does your poi taste the same as what your grandfather was making?"

"He used to grow certain varieties," said Jayson. "The poi would taste pretty much the same all the time. Now because of the hard times we have with rot, we grow different kinds, so that might make a difference."

The Mock Chews wanted to hike to the beach, so we waded through one of the streams and picked up the King's Trail, a pebbled path that lawless warriors once used when seeking refuge here. Alberta stopped under a banyan where passion fruit had fallen among the roots. I opened my backpack to gather some and realized my swimsuit was back at the farm.

"Just go in naked," Alberta said. "Nobody here is going to look."

"Wouldn't want to scare you."

She whipped around and lifted her shirt, exposing the scar on her chest. "Here is the scariest sight ever and I see it every day," she said, sternly. "This is my *champion* side."

We landed on a shoreline of lava rocks fringed by coconut palms. The iron sea rippled over a reef and turned a frigid shade of turquoise as it tumbled into the shallows. Salt foam misted our hair. In the distance, cars were visible on the palisade road.

"It's only five minutes to get down from there," said Jayson. "But from the top to the bottom, big difference."

"Do you ever think about going to the mainland?"

"Not really."

The Mock Chews left to tend the taro, but I lingered until a group of young campers humped past with heavy packs. They whooped loudly at the steep trail zigzagging up the far palisade. Turning back, I waded through the stream and stood on an exposed bed of river rock looking up at *o'hia* ferns growing in the notch of a banyan. I broke open one of the passion fruit and the tart juice splattered my shirt. Passing through the farm gate, I skirted the pond where Jayson towed his taro box.

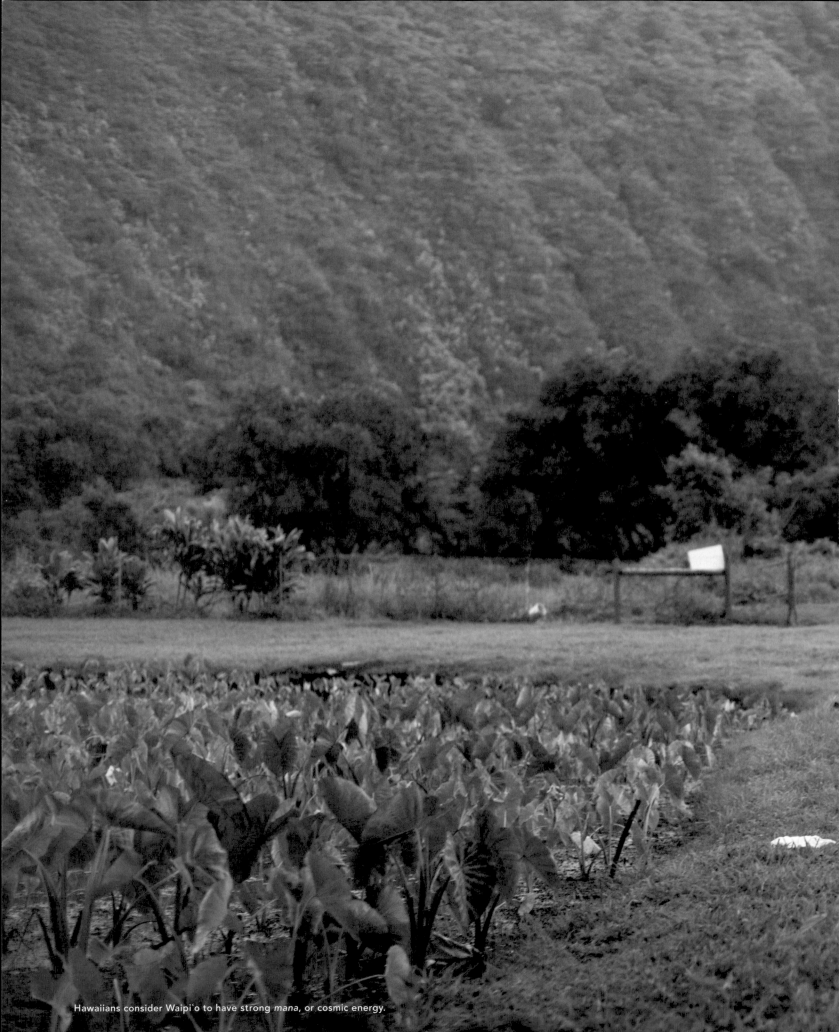

Hawaiians consider Waipiʻo to have strong *mana*, or cosmic energy.

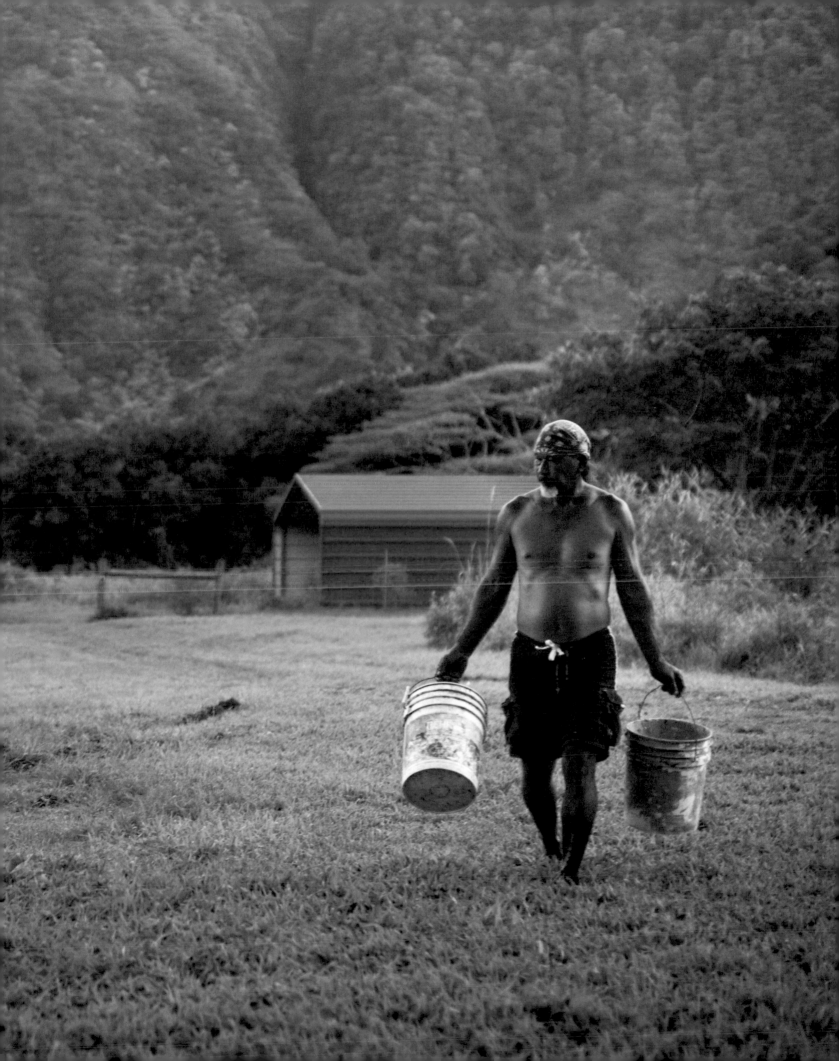

"Do you want help?"

"Well, two people make the work go faster."

I kicked off my shoes and set them next to his heel-worn flip-flops. The mud at the bottom plumed like mushroom spores. With every step, I sank deeper and stuck longer until decaying debris squeezed between my toes. Jayson tore suckers off each taro corm using horn-thick fingernails ingrained with tannic silt. Then he sliced off the stems and leaves with a buck knife.

The taro came out of the mire reluctantly. When I cradled an exposed corm in my palms, the pale roots resembled tangled hair. Brother of man, I wondered, who first thought to boil and grind your gnarled purple head?

"Sometimes we'll get carried away," Alberta had said the day before. "Start early and just keep going and going and going, and I think to myself, wow, I am so tired. Why did I choose this life? I want to stop, and then you feel a petting, yah?" She feathered one arm lightly with her fingers. "And it's the wind blowing the taro leaf, but it feels like 'Don't stop. I appreciate.'"

The mist held back all day by the Kohala Mountains gradually slipped down the palisades. Jayson paused to light a cigarette, contributing his own nicotine cloud to the greater twilight mood. The wooden box filled with corms drifted unnoticed toward the grass bank. Ash dropped as he looked up at the ridge, his bare feet planted in the swirling pond water. A flock of white egrets appeared from the forest canopy and dropped swiftly in altitude. All seemed to still in the moment—breeze, taro leaves, waterfall—as if the valley held its breath while the birds silently skimmed above the treetops. They winged past in formation, a dozen entrained ghosts, compelled to some roost beyond where the Pacific thundered on the black sand beach.

Jayson finished his cigarette.

"They do that every night. I always stop to watch."

Waipi'o exhaled.

OPPOSITE TOP: Wok-fried convict tang at the annual Mock Chew luau.

BELOW LEFT: Wild o'hia fiddlehead ferns.

BELOW RIGHT: Char siu pork with noodles. See recipe on page 156.

FRIED RICE OMELET

SERVES 2

One of my favorite Big Island mashups, this breakfast dish combines Portuguese linguica sausage, locally harvested hamakua mushrooms, Chinese-style fried rice, and a fluffy omelet. I first ate this at a Honalo restaurant owned by Mary Shizuko Teshima, a gentle Japanese-Hawaiian lady, who lived to 106 years old. She was the epitome of aloha spirit.

FRIED RICE

2 teaspoons sesame oil

1 teaspoon minced fresh ginger

1 clove garlic, minced

2 scallions, chopped, some green tops reserved

⅓ cup chopped linguica sausage

1 large hamakua, king oyster, or
shiitake mushroom, chopped

2 tablespoons peas

1 tablespoon chicken stock

½ cup day-old white rice

½ teaspoon soy sauce

OMELET

½ tablespoon butter

2 large eggs

¼ cup whole milk

Black pepper

To make the fried rice, heat the oil in a wok over high heat. Add the ginger and stir for about 1 minute, until softened. Add the garlic, scallions, and sausage and continue to stir, then add the mushroom and peas. Keep stirring. Blend in the chicken stock, and then add the rice. Continue to stir until all the ingredients are combined and heated thoroughly. Add the soy sauce to finish. Reserve the fried rice while preparing the omelet.

To make the omelet, in an omelet pan or small frying pan, melt the butter over low heat. In a small bowl, whisk together the eggs and milk until foamy. Pour into the pan and, holding the handle firmly, swirl to prevent the eggs from setting too quickly. Edge with a spatula, to keep from sticking. When almost cooked but not browned, fill the center with 3 to 4 generous spoons of fried rice, carefully fold the omelet to one side of the pan, and slide onto a plate.

LOMI LOMI SALMON

SERVES 4

When New England whaling ships first arrived in the early nineteenth century, seafaring Hawaiians signed on as crew and, soon after, these *sailamokus* brought back salt-cured salmon from the West Coast as an exotic treat, much like Yankee ship captains toted pineapples home to Nantucket. Now, Hawaiians buy fresh Pacific sockeye or coho salmon flown in from the mainland and cure it themselves with local sea salt. Lomi lomi salmon gets its name from the preparation method; in Hawaiian, *lomi lomi* means to "rub" or "massage." The salted fish is diced and rubbed by hand with other ingredients for an essential side dish at luaus.

1 pound salmon fillet

2 to 3 cups Hawaiian or other coarse sea salt

1 pound grape tomatoes, quartered

1 Maui or other sweet onion, chopped

Rinse the salmon. In a shallow, nonreactive pan or plastic tub, spread half of the salt in an even layer, place the salmon on top, then add the remaining salt, tossing to coat completely. Cover and refrigerate, adding more salt as needed, for 1 week. The salmon will dry out and become firm. When ready, the skin easily peels away from the flesh. Or you can just start with a skinless fillet.

Rinse the excess salt from the salmon and pat dry. Chop into ½-inch cubes, then shred by hand and transfer to a bowl. Add the tomatoes and onion. Rub the mixture vigorously by hand until combined, breaking down the juices in the tomatoes and marinating the onion. Chill thoroughly, adding some cracked ice, if needed. Best served cold.

CHAR SIU PORK WITH CHINESE NOODLES

SERVES 2

This dish is always a winner at the annual luau held in the Waipiʻo Valley. Pork is a staple on the island, where wild boars sneak into orchards to graze on fallen macadamia nuts. Most Hawaiians know a hunter or two who will share their prize to make beloved kalua pig, pan-fried chops, or char siu–style roast pork. Since I don't have the special hanging oven used in Honolulu's Chinatown restaurants for properly roasting char siu, I like to throw it on the grill. The marinade includes fermented red bean curd paste, which gives the meat its distinctive red hue. It's available at Asian markets or online (see Sources, page 294).

¼ cup hoisin sauce

3 tablespoons runny honey

2 tablespoons plus 1 teaspoon dark soy sauce

1½ tablespoons Shaoxing Jiu rice wine

2 tablespoons fermented red bean curd paste

1 teaspoon Chinese five-spice powder

1½ pounds boneless pork shoulder

1 (10-ounce) package Chinese dried medium egg noodles (or fresh if available)

5 tablespoons toasted sesame oil

1 cup peeled and shredded carrot

1 cup fresh mung bean sprouts

3 scallions, green and white parts, julienned, plus 1 whole scallion, thinly sliced, for garnish

Coarse sea salt

In a large, resealable bag, combine the hoisin sauce, honey, 2 tablespoons of the soy sauce, rice wine, bean curd, and five-spice powder. Seal and shake to blend. Add the pork, seal again, and shake to distribute evenly. Let marinate overnight in the refrigerator.

Build a hot fire in a charcoal grill or heat a gas grill to high. Remove the pork shoulder from the bag and wrap loosely in foil. Depending on the thickness of the cut, grill for 10 to 15 minutes on each side. Then, remove the foil and grill for 1 minute more on all sides, to create a nice char and caramelize the fat. Allow to rest before cutting into ½-inch-thick slices.

Bring a large saucepan of water to a boil over high heat, add the noodles, and cook, stirring, until al dente, 1 to 2 minutes. Drain the noodles into a colander and rinse under cold water. Drain the noodles again, transfer to a large bowl, and toss with 2 tablespoons of the sesame oil.

In a large wok or cast-iron skillet, heat the remaining 3 tablespoons oil. Add the carrot and stir constantly until soft, about 1 minute. Add the sprouts and julienned scallions and continue to stir until fragrant. Add the pork and toss until warmed through. Remove from the heat and stir in the noodles and remaining 1 teaspoon soy sauce. Transfer to a platter and garnish with the sliced scallion before serving.

O'HIA FERN SALAD

SERVES 4

O'hia is a native variety of fiddlehead fern that grows wild in Waipi'o Valley on the Big Island. The furled fronds, available year-round in the tropics, often appear in salads at luaus, tossed with everything from fish cakes to dried shrimp. One of the Mock Chew family friends, Tishia Spencer, pairs it with Lomi Lomi Salmon (page 155). Outside of Hawai'i, fiddleheads appear at select supermarkets and farmers' markets during their brief spring season.

Coarse sea salt

1 cup fiddlehead ferns

1 pound Lomi Lomi Salmon fillet, without salad (page 155)

1 cup grape tomatoes, quartered

1 small sweet onion, diced

Black pepper

Fill a medium saucepan halfway with water, add a pinch or two of salt, and bring to a boil. Prepare an ice bath. Blanch the ferns until bright green and tender, 1 to 2 minutes. Drain and transfer to the ice bath to chill. Drain again, and pat dry thoroughly. Coarsely chop the salmon into cubes and place in a serving bowl. Add the blanched fiddleheads, tomatoes, and onion, and toss until evenly combined. Season with salt and pepper, and refrigerate for 1 hour before serving.

NORI CHIPS

SERVES 2

One of the best bar snacks ever created. Hideaki "Santa" Miyoshi runs the one of the oldest *izkaya* in Hawai'i. He serves these nori chips at his bar. Wild-harvested, edible seaweeds have always been an important part of Hawaiian and Japanese diets, so this is a winner on both sides of the Pacific.

½ cup cornstarch

1 egg

½ cup water

1 cup vegetable oil

2 sheets nori, about 7 x 8 inches, cut into 6 squares

In a small bowl, whisk together the cornstarch, egg, and water. Heat the oil in a wok or deep saucepan to boiling. Dip one side of each nori piece into the batter, slide into the hot oil, and deep-fry until it gets crisp on both sides, about 1 minute. Use chopsticks to keep the seaweed from tangling. Drain on paper towels. Serve immediately.

LI HING SIDE MUI

SERVES 1

My friend Colin Nishida used to make illegal pineapple "swipe" as a kid. (*Swipe* is slang for a fruit-based moonshine originally created by field hands who worked on Hawai'i's pineapple plantations.) No wonder he grew up to be a bartender in Honolulu. His joint, Side Street Inn, is a regular stop whenever I pass through the islands. Fruit infusions, including lychee and mandarin orange vodka, steep in big glass jars on the bar. He also makes liberal use of li hing mui, a sweet-tart powder of salty pickled fruit from the *Prunus mume* tree. This flowering apricot originated in China's Guandong Province—*li hing mui* means "traveling plum." You can find it online (see Sources, page 294) or from Hawaiian "crack seed" stores.

SWEET-AND-SOUR MIX

3 ounces fresh lime juice

3 ounces fresh lemon juice

2 ounces simple syrup (1 part water,
1 part superfine sugar, boiled)

SIDE MUI

Lime wedge

Li *hing mui* powder

1½ ounces vodka

½ ounce Kahlúa

½ ounce sweet-and-sour mix

To make the sweet-and-sour mix, pour the lime juice, lemon juice, and simple syrup into a bottle. Shake well, seal, and refrigerate until ready.

To make the Side Mui, rim a martini glass with a wedge of lime, then dip it into a dish filled with *li hing mui*, so the powder adheres to the edge of the glass. Combine vodka, Kahlúa, and sweet-and-sour mix in a cocktail shaker filled with ice. Shake vigorously and strain into the martini glass.

PINEAPPLE PIE

SERVES 6 TO 8

Hawaiians love fruit pies. Before descending the palisade for an annual luau at the Mock Chew farm, I picked up a pineapple pie at the market in Waimea as a gift. I then stopped at a shave ice truck on the roadside near Waipi'o Overlook. The owner was selling his homemade fruit preserves, so I bought a jar of *lilikoi* (passion fruit) jam that I now use to glaze the crust for my own version of pineapple pie, which reminds me of visits to the Mock Chews.

FILLING

2 ripe pineapples, peeled and cored

3 to 4 tablespoons cornstarch

½ cup raw cane or light brown sugar

Pinch of salt

1 tablespoon lemon juice

1 tablespoon butter

2 chilled piecrusts (page 161)

2 tablespoons passion fruit jam

1 teaspoon water

Raw cane or light brown sugar, for sprinkling

Preheat the oven to 400°F.

To make the filling, reserve half of 1 pineapple. Chop the remaining fruit coarsely by hand or pulse in a food processor to yield 3 cups. In a saucepan, combine the chopped pineapple, cornstarch, sugar, and salt. Heat slowly while stirring until thickened and clear. Stir in the lemon juice and butter.

Slice the reserved pineapple into thin rounds.

On a lightly floured surface, roll out 1 piecrust and transfer to a 9-inch pie shell. Prick all over with a fork and chill for 30 minutes. Pour the pineapple mixture into the shell. Arrange the pineapple rounds to cover the filling. Roll out the second piecrust and cut into thin strips. Weave a lattice top crust and crimp the edges.

In a small bowl, whisk together the passion fruit jam and water. Using a pastry brush, swipe the piecrust lightly with the glaze. Sprinkle with additional sugar. Bake for 20 minutes, then reduce the heat to 350°F, cover the pie loosely with foil, and bake for 40 minutes longer, or until the filling bubbles and the crust is golden brown. Let cool before serving.

CHOCOLATE HAUPIA PUDDING PIE

SERVES 6 TO 8

Haupia is a firm, mildly sweet coconut pudding that regularly appears at luaus. My friend Donna Kimura, who meets me at the farmers' market in Waimea for plate lunch whenever I visit the island, shared her mother's recipe. It also shows up in luscious cakes and pies from Hawaiian bakeries like Liliha and Ted's.

CHOCOLATE PUDDING

5 large egg yolks

½ cup sugar

3 tablespoons cornstarch

2 tablespoons dark cocoa powder

¼ teaspoon coarse sea salt

2 cups whole milk

1 teaspoon vanilla extract

2 tablespoons unsalted butter

4 ounces dark chocolate, chopped

HAUPIA

⅓ cup cornstarch

½ cup sugar

⅛ teaspoon salt

3 cups unsweetened, first pressing canned coconut milk

1 chilled piecrust (page 161)

TOPPING

2 cups heavy cream

¼ cup sugar

Chocolate shavings, for garnish (optional)

To make the pudding, whisk together the egg yolks, sugar, cornstarch, cocoa, and salt in a bowl. In a medium saucepan, bring the milk to a boil. Remove from the heat and slowly whisk the milk into the egg mixture until blended. Clean the saucepan. Pour the mixture back into the pan and add the vanilla, whisking over medium-low heat for 3 to 5 minutes, until it thickens. Cook while whisking constantly, until glossy and thick. Add the butter and chopped chocolate, while continuing to whisk, until completely melted and combined.

Transfer the pudding to a bowl and press plastic wrap onto the surface to prevent a skin from forming. Refrigerate for 4 hours.

To make the haupia, combine all the ingredients in a saucepan over medium-low heat and stir constantly for about 3 minutes, or until the haupia thickens. Remove from the heat and transfer to a bowl. Cover with plastic wrap and chill thoroughly, about 2 hours.

Preheat the oven to 400°F.

Roll out the piecrust on a lightly floured surface to a uniformly even, 12-inch circle. Transfer to a 9-inch pie pan. Prick the bottom of the crust with a fork, crimp the edges, and chill for

30 minutes. Line the bottom of the piecrust with foil or parchment paper and fill with ceramic pie weights or dried beans. Bake for about 10 minutes, then remove the weights and foil and continue baking for another 5 minutes, or until the crust is light golden brown. Cool on a pie rack before filling.

To make the topping, using a hand or stand mixer, whip the cream with the sugar until stiff peaks form.

Whisk the chilled chocolate pudding until it is soft and smooth. Spoon into the cooled piecrust, filling the shell halfway.

Whisk the chilled haupia until soft and smooth. Spoon into the piecrust, filling to the top, being careful not to mix the two layers. Layer the whipped cream on the pie surface. Chill again for an hour before serving. Garnish with chocolate shavings, if desired.

PERFECT PIECRUST

MAKES 1 SINGLE CRUST

I often cheat and buy ready-made piecrusts. But this buttery crust is easy to prepare when time allows and it admittedly tastes so much better.

1¼ cups all-purpose flour, preferably White Lily
¼ teaspoon sea salt
10 tablespoons unsalted butter, cold and cut into cubes
2 to 4 tablespoons ice water, as needed

In a food processor, combine the flour and salt. Add the butter, and then pulse until the mixture starts to clump. Add the ice water, 1 tablespoon at a time, and pulse until the dough just comes together. Scrape the dough onto a lightly floured surface and gather into a ball, kneading once or twice to even it, then flatten into a disk. Cover tightly with plastic wrap and refrigerate for at least 1 hour.

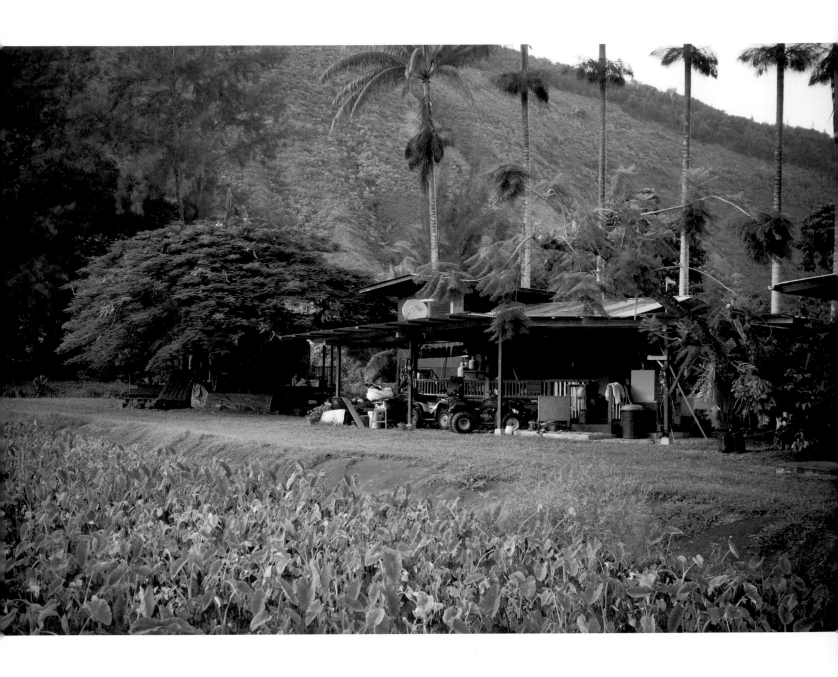

ABOVE: The Mock Chew bungalow.

OPPOSITE CLOCKWISE: Natumi, one of Alberta's beloved dogs. Jayson and Alberta Mock Chew. A family friend fishing in the stream behind the farm. The bungalow's front porch.

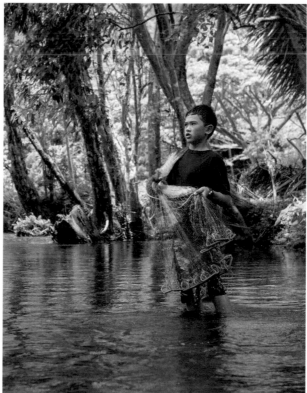

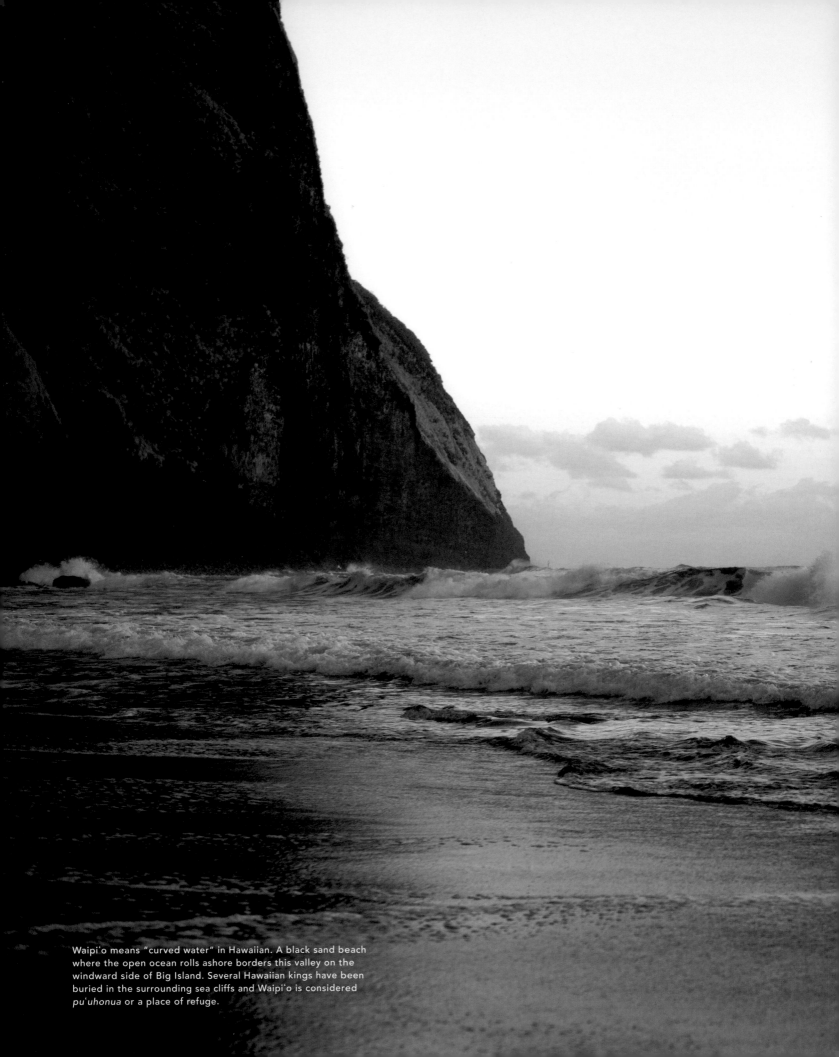

Waipiʻo means "curved water" in Hawaiian. A black sand beach where the open ocean rolls ashore borders this valley on the windward side of Big Island. Several Hawaiian kings have been buried in the surrounding sea cliffs and Waipiʻo is considered *puʻuhonua* or a place of refuge.

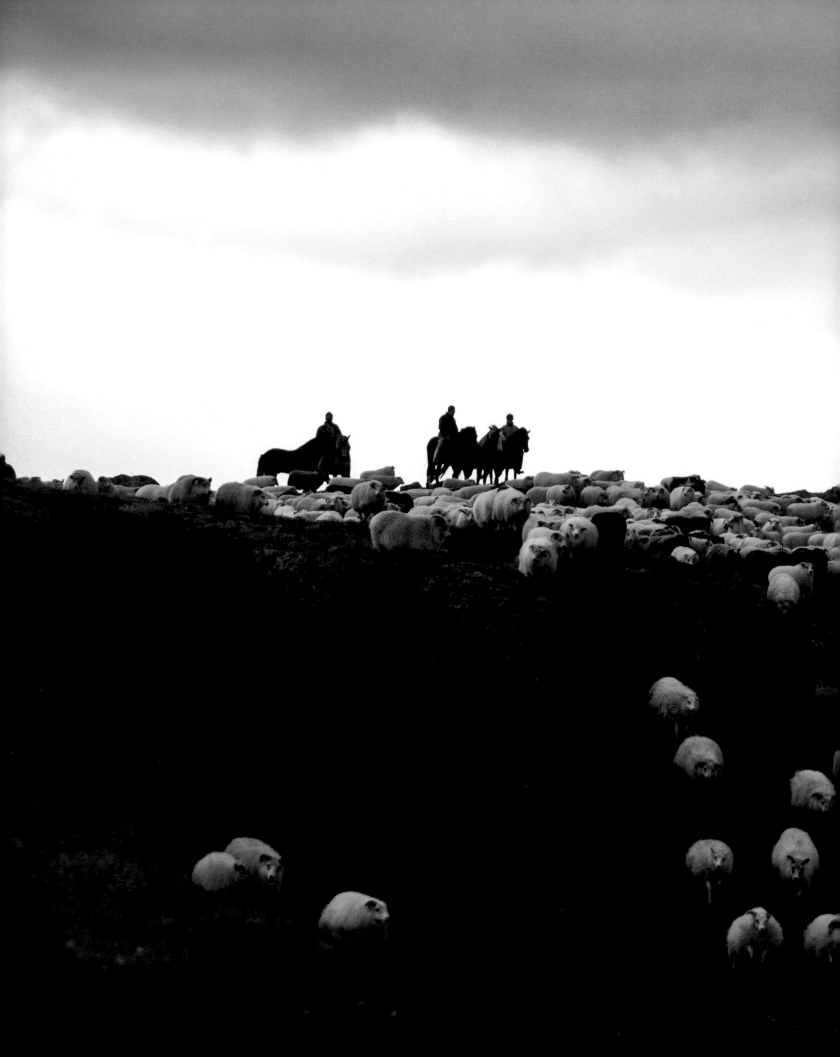

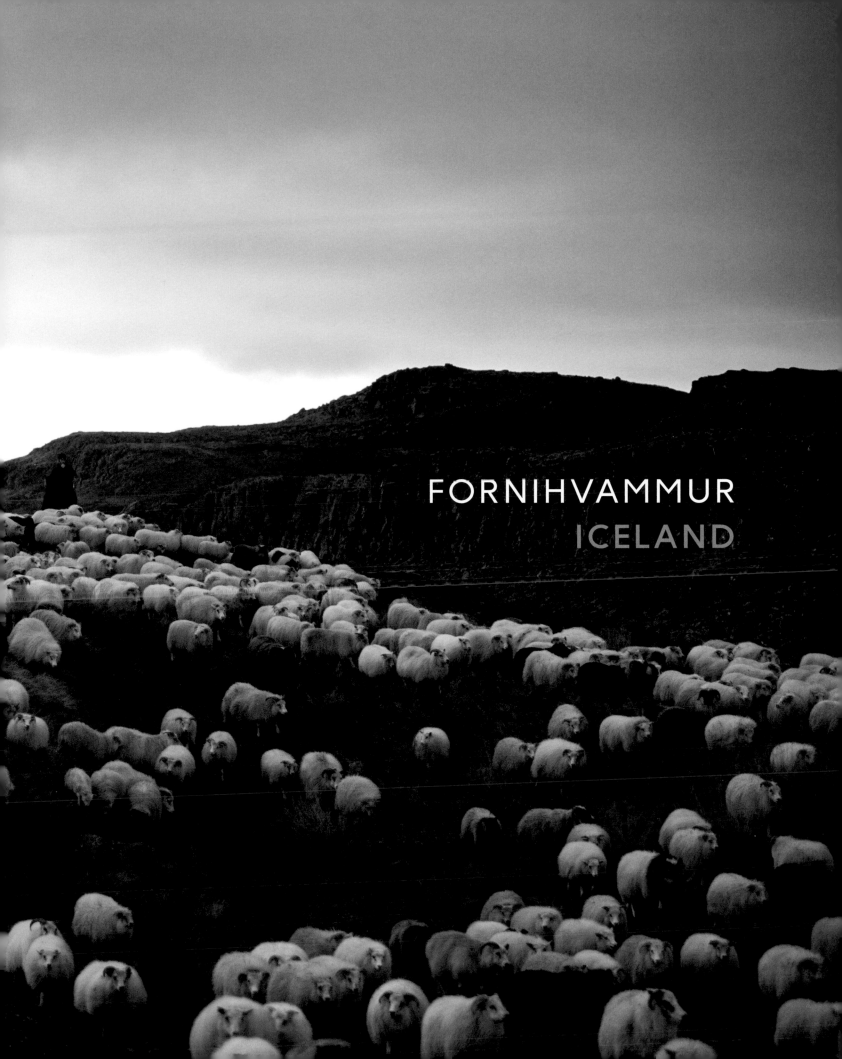

FORNIHVAMMUR

ICELAND

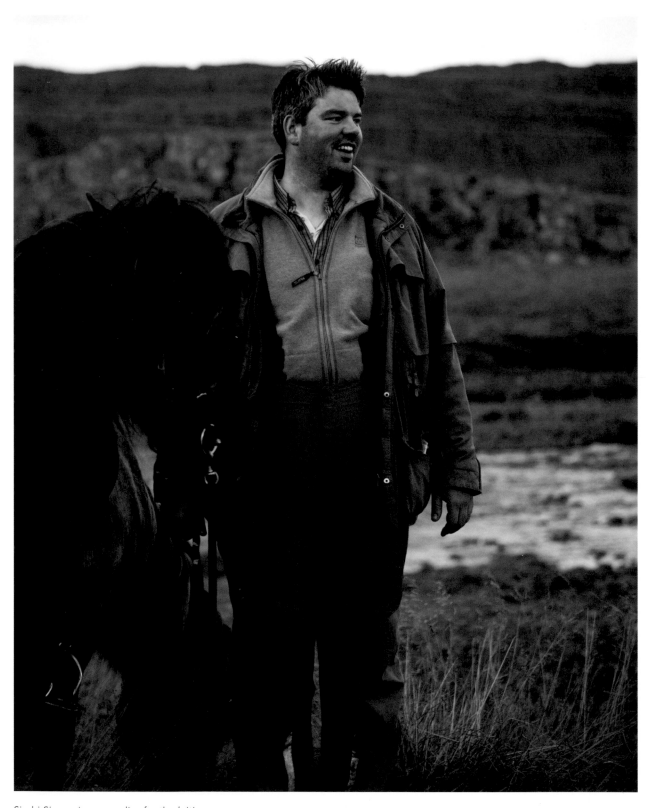

Sindri Sigurgeirsson readies for the *leitir*,
or sheep roundup, in the Icelandic highlands.

SINDRI / SHEPHERD

Fornihvammur, Iceland

At four in the morning, the first alarm beeped in the darkness of the Fornihvammur bunk-house. Sindri Sigurgeirsson rolled out of his sleeping bag and banged open the wooden door leading to the foyer, where his border collies were curled up on battered chairs and carpet remnants. Pulling on rubber boots, he left the cabin to wrestle with a gas generator that chugged awake and powered up the naked light bulbs inside. The sink tap gurgled and splashed as an electrical pump drew water from a glacial stream. The shepherd trudged back inside and knelt in front of the kerosene stove to strike a match under the pilot flame. The stove warmed damp riding breeches dangling from pipes running along the inner walls.

Someone coughed. Most of the thirty-three men, women, and teenagers remained curled on lumpy mattresses in the communal bunks of the converted pigsty, but a handful got up, donning long underwear and bulky woolen sweaters with knit patterns ringing the neckline. Agnar, a professional horse wrangler, threw a shirt over his pale torso and slipped down the wooden ladder to the carpeted floor. The law student on my other side nodded and smiled. One of the walkers, a pair of carved wooden hiking sticks tucked under his arm, turned in the doorway and waved benediction to those still sleeping.

"*Blesse Gud*," he murmured.

I hurried outside to watch the first crew depart. Truck headlights silhouetted saddles piled on the turf. Horses were being led out of the barn on the other side of the cabin foyer and loaded into a trailer. The collies excitedly circled Sindri's pickup. He grabbed a black-and-white one by the scruff and tossed it like a toolbox into the backseat. Other dogs followed, including an Irish setter and a foxy-looking mutt. Then the men climbed in. They were headed for a rough track below the stony pinnacle of a wind-blown massif to goad the most obstinate sheep down to a lower elevation. While full light was still three hours away, the biggest *leitir*, or roundup, was underway on the autumnal equinox in the western highlands of Iceland.

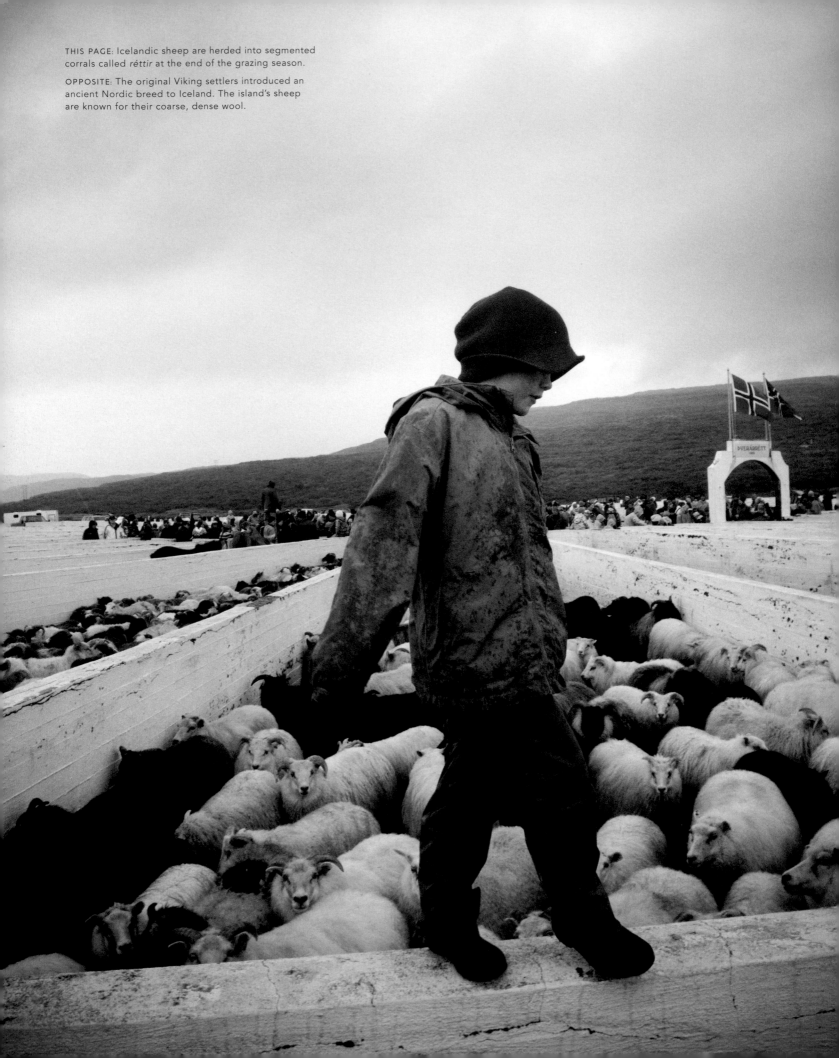

THIS PAGE: Icelandic sheep are herded into segmented corrals called *réttir* at the end of the grazing season.

OPPOSITE: The original Viking settlers introduced an ancient Nordic breed to Iceland. The island's sheep are known for their coarse, dense wool.

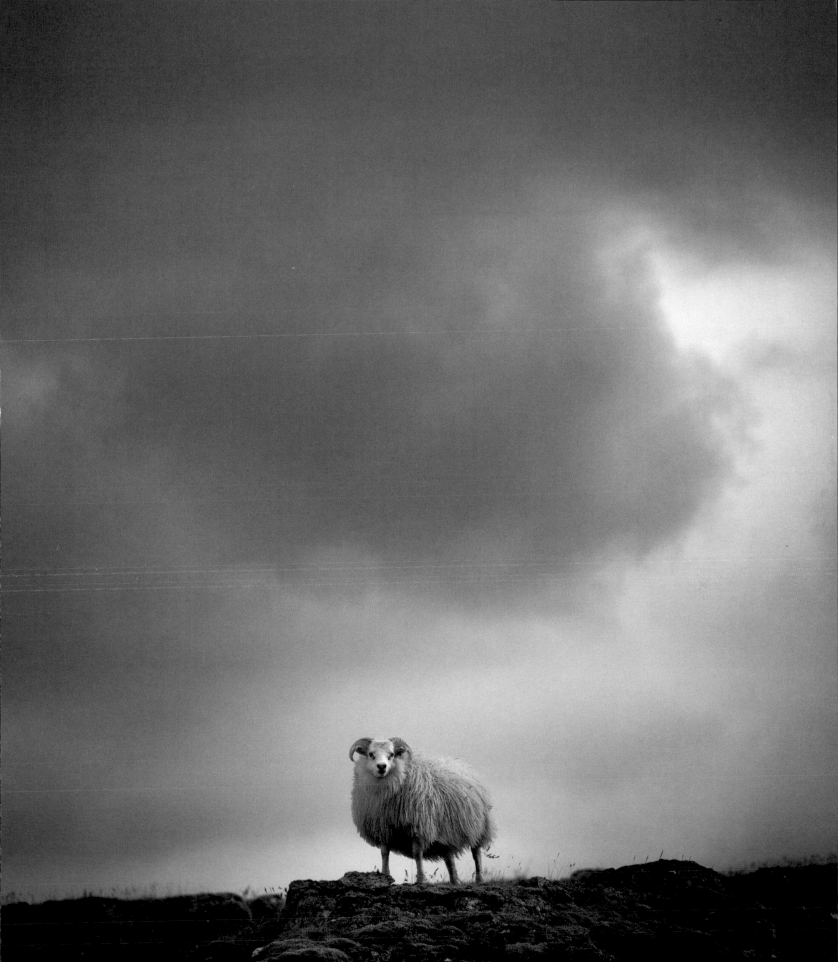

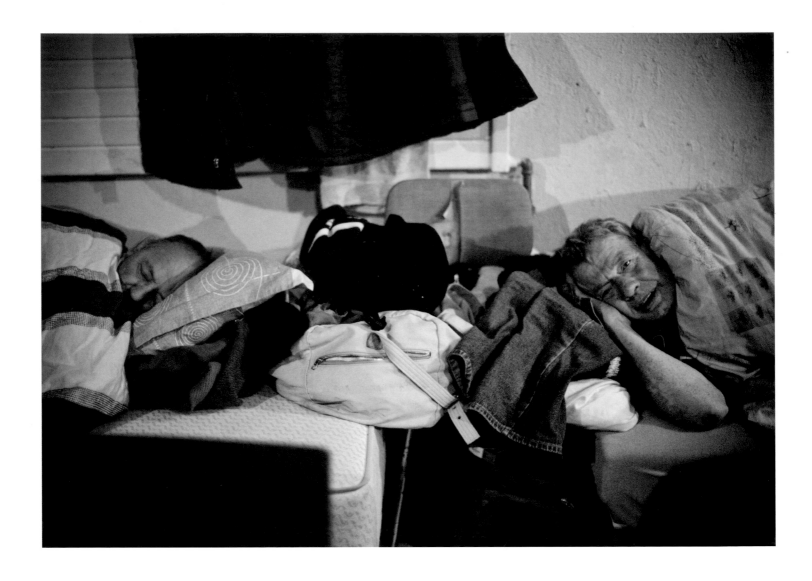

ABOVE: Crowded communal sleeping quarters in the bunkhouse at Fornihvammur. Dogs sleep in the foyer and horses are stabled in the connecting barn.

OPPOSITE: Starting the day early with coffee and cigarettes before saddling up.

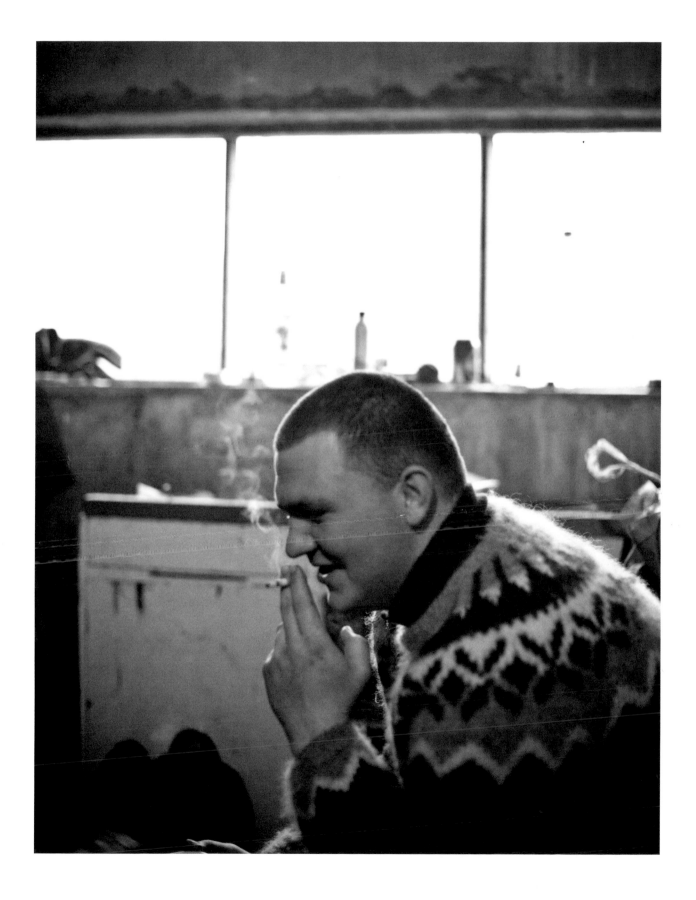

Once the truck and horse trailer pulled out of the yard, Sindri went back inside to warm his hands by the stove, where water for tea and instant porridge was boiling. His wife, Kristín, a compact woman with shy blue eyes, was seated at the table sawing chunks from a haunch of smoked lamb for sandwiches. Her father held the title of *fjallkongur* (mountain king), meaning he supervised the deployment of crews along the granite ridges above their farmstead where flocks ranged freely during the midnight sun of summer. Kristín was expected to ride hard like any of the men. She had missed only one *leitir* while pregnant with her daughter. Her sister Maria crawled out of a bottom bunk. Smiling weakly, she confessed to a sleepless night. She had also started riding the roundup as a teenager.

"I've been going ever since, except for the year I lived in Vancouver," she said. "My sisters called me on the phone from Fornihvammur and I could hear voices in the background. It was a lot more difficult than being away at Christmas." Maria bound her straight black hair in a bandanna and slipped an orange rain poncho over her head. "And I can tell you honestly that I cried a lot that weekend. How silly is that?"

In the diluted daylight, I stood in the churned mud and manure of the bunkhouse yard, Kristín's sandwiches bulging in my windbreaker pockets as Sindri led up a chesty butterscotch gelding named Glowi.

"He's very gentle. My son rides him."

I offered a carrot. Glowi ignored it.

"They like stale bread," said Sindri, adjusting the stirrups. "Icelandic horses are not accustomed to eating vegetables."

I stroked the long, coarse mane. Glowi flipped it out of my fingers. Most Icelandic horses are on the stocky side, but the language lacks a word for "pony." After helping me scramble onto Glowi's back, Sindri mounted his own horse. The leather saddle creaked. His legs dangled, not quite to the ground, but close.

We trotted on a grassy path that rose up the hill behind the bunkhouse, Sindri and Maria each leading a spare horse by the reins. Trikkur, one of the family's collies, charged ahead. "Hup, hup," Sindri commanded, and the dog leaped over a barbed wire fence. After ascending for an hour, Sindri palmed a can of ale from his weatherproof overalls and popped the tab. He dismounted next to a volcanic boulder the size of a humpback whale and huddled on the tundra below permanent patches of ice. We were almost as high as Langjökull glacier, a few miles to the east. Once in a while, Sindri mentioned, sheep wandered onto the ice shelf itself, full of dangerous fissures. In the distance, we spotted Kristín driving a line of sheep through a gully on the far side of a ravine. They rushed between black tumbled boulders in a tidy

grouping as she charged behind them. Sindri noted that once the sheep started to flock, they would all run in the same direction. Maria lay on the wet ground as Trikkur panted next to her. My fleece socks were already soaked.

✽

As early as 982 CE, the Icelandic Parliament passed laws prohibiting the importation of foreign livestock, which meant that, like the Vikings themselves, the island's sheep had been isolated for over a millennium, with intriguing consequences. Back in Reykjavík before the roundup, Emma Eythorsdóttir, a biologist with the Agricultural University of Iceland, explained to me that although the original animals brought over on Viking longships had been standard northern European stock, over the ensuing centuries, the island's extreme climate and terrain produced divergent traits.

"Because there are no natural predators here, our sheep lack the 'fight or flight' mechanism," she said. "Do you know some have leadership tendencies?"

Heroic sheep?

"Certain sheep instinctively know when winter is coming, and help the farmer by leading the flock to the barn. Some of us are concerned that this trait is disappearing now that we use dogs and modern technologies during the *leitir*." While Iceland's sheep don't appear divergent, their wool is singularly coarse and water resistant, which is suited to knitting outer garments, practically a national pastime for both men and women.

✽

On the mountain, waiting for further positioning orders from the *fjallkongur*, Sindri passed around a plastic Pepsi bottle filled with Cognac. He unzipped his XXL jacket.

"A couple of years ago, it was snowing like crazy up here during the search." Maria said. "I was sheltering near this rock for hours. My God, I thought I was going to die."

From his jacket pocket, Sindri removed a knife and a portion of *svið*, scorched sheep's head with the teeth and eye sockets exposed. He scraped meat off the cheek and popped it into his mouth, chewing absently as Trikkur begged for scraps.

"I only eat food with a face," he joked.

Maria confessed she couldn't bear the taste anymore. "One day when I was little, my father told me it was my pet sheep that I had raised from birth. That was it."

Changing the subject, I asked Sindri about leader sheep.

"Some farmers have one or two, but I don't like them in my flock."

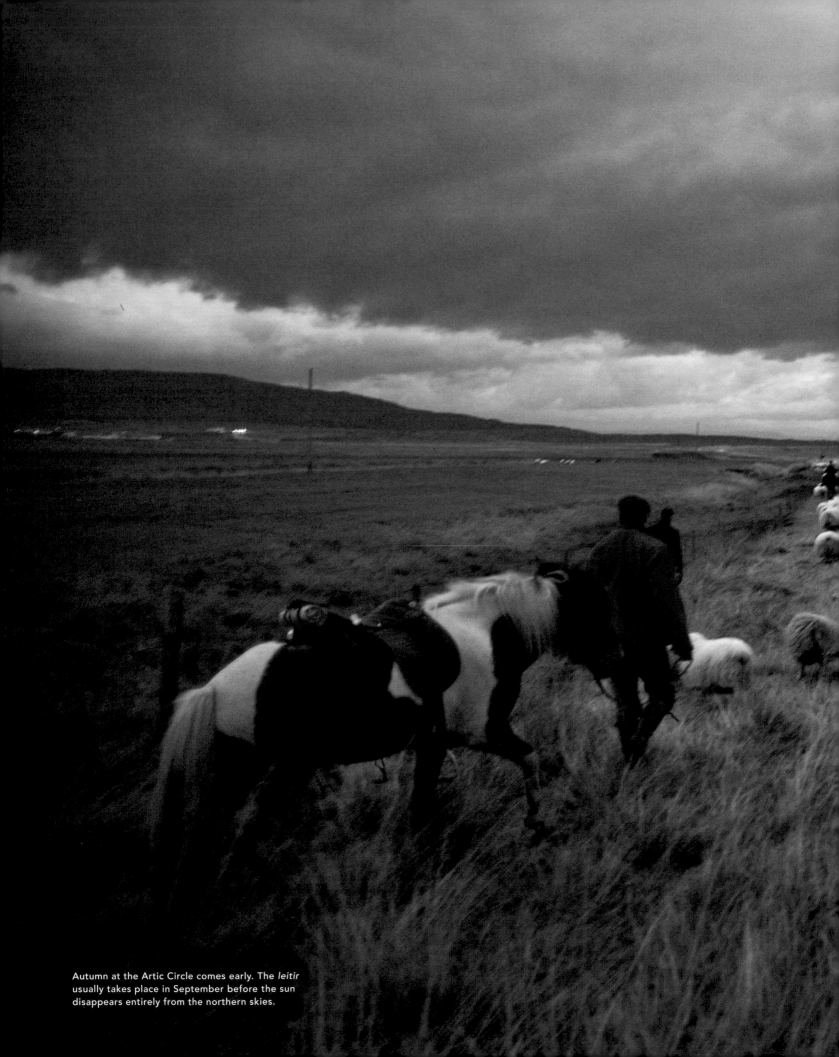

Autumn at the Artic Circle comes early. The *leitir* usually takes place in September before the sun disappears entirely from the northern skies.

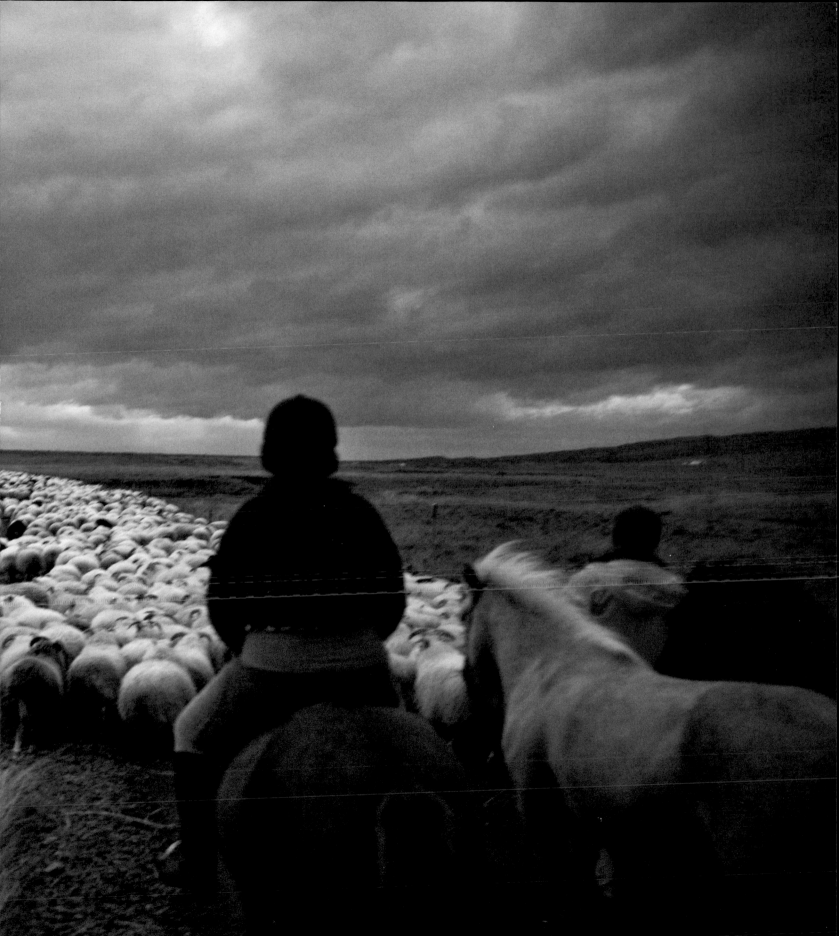

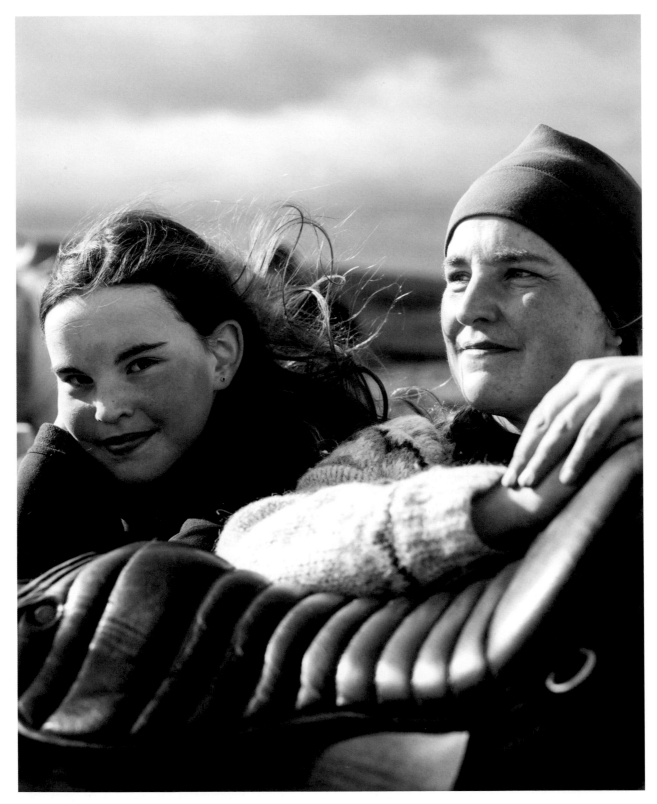

Like mother, like daughter. Kristín Kristjánsdóttir
with Lilja, which means "lily" in Icelandic.

"Why not?"

"They have a sixth sense, something more than others in their brain. There is an old story that they can survive in really bad weather but they are awful animals, so independent, and will break through fences."

So what did a leader sheep look like?

"They are brown and black with bigger horns. Leaner than other sheep. Not very good meat."

As we sat there in the heather and reindeer moss, wind roared up the slope and seared our cheeks. On the horizon, clouds slammed against each other with the violence of angry lovers and tumbled recklessly together across razor peaks that callously shredded them apart. Sindri's cell phone rang. We mounted again and, encumbered with the spare horses, traversed the slope to rendezvous with the walking brigade, which had picked their way down off the summit. Maria halted at her appointed spot. Sindri faded from sight seeking a better signal. I considered what it would have been like a thousand years before, when Icelanders relied on visual markers rather than electronics. Ancient lava rock cairns still paralleled the Ring Road, periodic signposts indicating the easiest route for shepherds to cross the island. When several of the walking brigades materialized in a gulley below my location, I recognized the law student who slept next to me in the top bunk. We waved to each other.

Glowi whinnied. He expanded his rib cage between my thighs, and whinnied louder, shaking his head and spraying droplets from his mane. His steel shoes clattered through a rocky vale. By midafternoon, I was still nowhere near Fornihvammur and had an unquiet moment when it occurred to me that I could get caught out here in the dark alone. For most people that would be daunting enough, but Icelanders heighten the drama with a palpable belief in things that go bump in the night: ravenous crones, bone-crunching trolls, sea monsters, homicidal cats, and succubus worms patched together by witches using scraps of wool and a dead man's ribs; trickiest of all, the elves, who occasionally show themselves to startled humans. The portal to their world was, as I understood it, always near erratic boulders. The ridges above Fornihvammur were full of them.

On a swiftly moving bend, one ewe scrambled across a gravel bar and powered up the opposite bank. A fat lamb got caught in the river current and became pinned against the undercut turf. The mother cried its distress as the soggy offspring struggled to keep from drowning. I twitched Glowi's reins and he moved forward into the water, startling the animal so that it swam back to a shallow spot on my side. Shaking its matted wool, the lamb ran uphill. Glowi spun in a tight turn as I headed the lamb back toward its parent. They stood on opposite sides of the stream bleating urgently. Finally, the baby bolted across as I brought the horse behind it. Two sheep herded all by myself.

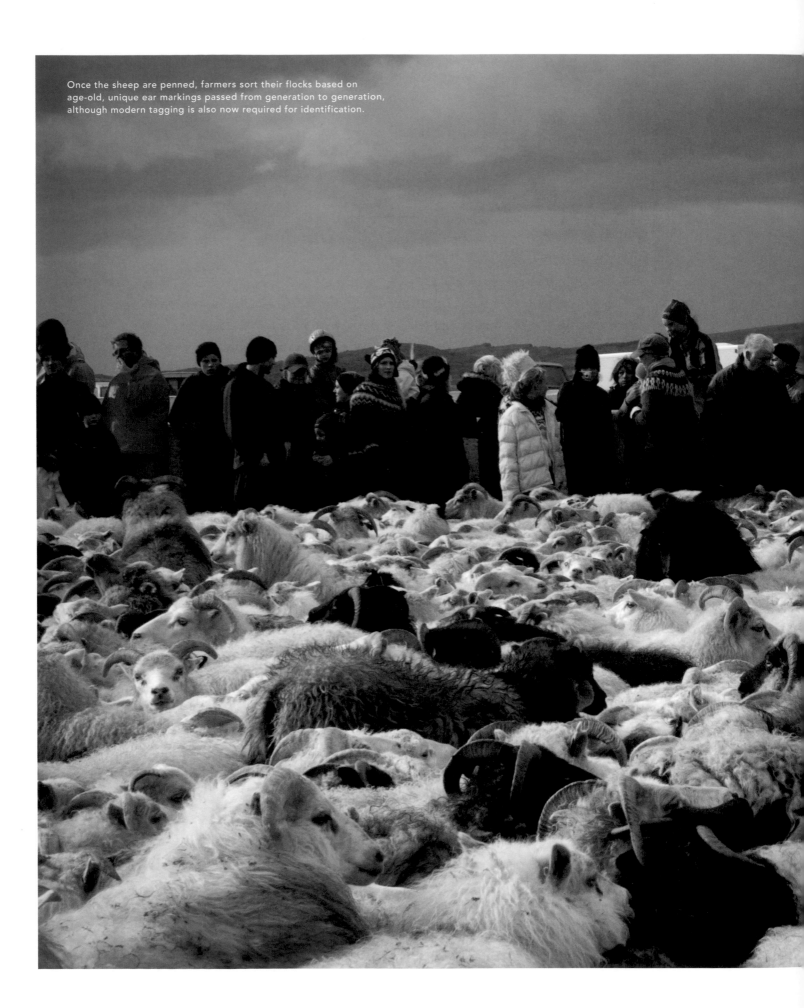

Once the sheep are penned, farmers sort their flocks based on age-old, unique ear markings passed from generation to generation, although modern tagging is also now required for identification.

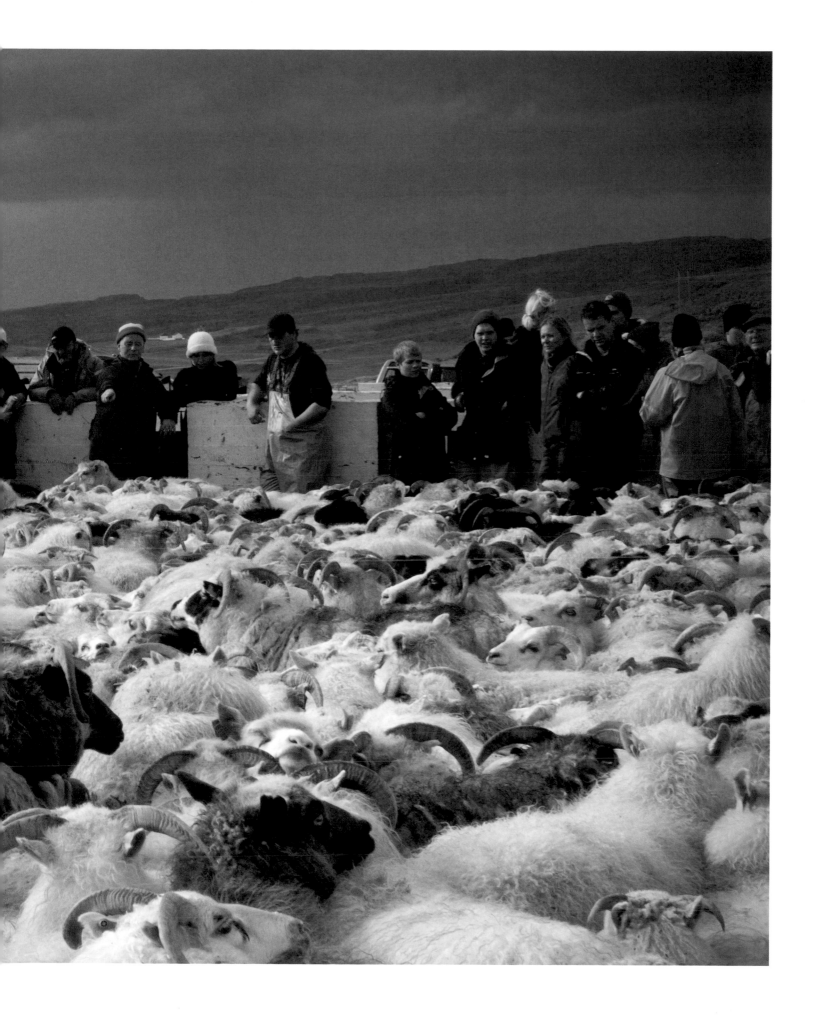

The light had faded by the time I reached the main road and, after a long day of seeing only half a dozen sheep, I dodged hundreds spilling across the asphalt as riders and walkers converged near the bunkhouse. Drivers merrily honked their horns, steering their cars against the flow. Agnar rushed past, his cheerful face crumpled with concern for the upturned burden in his arms, a lamb with its spindly leg broken. Other riders turned for the cabin and I noticed that the sheep were being left to their own devices along the driveway and in adjoining fields.

"What happens if they roam off?"

Sindri, grabbing Glowi's halter, shrugged. "Some do. We will just gather them again. Now and then, after the *leitir*, we hear that a stray has been spotted."

✳

Inside the bunkhouse, everyone peeled off wet layers and crawled into sleeping bags or collapsed on chairs around the table. Kristín went past holding a bowl full of boiled bones, glossy with fat and gristle, for the dogs. Trikkur slipped inside and hid under the table. He rested his chin on Maria's knee. She rubbed his damp head but then firmly pushed him back out the door. Dinner was prepared by a neighboring farmwife—ground lamb patties, a big bowl of dark gravy, two kinds of roasted potatoes, boiled red cabbage, and a sticky rhubarb-prune jam.

I chewed slowly while trying to keep my head out of the gravy. The lamb patty was cooked to the consistency of a hockey puck. Icelanders are not fans of raw food. The more aged, or even putrefied, the better to their palate, but after a long day of eating only some pocket-smashed sandwiches and squelchy chocolate bars, it's possible to be so hungry that "hot" becomes a flavor.

At my end of the table, those who spoke English switched languages and I noted the relationship of teacher, policeman, fire alarm salesman, and electrician sitting around me. Some were cousins, others grew up on a farm or owned sheep themselves. (Those not formally hired to work the three weekends when *leitir* takes place apparently consider a fifteen-hour trek in slashing rain a joy ride.) They all knew Sindri. They began telling bad jokes.

The electrician, deadpan, asked, "What should you do when you get lost in an Icelandic forest?"

I had no clue.

"Stand up."

A bottle of caraway-infused Brennivín "Black Death" schnapps made its way around the table. It was like drinking 75-proof rye bread. When the spirit was first distilled after

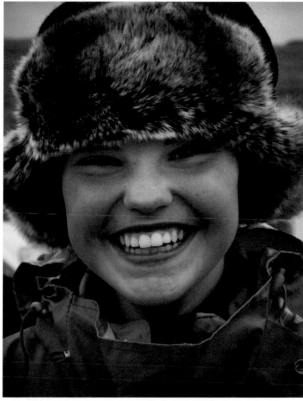

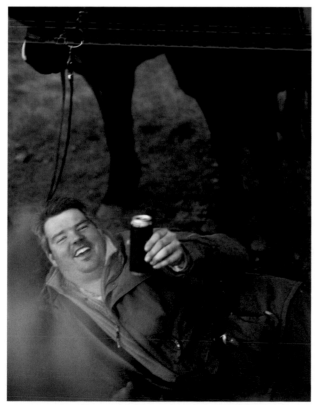

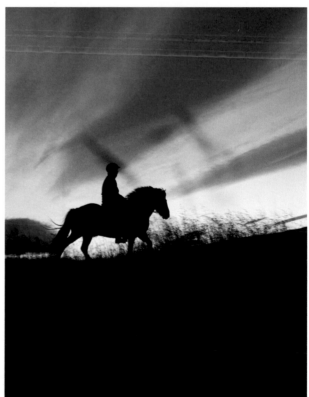

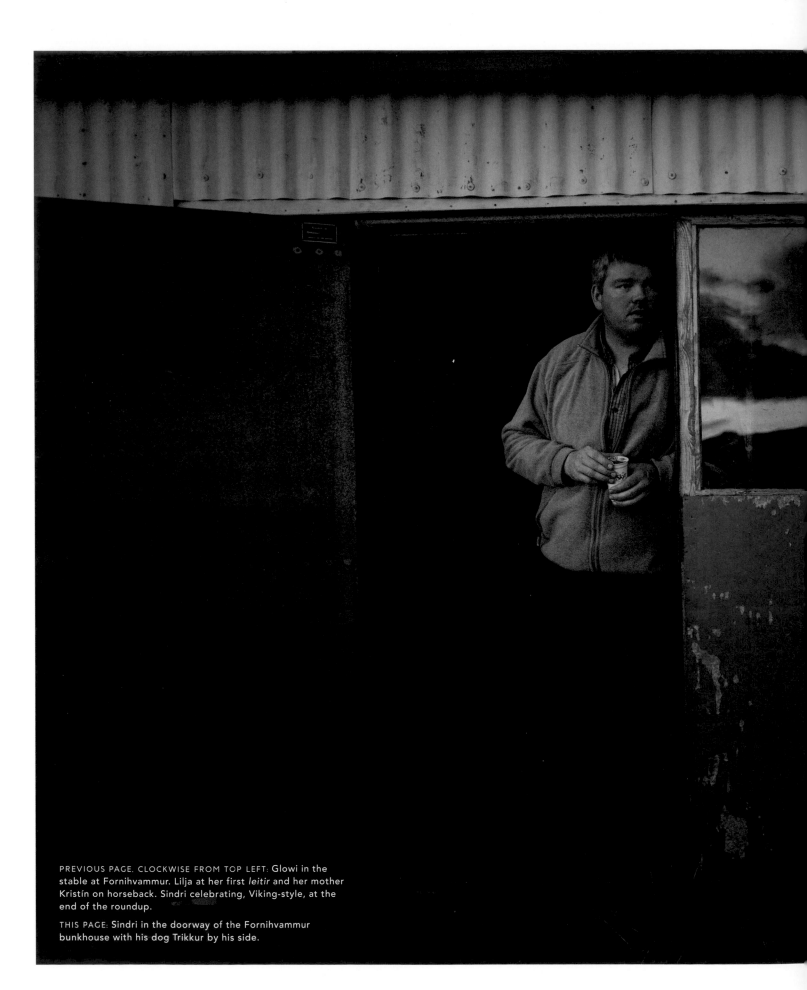

PREVIOUS PAGE, CLOCKWISE FROM TOP LEFT: Glowi in the stable at Fornihvammur. Lilja at her first *leitir* and her mother Kristín on horseback. Sindri celebrating, Viking-style, at the end of the roundup.

THIS PAGE: Sindri in the doorway of the Fornihvammur bunkhouse with his dog Trikkur by his side.

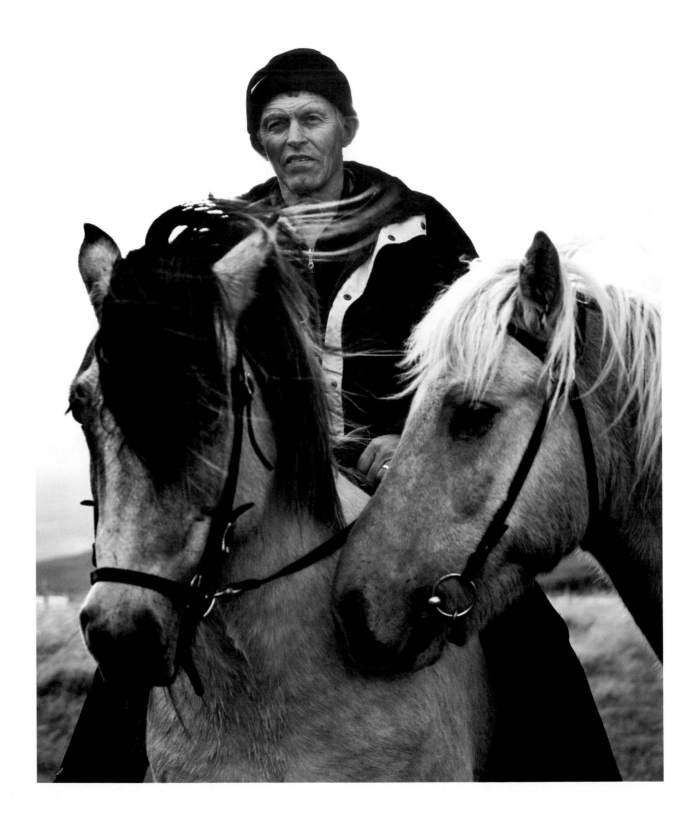

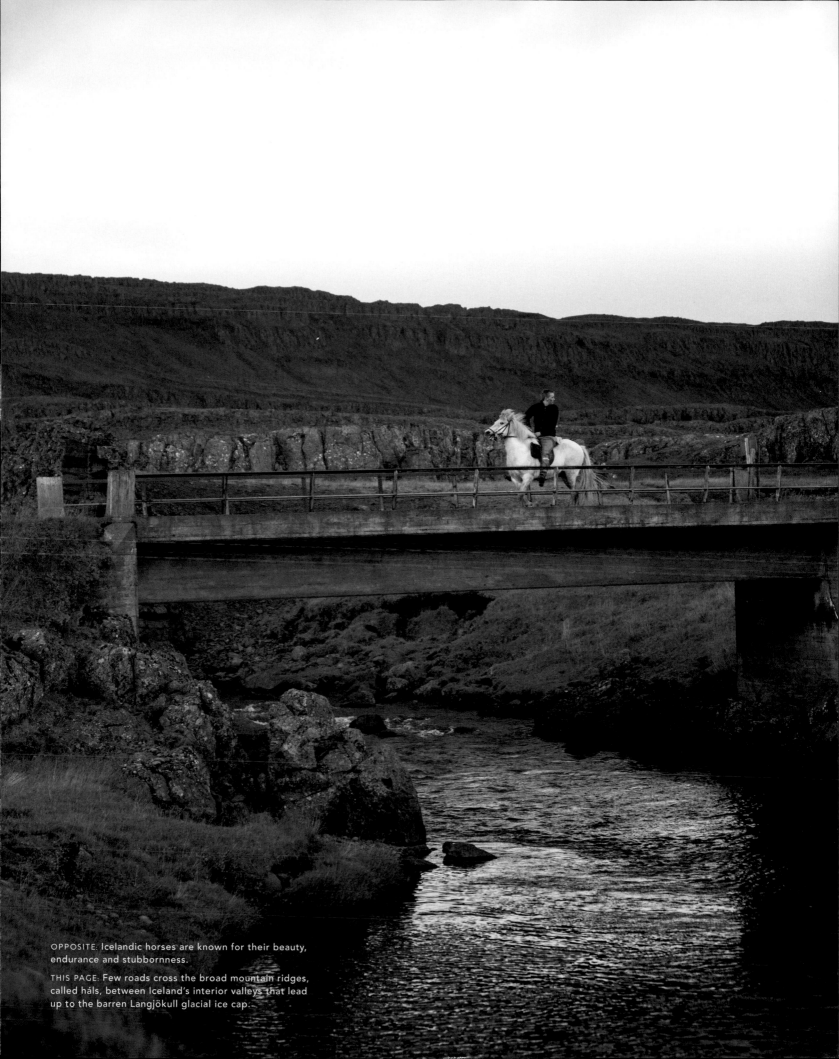

OPPOSITE: Icelandic horses are known for their beauty, endurance and stubbornness.

THIS PAGE: Few roads cross the broad mountain ridges, called háls, between Iceland's interior valleys that lead up to the barren Langjökull glacial ice cap.

Icelandic sheep are permitted to graze freely on the island, which lacks large predators, apart from the occasional polar bear that swims ashore at the Arctic Circle.

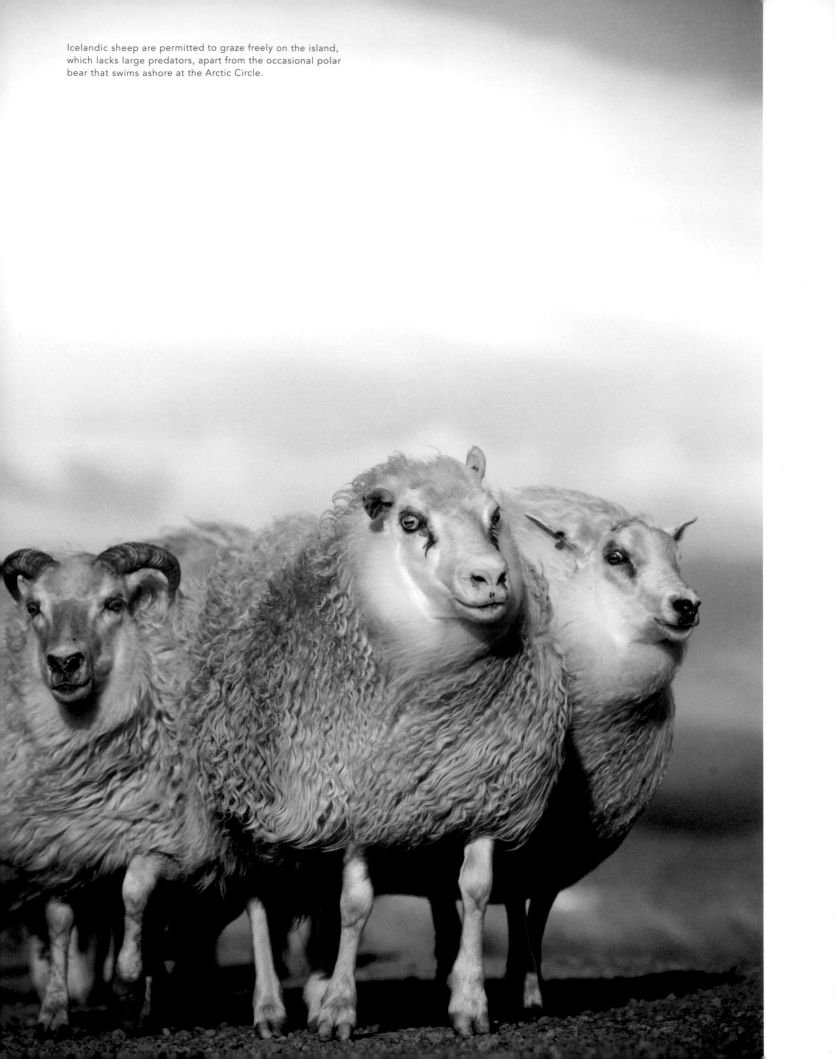

Iceland's own Prohibition ended in 1935, the original label displayed a *svarti dauði*, or "black death" graphic of a skull with a top hat, to caution against excessive consumption. No one paid much attention to the warning but the nickname stuck. Sindri hauled out a sack of snuff, sprinkled a tidy pile onto his fist, and inhaled, wiping a black streak across his nostrils. I asked where he grew up.

"Reykjavík," he replied. "But I always wanted to raise sheep."

A bridge game started at the far end of the table. Sindri got up to play. The hard drinkers filled flasks with vodka and Captain Morgan spiced rum for the ride the next day. As the lights were about to go out, Sindri warned me. "Tonight will be very cold. There is something wrong with the stove and we will have no heat."

Squashed the night before, I chose an empty top bunk next to an outer wall. Not bothering to strip out of clothing that smelled of horse sweat, I wrapped myself in a wool blanket and in the darkness listened to restless animals on the other side of the foyer. Damp crept through an open window. I lay shivering. My warm parka with a fuzzy lining was locked in a car outside, but retrieving it meant climbing out of bed and stumbling around sightless in a room full of snoring Vikings.

The next morning, the stove still refused to cooperate. The room smelled of stale beer. Sindri and Kristín's daughter Lilja arrived as others piled out of the cabin. She was turning thirteen at the weekend, so this was to be her first *leitir*. A pretty brunette with a wide smile, she was already taller than her mother. Lilja opened the Fornihvammur guest book to show me where Sindri signed *faðir* (father) while Kristín was still in the hospital after giving birth.

Just as Sindri fished the rings of the harness over Glowi's head, Trikkur trotted up and squatted. "This dog does not bark enough at the sheep," he said mildly. "I may have to get rid of him." Lilja sidled her dappled palomino next to me and adjusted my helmet's twisted chinstrap. Then she showed me how to hold the reins properly. No wonder Glowi had been cranky the day before.

We left the yard and crossed the Ring Road to turn southeast after the other riders. Then, as his wife and daughter went ahead slightly, I asked Sindri a tactless question.

"What is it like being so tall?"

"When I sat down in a movie theater, I would always hear someone in the seat behind me saying, 'Awwwwh.' But now I don't care."

Sindri and Kristín then climbed higher along a ridgeline as Lilja and I hugged the shoulder of the Ring Road. The ground seemed more crumbled and pitted, with boggy patches in the loam. The two of us drifted wider as we gathered more sheep. Sindri shouted somewhere

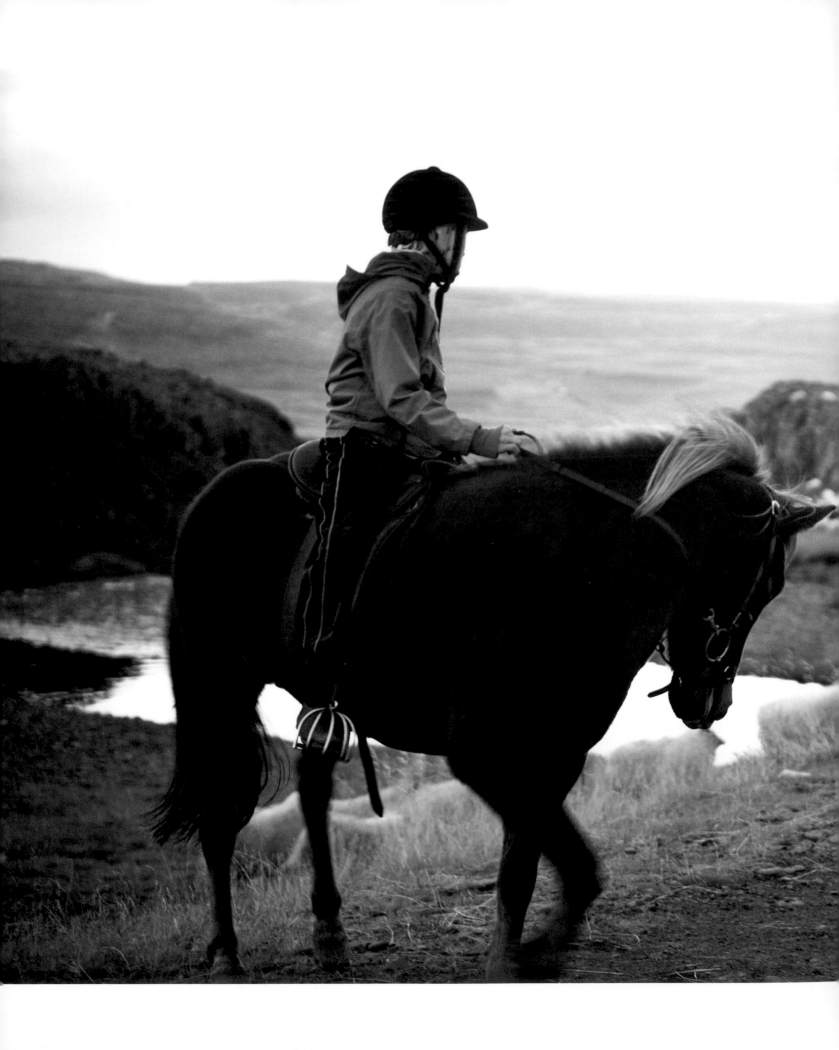

Participating in the *leitir* is a rite of passage for many farm children. Most join in by their thirteenth birthday.

above us. His warning came too late. Several dozen animals stampeded past, hell-bent for the highlands. One was brown with big horns. All the sheep in our care turned around and bolted as well. Lilja's horse balked and threw her to the ground. Kristín galloped down the slope at full speed and held her daughter until her breath returned.

We halted in early afternoon at a car park. A horse ridden by another of Sindri's crew had lost its footing and tumbled forward. Its forehead was scraped to the bone with bloody skin peeled back in a nasty gash. The steed kept rearing as its rider tried to offer comfort until a vet arrived. Sindri asked if I would give up Glowi. As the others from Fornihvammur drove the swelling flock across the river and the cries of "hup, hup, hup" faded, I caught a lift back to the bunkhouse and picked up my car.

Rolling through a snug vale dotted with barns and pastures, the sun came out and the sky was blue as a new iceberg. The rattle and hum of glacial wind died away. It even turned warm enough to strip off my mud-spattered jacket. I parked the car near a bridge where the *leitir* would have to pass and got out to lie down in the rusty grass by the stream's edge. Other cars pulled up. It felt like the moments leading up to a parade.

Ravens cackling overhead interrupted my reverie. A couple of sheep blithely jogged down the road. Behind them, silhouetted along the top of the granite hills, thousands more appeared. They poured over every rock, every ridge, into every gully and cove, attempting to ram through barbed wire fencing and ford the stream, trampling grass, startling hidden grouse and field mice as they rushed, a solid wave of wool. Behind them, a phalanx of riders from three separate *leitirs*, joined back on the heights for the final push. My car was engulfed. Climbing atop the hood to view the sheepish tsunami, I looked across the valley and saw more flocks—almost twenty thousand animals—headed to the concrete paddocks.

I recognized faces from Fornihvammur as riders trailed past. Agnar, leading two mounts, had a pant leg ripped from his overalls. Near-empty bottles of schnapps held high, Maria and Kristín galloped with friends. Lilja was next, her cheeks pink, sitting straight in her saddle. At dusk, Sindri and the hard-core walkers showed up. He stretched out his considerable length on the grass.

"We are glad to find you as there is sure to be something to drink in the back of that car."

Agnar peered inside the open tailgate. "I'm about to kill one of these people for a beer." I held up a six-pack. His eyes brightened.

"You've saved a life," he laughed.

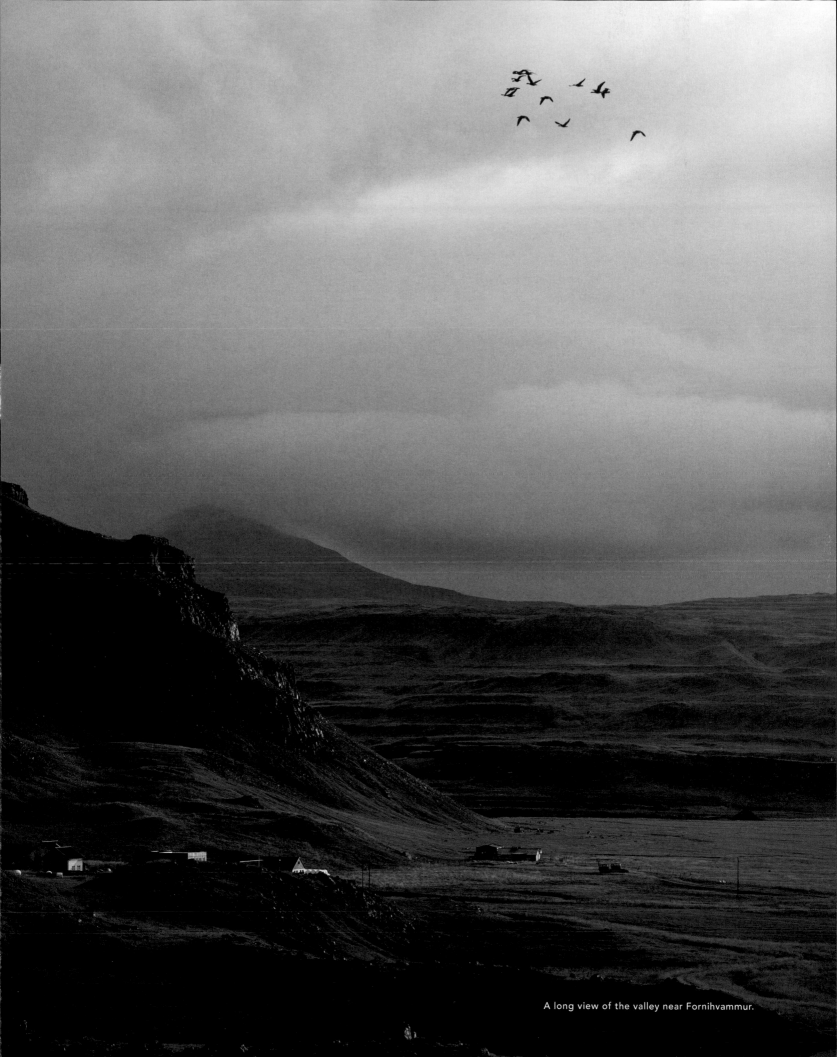

A long view of the valley near Fornihvammur.

FISKISÚPA / FISH CHOWDER

SERVES 6 TO 8

After bobbing around the Arctic Circle off the Westfjords coastline for a morning with two long-line cod fishermen, I wound up in a converted fish-drying shed back on the docks, where a self-taught cook, Magnús Hauksson, brought out a tureen of creamy chowder that had simmered on a back burner in his cramped kitchen. It's never the same from day to day because he adds whatever the boats bring home from the North Atlantic to the pot. For my own version of fiskisúpa, or fish chowder, fresh-caught haddock and arctic char swim in a rich shellfish stock.

To make the stock, eat two lobsters. Save the shells, and don't bother to rinse them. Then make the stock, which can be frozen for later use. Alternatively, use shrimp shells or tiny dried shrimp—tom kho thuong hang—available in most Asian markets. It makes umami-rich stock as well.

LOBSTER STOCK

Shells of 2 lobsters

1 carrot

1 handful flat-leaf parsley

1 small sweet onion, unpeeled, quartered

2 or 3 cloves garlic, crushed

1 tablespoon red peppercorns

1 whole dried bird's eye chile pepper

1 stalk celery

1 teaspoon coarse sea salt

SOUP

1 pound salt pork with rind, chopped

½ cup (1 stick) butter

2 pounds onions, peeled, halved, and cut into crescents

1 head garlic, or at least 4 large cloves, peeled and minced

1 leek, washed and sliced into rounds

2 tablespoons freshly ground pepper

½ cup minced flat-leaf parsley

1½ pounds Arctic char fillets, skin removed, rinsed

1½ pounds fresh haddock fillets, rinsed

6 to 7 cups lobster stock

4 pounds waxy yellow potatoes, such as Yukon gold, peeled and cubed

4 tablespoons browned flour (page 199)

1 (750 ml) bottle dry white wine

3 cups light cream

Coarse sea salt

To make the stock, in a 6-quart stockpot, combine all the ingredients and cover with cold water. Simmer until reduced by half, 2 to 3 hours. Do not allow to boil. Strain the liquid through a fine sieve and discard the solids. For a clearer stock, strain a second time through cheesecloth, but it's not necessary to apply French techniques among friends. Allow to cool before storing in large freezer-friendly containers.

To make the soup, in a skillet, render the salt pork. Remove the browned lardons, drain on paper towels or a brown paper bag, and set aside. Reserve the fat. Wipe out the skillet and reheat to melt the butter. Add 4 tablespoons of the reserved fat. Add the onions, garlic, leek, pepper, and parsley to the pan. Stir until softened but not browned.

Without shredding the flesh, carefully chop the fish into medium chunks.

In a 6-quart stockpot over medium-high heat, bring the stock to boil, add the potatoes, and lower the heat to a simmer. Cook until tender, 20 to 30 minutes. Add the fish and continue to cook until tender, 20 more minutes. Add the onion mixture. Sift in the browned flour carefully to avoid lumps. Pour in the wine and cream, stirring to blend all the ingredients. Allow to simmer for 3 to 4 hours, stirring occasionally to avoid sticking. The potatoes and fish will break down as the liquid reduces.

Before serving, add salt to taste. Spoon into large bowls and top with a tablespoon of the reserved lardons.

FARMHOUSE SPICE CAKE

SERVES 4

Near the Arctic Circle, the sun barely rises during winter. Icelanders celebrate its return with a tradition called Solar Kaffe, where everyone in the community gathers to drink strong coffee with home-baked cakes. Deep in the countryside, farmwives still favor a comforting spiced loaf that falls between pound cake and panettone. On a visit to the farm to see the sheep in their winter barn, Maria and Kristín Kristjánsdóttir's mother made this one for an afternoon coffee break.

2 cups all-purpose flour
1 teaspoon unsweetened dark cocoa powder
1 teaspoon ground cardamom
1 teaspoon ground cloves
2 teaspoons ground cinnamon
1 teaspoon baking soda
2 teaspoons baking powder
1 cup (2 sticks) butter, at room temperature
1 cup sugar
2 large eggs
1½ cups whole milk

Preheat the oven to 350°F. Butter a springform pan.

In a bowl, combine the flour, cocoa, spices, baking soda, and baking powder.

With a hand or stand mixer, cream the butter and sugar together until light.
Add the eggs and continue beating at medium speed.

In 3 batches, add the flour mixture to the butter mixture, continuing to blend, and then slowly add the milk and blend until the batter is smooth. Pour into the prepared pan.

Bake for 50 to 60 minutes, until firm. Cool on a cake rack before serving.

RABARBARASULTA / RHUBARB PRUNE JAM

MAKES 4 TO 6 CUPS

Rhubarb grows wild in most parts of Iceland. Farmwives gather and leave the stalks to dry for several days before making jam. Tart *rabarbarasulta* is often paired with the Sunday roast lamb; a large jar sat on the dinner table at Fornihvammur. My friend Svala Ólafsdóttir shared her mother's version, which contains prunes. I thought it a sad substitute for fresh fruit, but Svala gently reminded me that prunes are an imported luxury for Icelanders. "The *sulta* was given to guests," she explained. "It showed a farm always had good food even though they were poor." The condensed sweetness of prunes darkens the jam.

3 pounds red rhubarb stalks, cleaned and stemmed
1 cup packed brown sugar
3 cups granulated sugar
1½ cups prunes
1 cup water

Dice the rhubarb into small chunks. In a bowl, combine the rhubarb with both sugars. Cover and allow to stand overnight. The next day, pour the fruit and its collected juices into a wide saucepan. Dice the plump prunes and add to the mixture, then bring to a boil, stirring constantly. Reduce to a simmer. As the fruit cooks down, add the water, and stir regularly to prevent sticking. Cook until the fruit has thickened and the liquid is reduced, about 90 minutes. Pour into four to six 8-ounce canning jars, seal, and process in a hot water bath for 10 minutes.

BRÚNAÐAR KARTÖFLUR / CARAMELIZED POTATOES

SERVES 4

During the *leitir*, dinner at Fornihvammur was simple and filling. Pan-fried lamb patties smothered in gravy, with both plain field spuds and, as a special treat, *brúnaðar kartöflur*, boiled potatoes coated with a buttery caramel sauce. This dish usually appears on holiday tables but, after a long day in the saddle, it tasted like Christmas came early.

2 pounds small waxy potatoes, such as Yukon gold or Red Bliss

⅓ cup sugar

2 tablespoons water

3 tablespoons unsalted butter

4 tablespoons cream

In a pot over high heat, boil the potatoes until tender, about 20 minutes. Drain and allow to cool before peeling. In a clean saucepan, combine the sugar and water and simmer over medium-high heat until the syrup is golden, 6 to 8 minutes. Stir in the butter and potatoes; cook until glazed, about 5 minutes. Add the cream to finish.

ROAST LAMB SHOULDER WITH MUSHROOM GRAVY

SERVES 2 TO 4

Several varieties of Arctic thyme (*Thymus praecox* subsp. *arcticus*) thrive in the Icelandic highlands. Compact tufts spread underfoot in this seemingly hostile landscape, clinging to the tundra like the sheep themselves, who graze higher and higher in elevation as the grass gradually turns green. Icelandic lamb tastes sweeter and wilder than elsewhere. Icelanders serve roasts for Sunday dinner, but they also smoke shoulder and rump cuts for slicing atop flatbread with sweet butter.

LAMB

1½ to 2 pounds boneless lamb shoulder

Coarse sea salt

Black pepper

1 ounce fresh thyme

GRAVY

2¼ cups mushroom stock (page 199)

4 tablespoons browned flour (page 199)

1 to 2 tablespoons pan drippings

Black pepper

Coarse sea salt

Preheat the oven to 350°F.

To make the lamb, trim off any excess fat from the lamb shoulder, and then rub with salt and pepper. Spread the thyme on the bottom of a roasting pan and place the shoulder on top. Roast for about 1 hour, or until the interior turns pink. (Just nick the meat with a knife, for crying out loud. It's a surer test of doneness than using a thermometer.) Discard the charred herbs and drain the pan drippings into a gravy or fat separator. Allow the roast to rest before serving.

To make the gravy, deglaze the pan with 1 cup of the mushroom stock. Add the browned flour, 1 tablespoon at a time, alternating with the pan drippings. Add a dash of pepper and salt to taste. Blend in any juices from the resting lamb. Serve the gravy alongside the lamb.

MUSHROOM STOCK

Mushrooms convey earthiness. This quick stock is ideal for balancing the fat of lamb or beef drippings when preparing gravy to accompany a roast.

8 ounces dried wild mushrooms, such as porcini or morels,
or 12 fresh shiitake mushrooms and stems, cleaned

Add the mushrooms to a large saucepan and fill with cold water. Simmer until the liquid is reduced by half, about 30 minutes. The stock should resemble rich loam in color. Strain into a container and reserve the solids for other use. The stock can be frozen for later use.

BROWNED FLOUR

This is a classic technique for making a rustic roux base for pan gravies. Browned flour tastes almost nutty. Unlike raw flour, it doesn't create lumps and works as a thickener for stews and soups, too.

1 cup all-purpose flour, preferably White Lily, sifted

In a dry, cast-iron skillet, slowly heat the flour while stirring constantly with a spoon. (Don't stop stirring or the flour may scorch.) Continue to scrape the pan until the flour turns deep golden brown, about 10 minutes. Set aside to cool. Store in a sealed container for up to 6 months.

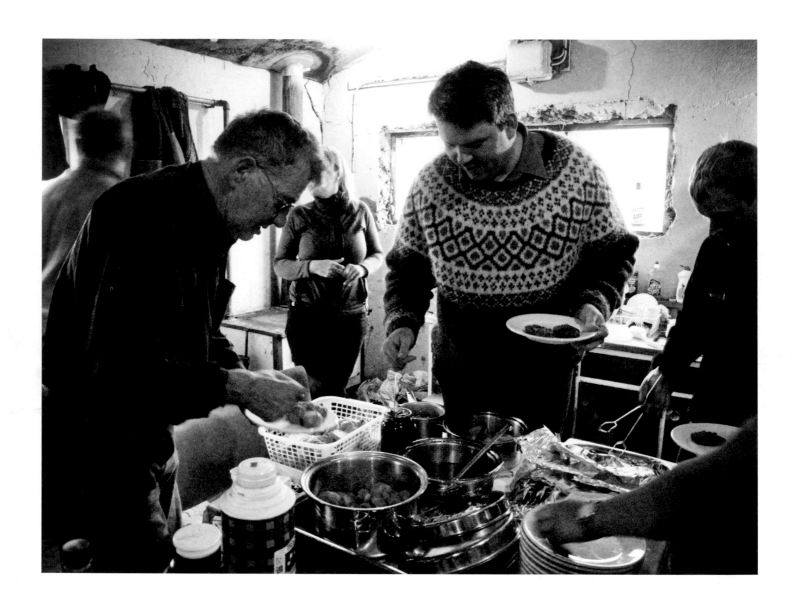

ABOVE: Dinner in the bunkhouse after a long day's ride includes lamb patties, caramelized potatoes, and thick mushroom gravy.

OPPOSITE: Before the invention of waterproof boots, Icelandic shepherds hunted sheep in inclement weather wearing untanned leather brogues.

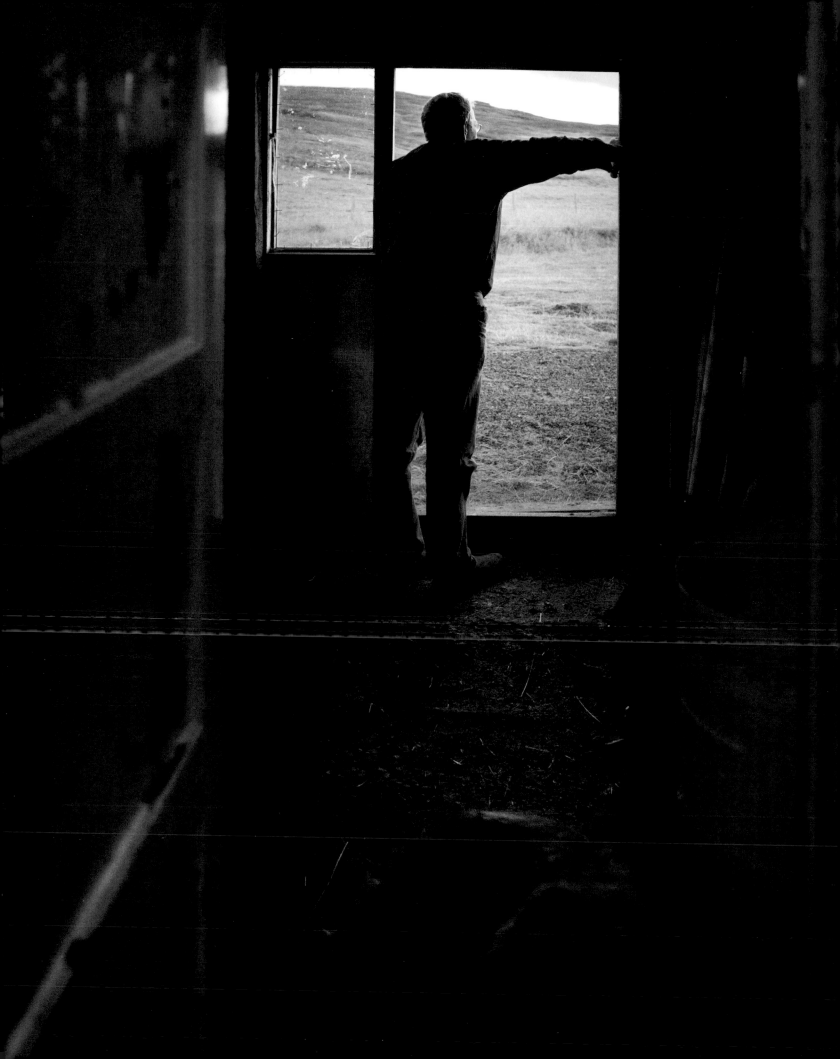

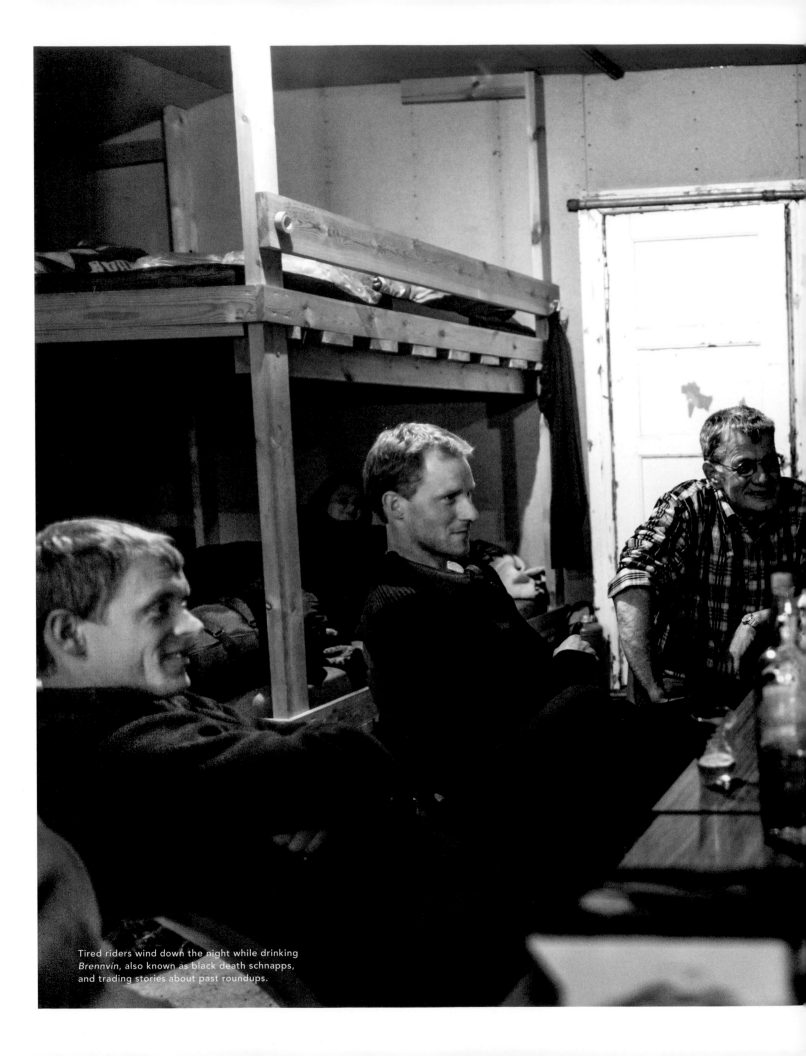

Tired riders wind down the night while drinking *Brennvín*, also known as black death schnapps, and trading stories about past roundups.

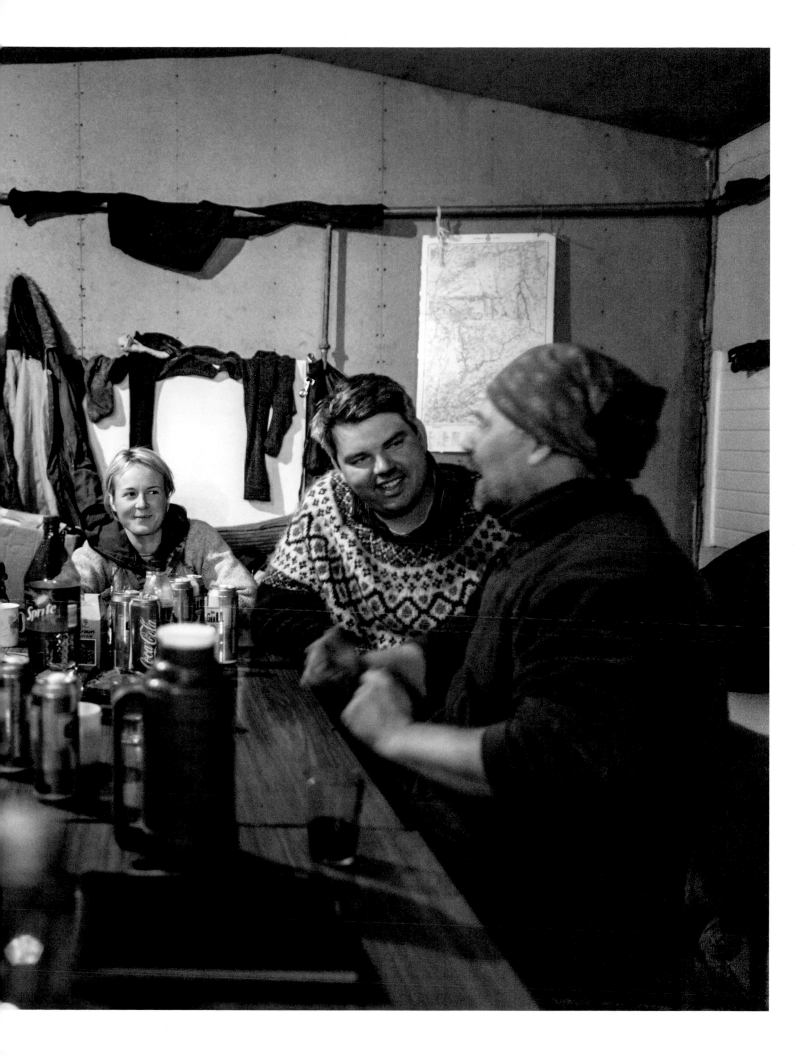

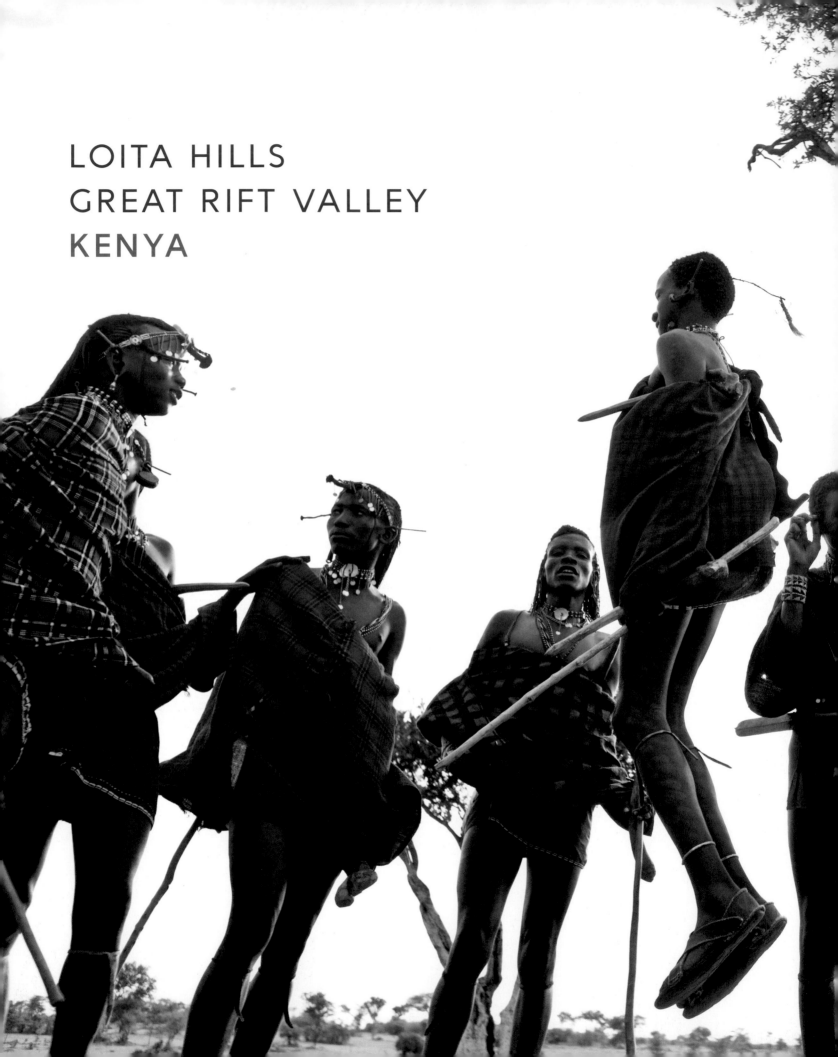

LOITA HILLS
GREAT RIFT VALLEY
KENYA

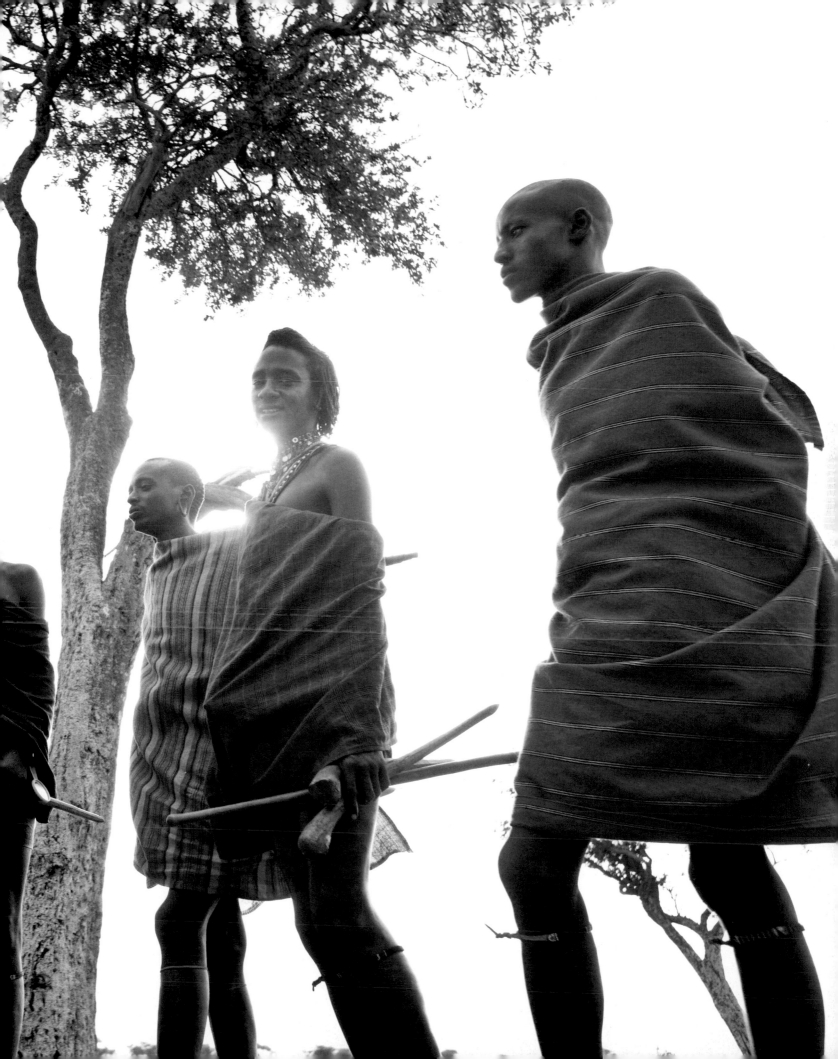

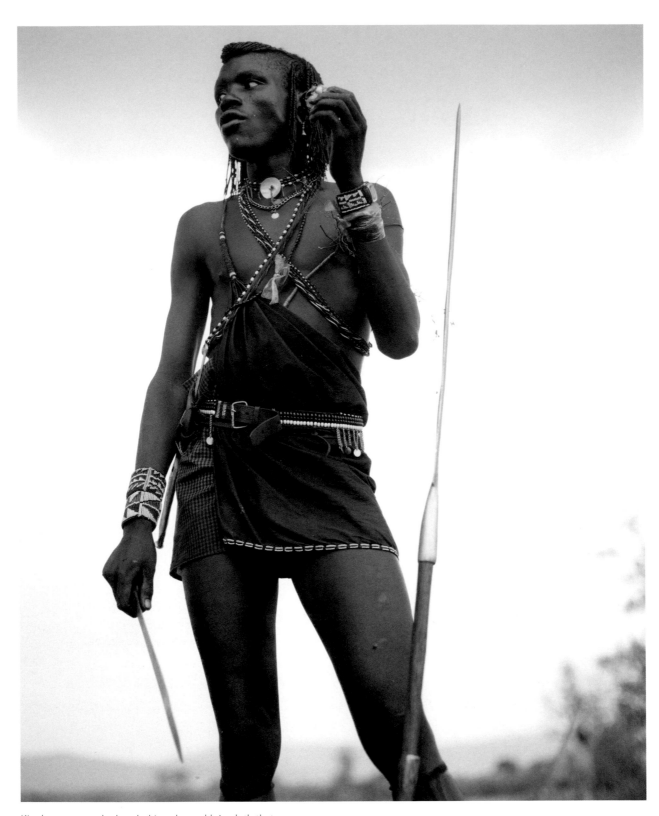

Kipalonga wears the beaded jewelry and loin cloth that
distinguishes young Maasai warriors.

KIPALONGA / MAASAI WARRIOR

Loita Hills, Great Rift Valley, Kenya

Shortly after dawn in the Loita Hills, on the border between Kenya and Tanzania, a roving band of teenagers, decked in beads and armed to the teeth with spears and machetes, approached my Land Rover, parked outside the thorn barricade that protected their village from predators. At first, one boy's head popped up to check his reflection in the car window. Then two more appeared. Finally, eight were bunched outside, peering in.

"Original Maasai," claimed the handsomest, whose face and tightly woven braids were smeared with henna paste. He perched his forearms on the base of the rear window and leaned into the vehicle.

"Give me money," he grinned.

"Honey, you've got to be kidding," I said. "Try harder."

His name was Kipalonga, he told me with a jut of his chin. He was at the stage in life when Maasai adorn themselves, roam unsupervised by elders, steal cattle, and flirt with girls. My translator, William Ole Siara, had cautioned me to avoid these dangerous young men, but he was off somewhere conversing with other herdsmen, and soon I was examining their carved wooden clubs as they swatted flies with my hand fan.

Some had strangely beautiful colloidal scaring on their arms and chests. Shells, buttons, strands of beads, and drinking straws dangled from their necks and ears. A trader out of Nairobi sold them small plastic mirrors marked "Made in China," which these dandies bound to their wrists like French courtiers. All wore the strap sandals fashioned from recycled tires known as Thousand Miles. *Safari* really means a long walk or journey, and this band had hiked overland from deep inside Tanzania, crossing the border into Kenya illegally through territory where lions stalked freely. They were gloriously conspicuous in a stark landscape of sand and scrub.

Maasai warriors, or *murran* in Kiswahili, can be secretive eaters. One of the biggest social taboos is the consumption of meat with others not belonging to their age group. It gets even more complicated when women are involved. Warriors can feel downright shameful eating

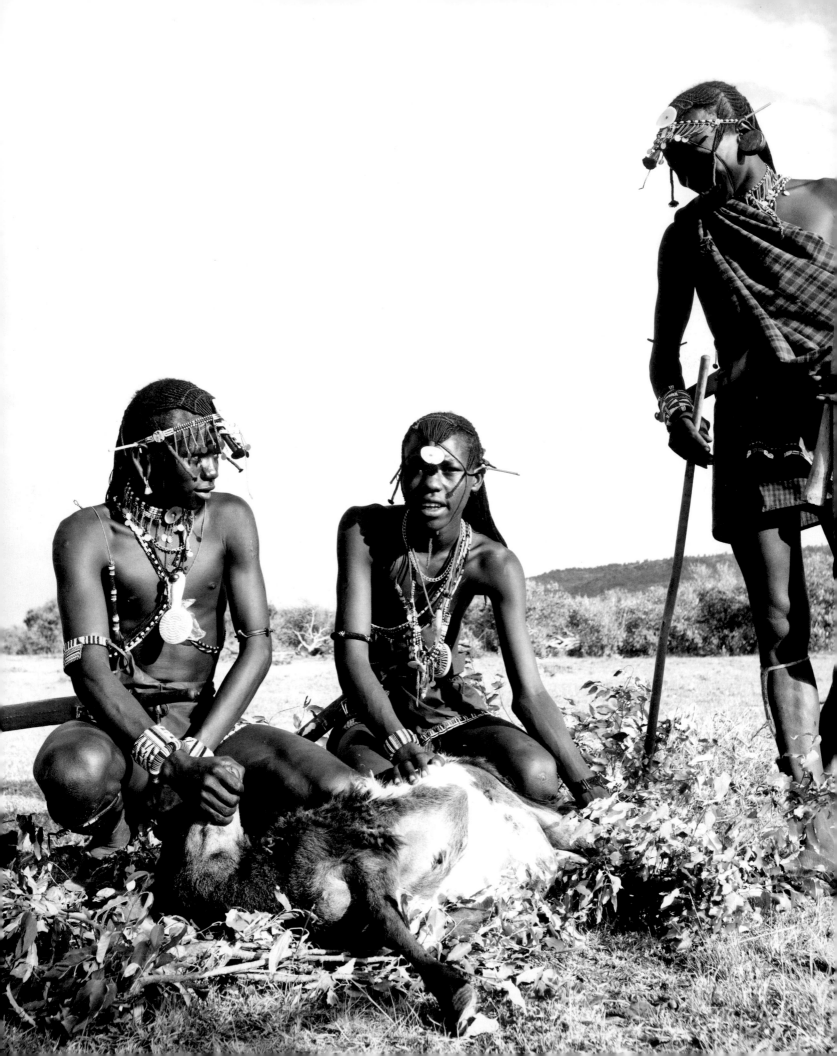

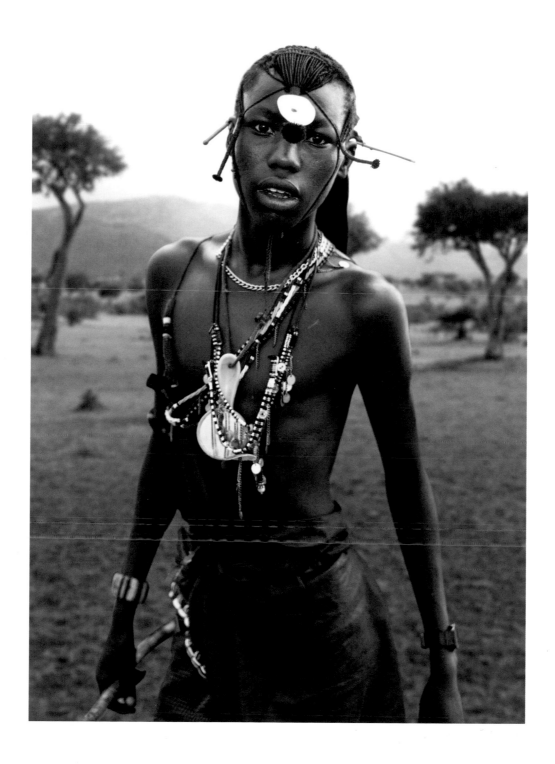

ABOVE: Maasai warriors take great
pride in their dandified appearance.

OPPOSITE: Two of the *murran* offer thanks
to the sheep for giving its life for their dinner.

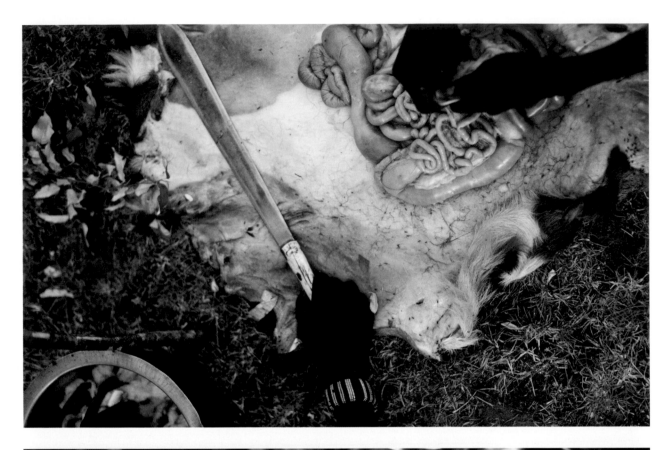

in front of their mothers and girlfriends. Even so, I offered to buy them a sheep. Nomadic tribesmen like the Samburu or Maasai in remoter regions of East Africa often subsist on a tin mug of milky chai tea in the morning followed by *ugali*, a bland cornmeal porridge introduced by more settled segments of the population, although historically, their diet consisted solely of milk, meat, and blood. There was a huddle at a distance, with much negotiation. Ole Siara came back to the car to let me know that the warriors would make an exception for me.

The slaughter took place later that afternoon at an improvised *olpul*, or meat-eating camp, with cooking pots borrowed from the village. I've never seen an animal killed with such grace. Two of the *murran* smothered the pied sheep—a hairy red Maasai breed—by gently laying it down on a bed of twigs and kneeling on its rib cage while clamping its mouth and nose closed. The sheep's eyes stilled as the boys offered a murmured prayer thanking the animal for its life. They slit the throat and allowed the hot blood to pool in a pouch improvised by stretching the neck skin. Then, one by one, each warrior leaned down to drink; their hennaed faces became a shade more crimson.

Using machetes, they skinned and gutted the sheep and separated the legs from the hip bones with a swift backward snap. Kipalonga sliced into the milky white intestines and dropped them in a curled mass on the hide, which lay hair side down on the earth. Several pounds of masticated greenery, still damp with bile, were extracted from the stomach. The tallest warrior hung the veined caul on a shrub where it billowed in the wind and dried like parchment. He shredded it into a pot of water, dumped in the organs and prickly acacia branches, then set the pot to simmer on a blazing fire. Ole Siara, adjusting the floral cloth wrapped around his waist, explained that this broth is prized for its medicinal value because any nutrients the sheep consumed are transferred to its cooks. Chunks of fat were tossed into another pot to fry; the head was roasted on a stick.

While the organs bubbled, they practiced dance moves. *Adumu* is a form of competitive jumping—knobby knees locked, heads erect—bouncing as high as possible in the air. Tossing their long tight braids back and forth, almost breathless with laughter, they carelessly abandoned machetes on the ground, more boys at play than fierce warriors. Kipalonga paused to wrap his arm around the back of his best friend, who held him close by the waist.

OPPOSITE TOP: Nothing goes to waste, including the entrails, when a sheep is slaughtered.

OPPOSITE BOTTOM: The organs make a nourishing broth, which is the first course consumed at a Maasai *olpul*, or meat eating camp.

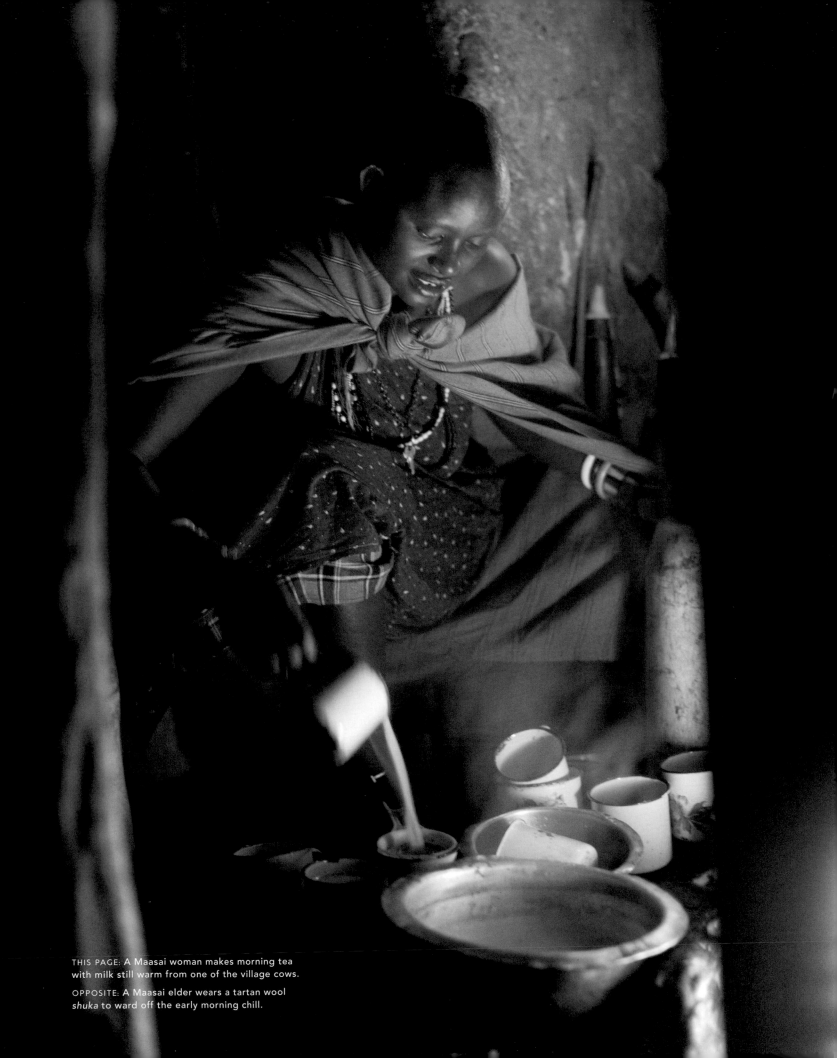

THIS PAGE: A Maasai woman makes morning tea with milk still warm from one of the village cows.

OPPOSITE: A Maasai elder wears a tartan wool *shuka* to ward off the early morning chill.

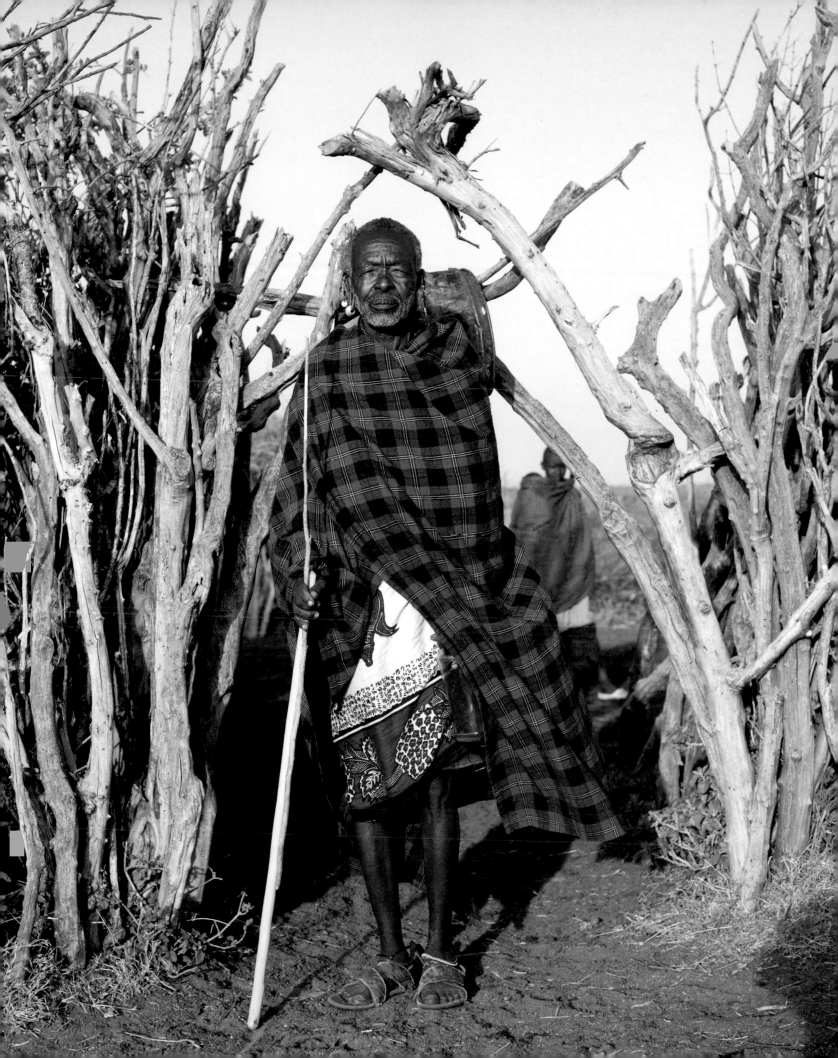

On the occasion when a Maasai village consumes one of its flock, the parts are portioned out according to a code. Men in their prime are awarded the thighs; women receive the large intestine, neck, and pelvis; elders take the diaphragm and liver. At a male-only *olpul*, the kidneys are eaten raw by the slaughterers. That afternoon, a warrior named Parmat eagerly sucked the marrow from a cloven hoof attached to a blackened, splintered shin bone. As others gnawed on the ribs, Parmat offhandedly passed me a juicy gob of smoky, barely cooked sheep fat the size of my thumbnail. I held it between my fingers and everyone paused to watch. I put the fat in my mouth and chewed. And chewed. It tasted like snot. Swallowing, I nodded curtly and smiled. The *murran* smiled, too. Then they handed me more.

In the gathering darkness, we surrounded the blazing fire, wrapping ourselves tightly in tartan blankets. Lightning illuminated an escarpment as the boys sang about their luck meeting someone willing to feed them. Kipalonga took the role of *olaranyani*, or lead vocalist, calling out a line of the chant in a sweet tenor as the others responded with whistles, yips, and throat humming. Metal disks on their headbands jangled. Before attaining the rank of elder, these boys would pass through several more coming-of-age trials, including one called *enkang e-kule*, the milk ceremony, where their mothers would shave off their marvelously hennaed locks. Afterward, all other finery would be discarded when the time came to progress to junior elder and take up the task of herding livestock.

Some *murran*, I learned later, suffered depression when graduating from the way of warriors. Others might not survive to rest in an elder's chair. Life in this lonesome corner of Maasai Mara National Reserve is full of random violence. Elephants or wildebeest might stampede; a cheetah or leopard could attack.

For this one night, however, they had bellies full of meat and no cares to spoil their rejoicing. The warriors stood shoulder to shoulder, moving closer to the blaze, and unintentionally, I was squeezed from the tightening circle as they continued to sing under a stormy sky.

OPPOSITE: The traditional Maasai diet consists of meat, milk, and blood from their prized cattle. Livestock is kept safe from predators overnight in thorny enclosures called *boma*.

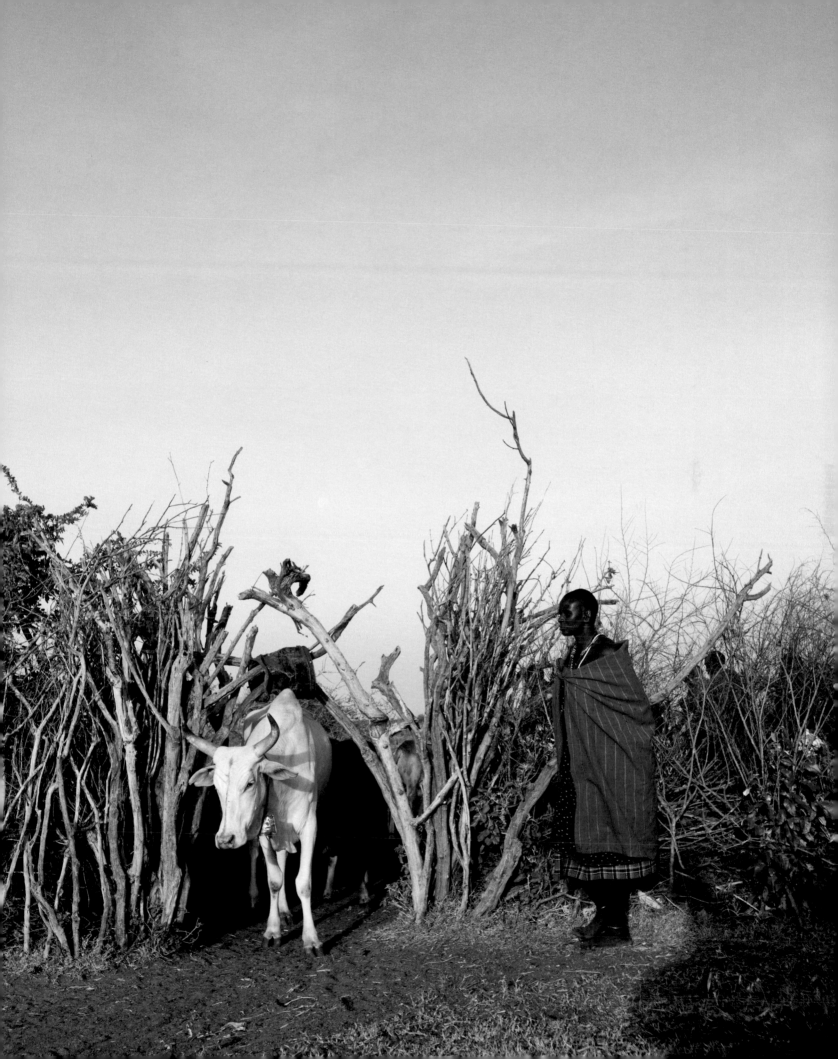

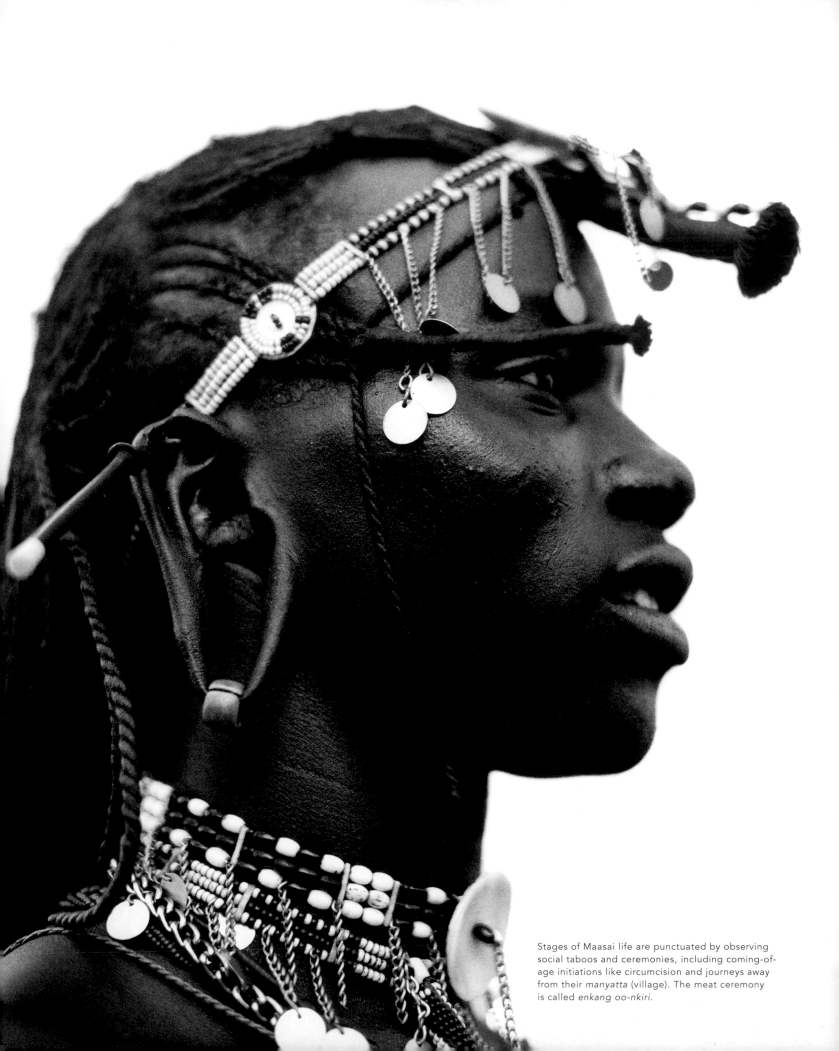

Stages of Maasai life are punctuated by observing social taboos and ceremonies, including coming-of-age initiations like circumcision and journeys away from their *manyatta* (village). The meat ceremony is called *enkang oo-nkiri*.

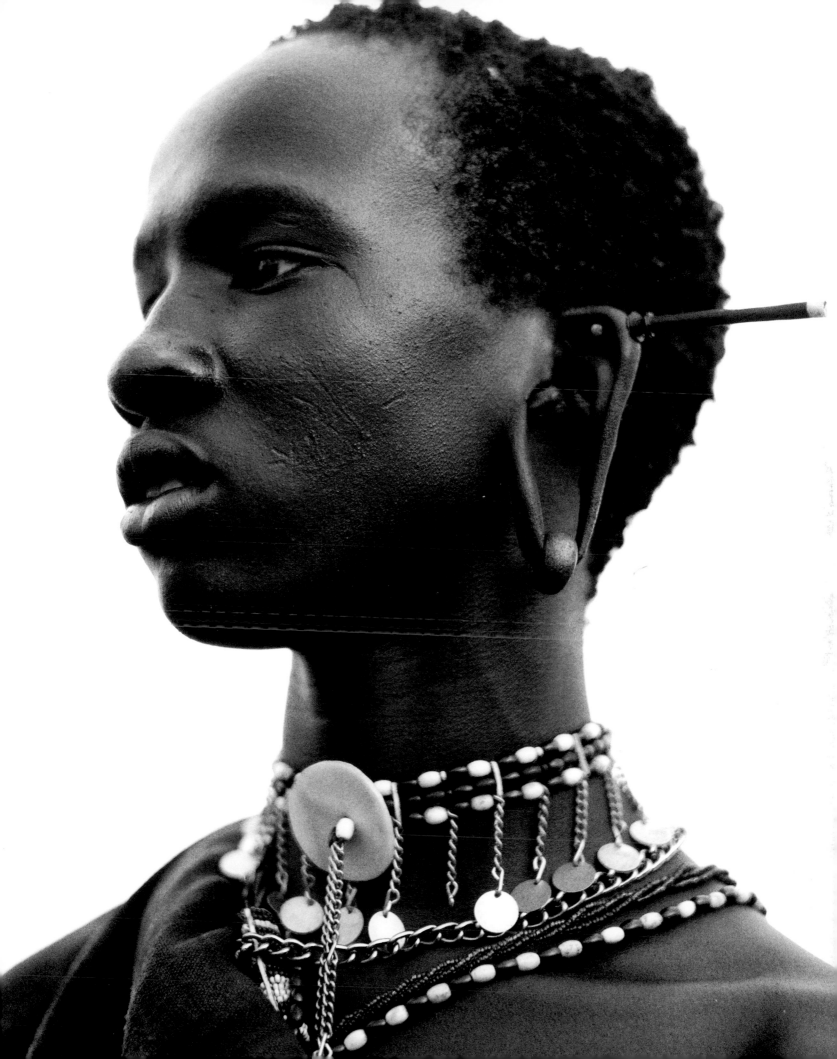

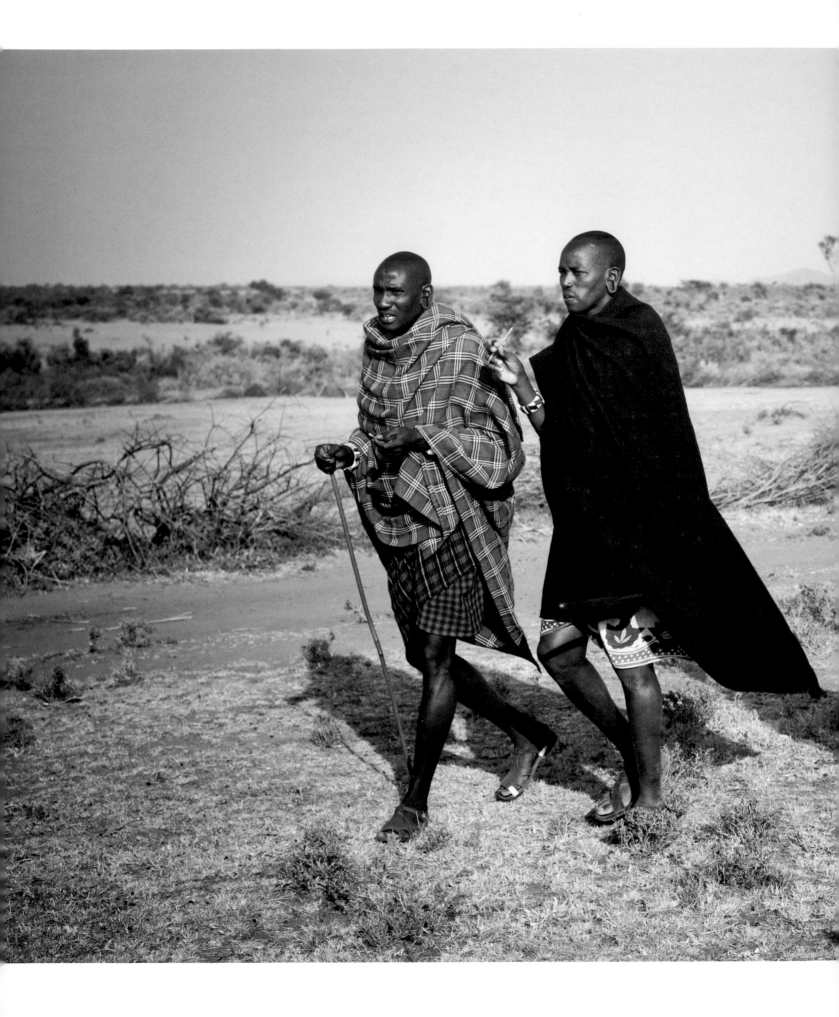

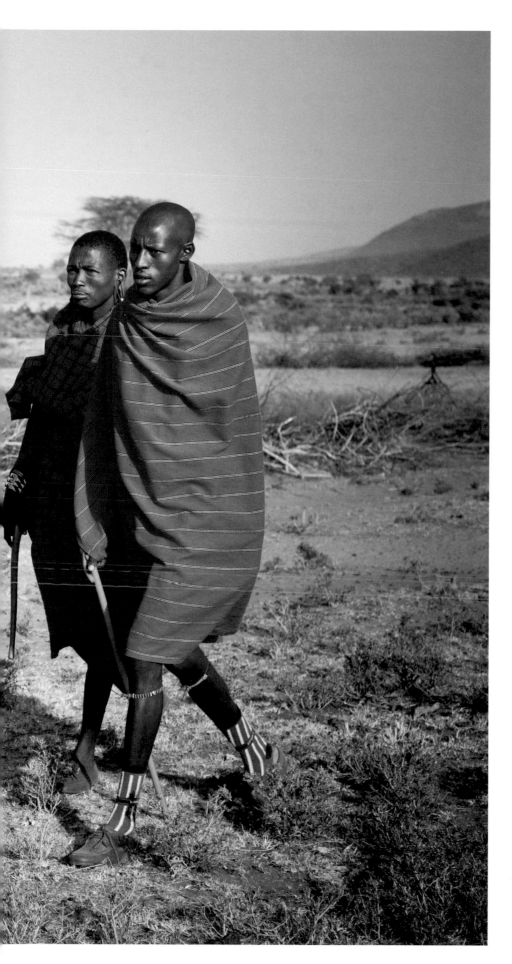

The seminomadic Maasai move their livestock to fresh pastures based on seasonal rotation, but as droughts become more severe in East Africa with climate change, many herders are being forced to seek alternate livelihoods.

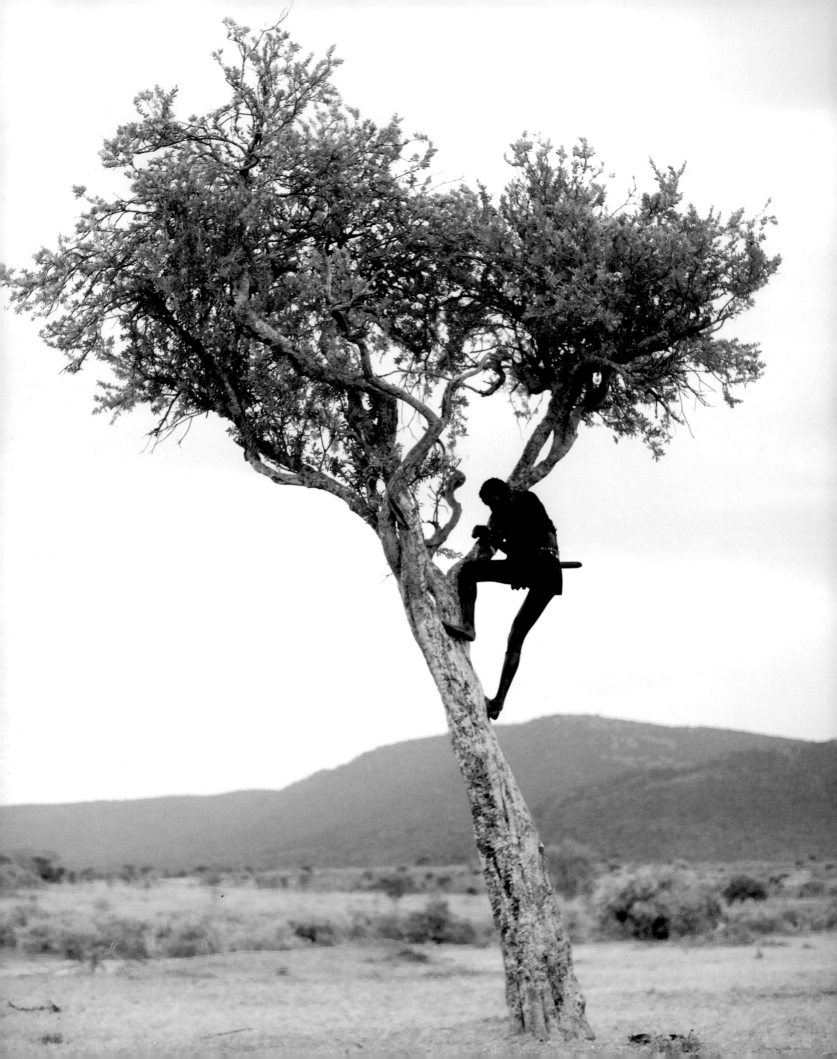

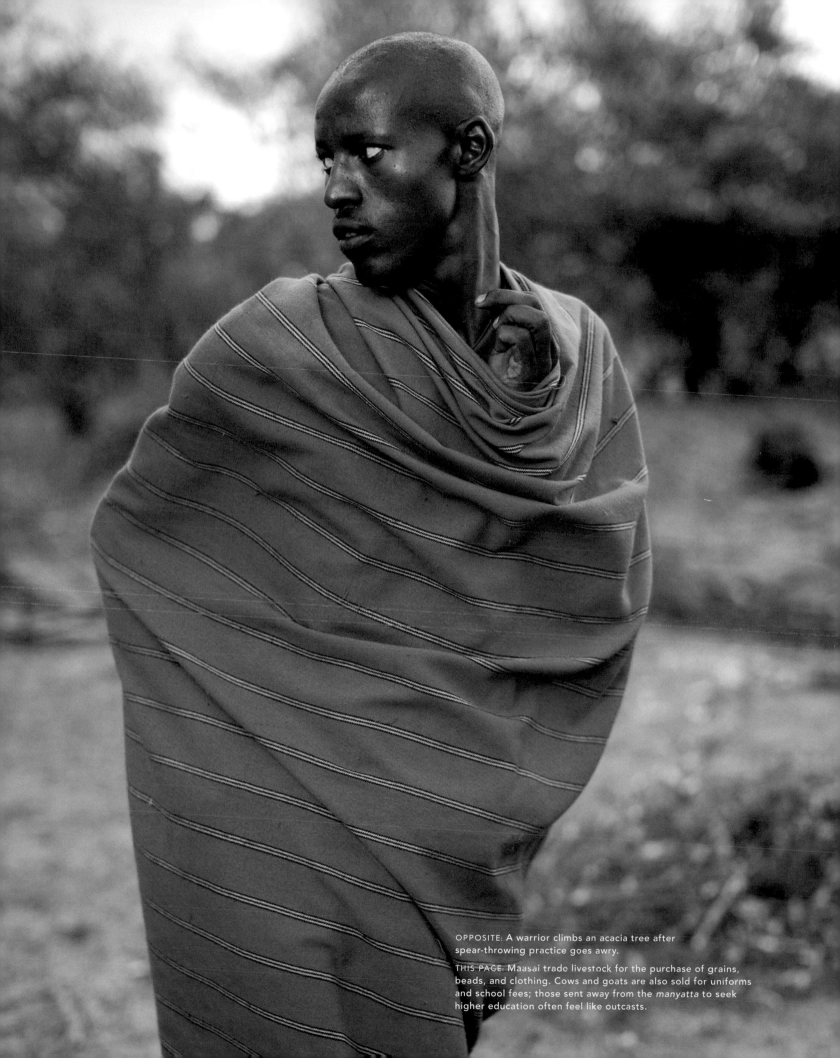

OPPOSITE: A warrior climbs an acacia tree after spear-throwing practice goes awry.

THIS PAGE: Maasai trade livestock for the purchase of grains, beads, and clothing. Cows and goats are also sold for uniforms and school fees; those sent away from the *manyatta* to seek higher education often feel like outcasts.

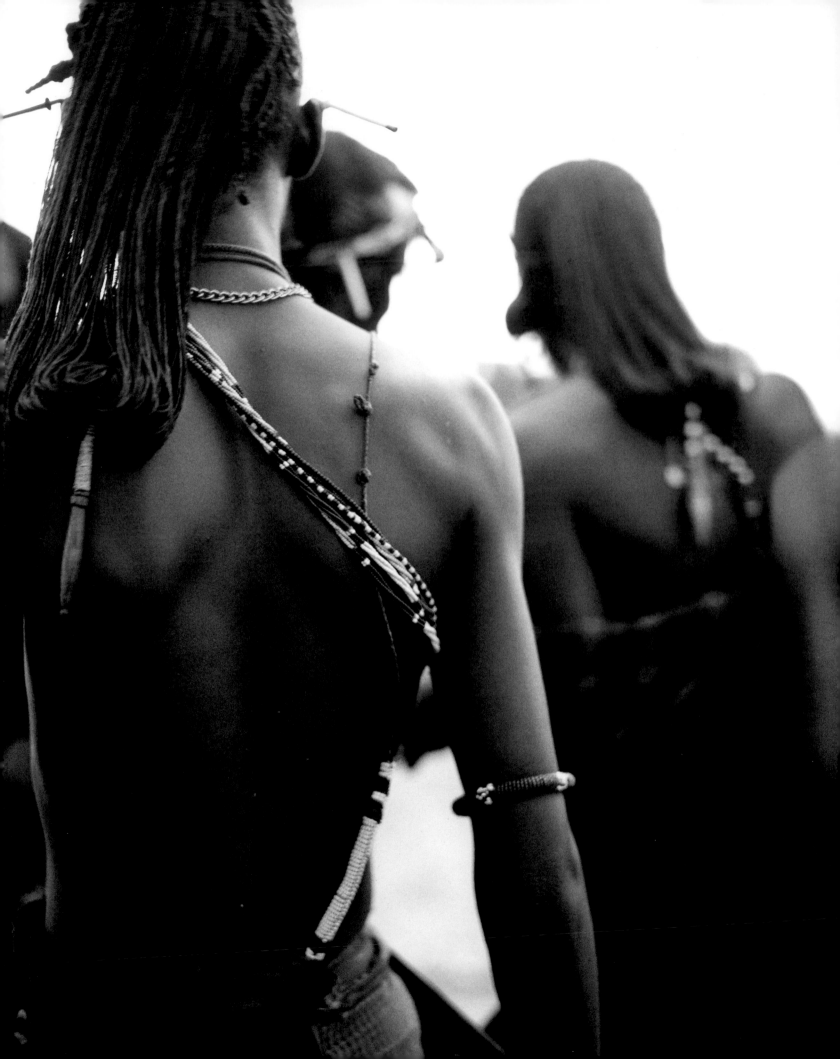

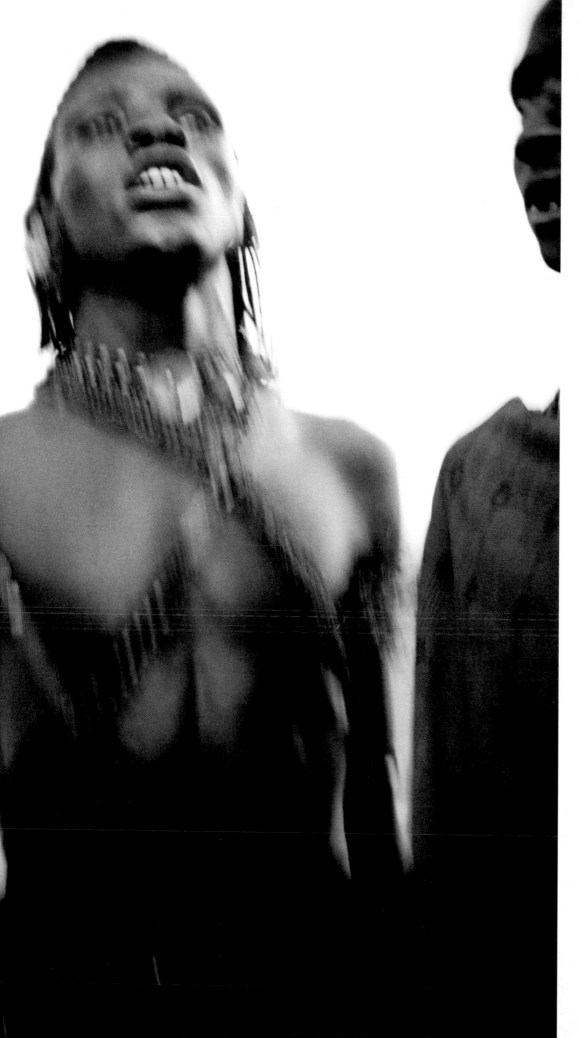

A Maasai prayer: *Meishoo iyiook enkai inkishu o-nkera*. Translation: "May Creator give us cattle and children."

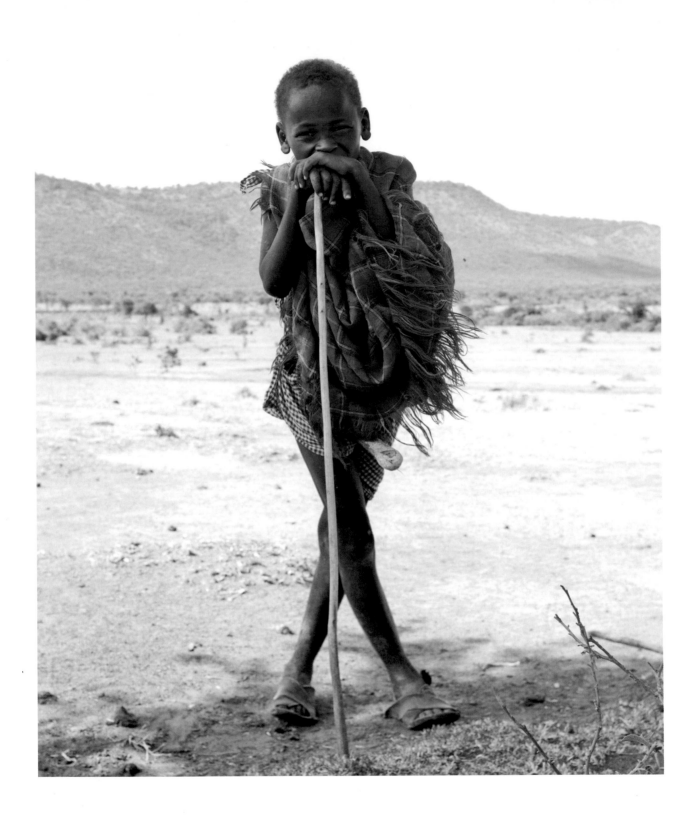

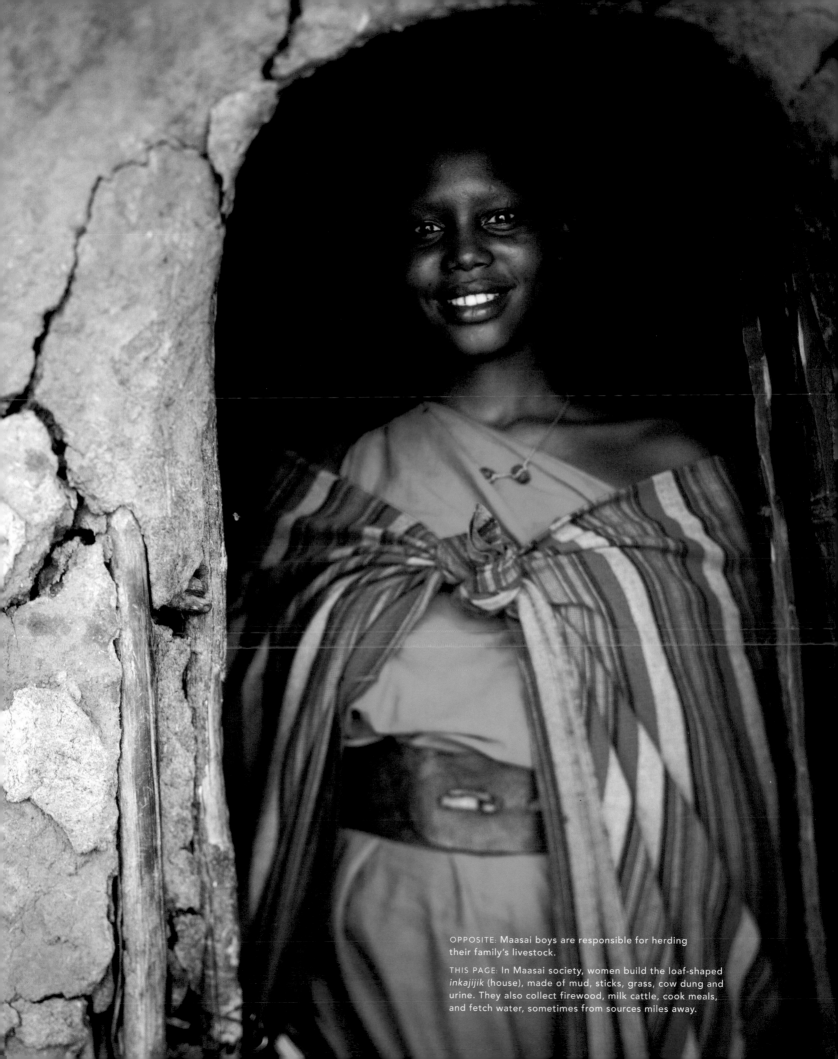

OPPOSITE: Maasai boys are responsible for herding their family's livestock.

THIS PAGE: In Maasai society, women build the loaf-shaped *inkajijik* (house), made of mud, sticks, grass, cow dung and urine. They also collect firewood, milk cattle, cook meals, and fetch water, sometimes from sources miles away.

Bordering Tanzania, the Loita Plains are part of a greater savanna south of the Great Rift Valley. The surrounding hills and pastoral grazing grounds have officially belonged to the Maasai since the nineteenth century.

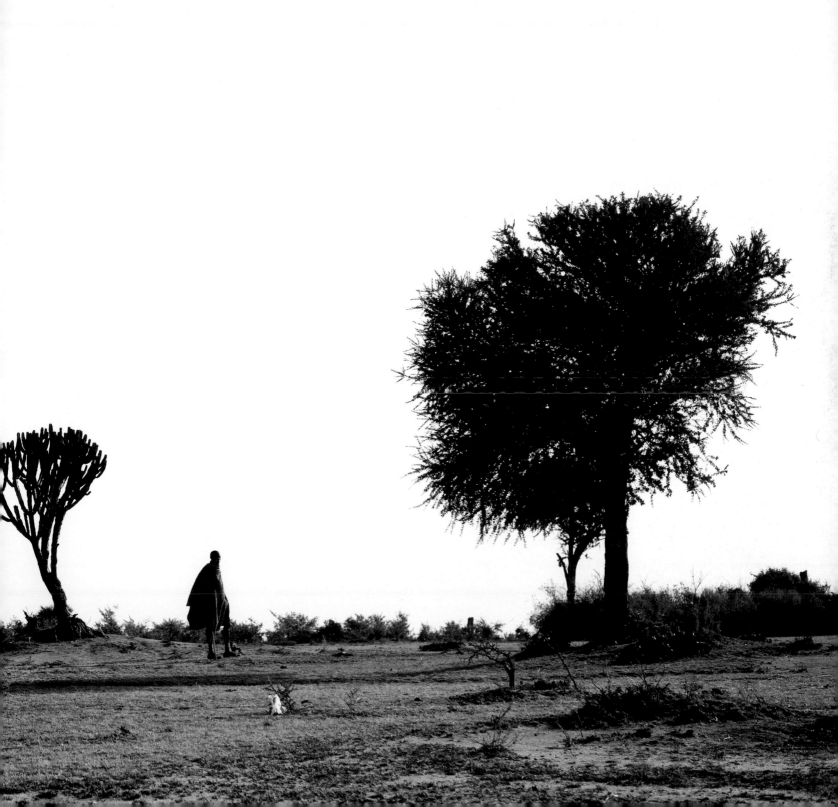

QULLQI CRUZ
PERU

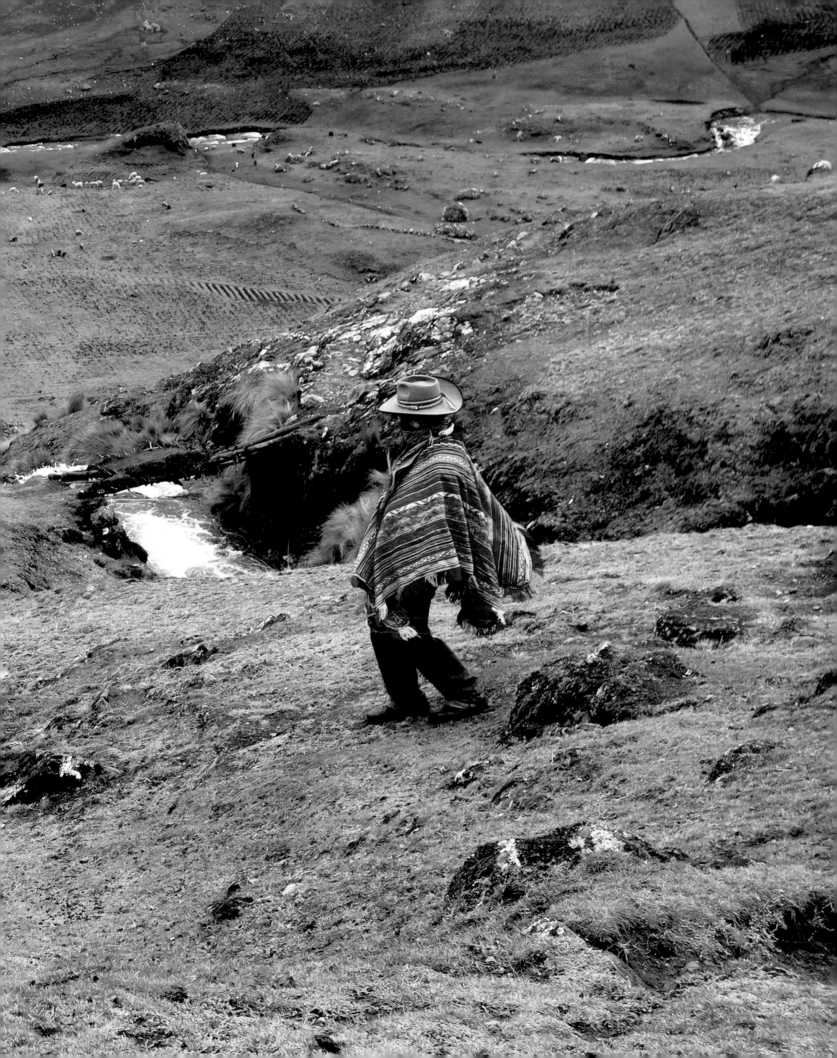

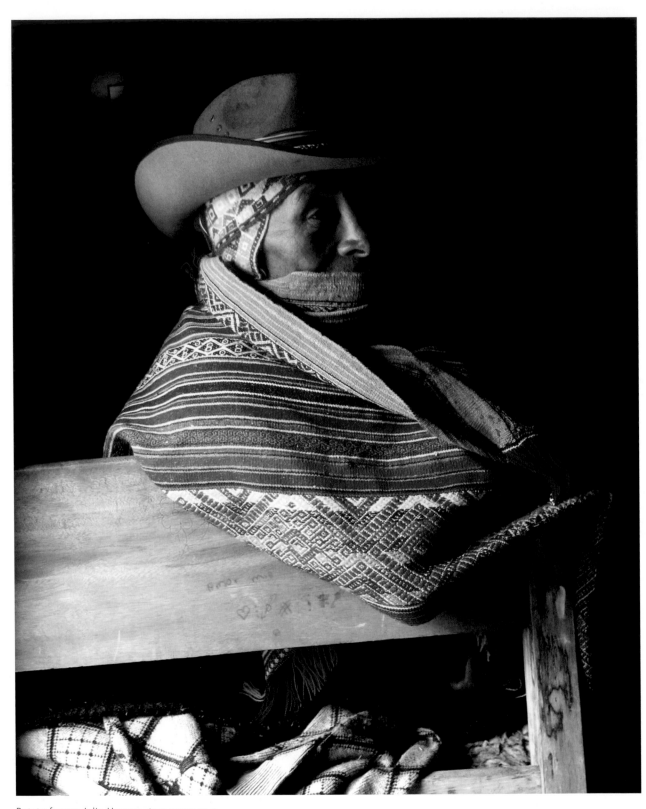

Potato farmer Julio Hancco stays warm on a
chilly spring morning in the Peruvian Andes.

JULIO / POTATO FARMER

Qullqi Cruz, Peru

"The path to the sky," said Yieber Cueva, pointing to a faint track leading upward into the mist. Lowering clouds masked Qullqi Cruz, the Silver Cross, a glacial peak thousands of feet above the unpaved road. Rockslides left gravel streaked like tears down the mountain. It was the rainy season in the Andes. I took it on faith that we were heading in the right direction and clambered after my translator, a stocky former porter on the Inca Trail. My heart pounded. My head felt like it might explode. Putting one foot in front of the other took all my will. At this elevation, oxygen deprivation was a threat, and chewing astringent coca leaves, a local remedy for mild altitude sickness, and a psychoactive alkaloid, didn't give me the slightest relief. Yieber paused to wait, his cheerful face framed by a knit wool cap with extravagant tassels.

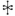

In Cuzco, everyone kept asking: "When are you going to Machu Picchu? Are you going to Machu Picchu?" I couldn't have cared less about an old pile of rocks swarming with thousands of day-trippers.

"I'm here to see an old man about a potato."

I got some strange looks.

During the Southern Hemisphere spring of 1533, Francisco Pizarro arrived overland in Cuzco to conquer empires and plunder gold. Spanish colonial haciendas with red tiled roofs and carved timber balconies still radiate from the Plaza de Armas, the central square where a Gothic cathedral rose on the earlier domain of a forgotten sun god. Now the plaza was packed with trekkers and vision questers. Signs advertised shamanic *ayahuasca* retreats, all-night discos, *casas de cambio*. Quechua women in embroidered costumes posed for dollars. Street urchins hawked *chakana* (Inca Cross) necklaces.

The commercial assault was too much. For sanctuary, I paid twenty-five pesos to enter the cavernous Catedral de Santo Domingo, full of dead bishops framed in melted Inca ingots. I'd never seen so much precious metal in one place; the main altar was completely covered in

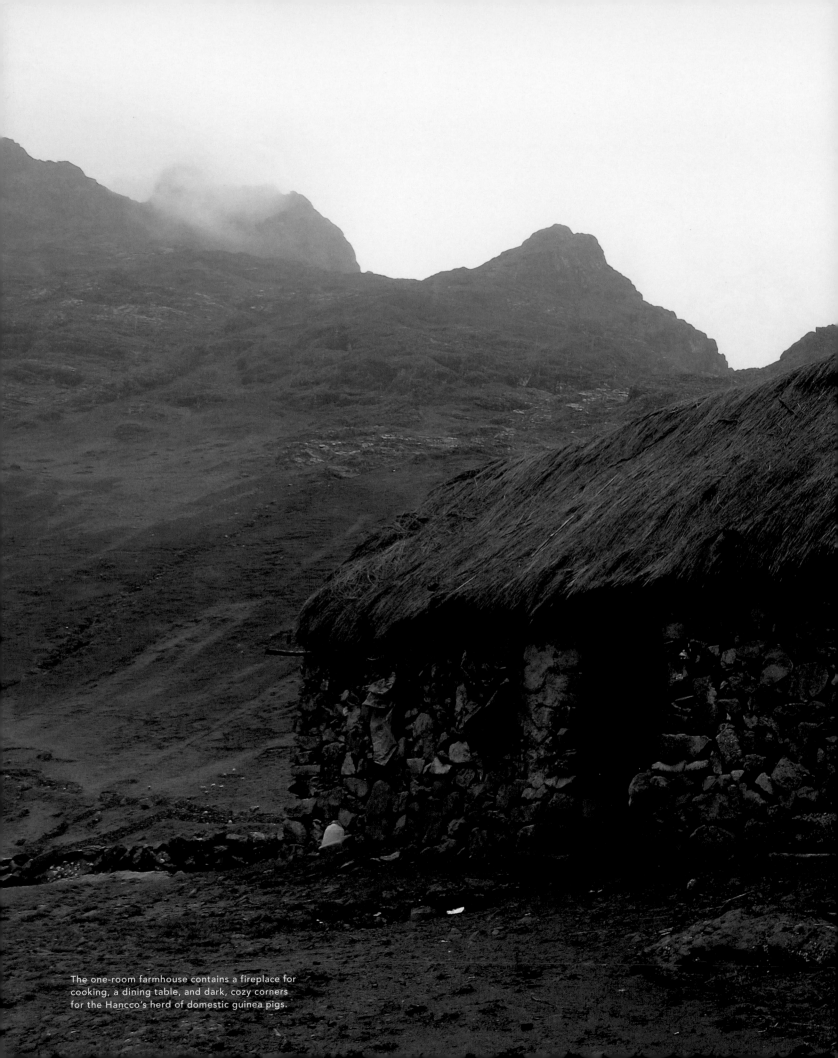

The one-room farmhouse contains a fireplace for cooking, a dining table, and dark, cozy corners for the Hancco's herd of domestic guinea pigs.

beaten silver leaf. Next to a sacristy, a priest spritzed the faithful with holy water. Some drops landed on me accidentally.

Later, I stalked the darkened streets for dinner. San Pedro market, with its snack stalls selling comforting *caldo de gallina* (hen soup), was already closed. I walked past Irish brewpubs and vegan raw bars. Sushi this far from an ocean didn't appeal. I wound up eating pizza with a bunch of backpackers on my first night in the navel of the world.

✳

The streets were empty the morning I departed with Yieber. Weak sunlight crested rooftops decorated with ceramic bulls and wire crosses. Cuzco dropped behind us, the outskirts a tangle of slums and stray dogs picking through piles of garbage. We drove higher into the Cordillera Urubamba, skirting valleys where corn was already tall. Moss and lichen clung fiercely to age-old terraces carved into sheer slopes. By the roadside, llama and alpaca chomped grass. A sturdy woman wearing a black bowler hat stood watch over her herd with a trio of barky dogs as we lumbered around a harrowing switchback. To pass the time, almost four hours on this bumpy route, Yieber told me tales about growing up in the Andes. His family mined prized pink salt in the town of Maras.

"We are farmers, too. I was terrible at it, so they sent me to school in Cuzco. My brothers call me Lady Hands." He laughed.

Yieber was in his late twenties. He was fluent in Quechua, Spanish, and English. He wore hiking boots that cost far more than his daily salary—about twenty dollars—hauling heavy packs for a trekking company. "Friends from the United States sent them," he said. "You can't get good shoes here." His mother had knit *chakana* on his hat. Yieber traced the yin-yangy stepped cross with a hole at its midpoint. Supposedly, he explained, it represents Cuzco as the center of the Inca world, the Southern Cross constellation, the cosmic vault, a shamanic journey, the tree of life. But *chakana* are bogus. The ziggurat design did appear in precontact Andean textiles and architecture; however, the mythos surrounding this graphic is firmly rooted in the twentieth century, a cultural appropriation for gullible tourists and New Age wackos.

"You know when the Spanish built the church in Cuzco? They used forced labor. So the workers added their own jaguars and snakes among the carvings," he said. "They're powerful symbols from Inca mythology. The snake represents Pachamama."

Appropriation can cut both ways.

The steep valley below Qullqi Cruz, the Silver Cross,
one of the highest in the Urubamba mountain range.

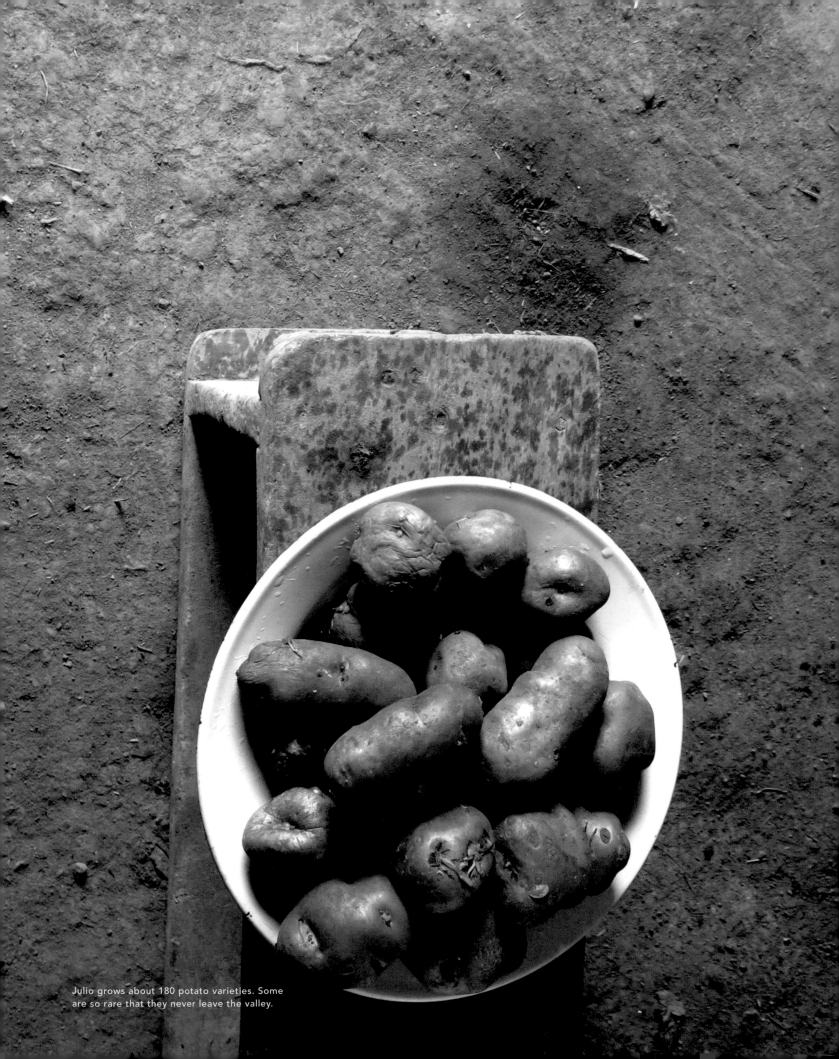

Julio grows about 180 potato varieties. Some are so rare that they never leave the valley.

We passed through the market town of Calca as round loaves of coarse bread were being loaded into mototaxis for delivery. Yieber pulled over at a *chicha* stand displaying ripe berries. "The first strawberries!" he said. "We have to try." *Chicha* is a harsh fermented corn liquor, but in the spring strawberries are added to make *frutillada*. The vendor scooped a foaming pint out of her plastic bucket—a harmless-looking pink smoothie. Yieber tipped some from his glass onto the ground. "We offer a drink to Pachamama first. It is considered polite."

One sip. That's all it took to feel like my skull was being crushed between two cement blocks. Yieber downed the rest. "Oh, my goodness," he confessed. "I might be a little drunk."

As we continued upward to sixteen thousand feet, crossing through Abra Azulcocha Pass, the peaks folded tighter, the landscape barren of trees. Nothing but air ahead of us.

"How does he know we're coming?" I asked.

"His son sent a message on the radio," said Yieber. "But that was a couple of days ago."

Just then I realized that we might not find one of Peru's most celebrated potato farmers.

The origins of the potato, *Solanum tuberosum*, can be traced to the highlands of the Andes, on the border between present-day Bolivia and Peru, almost eight thousand years ago. Early hunter-gatherer communities began by domesticating wild plants that grew abundantly around Lake Titicaca. Beyond Cuzco, in the sacred valley of Urubamba, pre-Colombian farmers cultivated other crops—tomatoes, beans, and corn—but the potato proved most suited to the *quechua* (valley) zones; growers eventually developed frost-resistant species that thrived on alpine tundra as well. The potato would become fundamental to the Andean worldview; time was measured by how long it took for a pot of spuds to cook. In 1995, a Peruvian-American research team found that families in one mountain valley grew an average of ten traditional varieties, each with its own name. The International Potato Center has documented almost five thousand kinds indigenous to Peru, many so rare they never get to market but are instead traded within the immediate community where cultivated.

Julio Hancco grows 180 of them.

As Yieber and I slogged up the path next to the waterfall, the sun cracked through clouds long enough to expose ice fields on the lower face of Qullqi Cruz. A glacial stream threaded down, picking up speed and depth, a turbulent white in a viridian green mountain bowl. We passed cultivated plots where furrows were black, in contrast to the ferrous soil of Cuzco. By the time we reached the cluster of stone-and-loam brick farm buildings, the wind had picked up and the heavy mist had turned to drizzle.

Julio Hancco stood in a doorway, waiting. He wore jeans, heavy work boots, a bronze tracksuit jacket. A jaunty cowboy hat topped his knit cap. His narrow face was weathered, guarded. We entered a bedroom hut, where makeshift cots crowded the earthen floors. Clothing and alpaca skins hung from beams. An outdated calendar and plastic banner that read "*Asociacion de Productores de Papa Nativa de Peru*" were tacked to the walls. I settled on a pile of wool blankets. Julio sat opposite.

"How did you wind up growing so many different kinds of potatoes?" I asked.

Julio answered swiftly. Some varieties, he explained, were inherited from his father. He traded for others and found more in the markets. "It's sacred to grow these kinds of potatoes," he said. "The first person to farm in this area was my grandfather; it is easier in Urubamba, but houses and cities are next to there now."

Julio's wife, Rosa, stuck her head around the open door. She had on four sweaters and open-toe sandals. Her toughened feet were ingrained with dirt, her gentle face was framed by a fuchsia *montera*. These saucerlike embroidered hats have floppy brims so the women who wear them resemble flowers in a hostile place that doesn't sustain delicate blooms. She deposited a flask of hot coca tea, asked if we wanted something to eat, and then disappeared again.

When the rain slowed, I followed Julio outside. He climbed into one of his potato patches, protected from the weather by stone walls. We bent to examine tender sprouts. "Our llamas, alpacas, and sheep eat everywhere," he said. "That's how we fertilize the soil. One hand of dried guano together with the potatoes. As they grow, I build up the mound, so the older potatoes, the higher the mound. We plant in August, then harvest in April or May."

Five acres dug by hand, knees bent, back to the wind.

Short-handle shovels lay on the ground, along with two primitive furrow hoes fashioned from crooked tree limbs and hammered sheet metal. Julio pointed to a smaller hoe, fit for a child's hand.

"That one belongs to my youngest son," he said. "He wants to be a farmer, too."

"Do all your children grow potatoes?"

"No. My eldest went to Lima to try his luck there."

"What does he do for a living?"

Julio tilted his head, golden brown eyes serious.

"Sells potato chips."

✳

Rosa Hancco serves roasted alpaca with white *chuño*, potatoes
naturally freeze-dried in the low temperatures of Andean Altiplano
nights, a painstaking process that dates back to the Inca empire.

Smoke poured from a chimney under the thatch roof of Rosa's kitchen hut. I stepped over the threshold into a room lit by a fireplace filled with glowing coals. Two cats napped close to the heat. Shelves held sugar, a bunch of cilantro, some onions, cooking pots. A propane tank and new two-burner stove-top unit were stored under the dining table. Rosa spooned pan-fried alpaca and caramelized onions with pimentón into shallow bowls. She set a bowl of boiled potatoes on a stool. They looked dull gray, unremarkable. I picked one at random, broke it open with my fingers, and discovered a subtle red veining in the flesh.

"Puka Ambrosio," said Julio.

"That's what he's named this potato," said Yieber. "*Puka* means 'red' in Quechua."

It tasted sweet.

We sat on low chairs around the fire with dishes on our laps. The alpaca was chewy and difficult to cut with a spoon. I peeled a purple fingerling potato, which had a nuttier flavor than the Puka Ambrosio.

"Do you ever leave the mountains?" I asked.

Rosa shrugged.

"In the city, there is not enough air," she said. "For people used to the highlands, the city is poison."

Julio agreed. "When we go to Lima, there is no chance for work. Here, I am with the llamas and alpacas. If we want corn, shoes, clothes, money for our children's education, I take potatoes to Lares, about one hour by bus, and trade them for anything we want. Potatoes are like gold."

A chicken wandered in, followed by a fuzzy, snub-nosed puppy. Faint squeaking came from under a bench on the other side of the hut. Julio rose from his stool and scattered fresh grass on the floor.

Cuy is a delicacy in Peru. While Westerners adore these fluffy balls of piebald cuteness solely as pets, the common guinea pig was first domesticated in the Andes as a food source seven thousand years ago. They still appear on menus in fancy Lima restaurants. I had seen a baker pull a pair out of a bread oven, roasted to a deep rich brown, little claws curled, buckteeth still attached, in the highland town of Pisac. In the cathedral at Cuzco, a depiction of the Last Supper by famed Quechua painter Marcos Zapata shows Christ and his disciples dining on guinea pig.

"Do they stay inside?"

"Yes," replied Rosa. "Because it's warm in here. When we eat them, we throw the bones in the fire. Don't want the cats to get a taste for it."

Yieber joined in. "My mother used to keep 150 guinea pigs." The Hanccos looked impressed.

Rosa twirled red wool thread on a drop spindle. Women in the Andes do this task reflexively, much like worry beads or a rosary, while watching their flocks, chatting with friends, waiting for the bus to town. Her husband donned a poncho to hike with us to the road. Almost half an hour to trudge up, only ten minutes to tumble back down. Julio had pressing obligations to other farmers in the valley. We were keeping him from this work. Quechua practice *ayni*, a form of mutualism. A broad definition of the concept involves the exchange of energy between man, nature, and the universe. Among highland communities, where surviving a poor growing season means sharing at the most elemental level, that translates into bending over in your neighbor's field to help pull weeds.

Before descending, I looked up toward Qullqi Cruz one more time. Still hidden.

"Who is Ambrosio?"

Julio wrapped his neck in a long scarf, his gravelly voice muffled. "Ambrosio was my nephew, my sister's son. He fell on the mountain and died. So when that happened, I used the name for the Puka Ambrosio potato. In order to remember this boy."

"It's not easy to live so close to the gods," I remarked.

Julio nodded curtly.

"*Claro.*"

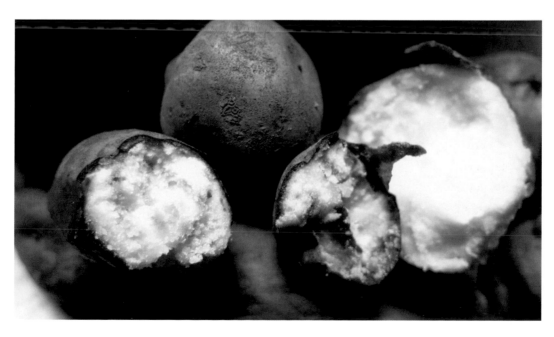

LOMO SALTADO / BEEF STIR-FRY

SERVES 2

Chinese contract laborers arrived in Peru during the sugar boom of the 1800s. Among the small businesses some immigrants started were *chifas*, or Chinese-Peruvian restaurants. (The word is Cantonese in origin; it means to "eat rice" or "have a meal.") As with many migrant cuisines, *chifa* recipes marry New and Old World ingredients: tomatoes, potatoes, chiles; soy, garlic, beef. *Lomo saltado* is a cross-cultural stir-fry of marinated beef, paired with both rice and fried potatoes (*papas fritas*). The recipe varies according to taste and takeout menu, and some Peruvians add a dash of *salsa mensi*, a locally produced fermented black bean seasoning, to the cooking process. I ate *lomo saltado* for the first time in Cuzco; this version substitutes fermented black bean paste as a flavor booster. You can find *salsa mensi* online (see Sources, page 294) and fermented bean paste from Asian grocers.

2 tablespoons soy sauce

2 tablespoons red wine vinegar

1 tablespoon fermented black bean paste

1 to 1½ pounds rib eye or sirloin, sliced into medium strips

1 tablespoon safflower oil

1 large clove garlic, minced

1 large red onion, sliced into rounds

1 large yellow bell pepper, stemmed, seeded,
ribs removed, and julienned

2 ripe tomatoes, quartered

¼ cup chopped flat-leaf parsley

Coarse sea salt

Black pepper

In a bowl, whisk together the soy sauce, vinegar, and black bean paste. Place the sliced beef in a nonreactive baking dish, pour the mixture over the beef, and allow to marinate for up to an hour.

Heat the oil in a wok or deep skillet. Add the meat, a few slices at a time, and brown on all sides. Remove and reserve. Add the garlic, onion, and bell pepper to the pan juices and cook until softened. Add the tomatoes and continue to stir. Return the beef to the pan and cook 5 minutes more, or until the beef is medium-rare.

Serve over *papas fritas* (page 243) and white rice, or on the side.

PAPAS FRITAS / FRIED POTATOES

SERVES 2 TO 4

The humble potato made its way out of the Andes and traveled to Europe in the late sixteenth century, where it quickly supplanted wheat and oats. Second only to rice as a staple starch, the spud is used the world over. I have seen fries cooked into *chipsi mayai* omelets on the street in Lamu, Kenya; stuffed into *paratha* in Delhi; seasoned with dried bonito seaweed *furikake* in Japan; and paired with *saag* (creamed spinach) in a refugee encampment outside Calais, France.

3 or 4 large russet or other floury potatoes, unpeeled

Peanut or olive oil

Coarse sea salt

Preheat the oven to 425°F.

Cut the potatoes in half lengthwise, then slice each half into 3 equal wedges. In a large bowl, combine the potatoes with the oil and salt, tossing to fully coat. Spread the wedges evenly in a shallow roasting pan. Roast for 15 minutes on one side and, using a spatula, flip the potatoes to brown on the other side. Use a fork to test for doneness: the potatoes should be crisp on the outside and soft inside.

CALDO DE GALLINA / HEN SOUP

MAKES 4 QUARTS

Chicken soup doesn't cure altitude sickness, but it definitely helps with homesickness. A corner of Cuzco's San Pedro market is devoted to open kitchens where Quechua ladies make this soup with new crop potatoes and tough old stewing hens. As a friend in Peru says, "The idea is to have a really rich soup, boiled for hours, and full with starch from the potato and the pasta, and at the end, when serving at the table, you add chiles, chives, and a dash of fresh lime—the really strong Peruvian one."

4- to 6-pound stewing hen, quartered
1 large leek, washed and chopped
2 stalks celery, trimmed and chopped
4 carrots, peeled and chopped
1-inch piece ginger, peeled and minced
2 cloves garlic, chopped
6 quarts cold water
6 medium Yukon Gold potatoes, peeled and finely chopped
8 ounces dried egg noodles, like kluski
Coarse sea salt
2 tablespoons chopped fresh cilantro
¼ cup chopped chives
2 limes, quartered
1 fresh red bird's eye chile, stemmed, seeded, and finely chopped

Rinse the chicken under cold water and remove the giblets. (Reserve for another use.) Put the chicken, leeks, celery, carrots, ginger, garlic, and the cold water into a stockpot. Bring to a boil over high heat; reduce to medium-low and simmer, skimming occasionally, until the broth becomes rich and golden, 4 to 5 hours. (You can add more cold water if soup has reduced too much during simmering.)

Transfer the chicken to a plate and set aside. Add the potatoes to the broth, bring to a boil over medium-high heat, and cook until tender, about 20 minutes.

Meanwhile, remove the skin from the chicken, and then pull the meat from the carcass. (Reserve the skin and carcass for chicken stock, page 127.) Shred the meat into large chunks.

Bring the broth to a boil over high heat. Add the egg noodles and cook until al dente, about 10 minutes. Add the reserved chicken pieces and warm through. Season with salt to taste. Before serving, garnish each bowl of soup with the cilantro, chives, limes, and chopped chiles.

CHILCANO

SERVES 2

My Limeña friend Paola Miglio introduced me to this potent cocktail at a modern *picantería*, Peru's equivalent of a lunch counter. Made with Pisco, the brandy produced in Peru and Chile, and topped with ginger ale, it's ideal for summer afternoons when you're not going anywhere fast.

Ice cubes

½ cup Pisco

2 tablespoons fresh lime juice

1 to 2 tablespoons simple syrup (page 158)

3 or 4 drops Angostura bitters

1 teaspoon rose water

Ginger ale, preferably Blenheim or Fever Tree

2 lime rounds, for garnish

In a cocktail shaker filled with ice, mix the Pisco and fresh lime juice. Stir in the simple syrup to taste. Then add the bitters and rose water. Shake until chilled. Add 1 ice cube to each of 2 lowball glasses, strain in the chilled mixture, and top off with ginger ale. Garnish with a lime round.

Low stone walls guard tender potato plants against the
fierce winds and rain blowing off the ice-capped mountains.

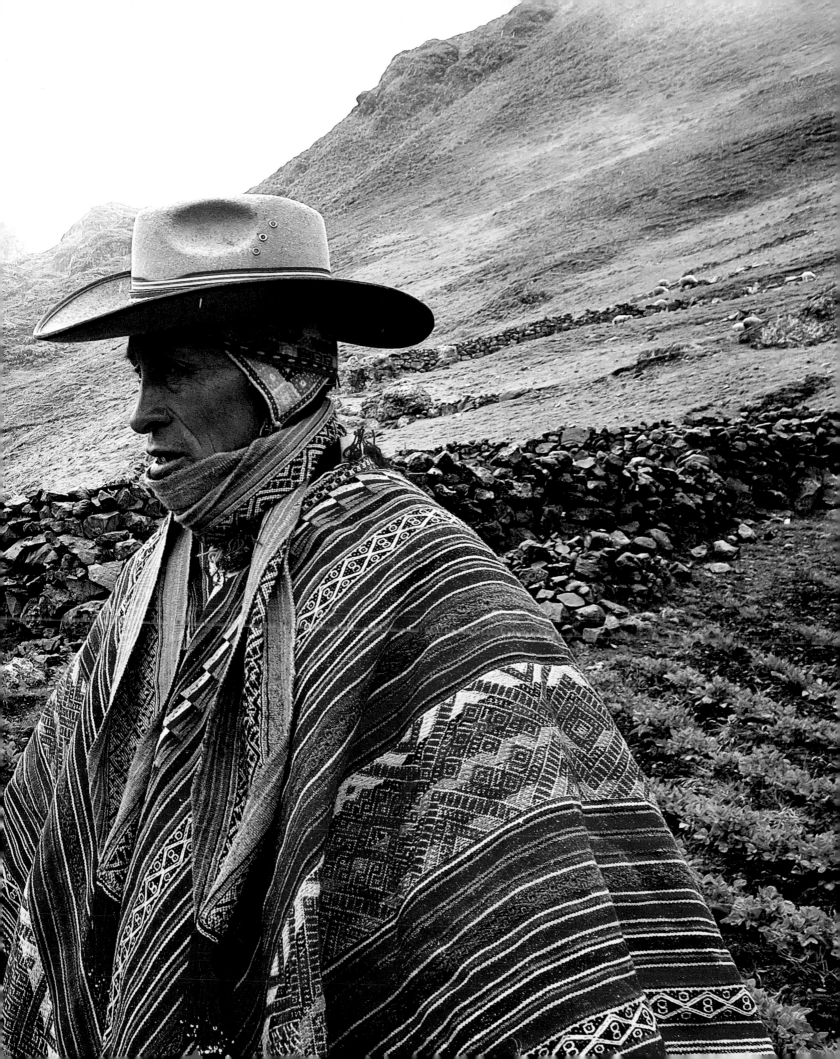

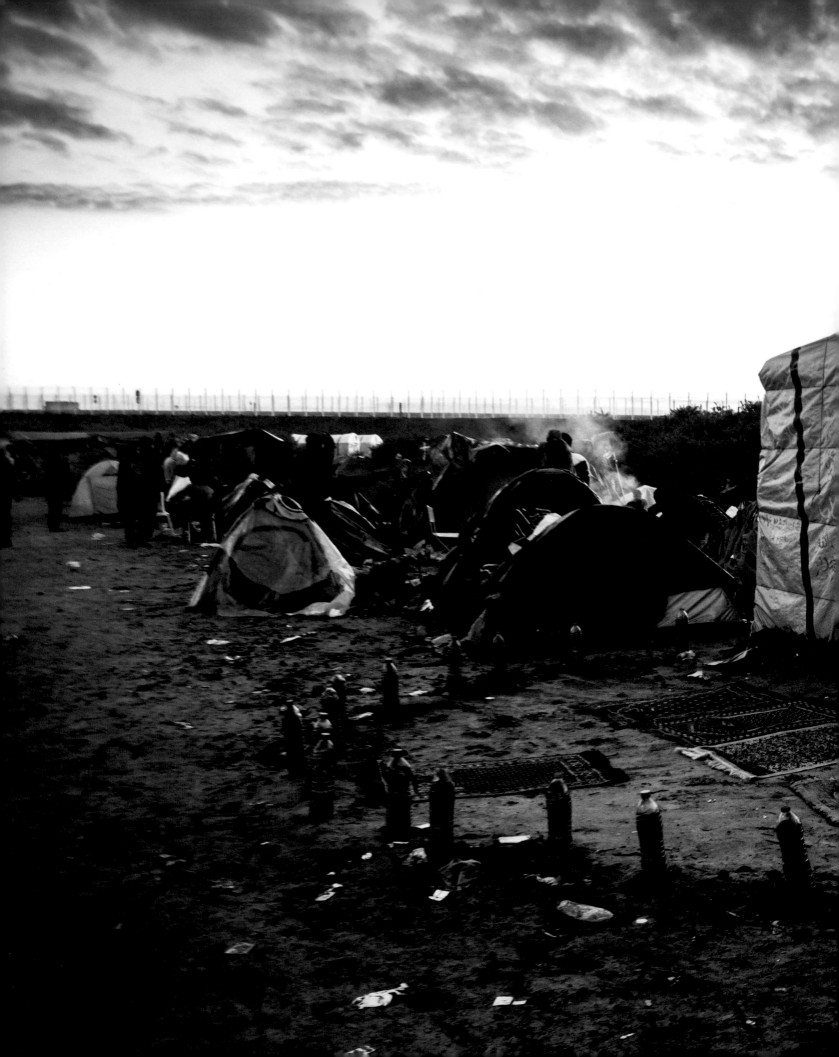

THE JUNGLE
CALAIS
FRANCE

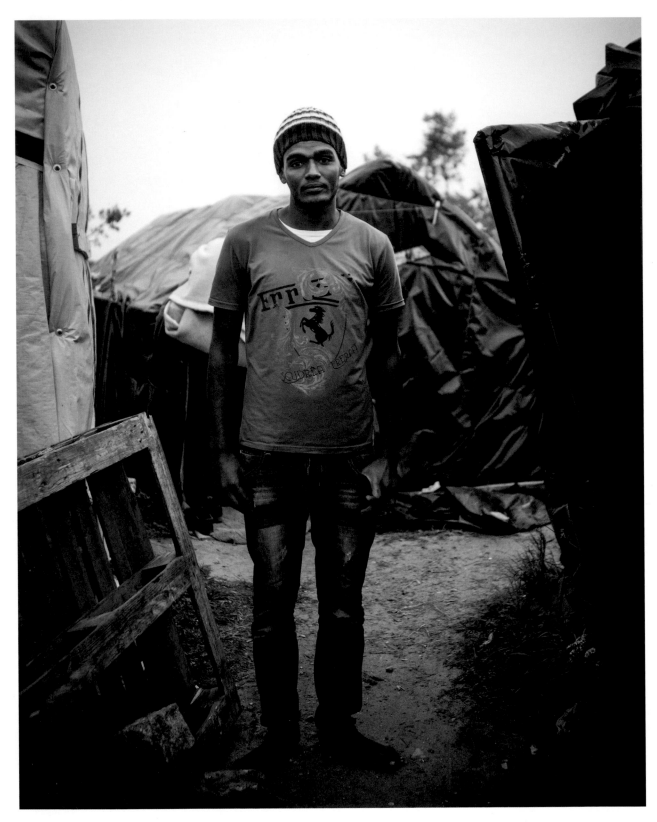

Hamada in the Sudanese sector of The Jungle.

HAMADA / REFUGEE

The Jungle, Calais, France

"Before I try, I eat garlic," said Hamada. "I take five pieces with me. I eat two after I get on the track and three near to the checkpoint." A gangly Sudanese wearing a red "Dismaland" hoodie sweatshirt and down-at-the-heel sneakers, Hamada guided me around standing puddles next to a row of overflowing portable toilets.

"Why garlic?" I asked.

"Because the guard dogs don't like it," he replied.

On an overcast morning spitting with rain, we walked along Afghan Way, lined with makeshift shops fashioned from plastic tarpaulins and scavenged pallets. Small grocers sold fruit, canned goods, energy drinks, and tobacco. Steam clouded the plastic windows of a *hammam*. Brightly colored hookahs sat on counters inside cafés. A new bakery tacked up a round piece of naan above its open doorway, the enticing smell of bread hot from a tandoor oven escaping. The rubble strewn path closely paralleled Autoroute 216 leading to the port of Calais. Chain-link fence topped with razor wire protected the overpass, where armed Gendarmerie Nationale officers, in full riot gear, were positioned every few hundred yards.

Welcome to The Jungle.

This illegal encampment emerged in an empty lot due east of the city's industrial zone just as the latest refugee crisis in Europe reached an unprecedented level. Jungle residents number in the thousands, representing the diaspora from Afghanistan to Eritrea, all fleeing war, terror, conscription, prostitution, or human trafficking back home. Those who landed in Calais were there because of its proximity to England, perceived, rightly or wrongly, as being more tolerant of migrants who reach the scepter'd isle. The cliffs of Dover are visible on sunny days at the beach, and the entrance to the Eurotunnel, where freight and passenger trains pass under the English Channel, is five miles away in the suburb of Fréthun, a Francization for "Free Town." However, the British and French have spent millions building fences around the rail tracks and terminal, rather than building détente with those desperate for safe haven. It's a limbo of the worst kind, unable to go forward legally, unwilling to claim asylum on the

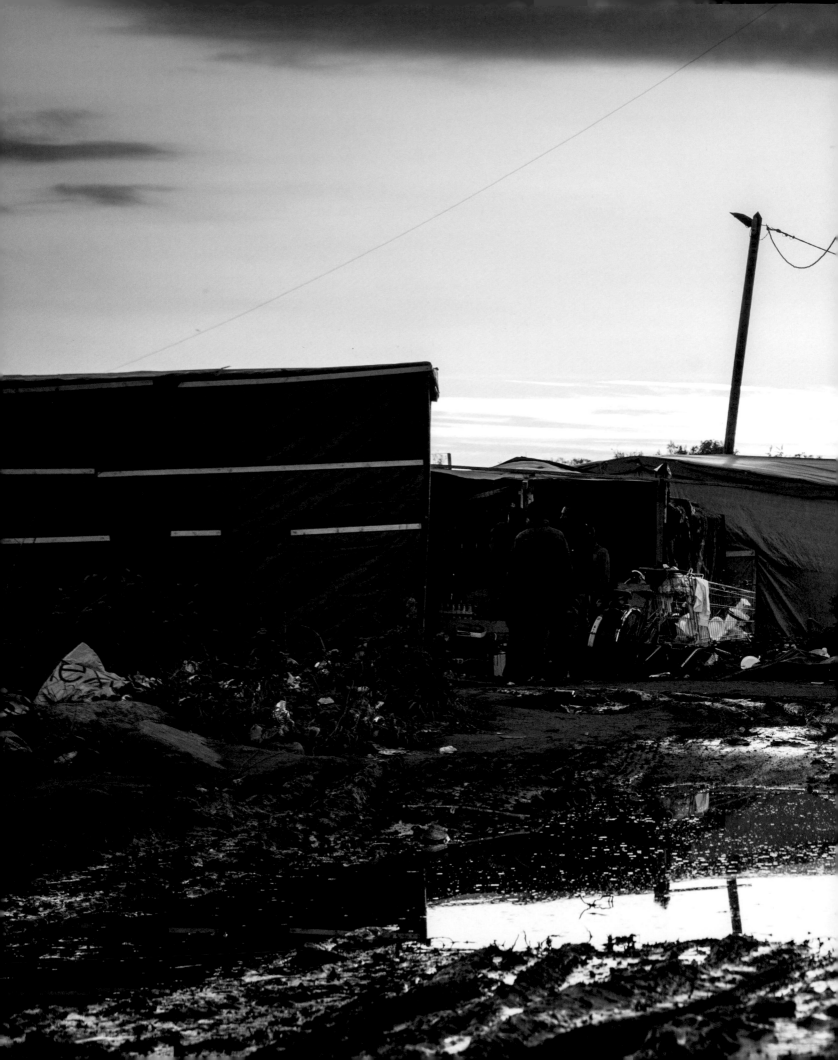

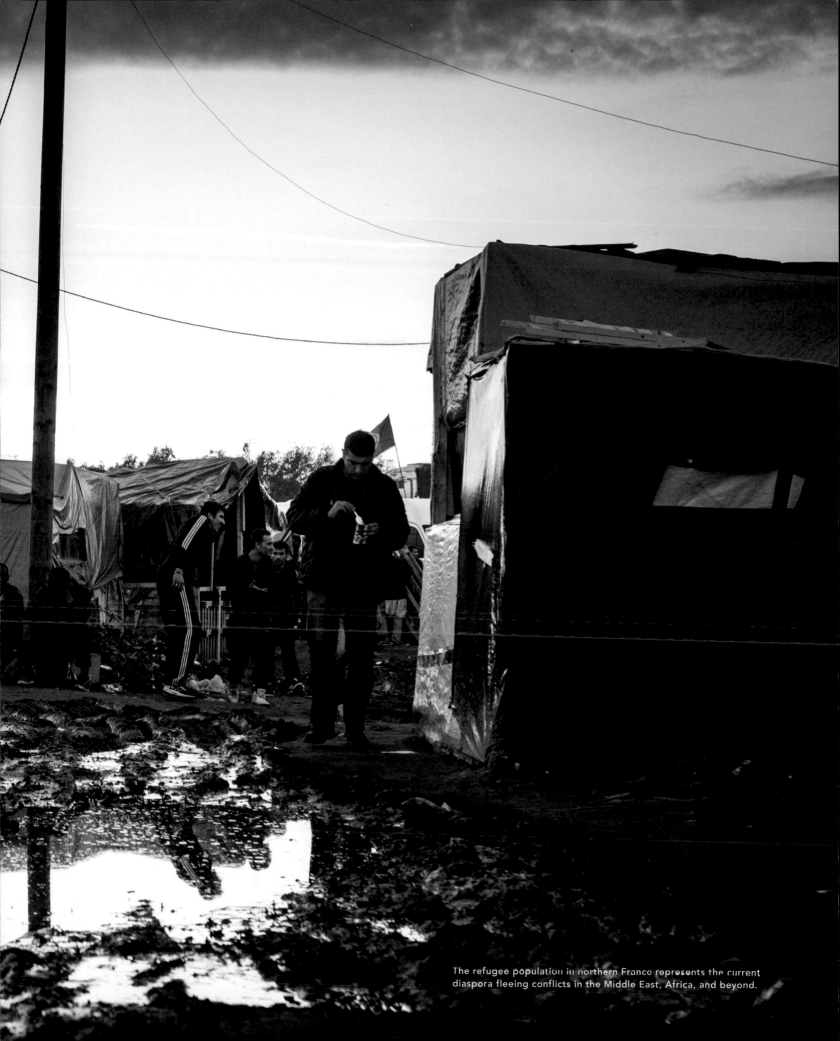

The refugee population in northern France represents the current diaspora fleeing conflicts in the Middle East, Africa, and beyond.

Continent. Most refugees harbored in a sea of sodden tents flapping in the sharp winter wind. Smoke from trash fires mingled with the noxious plumes of a graphite electrode manufacturing plant on the other side of the autoroute. Health warnings and language lesson flyers were posted at the Coptic church and a library wryly named Jungle Books. There were two public water taps for cooking and washing. Shopping carts and bicycles were mired in mud. Toughened young men, some limping on crutches, heads down, avoided eye contact. Graffiti was scrawled everywhere. "Long live Kurdistan." "I need go to UK." "Afghanistan is bleeding." "No worry, eat curry."

"Shawarma!" exclaimed Hamada. "This is my favorite."

A hunk of mystery meat twirled on a rotisserie spit inside one of the cafés. Entering, he placed an order. The man behind the counter shaved off juicy pieces and rolled them into lavash bread, along with chopped onions and tomatoes. After one bite, his face fell.

"I don't like it," he said. "It's not as good as home."

Hamada was born in Khartoum. He walked across Sudan and Libya before finding passage to Marseilles, and eventually Calais. Hamada has attempted to jump Folkestone-bound trains multiple times, and, more recently, paid human smugglers to hide him in the back of a freight truck, venturing as far away as Hazebrouck on the Belgian border for the chance.

Earlier in the day, before sunrise, a motorist accidentally struck and killed another Sudanese as he fled across the autoroute.

"I'm sorry to hear about your friend."

"*Inshallah*," he replied.

"Where is he now?"

"The hospital. Authorities will notify his family to see if they want the body sent home. Or buried here."

<p style="text-align:center">✳</p>

The next day, a text arrived from Hamada: *We want to cook for you*.

The Sudanese area backed onto Chemin des Dunes, a rural road bordering the eastern edge of The Jungle. Opposite, farm fields lay fallow in winter. The sturdier structures were no bigger than a child's playhouse. Some had modest picket fences and potted plants, bicycle racks, shelves to store street shoes and toothbrushes. Sleeping bags cleverly zipped as windbreaks in doorways. A *dala* game board—the Sudanese version of chess—fashioned from plywood and broken clay tiles left midplay. One tent ballasted by a cracked gravestone. In a central courtyard, a *lumma*, or gathering space, contained a fireplace fashioned from a steel drum.

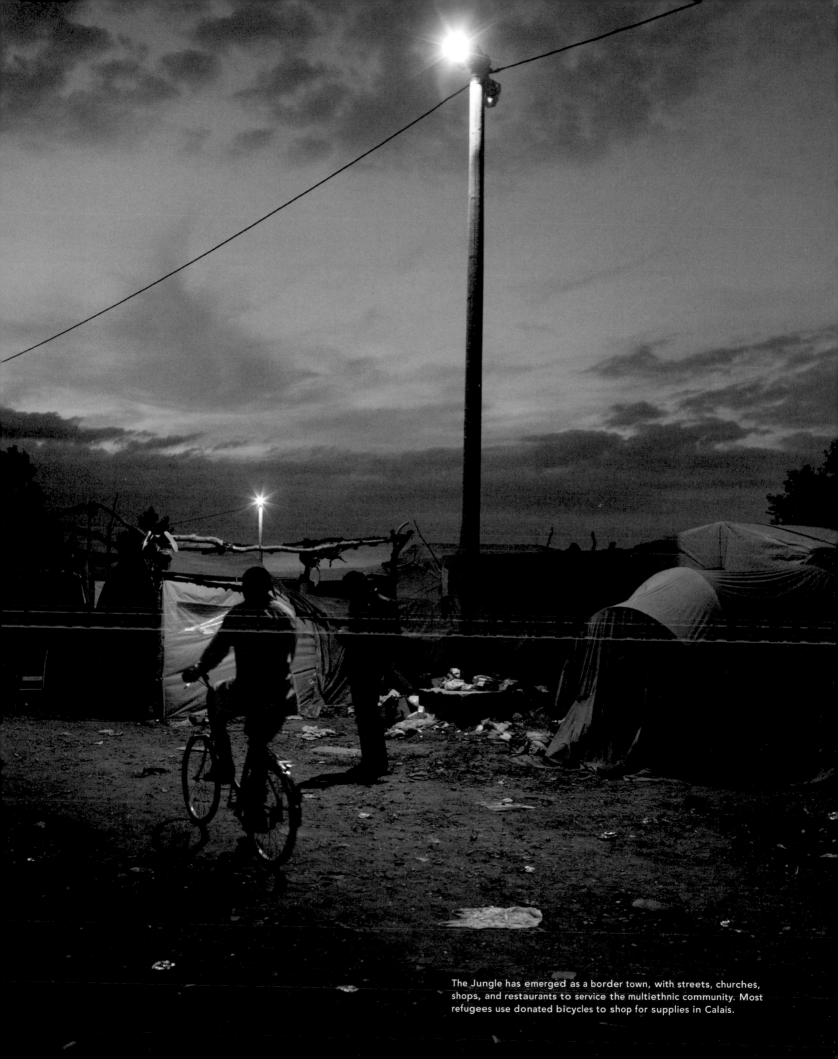

The Jungle has emerged as a border town, with streets, churches, shops, and restaurants to service the multiethnic community. Most refugees use donated bicycles to shop for supplies in Calais.

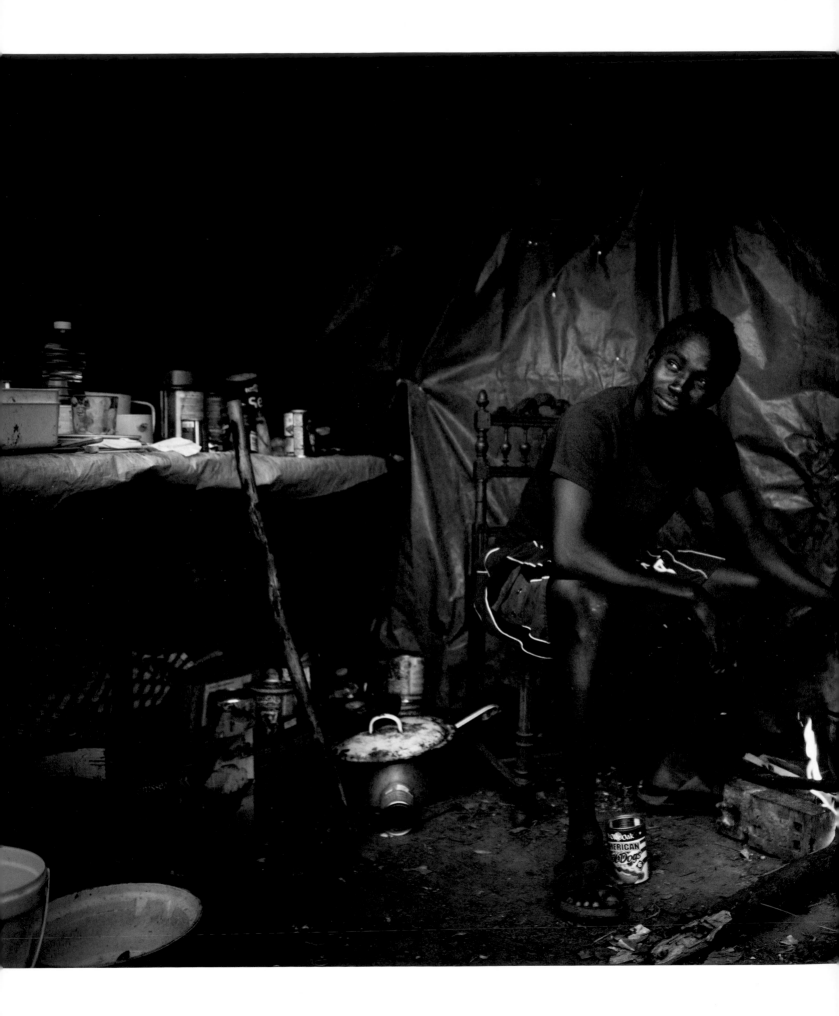

The Sudanese prepare daily meals with donated canned goods and cookware in makeshift communal kitchens, a tradition they continue after leaving a troubled homeland.

Hamada introduced his neighbors. All wanted to take pictures, become Facebook friends, offer cups of spiced tea. While Hamada changed clothes, his girlfriend, Njat, waved me into a framework shanty where other women stayed warm among piles of foam mattresses. A lavish display of oranges, bananas, and pineapple occupied a shelf. Clothes hung from walls padded against the cold with old leopard-print blankets. They fussed over bright-eyed Yarra, crawling around in the semidarkness seeking her teddy bear. The Sudanese considered the toddler incredibly lucky. Yarra left the hospital where she was born just before it was bombed. Her nickname is "Euro."

"Like the coin," said Rasha, a middle-aged woman wearing a purple knit scarf and pierced earrings.

By the time we set off for the city center, the halal butcher on Avenue Antoine de Saint-Exupéry had closed for lunch.

"Does it really matter if the meat is halal?" I asked.

"Yes," replied Hamada. "Or we won't be able to eat it."

Halal means "permissible" in Arabic. It applies to all aspects of life for Muslims, including food and drink. (Sharia law notably forbids consumption of pork and alcohol.) A certified practitioner must slaughter animals according to established blessings and methods. Since most other shops in central Calais also kept French business hours, we hopped on the autoroute and headed west toward the suburb of Coquelles, passing a decaying bunker, once part of the Atlantic Wall fortifications erected by Hitler's occupying army to ward off the Allied invasion in the final years of World War II. In the middle of a roundabout after the exit, a massive tunnel-boring machine has been turned into a monument to the Eurotunnel builders. The French used six "iron ladies" to dig under the English Channel. This one is named Virginie.

We parked in the giant lot outside Auchan Hypermarket. French families packed the in-store brasserie, sawing away on *steak-frites*. Loudspeakers announced sale items in the garden and electronics departments. The two of us made an odd couple: a short American and a beanpole African, pushing a shopping cart through aisles stacked with European bulk goods.

"You can take off your hoodie," I suggested.

"I am refugee," Hamada shrugged.

"But you don't have to look like one."

He removed it reluctantly, exposing a mop of unruly hair.

I threw large packs of tea and sugar into the cart while Hamada hunted the produce aisle for onions, garlic, and tomatoes. Wandering through an unfamiliar supermarket can

be nerve-wracking at the best of times; in a foreign country on the weekend, it's downright chaotic. We got lost searching for yogurt. In the meat department, I asked a butcher if he had halal lamb. He shook his head. Hedging bets, I grabbed a small packet of shoulder cuts.

Hamada looked surprised. "You speak French?"

"Why not? You speak Arabic and English."

I added lamb bouillon cubes and coffee to the growing pile in our cart. Hamada paused, a perplexed look on his handsome face.

"We need this kind of bean," he said. "I don't know the name in English."

"What color is it? Is it dried? In a can? What do you do with it?"

He texted Rasha and Njat. They couldn't translate either. We headed toward check-out. Rounding a corner in the condiment aisle full of fancy French conserves and mustards, Hamada became excited.

"There it is! That's the bean we need! I knew if I saw it, I would recognize it." He pointed to Skippy creamy peanut butter. We bought two jars.

Back in The Jungle, Rasha unloaded groceries in one of the less primitive private kitchens. She set a pot on a burner and sliced onions expertly. She flipped her scarf out of the way while mincing lamb for the *mullah robe*, or yogurt stew.

"We use dried meat at home," she explained. "And sometimes dried okra."

I told her the lamb wasn't halal. "Then we will just put in a little, for flavor," she said.

The meat sizzled in oil. Hamada dropped peeled garlic cloves into an empty plastic water bottle and then smacked it repeatedly against a table, a neat trick for pulverizing the contents. Rasha added it to the stew, along with onions, tomatoes, and yogurt, and finally stirred in the peanut butter. As it simmered, she mixed flour with oil, salt, and water, and then pounded away with a yardstick to make *aseeda*, a doughy porridge beloved by Saharans and Middle Easterners. By this time, men had gathered outside, waiting for a treat. They ate quickly, scooping up the contents of the pot with the first two fingers of their right hands. Rasha neglected to mention the lamb's questionable grace. To me, the stew tasted overwhelmingly of peanuts, but everyone else enjoyed it immensely.

Rasha departed for a government-sponsored dormitory at Centre Jules Ferry, on the northern extreme of the encampment, where women and children sheltered at night. Plump Njat, who has an uncle in Britain, risked staying in the wider population to try crossing with Hamada. The men rushed away as the evening call to prayer sounded in one of The Jungle's single-room mosques.

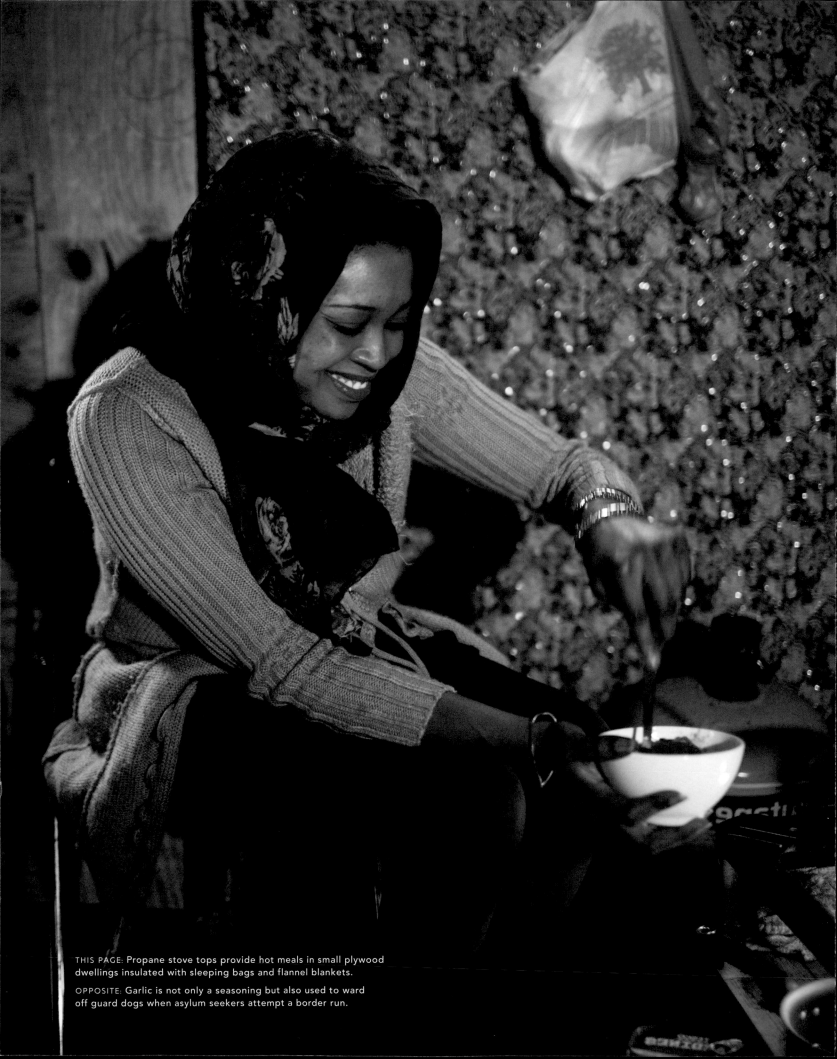

THIS PAGE: Propane stove tops provide hot meals in small plywood dwellings insulated with sleeping bags and flannel blankets.

OPPOSITE: Garlic is not only a seasoning but also used to ward off guard dogs when asylum seekers attempt a border run.

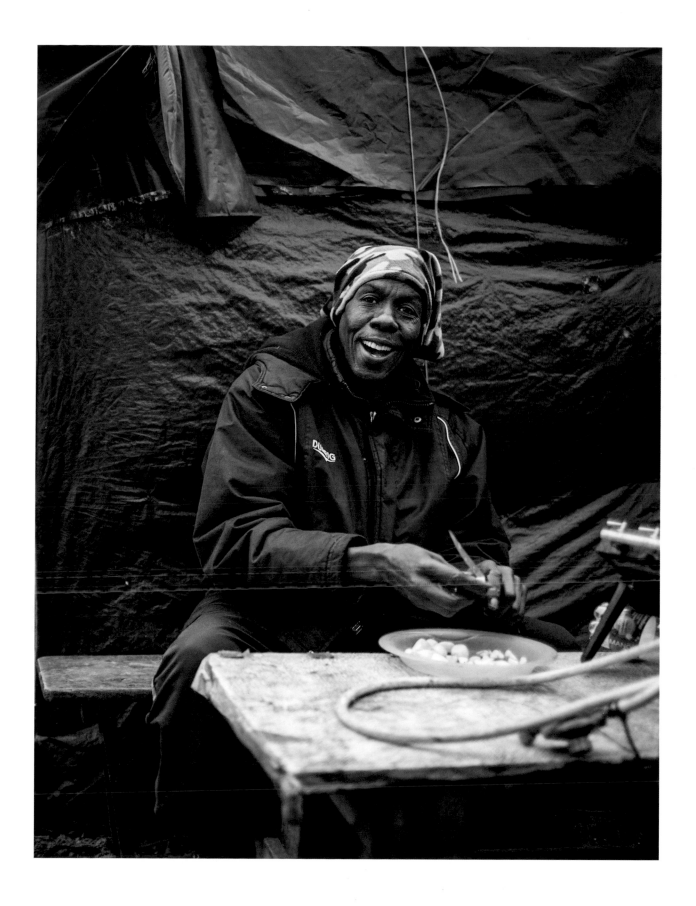

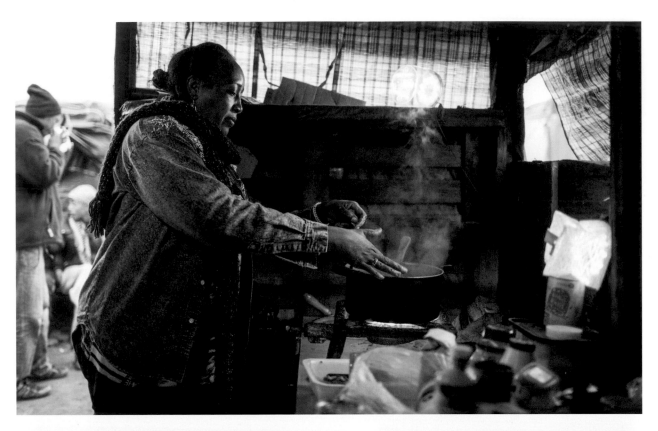

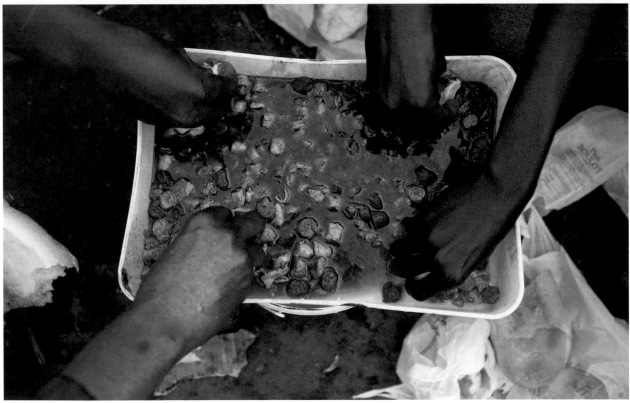

I avoided liquids most of the day, not relishing the search for a clean toilet, but how to refuse hospitality from those who have so little to offer? Finished with prayers, Hamada and two friends, Ibrahim and Algoks, urged me inside the *lumma*. It was snug with cast-off bar chairs, a coffee table, and a real stove. Two French aid workers sat on a couch with a Syrian translator named Ahmed.

Cherubic Ibrahim dunked fresh tea bags into boiling water and added powdered cinnamon. Algoks handed me a mug. I thanked him.

"No thanks for duty," he replied, kindly.

The Sudanese heaped sugar from a bowl. Spoons clattered in mugs. I lifted my tea to the hosts. "Cheers."

The Parisian women clinked their mugs, exaggerating for effect the Gallic ritual of eye contact during a toast. The Sudanese followed, beaming.

"*Haraam*," said Ahmed, sternly.

"Excuse me?"

"We do not say 'cheers.' It is forbidden."

It was just tea. The Sudanese looked sheepish.

⁜

Sunday was a busy night at the 3 Idiots restaurant. Shoes were left in piles on the dirt floor, as tired men leaned back on raised platforms upholstered with sleeping bags. Some sipped chai from plastic cups, others smoked hand-rolled cigarettes while waiting for their cell phones to charge. A chandelier powered by a generator hung from the ceiling. Everyone stared at the flat-screen television as actor Shah Rukh Khan dangled off a skyscraper in *Happy New Year*, the Bollywood blockbuster about a jewel heist during a campy dance competition in Dubai. No one cared about absurd plot holes big enough to drive a truck through. The songs, the saris, and the fight scenes helped distract from reality.

Ali offered around a plate of *jalebi*, fried sweets common to street stalls back home. The dark-haired economics major from Peshawar learned to cook from his mother. "In Pakistan, I helped my mum in the kitchen," he grinned. "She said I would make a wife very happy some day."

OPPOSITE TOP: Rasha preparing *mullah robe*. See recipe on page 268.

OPPOSITE BELOW: Chicken and sausage *dammah*. "When guests come a long way or someone is dear to your heart, we honor them with this dish," says Hamada.

As I bit into one of the *jalebis*, sticky with syrup, Ali showed me pictures of his brothers. Originally, there were nine, but one died during a suicide bombing two years before.

"We came here for trying UK," he said. "It was very difficult and I had lots of problems. So I think with my other friends, let's open a restaurant or shop." (The name 3 Idiots references a popular film rather than the acuity of its owners.) While Ali supervised the kitchen, Gulsher, a stocky man in his midtwenties, played host, greeting newcomers with backslaps and bear hugs. Osom, their third partner, tended the adjacent shop.

Ali prepared the same menu every night. Plain basmati rice, spinach *saag*, kidney bean and lentil *dal*. Hot bread delivered from the new bakery across the pathway. Among the babel of dietary laws and requirements, French fries were the lingua franca here. Salty, hot, comforting; everyone in The Jungle ate them. But Ali's fried chicken was a miracle. Better than Popeye's, better than KFC. World-class fried chicken. Maybe Michelin-star fried chicken. (The chicken was French, after all.) Here, atop a toxic landfill, mired in mud and muck, in a makeshift kitchen lacking running water or refrigeration, was a bird to sing about. A spicy paste clung to pieces of meat, juicy without being greasy. What do you crave when you can't go home again? Or worse, fear being sent back? Perhaps this drumstick, Day-Glo red with tandoori coloring.

The restaurant was often busiest at five o'clock in the morning, when weary men like Hamada returned from unsuccessful bids to climb into trucks, but as the weather grew colder it proved better shelter than a tent. More people piled inside. Kuwaitis, Iraqis, Afghans, Sudanese. The restaurant was also a favorite of aid workers and volunteers, who squeezed together with the migrants and refugees. Everyone was made to feel welcome, whether or not they could afford to pay. I shared the *jalebis* with the men sitting closest to me. They accepted silently and turned to watch the film again.

Hamada wanted a pair of pants from Osom's grocery. I had to duck under a barrier between shop and restaurant. A thin Pakistani with graying hair, Osom sat surrounded by shelves filled with cooking oil, Fanta, lemon juice, and boxes of cookies. Customers handed him coins through a gap in the wire mesh window display. A bucket on the floor served as the store cash register. A boy in a puffy down jacket appeared, wanting a banana. Osom tossed him a candy bar as well.

"We call him Bambino," he said. "He showed up alone, only fourteen years old, so we adopted him a little."

"Where did you meet Ali and Gulsher?" I asked.

"We're all from one region," he said. "And we accidentally met here, but I knew Gulsher's brother before."

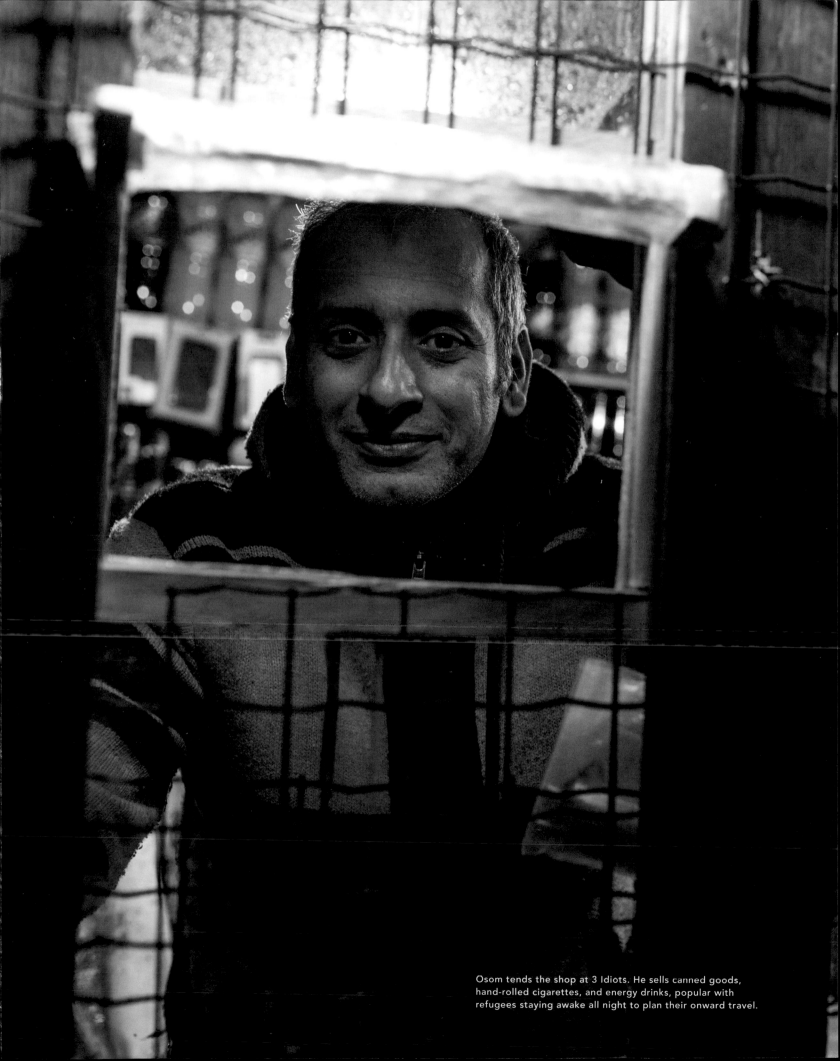

Osom tends the shop at 3 Idiots. He sells canned goods, hand-rolled cigarettes, and energy drinks, popular with refugees staying awake all night to plan their onward travel.

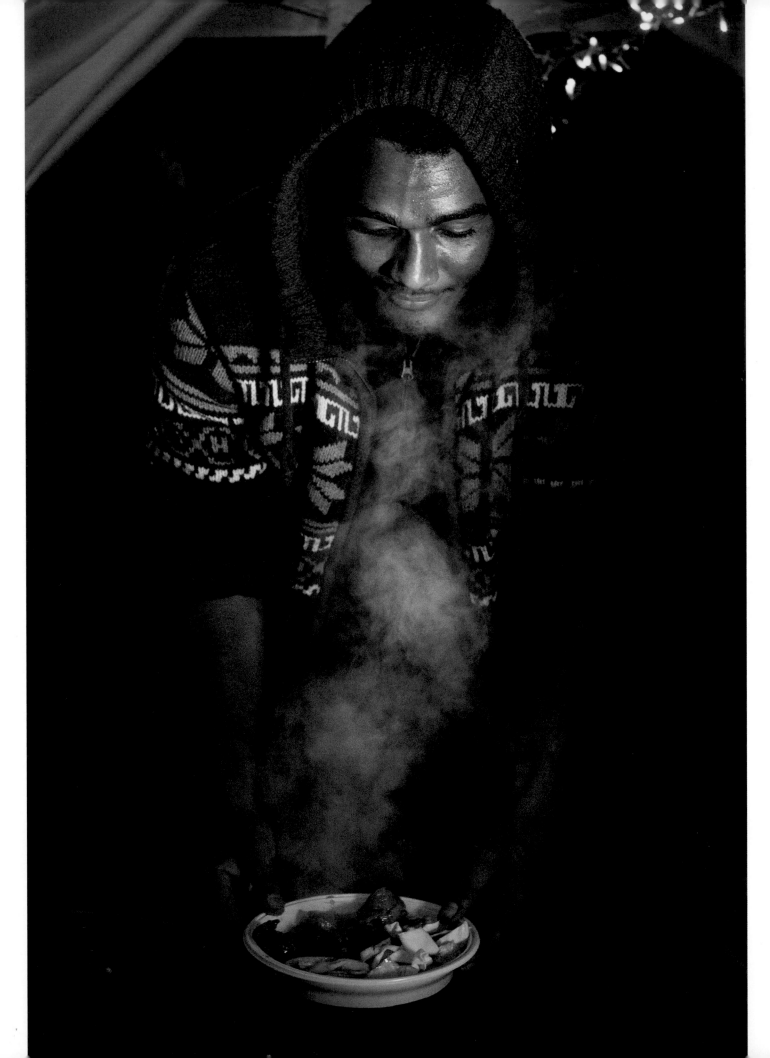

I patted a stuffed toy tiger, as big as a standard poodle, crammed among the dry goods. "And how did *he* get here?"

"This jungle creature has eaten a lot of humans," Osom grinned. "Where the bushes are, this means 'jungle' in Hindi and Pashto. Sometime we hear rumors the government will end this Jungle, but where will they take these people? They cannot drop them in the city. Jungle will survive."

While Hamada continued to haggle with Osom, Ali pulled me into the kitchen to show me his secret recipe. Nusrat Fateh Ali Khan, the Pavarotti of Sufi devotional music, wailed on his phone. "I make the masala in the night," he instructed. "Then put the chicken in so it catches the sauce and makes it more tasty." He picked up a chicken leg and dangled it over a wok filled with oil.

"It's hot! Don't put your finger in!" he said, joking. The chicken bubbled the oil, fiery red masala paste puffing. "Twenty minutes and it will be done."

But I had a train to catch. The chicken wasn't ready, so Ali wrapped another cooked piece in foil. "Take it with you, auntie." As I left, Gulsher changed the film. On the screen Cate Blanchett in *Elizabeth: The Golden Age* replaced Shah Rukh Khan. The juxtaposition seemed deeply ironic in that moment: refugees from the far reaches of the former empire, desperate to reach England, watching a film about its virgin queen. Later, I learned that Pakistani-born filmmaker Shekhar Kapur had directed it, and that somehow contributed even more to the paradox.

Outside 3 Idiots, blue strobes from tactical vehicles lit the horizon. Hamada escorted me through the black market, in full swing at a crossroads close to the autoroute overpass. Men held up pants, new sneakers, sweatshirts, pay-as-you-go phone cards. Strings of fairy lights illuminated a rough-looking nightclub. Boys rode past on bicycles, kicking up mud. While the long-term survival of The Jungle is dubious, and despite tear gas attacks or bulldozers at the door, on this night it was a border town in full flourish. My self-appointed bodyguard and I weaved around tents next to piles of discarded clothing and wound up on Route des Gravelines, where most volunteers left their cars. We shook hands. As Hamada turned back into the darkness, he bid me good-bye.

"Arrive safely."

OPPOSITE: Hamada serves halal beef and French fries to friends during a holiday feast in The Jungle.

MULLAH ROBE / LAMB AND YOGURT STEW

SERVES 2

This *mullah*, or stew, is a classic Sudanese dish. In Arabic, *robe* is the word for yogurt. During the Ottoman Empire, Syrian traders and Arab settlers heavily influenced the regional cuisine with the introduction of garlic and red pepper, among other seasonings. Dried okra is often used as a thickener in *mullah*, but many Sudanese, like Rasha, also favor peanut butter. Back in her home country, she would have prepared this stew with dried lamb jerky; as a substitute, she used minced lamb while cooking in The Jungle.

2 tablespoons canola or safflower oil

2 medium onions, chopped

3 large cloves garlic, finely minced

1 pound lamb, ground or finely minced

2 cups water

2 tablespoons flour

2 to 3 tablespoons lamb bouillon,
see recipe page 269

2 tablespoons peanut butter, preferably an
unsweetened creamy variety

2 tablespoons tomato paste

1 cup plain yogurt

Coarse sea salt to taste

Red pepper flakes

Heat the oil in a saucepan over low heat. Add the onions, garlic, and lamb, stir to combine, and sauté until brown. Add the water and simmer for 10 minutes. In a separate bowl, combine the flour and bouillon to make a roux. Add to the saucepan along with the peanut butter, tomato paste, and yogurt. Stir to combine. Lower the heat again and continue to cook for another 5 minutes, until thickened Add the salt and red pepper flakes to taste. Serve with crusty bread.

LAMB BOUILLON

Making bouillon from scratch only requires a little forethought: save the bones from a leg of lamb or chops, because the flavor extracted from them is far more subtle and refined than oversalted, dehydrated meat stock in cube form. Perfect as a base for gravies and roux, bouillon adds richness to a meat dish from a country where animal protein is a real luxury.

1 pound lamb bones
¼ cup white vinegar
1 carrot
1 stalk celery
1 whole scallion or small shallot
1 clove garlic
1 whole bird's eye chile
1 teaspoon coarse sea salt

In a saucepan, cover bones with cold water, and add vinegar. (Vinegar helps pull nutrients from the bones.) Allow to rest for one hour. Then add all other ingredients. Bring to boiling point, and skim scum from the surface. Lower heat and gently simmer for at least 4 to 6 hours. A longer cooking process means deeper flavor. Add more water if needed. Allow to cool, remove bones, and strain liquid through a fine sieve into a container. Broth should become gelatinous after refrigerated. Can be frozen, if not used immediately.

FRIED CHICKEN À LA JUNGLE

SERVES 4 TO 6

For his fried chicken, Ali removes the skin from the legs and thighs he marinates in a spicy masala blend. This creates a thick paste that clings to the meat when immersed in boiling oil. He also uses powdered food coloring to approximate a tandoori-style dish that hails from the Punjab region of Pakistan. You can find tandoori food coloring and garam masala online (see Sources, page 294) and from Indian grocers. (If you prefer natural coloring, substitute dried Kashmiri chile powder instead.) The invention of tandoori chicken is credited to Kundan Lal Gujral, a man who founded the Moti Mahal restaurant chain in Peshawar during the 1920s. The fried variation, however, is Ali's own creation.

1½ cups chickpea flour

1 tablespoon chile powder

1 tablespoon garam masala

1 tablespoon salt

⅛ teaspoon powdered red food coloring

1½ cups water

8 pieces bone-in chicken, preferably drumstick and thighs, skin removed

1 quart safflower, canola, or peanut oil

In a large bowl, combine the flour, spices, and food coloring. Add the water, stirring until a smooth batter forms. Slightly score the chicken with a knife, and immerse the pieces in the batter until coated thoroughly. Marinate for at least 6 hours or overnight in the refrigerator.

In a wok or cast-iron Dutch oven, bring the oil to the boiling point. Add the chicken coated with marinade, 1 or 2 pieces at a time, without crowding the pan. Fry over high heat for about 5 minutes, which will help the masala paste adhere properly and form a crust. Then lower the heat and cook for another 20 to 30 minutes, turning the meat once to brown crust on all sides, until browned all over. Repeat with the additional chicken pieces. Remove to a cake rack or paper bag to drain. Serve while hot.

OPPOSITE: Most weekends, volunteers from Britain and elsewhere arrive in Calais with clothing, tents, and warm blankets. Chickpeas, rice, and canned fish are also popular supplies.

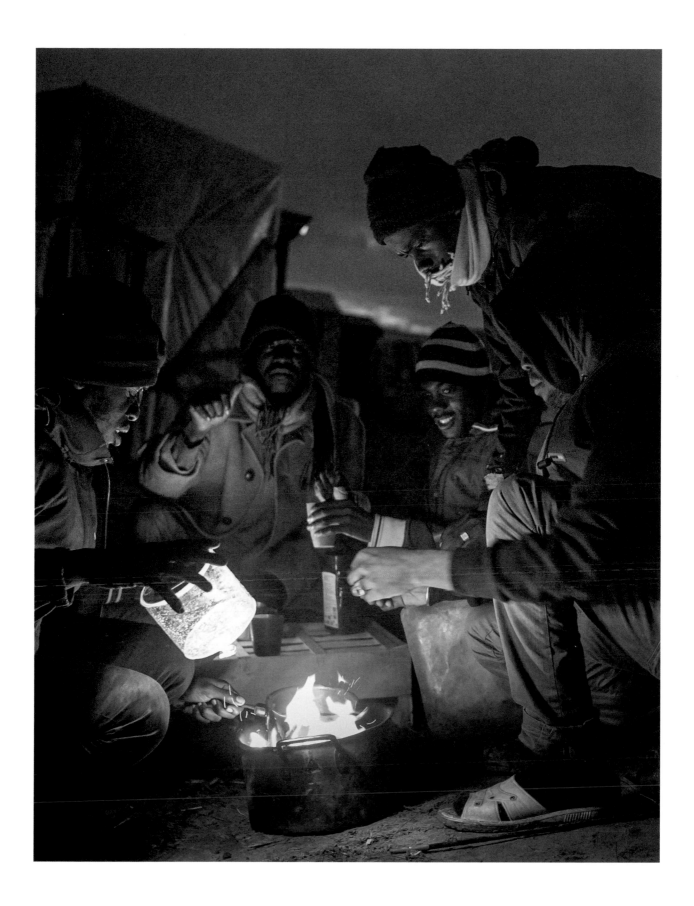

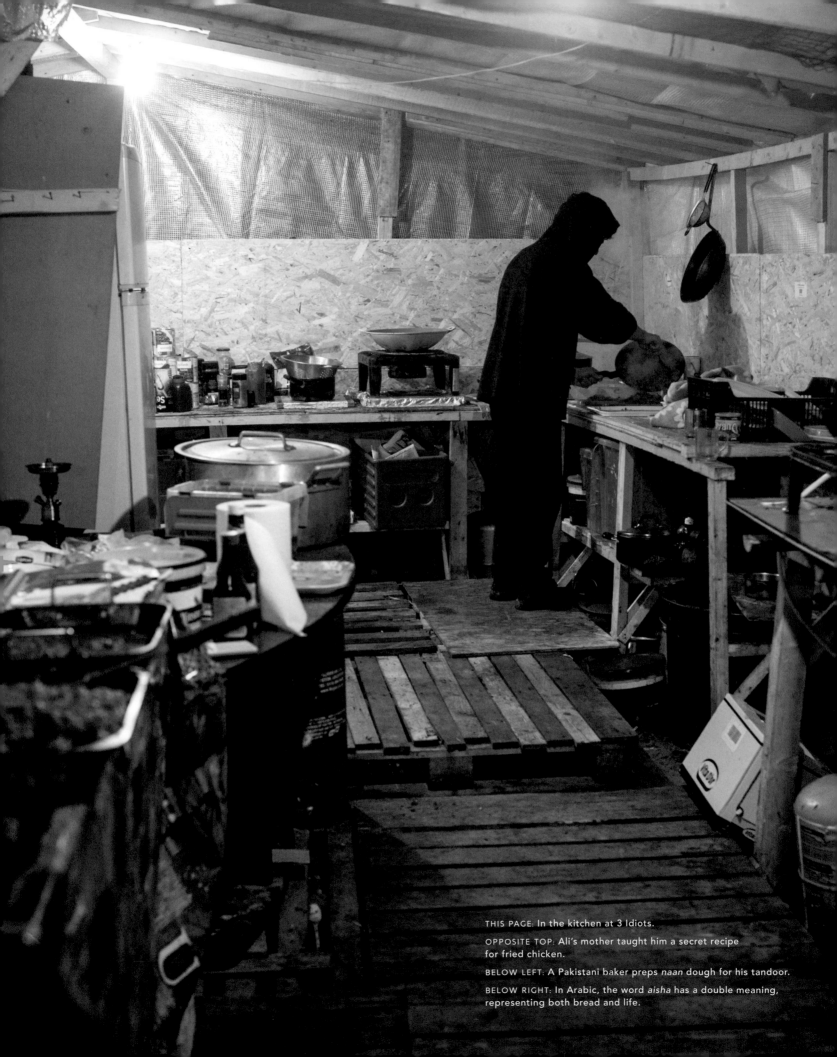

THIS PAGE: In the kitchen at 3 Idiots.

OPPOSITE TOP: Ali's mother taught him a secret recipe for fried chicken.

BELOW LEFT: A Pakistani baker preps *naan* dough for his tandoor.

BELOW RIGHT: In Arabic, the word *aisha* has a double meaning, representing both bread and life.

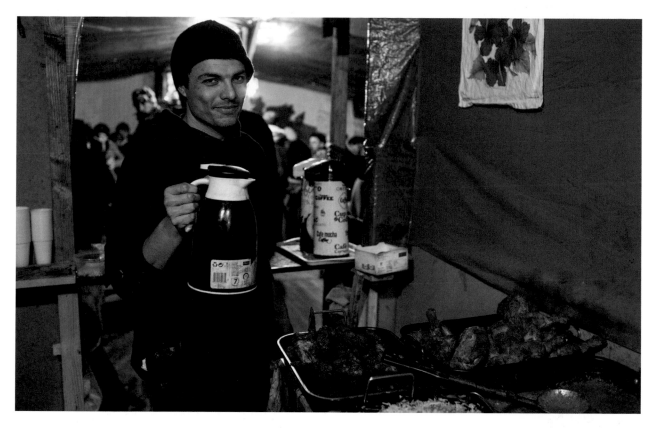

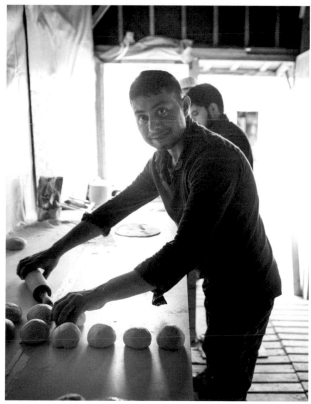

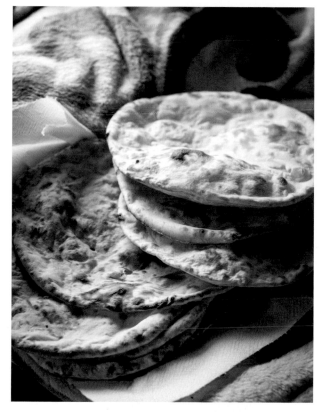

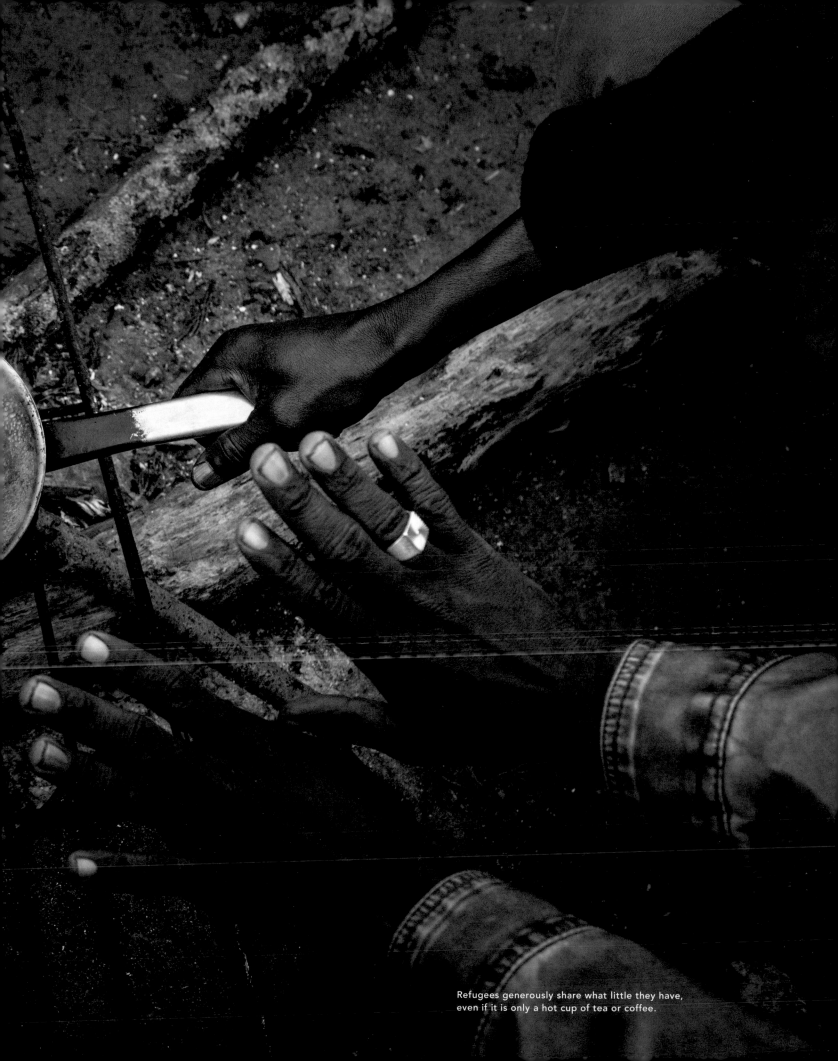

Refugees generously share what little they have,
even if it is only a hot cup of tea or coffee.

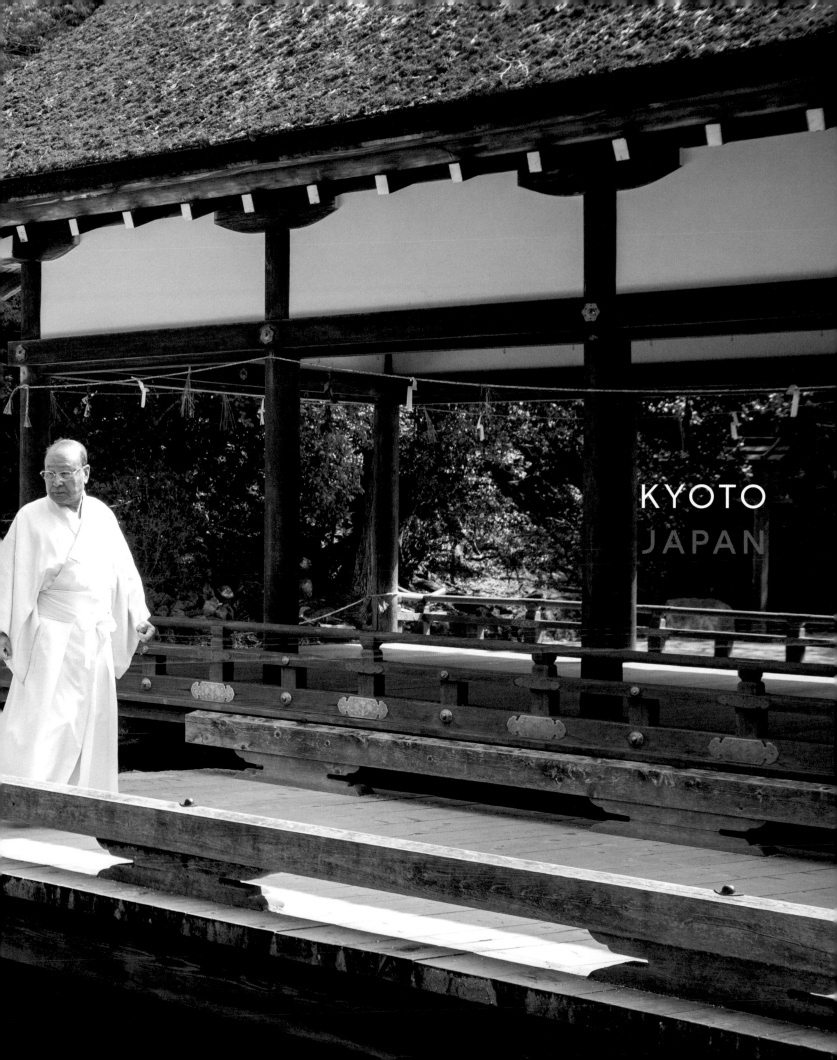

KYOTO

JAPAN

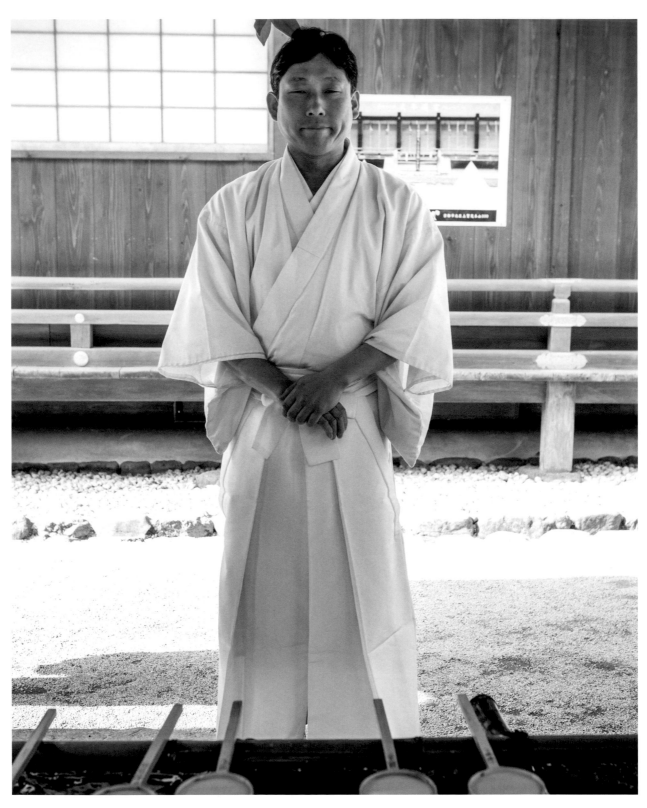

Mitsutaka Inui at the *Tsuchi-no-ya* (purification place)
outside the main sanctuary.

INUI-SAN / SHINTO PRIEST

Kyoto, Japan

Snow had fallen the night before. A dusting still covered the lawn outside the orange *torii* gate as Reverend Mitsutaka Inui walked at a measured pace toward the entrance to Kamo-wake-ikazuchi-jinja Shrine. His white vestments appeared translucent in the chill air. He wore a lacquered black conical hat tied under his chin with a white string. Inui passed weeping cherry trees, barren of blossoms, then circled two cones of mounded pebbles and paused to purify his hands in a stone trough. I used a bamboo ladle to pour the icy spring water over my fingers, too. This early in the morning we had the shrine to ourselves. A narrow wooden bridge spanned a clear-flowing stream, dividing mundane from divine. Not far from there, atop Mount Koyama, one of the weather spirits was hungry.

Before we crossed over, Inui turned to me. "After 9/11, I lived in Hamilton Heights, on 144th Street and Amsterdam. Such a lovely spot."

Days earlier, when I stepped off the bullet train in Kyoto, toxic smog drifted across the East China Sea from Beijing. The choking yellow haze caused a persistent cough and gluey eyes; I fell victim as well, rudely sniffling in public without a handkerchief or one of those surgical masks deemed polite in Japan. Flu knocked Tokyo on its knees. Minor tremors unsettled the place almost every day. (The islands of Japan lie within the Ring of Fire, that seismically active basin of the Pacific prone to earthquakes, tsunamis, and volcanic eruptions.) But it was the aftermath of the Fukushima Daiichi nuclear disaster (known in Japan as 3/11) that truly scared everyone—not just those raised on a steady diet of Toho Company B-movies and their *daikaijin* (giant monsters) spawned by nuclear radiation. One accidental viewing of *Godzilla vs. the Smog Monster* as a child gave me nightmares for years; it wasn't difficult to guess how the Japanese felt after Fukushima.

While more imposing shrines exist in Kyoto, serene Kamo-wake-ikazuchi-jinja, familiarly called Kamigamo, is one of the oldest. It lies north of the central district, closer to the mountains that encircle the city. The urban sprawl barely touches its front gates.

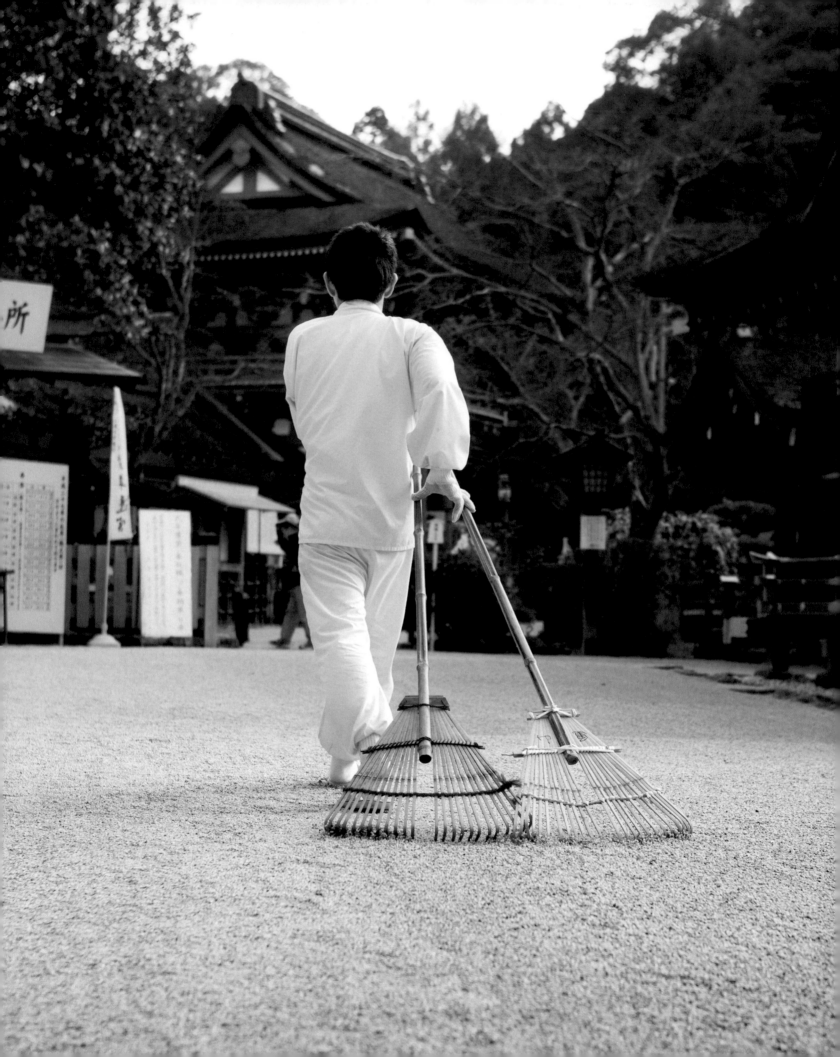

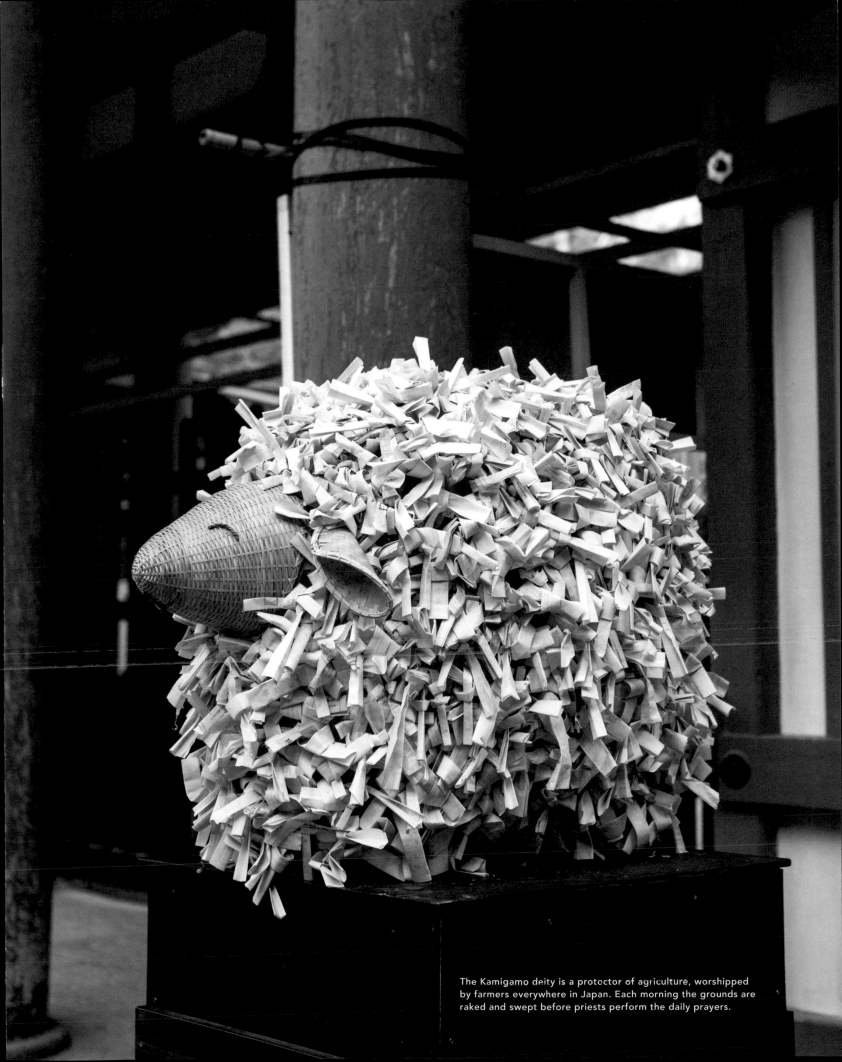

The Kamigamo deity is a protector of agriculture, worshipped by farmers everywhere in Japan. Each morning the grounds are raked and swept before priests perform the daily prayers.

Inui stopped me as I set foot on the bridge. "Never walk straight in the center. Walk on right or left side. It's respect for the divine."

His black clogs crunched on the freshly raked gravel path.

"What brought you to New York?" I asked.

"The shrine sent me. After 9/11, so many people were a little bit tired and had sad feelings. I performed many blessings, many purifications, many ceremonies to maintain the peace. In the history of Japan, we faced many big earthquakes or disasters, but we recovered, so I thought it helpful. It was my duty, not Kamigamo duty, but *life* duty."

"Did you like living in Harlem?"

Inui's solemn face lit up. "My neighbors were mostly Puerto Ricans. They were very kind, but my friends who came from Japan, they were worried, their faces broken. At midnight, parties outside with drinking and big sounds. That culture is not about inside house!"

The path sloped upward. Ascending past a stand of pines, he indicated a small rock, cordoned with rope. It was one end of an energetic lay line that extended up the sacred mountain. The Japanese call this energy *ki*. A two-story structure with a pagoda roof guarded Kamigamo's main sanctuary. We passed through gates and shut them behind us. Steep stone stairs led to an inner gallery and courtyard facing the ancient shrine. Inui indicated where I should leave my shoes, and then pushed open a *shoji* screen door to reveal a side chapel. The young priest knelt on soft tatami mats, then bowed at an altar. I sat directly behind, following his example. Inui lifted a wand of white paper fronds and waved it gently above my head three times.

Shinto derives from the Chinese characters for *shen* (divine being) and *tao* (way) and means Way of the Spirits. Rituals, rather than faith, allow for communication with *kami* spirits who may intervene in the mortal realm. No scripture, no afterlife, no missionaries. A deep appreciation of the natural world is key to the practice of Shinto; pollution of any kind—spiritual or physical—is anathema. Wake-ikazuchi, the spirit of Kamigamo, is a special favorite of farmers.

"Are you finding more people gravitating to Shinto after Fukushima?" I asked.

Inui nodded. "Yes. We're especially focusing on the nuclear power plant. Every morning we perform a prayer for recovery."

He rose and opened another sliding door, and we entered a covered gallery facing the inner shrine. The high priest, wearing a russet robe over wide purple trousers, arrived bearing a plain cedar box. He climbed the stairs and placed it on a low table between a pair of guardian dog statues flanking blackened doors. The box contained rice, sake, and other offerings.

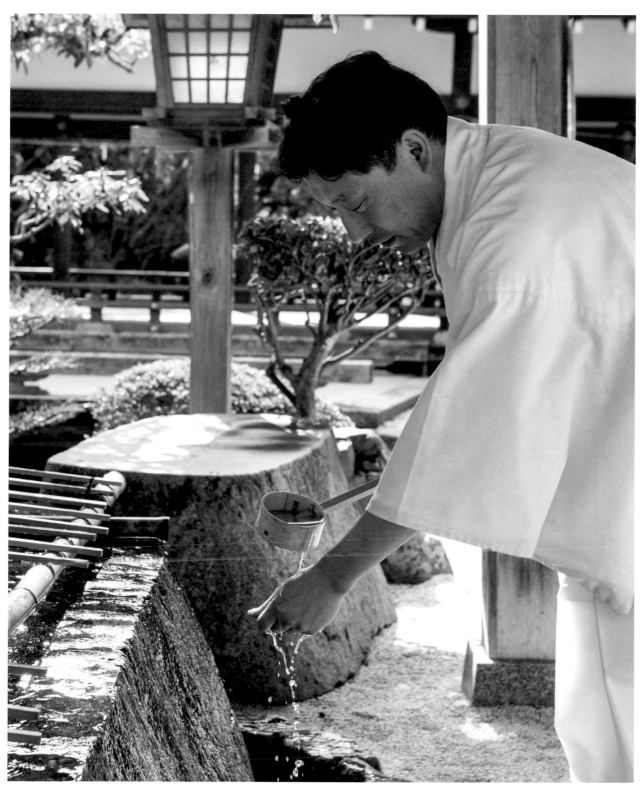

This shrine is one of the oldest in the ancient city
of Kyoto, where the same rituals have been performed
since the reign of Emperor Kinmei in the sixth century.

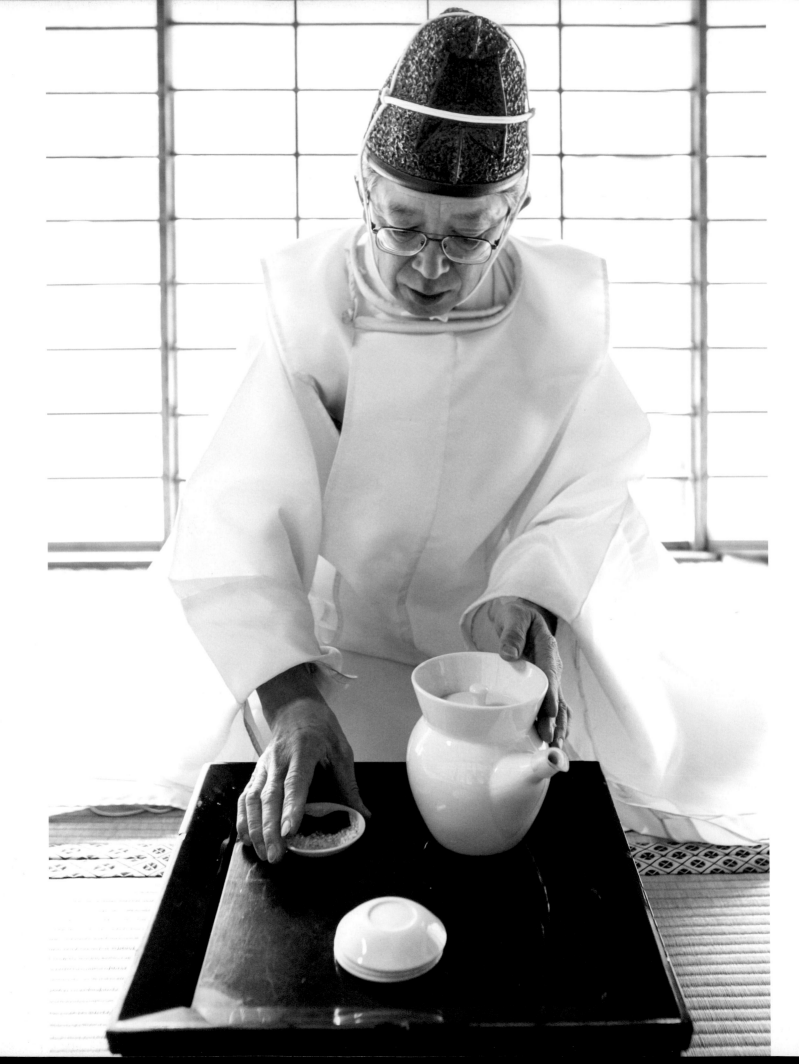

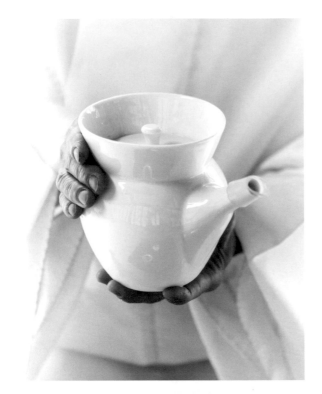

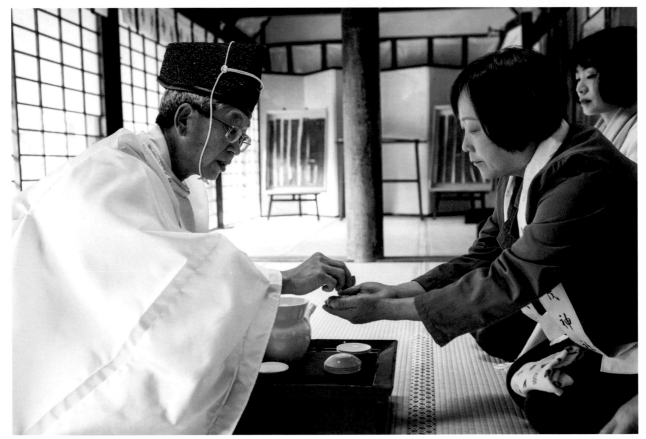

Earlier, Inui explained this ritual: "Japanese *kami* like to eat. From sea, from land. Snapper, wakame, mochi cakes, carrots, apples. Salt and water. Everything, he wants to eat. We give the food to show appreciation, and then we talk to the divine. 'Thank you for everything; please make us happy, all over the world.' We say this early in the morning. Same way for two thousand years."

The high priest knelt in front of the inner shrine. He bowed low, clapped twice, and chanted a prayer. It didn't take long. When he was finished, we all bowed and clapped again, and returned to the side chapel. Inui asked me to sit as his fellow celebrant presented a red lacquer tray holding a pitcher and a shallow bowl of uncooked rice. He poured cold sake into a cup. It was just a sip, really, but I've never tasted anything so pure, more ambrosia than alcohol.

One of the more poetic names for Japan is "Land of Abundant Rice." The grain was first cultivated in the Yayoi period, sometime during the third century BCE. Farmers pray at Shinto shrines for *gokoku hojo*, a bountiful harvest. The word *gokoku* actually represents five grains: wheat, rice, adzuki beans, proso millet, and foxtail millet. But rice is divine. It's considered bad manners to leave even a single grain uneaten. At the final stage of the ceremony at Kamigamo, in which guests are offered a Shinto version of communion, Inui carefully selected five grains of hard rice in a paper scoop. I put them on my tongue and rolled them around until the starch dissolved.

Inui and I donned our shoes again. As we walked down a cobbled path on the way back to the entrance, the rising sun caught ice crystals on the pines. The cold, white morning gained warmth and color.

The Japanese concept of *mono no aware* is the wistful comprehension that the most exquisite moments in life occur immediately before they end. The falling cherry blossom, the penultimate chord, a plain bowl of rice after an elaborate banquet. Thanking Inui for the morning ceremony, I headed to a sake shop in Kyoto's Nishiki Market. I couldn't find *omiki*, the communal wine served to the shrine's deity, but the salesman had something almost as special. He recommended a bottle of aged sake produced by a lady brewer on the coast near Kyoto. The charming label depicted two young boys sitting by the ocean next to an inscription about the end of their vacation: *mada kaeritaku-nai*. It means, "I don't want to go home yet."

TOP LEFT. A porcelain pot contains *omiki* sake, which is reserved solely for use in shrines.

RIGHT: Local brewers donate barrels of sake to Kamigamo, where they are prominently displayed inside the main *torii* gates.

BELOW: The final stage of the morning ceremony.

WINTER SOLSTICE

SERVES 4

Sake is one of the sacred offerings at Kamigamo Shrine. Barrels known as *sakedaru* are donated by brewers and stacked on a wooden frame at the entrance to the outer shrine. The production of sake dates back to 300 BCE in Japan; the oldest texts refer to the rice-based spirit as *omiki*, or god food. Even now, the drinking of sake is considered a way to connect with the gods. Luckily, that can take place in bars as well as shrines. This cocktail, served during the winter months at the Ritz-Carlton in Kyoto, pairs sake with yuzu, a tart, aromatic citrus variety, and salty powdered shiso, a member of the mint family.

1 tablespoon red shiso powder

6 ounces junmai sake, preferably from a Kyoto-based brewer such as Tozai

2 ounces Drambuie

2 tablespoons yuzu juice

Club soda

Rim martini glasses with a small amount of yuzu juice. Dip glasses in shiso until it adheres. In a cocktail shaker filled with ice, combine sake, Drambuie, and remaining yuzu. Shake and strain into glasses. Top with club soda.

WAKAME BUTTER SCALLOPS

SERVES 4

Kyoto is the birthplace of *kaiseki*, a formal progression of artfully presented, seasonal dishes, a tradition with roots in Zen Buddhist meditation. These meals are rigorous and expensive, so I often prefer to eat in *izakayas*—casual bars with down-to-earth snacks prepared to order. These scallops, grilled in their shells on a hibachi and drizzled with seaweed compound butter, is one of my favorite *izakaya* dishes. You can find shells and wakame online (see Sources, page 294).

BUTTER

1 tablespoon dried wakame seaweed

½ teaspoon soy sauce

¼ teaspoon rice wine vinegar

½ cup (1 stick) unsalted butter

Pinch of coarse sea salt

SCALLOPS

1 pound fresh bay scallops

4 scallop shells, cleaned

6 ounces enoki mushrooms

To make the butter, in a bowl filled with cold water, rehydrate the seaweed for 15 to 20 minutes. (Makes about ⅓ cup.) Strain in a sieve, reserving ¼ cup of the liquid from the bowl, and pat the wakame dry with paper towels. Transfer to a food processor, add the seaweed water, vinegar, and soy sauce, and puree until smooth.

In a stand mixer with a whisk attachment, combine the butter, 2 tablespoons of the seaweed puree, and a pinch of sea salt. Beat together until aerated, scraping down the sides of the bowl as needed, about 5 minutes. Scoop into plastic wrap and press into a roll. Refrigerate until needed.

To make the scallops, spoon equal portions of the scallops into the shells. (If you can't source shells, fashion small rectangular packets with foil instead.) Add 3 or 4 pats of butter, then top with 4 to 6 enoki mushrooms. Place on a charcoal or gas grill and cook until the scallops are browned, the butter is melted, and the mushrooms are softened, about 5 minutes. Serve immediately.

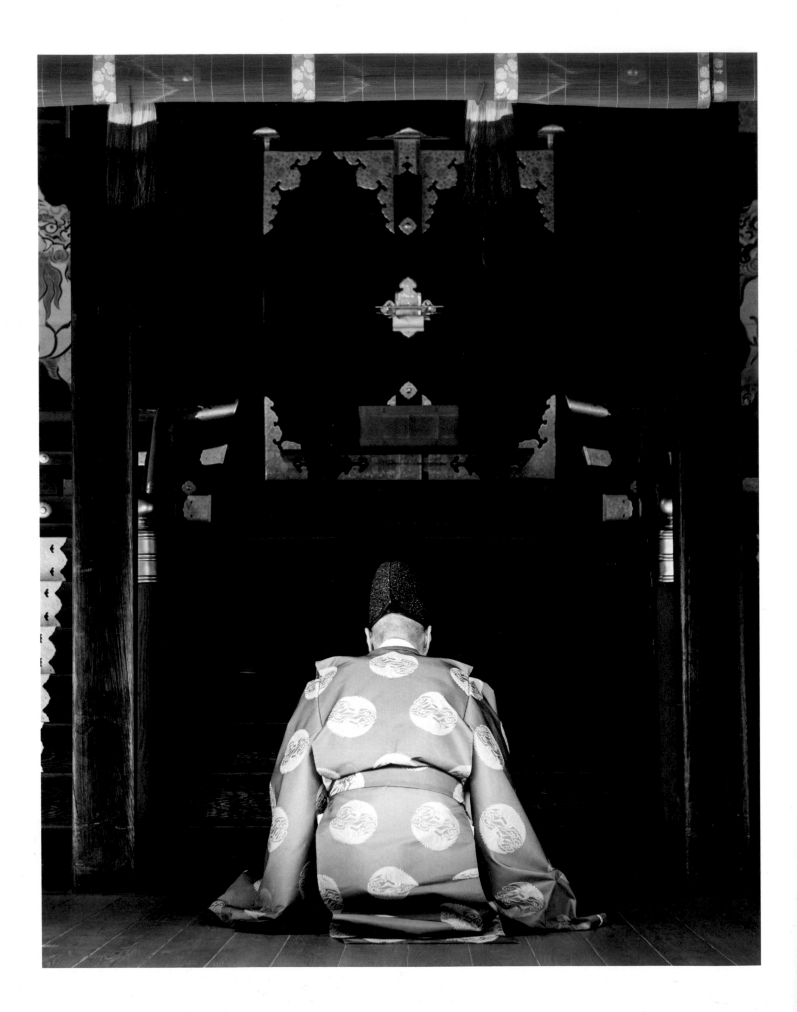

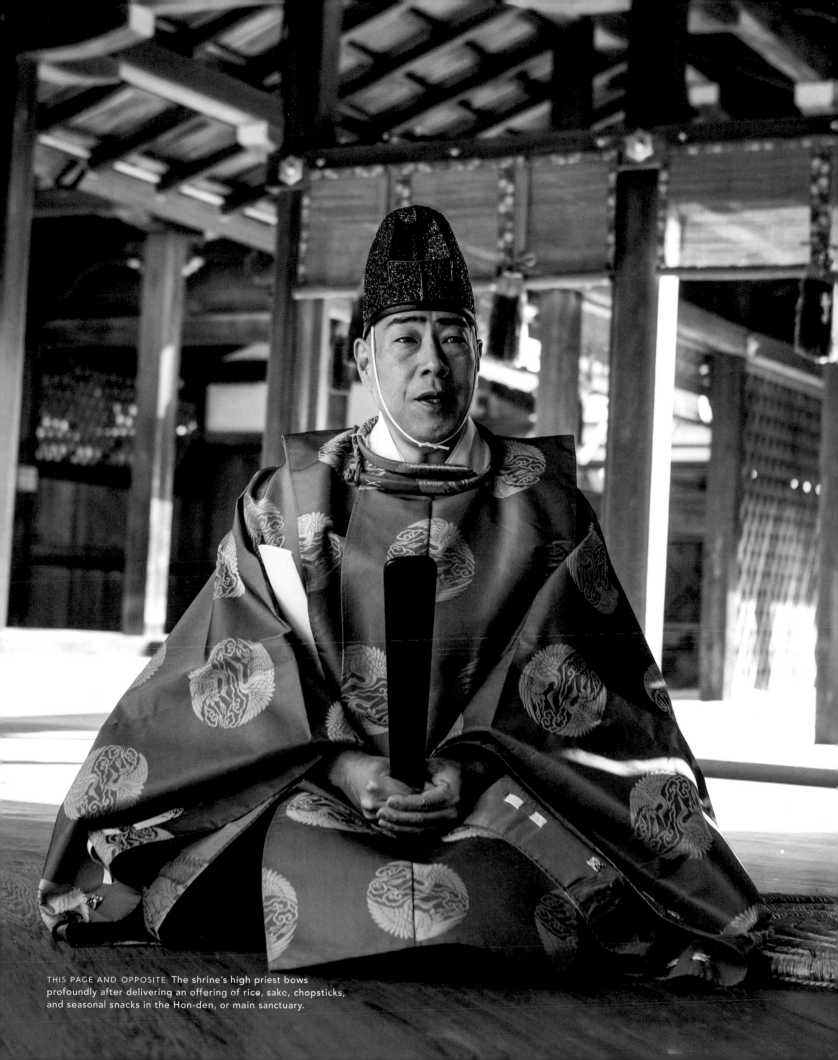

THIS PAGE AND OPPOSITE: The shrine's high priest bows profoundly after delivering an offering of rice, sake, chopsticks, and seasonal snacks in the Hon-den, or main sanctuary.

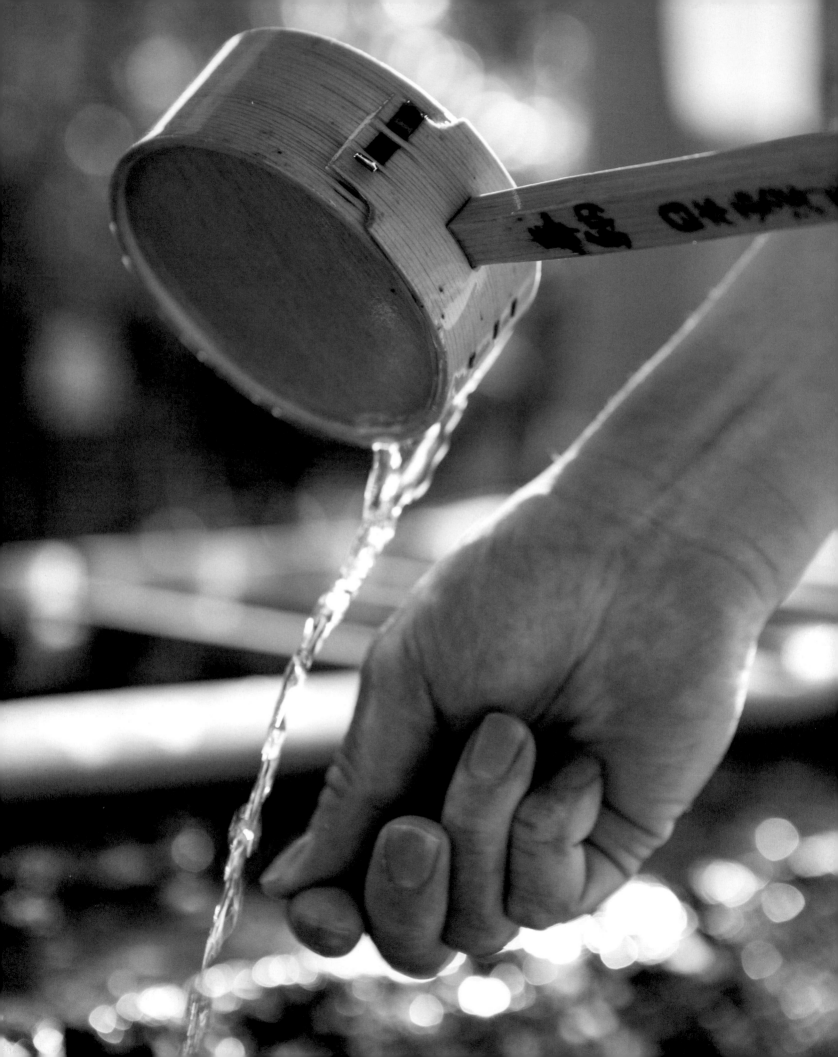

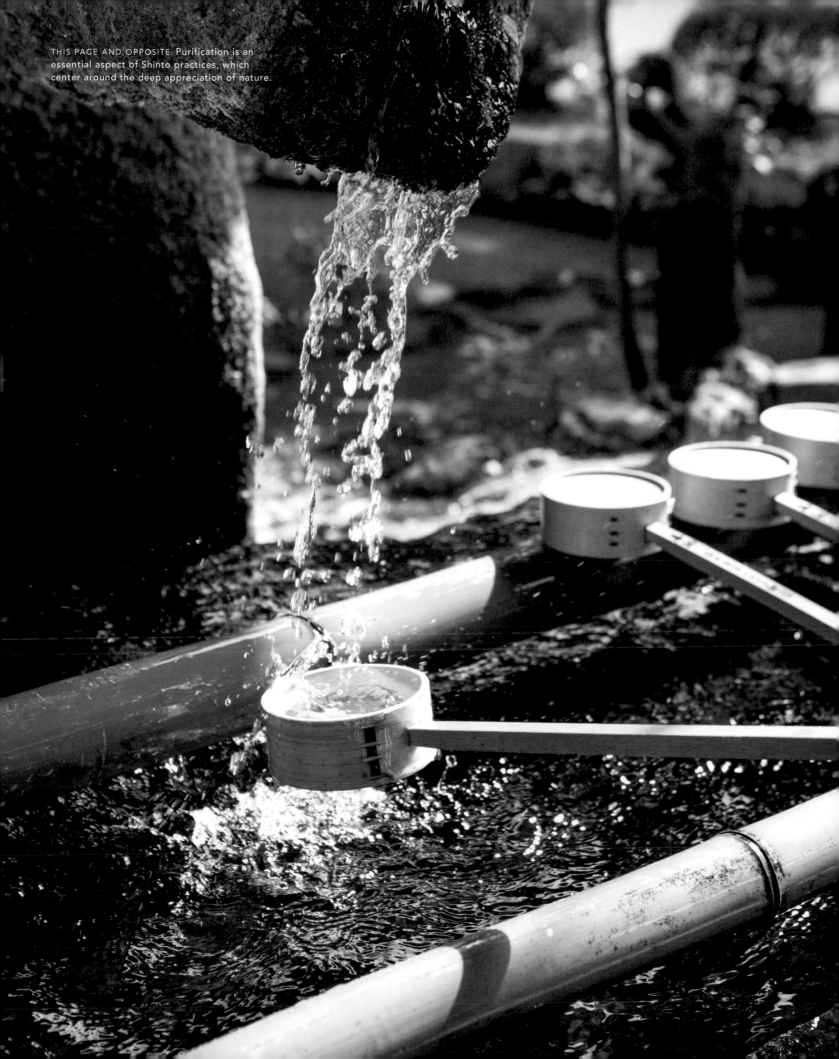

THIS PAGE AND OPPOSITE: Purification is an essential aspect of Shinto practices, which center around the deep appreciation of nature.

SOURCES

Wherever I travel, certain condiments return home in my luggage. Salt, honey and spices especially, which convey a taste of place like no other ingredients, as they are dependent on qualities of water, earth, fleeting blooms. Deep sea salt from Hawai'i and Kashmiri saffron are some of my most prized seasonings. When cooking the recipes in this book, here are sources for uncommon ingredients.

AMAZON

A good source for natural scallop shells, egg noodles, fermented red bean curd, fermented black bean paste, powdered shiso, yuzu juice, salsa mensi, and organic wakame seaweed.
www.amazon.com

D'ARTGANAN

A mail-order source for rabbit, wild hare, and bacon.
800-327-8246; www.dartagnan.com

KALUSTYAN'S

This Manhattan-based dry goods merchant is my virtual spice bazaar. An excellent source for food-grade mustard oil, Hawaiian li hing mui, dried Mexican oregano and epazote, Kashmiri chiles, and saffron.
800-352-3451, 212-685-3451;
www.kalustyans.com

KONA SEA SALT

This low-sodium salt is extracted from deep seawater off the coast of Hawai'i, and dried naturally under the sun. It has an elegant flake and mineral-rich flavor.
800-262-7290, 808-887-1046;
www.parkerranchstore.com

KORIN

Founded by Saori Kawano, this Manhattan-based trading company imports some of the finest Sakai knife brands, binchotan charcoal, kitchen tools, and specialty cookware.
800-626-2172, 212-587-7021;
www.korin.com

MELISSA'S

One of the largest specialty produce distributors in the United States, this is an excellent source for fiddlehead ferns, Key limes, enoki mushrooms, and baby eggplant.
800-588-0151; www.melissas.com

THE SPICE HOUSE

A Midwestern institution since 1957, this merchant stocks dried herbs, seasonings, extracts, and imported spices. A great source for orange-flower water, asafoetida, black cardamom, and whole stick cassia cinnamon.
847-328-3711; www.thespicehouse.com

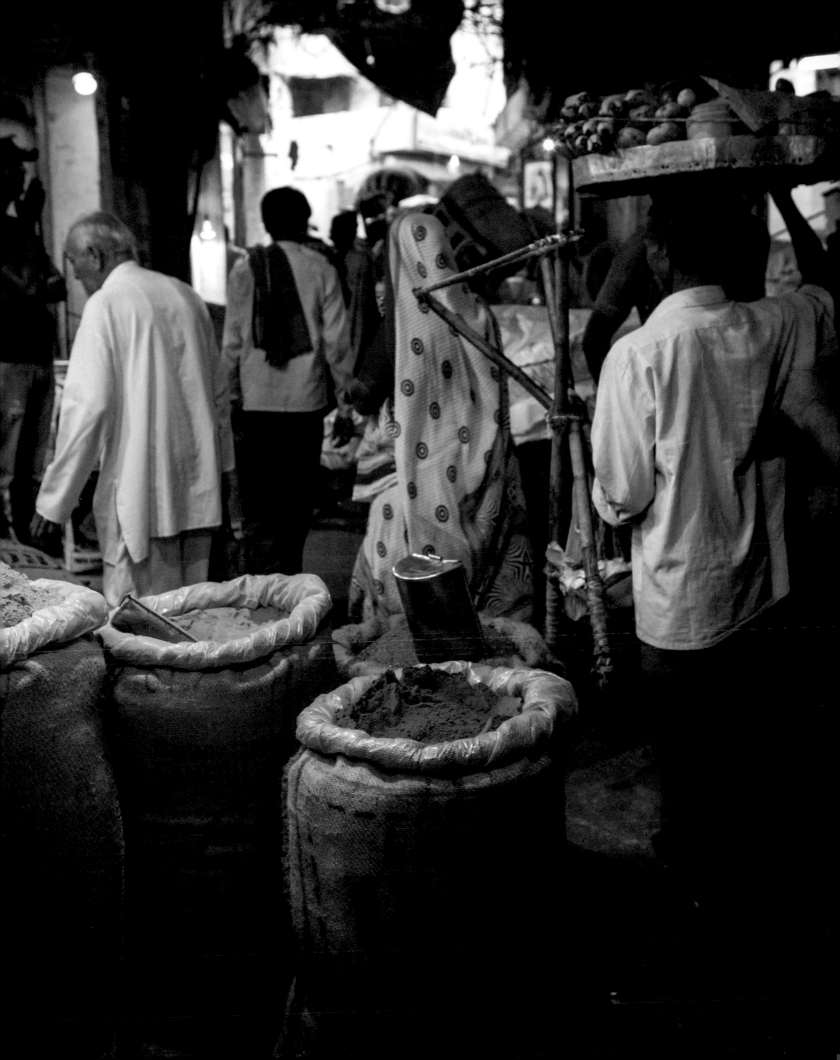

ACKNOWLEDGMENTS

Thanks to my husband, Bronson Hager, who keeps the home fires burning, because I have promised to always come back. My sister Hilary Mitchell for her discerning eye and creative support.

The people who opened their kitchens and welcomed me to the table: the Hanccos, Kipalonga, the Mock Chew ohana, the Mohammeds, the Ram family, the Sigurgeirssons, the Singh family, the von Bonstettens and Peter Wirth, the Reverends of Kamo-wake-ikazuchi-jinja Shinto Shrine, the ladies of Warmun, Hamada, Aborega, Rasha, Mona, Mubarak, and the Sudanese community of The Jungle in Calais.

Friends, fellow travelers, and dinner companions who helped along the way: Gastón Acurio, Danny and Anna Akaka, Marcela Baruch, GSN Bhargava, Sugan and Vijay Bedla, Max Broquen, Paula Fitzherbert, Gunnar Karl Gíslason, Svala Ólafsdóttir and Siggi Hall, Sakiko and Takeshi Hasegawa, Baldvin Jonsson, Donna Kimura, Vijay and Sulaiman Khan, Akemi Koyama, Agustin Leone, Rafael Micha, Paola Miglio, Inui Mitsutaka and Teruo Muramatsu Lloyd Nakano, Jane Newman, Nancy Novogrod, William Ole Siara, James Oseland, Adam Sachs, Sharon Sakai, Patricia Tam, Sheila Donnelly Theroux, Philip Treacy and Stefan Bartlett, Anna Trzebinski, and the 3 Idiots. Also Hiroki Fukunaga of Luxury Ryokan Collection, Will Jones and Angela Sacha of Journeys by Design, Bertie and Victoria Dyer of India Beat, Robyn Bickford and Manav Garewal of The Lodhi, Nikhilendra Singh of Raas Hotels, Kaushika and Shakti Kumari of Diggi Palace, All Nippon Airways, Icelandair, Japan National Tourism Organization, the Hawai'i Visitors Bureau, Maybourne Hotels, Grupo Habita, Ritz-Carlton Kyoto, Grand Hyatt Kyoto, Inkaterra La Casona, Mauna Kea Beach Hotel, Four Seasons Hualalai, and Vik Retreats.

Gentle readers George Hager, Susan Hager, Nelson Mui, Pat Nourse, Penelope Partlow, Constance Umberger, and Marietta von Bernuth.

My editors, past and present, at *Saveur*, who gave me license to roam.

Colleagues Andrea Nguyen and Anya von Bremzen for their enthusiastic encouragement during the hunt for the right publisher.

Ten Speed Press publisher Aaron Wehner for having the vision to publish this project. Editor Kaitlin Ketchum and designers Margaux Keres and Rita Sowins for shepherding me through the process with patience and flair.

Photographer James Fisher for riding shotgun in countries with the wheel on the left and driving skills in countries with the wheel on the right.

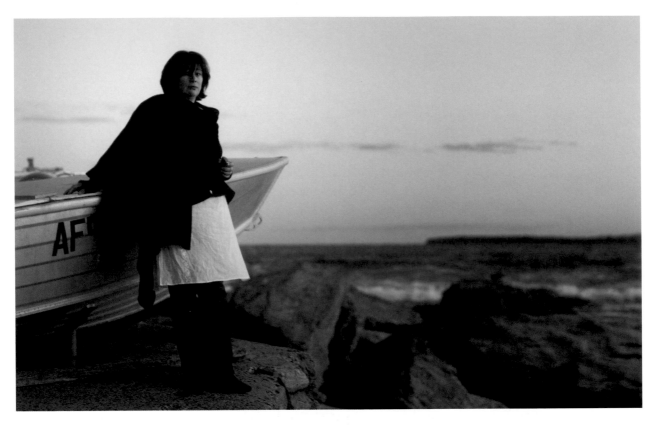

ABOUT THE AUTHOR & PHOTOGRAPHER

SHANE MITCHELL is a *Saveur* contributing editor. She writes about food and culture for *Australian Gourmet Traveller*, *The Bitter Southerner*, *Departures, Serious Eats*, and other publications. She is a James Beard Foundation Award finalist, has been awarded the IACP Culinary Writing prize, and collects handmade knives wherever she travels. She lives in New York state's North Country.

JAMES FISHER an Australian portrait photographer and film director based in London. His editorial client list includes *Vanity Fair*, *L'Uomo Vogue*, *Saveur*, *Travel+Leisure*, *Vogue Living*, and *Empire*. Commercially his focus is on film and entertainment advertising, tourism, and travel photography, and his commercial clients include Tourism Australia, 20th Century Fox, Warner Bros, Disney Pictures, and NBC Universal. James's work with refugees in Europe forms part of his wide global portraiture project investigating the personal experiences of displaced and marginalized populations.

INDEX

Map on pages 10–11 courtesy of Shutterstock.
Library of Congress Cataloging-in-Publication Data

Names: Mitchell, Shane, 1957- author. | Fisher,
James, 1976-photographer.

Title: Far afield : rare food encounters from around
 the world / by Shane Mitchell ; photographs by
 James Fisher.
Description: Berkeley : Ten Speed Press, 2016. |
 Includes bibliographical references and index.
Identifiers: LCCN 2016012457 (print) | LCCN
 2016020966 (ebook)
Subjects: LCSH: International cooking. | Mitchell,
 Shane, 1957—Travel. | Travel photography. |
 BISAC: COOKING / Regional & Ethnic
 / International. | COOKING / Essays. |
 PHOTOGRAPHY / Photoessays & Documentaries. |
LCGFT: Cookbooks.
Classification: LCC TX725.A1 M5375 2016 (print) |
 LCC TX725.A1 (ebook) | DDC
641.59—dc23
LC record available at
 https://lccn.loc.gov/2016012457

Hardcover ISBN: 978-1-60774-920-2
eBook ISBN: 978-1-60774-921-9

Printed in China

Cover design by Margaux Keres
Design by Rita Sowins / Sowins Design

10 9 8 7 6 5 4 3 2 1

First Edition

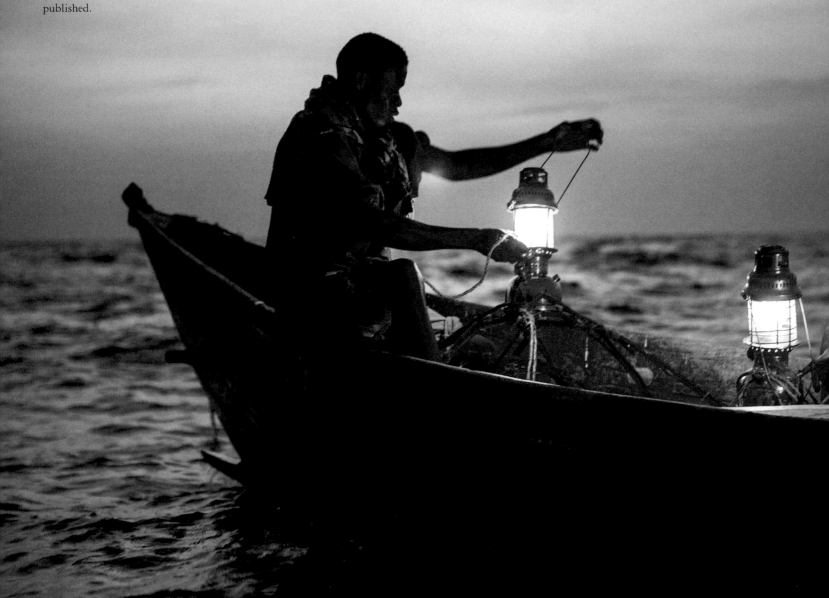